W9-DFL-641

METROPOLITAN LIVES

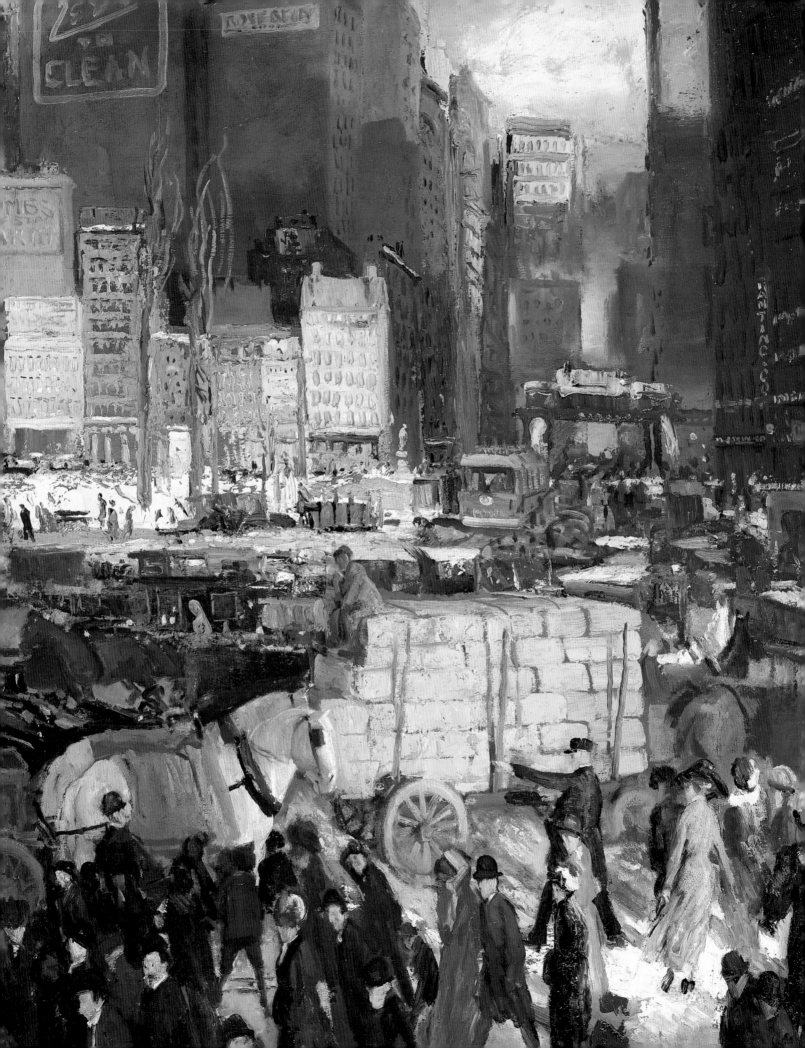

METROPOLITAN LIVES

THE ASHCAN ARTISTS AND THEIR NEW YORK

REBECCA ZURIER

ROBERT W. SNYDER

VIRGINIA M. MECKLENBURG

NATIONAL MUSEUM OF AMERICAN ART

IN ASSOCIATION WITH

W. W. NORTON & COMPANY, NEW YORK • LONDON

Published on the occasion of the exhibition *Metropolitan Lives: The Ashcan Artists and Their New York,* organized by the National Museum of American Art, Smithsonian Institution.

Curators: Rebecca Zurier, Robert W. Snyder, Virginia M. Mecklenburg
Research Assistant: Julie Aronson
Project Assistants: Kelly A. Johannes, Carol A. Dickson

This book and the accompanying exhibition were made possible in part by generous gifts from the William R. and Nora H. Lichtenberg Foundation, the Overbrook Foundation, and Mr. and Mrs. Richard J. Schwartz. The Smithsonian's Special Exhibition Fund also provided significant assistance. Preliminary funding was provided by the Smithsonian's Scholarly Studies Fund.

National Museum of American Art
Washington, D.C.
November 17, 1995–March 17, 1996

© 1995 by the National Museum of American Art, Smithsonian Institution. All rights reserved. No part of this publication may be reproduced or transmitted in any form or by any means, electronic or mechanical, including photocopy, recording, or any other information storage and retrieval system without permission in writing from the National Museum of American Art.

Editor: Janet Wilson
Editorial Assistant: Abigail Grotke

The National Museum of American Art, Smithsonian Institution, is dedicated to the preservation, exhibition, and study of the visual arts in America. The museum, whose publications program also includes the scholarly journal *American Art,* has extensive research resources: the database of the Inventories of American Painting and Sculpture, several image archives, and a variety of fellowships for scholars. The Renwick Gallery, one of the nation's premier craft museums, is part of NMAA. For more information or a catalogue of publications, write: Office of Publications, National Museum of American Art, MRC-210, Smithsonian Institution, Washington, D.C. 20560. NMAA also maintains a gopher site at **nmaa-ryder.si.edu** and a World Wide Web site at **http://nmaa.si.edu**. For further information, send e-mail to **NMAA.NMAAInfo@ic.si.edu**.

Library of Congress Cataloging-in-Publication Data
Zurier, Rebecca
 Metropolitan lives: the ashcan artists and their New York/Rebecca Zurier, Robert W. Snyder, Virginia M. Mecklenburg.
 p. cm.
 National Museum of American Art, Washington, D.C., November 17, 1995–March 17, 1996.
 ISBN 0-393-03901-3 (cloth)—ISBN 0-937311-27-8 (paper)
 1. Ashcan school of art—Exhibitions. 2. Eight (Group of American artists)—Exhibitions. 3. Art, Modern—20th century—United States—Exhibitions. 4. New York (N.Y.) in art—Exhibitions. I. Snyder, Robert W., 1955– . II. Mecklenburg, Virginia M. (Virginia McCord), 1946– . III. National Museum of American Art (U.S.) IV. Title.
 N6512.5.E4Z87 1995
 760'.09747'1074753—dc20 95-19609
 CIP

Frontispiece: George Bellows, *New York* (detail), 1911, oil on canvas, 106.7 x 152.4 cm (42 x 60 in.). National Gallery of Art, Washington, D.C., Collection of Mr. and Mrs. Paul Mellon

Front cover: John Sloan, *Pigeons* (detail), 1910, oil on canvas, 66 x 81.3 cm (26 x 32 in.). The Hayden Collection, Courtesy, Museum of Fine Arts, Boston

Back cover: George Bellows, *Men of the Docks*, 1912, oil on canvas, 114.3 x 161 cm (45 x 63 ½ in.). Maier Museum of Art, Randolph-Macon Woman's College, Lynchburg, Virginia, First purchase of the Randolph-Macon Art Association, 1920

CONTENTS

FOREWORD

In the first years of the twentieth century, America's poets and painters located the pulse of the nation in New York City. The rhythm of daily life in the city's streets and parks, markets and harbors, developed a syncopated beat as the differing paces of people's activities overlapped in new public places.

Just a few years earlier, the center of culture in the United States was still an open competition. Nation-building, with its westward thrust along emigrant trails and railroad lines, had preoccupied Americans for decades, so that civilization—the conventions and expressions of our social interactions—scarcely had time to take root, much less flourish. But in 1889 and 1890 North and South Dakota, Montana, Washington, Idaho, and Wyoming all entered the Union, marking the end of expansion to the Far Northwest and suggesting that the slower process of nurturing communities and culture would now begin. Increasingly, images of "purple mountain majesties" and "amber waves of grain" would come to symbolize the nation's past. The best visual expression of its future would have to be a city.

Washington, D.C., was never a serious contender for the role of cultural capital. In the 1890s it remained a provincial district dedicated solely to federal government, without having achieved a culture that could rise to any claim of being truly national.

Perhaps the strongest bid in the early 1890s was from Chicago. If Washington was "centered" among the early colonies, Chicago could claim to occupy the geographic midpoint of the newly continental nation, or at least the most westward industrial star on the map. A burgeoning hub of trade, industry, and capital, and a destination for many immigrants, it seemed to combine frontier energy and urban ambition. Chicago was selected as the site of the 1893 World's Fair—eclipsing New York City—because it mounted a stronger proposal than any other city and guaranteed to raise all the funding from private rather than government sources.

At that landmark World's Fair, historian Frederick Jackson Turner read his influential thesis about the "closing" of the American frontier. The most popular painting in the American Section of the Fine Arts Palace was Thomas Hovenden's *Breaking the Home Ties*, depicting a young man taking leave of his family and rural home. For the thousands of visitors who were moved by this sentimental picture, it seemed emblematic, evoking the migration of young people both from the country to the city and from the old countries of Europe to the United States.

Both migrations finally tipped the balance in favor of New York City as the nation's culture capital, the city where what would be the future for most Americans was already on display as the present. New York had attracted many artists even before the Civil War, being one of the few cities offering formal art instruction, but it was not until the 1880s and 1890s that the city itself became a primary subject of their work.

In those decades, a generation of American painters including Childe Hassam and William Merritt Chase discovered the pictorial potential of New York's avenues, skyscrapers, squares, parks, and churches. Filtering their

impressions through a French aesthetic and emphasizing urban design and architecture rather than the city's inhabitants, they allied their art to the formal conventions of nineteenth-century academies.

It was, then, the Ashcan artists who anointed New York as America's "shock city" of the future; Walt Whitman was their prophet. Their insight was to reverse the formula of the previous generation of New York painters, placing the unstructured dynamic energy of the people at center stage and relegating designed urban spaces to background settings. Through this simple reversal, they gave the city—and American life in general—the appearance of excitement, opportunity, and casual ease, inviting ordinary people to participate in the nation's future.

Metropolitan Lives traces this development through the insights of three scholars. Rebecca Zurier, assistant professor of American art at the University of Michigan, has brought her extensive expertise in the history of magazine illustration and urban politics to the study of these artists who celebrated New York's "new masses." Robert W. Snyder, managing editor of the *Media Studies Journal* published by the Freedom Forum Media Study Center at Columbia University and a social and cultural historian, traces in broad strokes the dizzying transformation of a great city still in its infancy by the standards of world history. Virginia Mecklenburg, chief curator of the National Museum of American Art and

coordinator of the exhibition that accompanies this book, traces the reaction of contemporary critics and journalists to the Ashcan artists, helping us understand how closely they touched both the nerves and heartbeat of the city and the nation.

It is intriguing to speculate on the reasons why the Ashcan artists' portrait of New York holds such a special place in our affections. In part, of course, it is the timeless appeal of an optimistic vision, but it also suggests the power of symbols to animate and inspire. New York became a point of pride for all Americans; its social diversity, rough politics, and competing cultures stood for our strengths and ambitions. As we look toward the turn of another century, our collective dreams no longer seem so securely identified with a single place. Will Los Angeles or Miami, with their new demographics, become America's "shock city" for the next century? Will Seattle emerge as the sleek center of a new information age? From our vantage point today, it is hard to see how any single city could embody national ambitions with quite the same exuberance announced by the artists presented in this book. If the Ashcan artists' New York looks especially appealing, it is because they caught the high spirits of an age when everything seemed possible.

Elizabeth Broun
Director
National Museum of American Art

ACKNOWLEDGMENTS

We are deeply grateful to the lenders, public and private, whose willingness to share their treasures has made the exhibition possible, and to Julie Aronson, our research assistant, whose collaboration on this project was crucial in all phases of the book and the exhibition. For their help with loans and photography, we would especially like to acknowledge Warren Adelson and Susan Mason, New York; Susan Faxon and Jock Reynolds, Addison Gallery of American Art, Phillips Academy; John Lancaster, Amherst College Library; Sinclair Hitchings, Boston Public Library; Linda Ferber and Barbara Gallati, Brooklyn Museum; Tom Hinson, Cleveland Museum of Art; Ted Cooper, Washington, D.C.; Richard Strassberg, Cornell University; Nancy Rivard Shaw and James W. Tottis, Detroit Institute of Arts; Steve Nash and Mark Simpson, Fine Arts Museums of San Francisco; Arthur Goldstone, New York; Anne-Louise Marquis and Phyllis Rosenzweig, Hirshhorn Museum and Sculpture Garden; Vance Jordan, New York; Janet L. Farber, Joslyn Art Museum; Carole Pesner and Katherine Kaplan, Kraushaar Galleries; Mary Lublin, New York; Ellen Agnew and Sarah Cash, Maier Museum of Art, Randolph-Macon Woman's College; Susan Danly, Mead Art Museum, Amherst College; Kevin Avery, Ida Balboul, and Della Clason Sperling, Metropolitan Museum of Art; Martha Mayberry, Mint Museum; Mary Murray and Paul Schweizer, Munson-Williams-Proctor Institute, Museum of Art; Jorge Santis, Museum of Art, Fort Lauderdale; Charles McGovern, National Museum of American History; Joseph Jacobs, Newark Museum; Glenn C. Peck, H. V. Allison Galleries; Richard Samuel West, Periodyssey; Bennard Perlman, Baltimore; Elizabeth Turner, Eliza Rathbone, and Erika Pasantino, The Phillips Collection; George Neubert and Daphne Deeds, Sheldon Memorial Art Gallery, University of Nebraska; Clyde Singer, Youngstown, Ohio; Debra Bernhardt, Tamiment Institute, Elmer Holmes Bobst Library, New York University; Scott Atkinson, Terra Museum of American Art; Elizabeth Kornhauser, Wadsworth Atheneum; and Jules Prown, Yale University. A special note of appreciation to kindred spirits Jan Seidler Ramirez, Leslie Nolan, Peter Simmons, Marty Jacobs, Terry Ariano, and Marguerite Lavin at the Museum of the City of New York and to Mrs. John C. Leclair, Jean Bellows Booth, and Helen Farr Sloan for their support and cooperation.

Ellen Todd, Roy Rosenzweig, and Jack Rachlin kindly consented to read the first draft of the manuscript. We especially appreciate their advice and recommendations. We are deeply grateful to the William R. and Nora H. Lichtenberg Foundation, the Overbrook Foundation, and Mr. and Mrs. Richard J. Schwartz for their generous gifts in support of the exhibition. Special thanks go to the Smithsonian for institutional support through the Scholarly Studies Fund and the Special Exhibition Fund, which awarded grants for both planning and implementation, and especially to Barbara Schneider for her encouragement.

Within the Smithsonian, we are deeply grateful to our colleagues at the Archives of American Art, especially Judy Throm, for continued expert assistance. Pat Lynagh, Joann Hartzell, Kim Clark, and Cecilia Chin of the National Museum of American Art and National Portrait Gallery library have provided

excellent guidance in our search for materials. Robert S. Harding, Fath D. Ruffins, and other members of the staff at the Archives Center, National Museum of American History, have assisted us with the fascinating search through sheet music and advertising materials. We are deeply grateful to Kelly Johannes, Carol Dickson, and Lara Scott of NMAA's curatorial office and to intern Deborah Freund. Their help has been essential to the project's completion. To paper conservators Kate Maynor and Fern Bleckner, thanks for assistance with mounting archival materials. Melissa Kroning, Patti Hagar, Michael Smallwood, Courtney DeAngelis, and Gene Young of the registrar's office have assisted immeasurably in securing loans, arranging photography, and planning the exhibition. Claire Larkin and Val Lewton of the NMAA design and production office have envisioned an exhibition that is beautiful as well as informative, and Charles Robertson, deputy director, has brought his exceptional administrative abilities to all phases of the project. Janet Wilson, editor extraordinaire, brought sensitivity and insight as well as expert editorial skills to the book.

Rebecca Zurier would like to extend special thanks to Cynthia and Charles Field, Richard Hilker, Dr. and Mrs. Harold Kirschner, Steve Winnett, and Laura Knoy for their kindness and hospitality. For stimulating discussions she is grateful to Elizabeth Blackmar, Robert Haywood, Elizabeth Milroy, Joan Morris, Nesta Spink, Ellen Todd, and students in the Ashcan School Seminars at the University of Pennsylvania, Syracuse University, and the University of Michigan. For research assistance above and beyond the call of duty, she thanks Paul Buhle, Francis Couvares, Naomi Sawelson Gorse, Ellen Grayson, Robin D. G. Kelley, and Sarah Zurier. Robert Snyder also thanks Peter Eisenstadt, Elaine Abelson, Josh Brown, and James W. Carey for their helpful suggestions.

We all wish to express appreciation to our families: Clara Hemphill and Max, Tom Willette, Marion and Edward Mecklenburg.

Rebecca Zurier
Robert W. Snyder
Virginia M. Mecklenburg

METROPOLITAN LIVES

REBECCA ZURIER AND ROBERT W. SNYDER

INTRODUCTION

In a city park a military recruiter and some strolling women size up a potential soldier. Onstage an exotic dancer seizes her audience with a glance that is both cool and provocative. Children of the tenements play in the streets, inches away from the hooves of draft horses. Greenhorn immigrants and their American cousin gab with pushcart peddlers.

All are scenes from everyday life in New York City during the late nineteenth and early twentieth centuries; all are images produced by the Ashcan School—six artists who moved to New York City around the turn of the century to create art rooted in the "real life" of their time. They were never a formal school, and their title was applied only in retrospect.[1] Nevertheless, their work presents a distinctive vision of urban life that was concerned with the people of the city and inspired by its commercial energy. In broadly brushed paintings and graphic works rendered with vigor and wit, they forged a contemporary form of realism that conveyed partial but real truths about New York City, its mosaic of communities, and the complexities of life and art in a diverse city where most people were strangers to one another.

Unlike their contemporaries who celebrated the architectural developments that transformed Manhattan's skyline in these years, the Ashcan artists approached New York at street level and engaged the equally new social trends that were changing the daily life of the city: immigration, advertising and mass communication, popular entertainment, shifting gender roles, the opulent display of high society. Their pictures mapped out new territory for American art by identifying moments of interaction between the people of the city and its massive culture of commerce.

The members of the Ashcan School are best understood as New York artists. The dynamics of urban change were essential to the force and complexity of their art, which was largely a response to the challenge of representing a tumultuous era in the city's history. These six men, who moved to New York in pursuit of careers, were part of the same trends that attracted immigrants from all over the world and Americans from the heartland, who together transformed the city. Their individual voices reveal six related but distinct approaches to a problem faced by all New Yorkers, that of trying to understand life in a changing metropolis. Their pictorial solutions still speak to issues that characterize living and making art in a dynamic, turbulent, and heterogeneous city.

Many artists in Europe and America experimented with this subject in the early years of this century. The French impressionists, particularly Edgar Degas and Édouard Manet, had pioneered the painting of modern urban life, and by 1900 there were artists in most major cities who depicted their contemporaries at work and at leisure. In New York Jerome Myers made colorful but sentimental paintings of immigrant neighborhoods, while Alfred Stieglitz created a new form of artistic photography with his atmospheric images of New York streets.[2] A few years later, Fernand Léger in Paris, the German Expressionists, and the Futurists in Italy would paint fantastic visions of the twentieth-century metropolis.

The Ashcan artists—George Bellows, William Glackens, Robert Henri, George Luks, Everett Shinn, and John Sloan—made New

Everett Shinn, *Cross Streets of New York* (detail), 1899, charcoal, watercolor, pastel, white chalk, and chinese white on paper, 55.3 x 74.3 cm (21 ⅝ x 29 ¼ in.). Corcoran Gallery of Art, Gift of Margaret M. Hitchcock by exchange (see fig. 69)

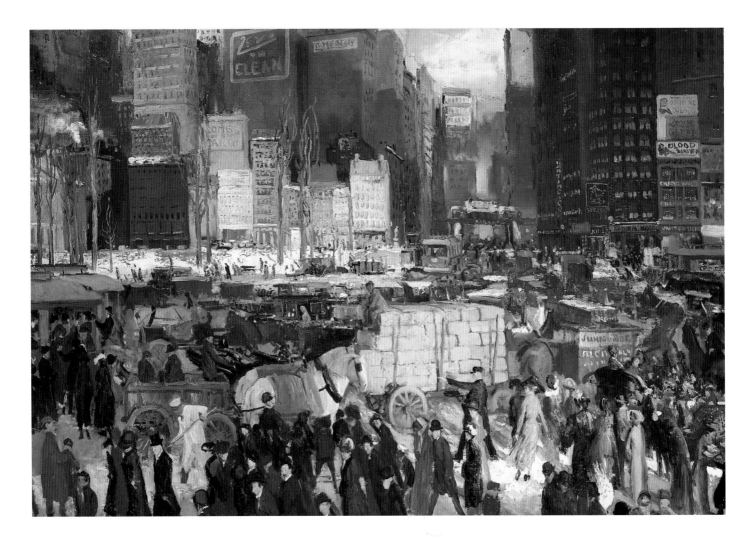

Fig. 1
George Bellows, *New York,* 1911, oil on
canvas, 106.7 x 152.4 cm (42 x 60 in.).
© 1995 Board of Trustees, National
Gallery of Art, Washington, D.C.,
Collection of Mr. and Mrs. Paul Mellon

York their own by interpreting the city from a distinctive viewpoint during the years between 1897 and 1917. They exchanged ideas, collaborated on projects, and shared artistic beliefs. All were intimately acquainted with journalistic illustration and its claims to represent reality. All of them admired Walt Whitman, a former newspaperman whose poetry celebrated the lives of ordinary Americans. All of them were less inclined to paint the skyscraper than the people who built it. Filled with references to specific places and social practices, their art emphasized the street scene over the distant panorama, the particular over the universal.

Metropolitan Lives situates the art of the Ashcan School within the social and cultural currents that characterized New York at the turn of the twentieth century. Because the artists sought to integrate art and experience,

this book considers how their work represented aspects of the urban life that inspired it. All six artists were newcomers to the city, and their work reveals experiences common to most New Yorkers at the time: the challenge of making sense out of encounters with strangers in a city of unprecedented scale and heterogeneity (figs. 1 and 2). They lived and worked in an era when mass-produced images played an increasingly important role in defining the city and introducing its inhabitants to each other. The many guidebooks, plays, movies, maps, and illustrated articles about New York that proliferated during the period are part of the same trend and form an integral part of this study.

The artists had other goals as well: to create an art that spoke to contemporary viewers and to make images that gave the transitory experience of the city memorable form. They

transmitted these local images to the rest of the country and around the world to create an urban iconography that still represents New York. One need only compare the art in this book to feature photographs in today's *New York Times* to see its lasting impact.

Metropolitan Lives looks at how turn-of-the-century New York influenced the artists' work, and what their work tells us about the experience of living in the city at that time. The book is organized around the topics of greatest concern to the artists and their fellow New Yorkers: the changing geography of the city, the disparity between wealth and poverty, the city's ethnic populations and neighborhoods, the public display played out in streets, parks, squares, and stores, commercial entertainment—from shopping to theatergoing—and the changing relationship between men and women. Within each section of the exhibition on which this book is based, viewers can compare the interpretations of a subject by the artists and also examine its representation in other forms ranging from social-science survey reports to popular films. At times these images display surprising similarities, showing just how topical Ashcan School art could be. In other cases, the differences reveal the artists' evasions, predilections, or prejudices. And some comparisons suggest the artists' insights into matters overlooked by other observers.

For all their differences, the Ashcan artists shared certain traits. One was a preference for looking at the city from the ground up, as John Sloan did in a 1909 painting later inaccurately titled *Recruiting, Union Square* (fig. 3). It is set in Madison Square Park in the shadow of the Metropolitan Life Insurance Building, then the tallest building in the world: forty-five stories crowned with a roof and cupola modeled after the campanile at the cathedral of San Marco in Venice.[3] More than four thousand people were employed in the insurance-company offices. To ensure the highest standards of efficiency and respectability, men and women worked in largely segregated areas, with separate entrances,

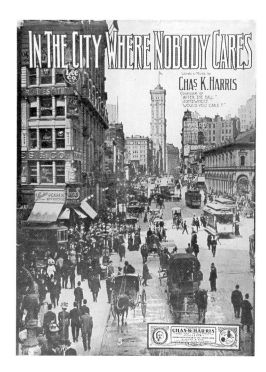

elevators, offices, and dining facilities. All of the cashiers were men; all of the stenographers were women, who dressed uniformly in neat white blouses and aprons over black skirts. The building itself became a popular tourist attraction. Visitors rode elevators to the roof garden to enjoy a view that extended for miles and bought postcards that presented the building as a symbol of modern organization (figs. 4 and 5).

As the Metropolitan tower neared completion, Sloan made a painting based on an incident he had observed in Madison Square. Like many Ashcan images, it refers to a new development: the U.S. Army had recently begun a campaign to increase its forces by setting up this sort of display in several New York City parks (fig. 6). Densely painted in thick strokes that suggest "trees heavily daubed with fresh green," Sloan's *Recruiting* shows a shaded pathway lined with benches filled with people. At the center, a sharply dressed soldier talks with a potential recruit whose soft cap and wrench identify him as a laborer. His rumpled clothes and slouching posture contrast with the recruiter's spit-and-polish bearing.

This central cluster of figures is balanced by two others: in the foreground, two children

Fig. 2
"In the City Where Nobody Cares,"
© 1910, sheet-music cover. Sam DeVincent Collection of Illustrated American Sheet Music, National Museum of American History, Smithsonian Institution

The idea of New York as a "city where nobody cares" was grounded in the sense that it was a vast, impersonal metropolis. At their most incisive, however, the Ashcan artists illuminated the many neighborhoods where everyday life was distinguished by close knowledge of neighbors and immediate surroundings.

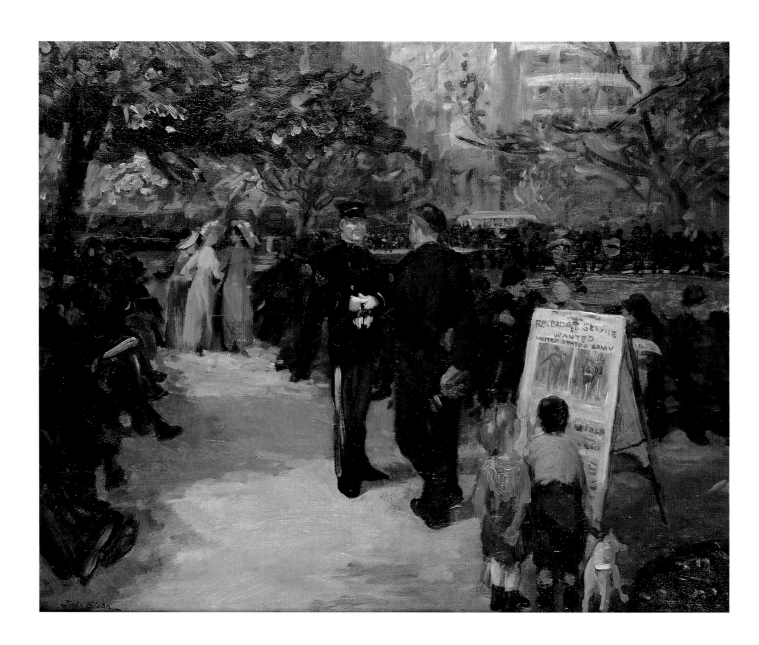

Fig. 3

John Sloan, *Recruiting, Union Square,*
1909, oil on canvas, 66 x 81.3 cm (26
x 32 in.). The Butler Institute of Ameri-
can Art, Youngstown, Ohio

Sloan lived around the corner from Madi-
son Square, on Twenty-third Street. He
described the origins of the painting in
diary entries for May 1909: "Read some
of Whitman's 'Song of Myself.' Then out
for a walk in the sunshine. . . . Sat in
Madison Square. . . . I saw a mother
explaining to her little son (about six
years) the vastness of the Metropolitan
Insurance Building tower. He was not

apparently impressed!" "Loafed about
Madison Square where the trees are
heavily daubed with fresh green and the
benches filled with tired 'bums.' In the
center near the fountain is a U.S. Army
recruiting sign, two samples of our mili-
tary are in attendance but the bums stick
to the freedom of their poverty. There is
a picture in this—a drawing or etching,
probably." Although clearly painted in
Madison Square, the picture became
known as Recruiting, Union Square *at*
some later date.

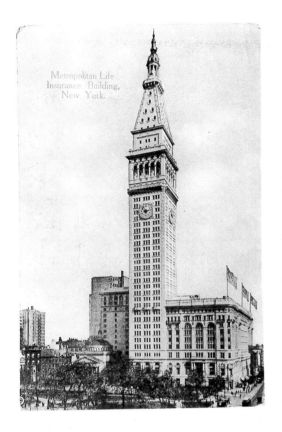

Metropolitan Life Insurance Building, New York.

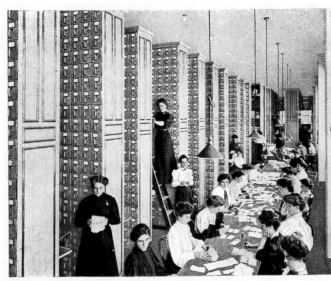

Metropolitan Life Insurance Co.'s Home Office Bldg., N.Y.City. Glimpse of the Filing Section. The largest outfit of steel filing cases in the world.

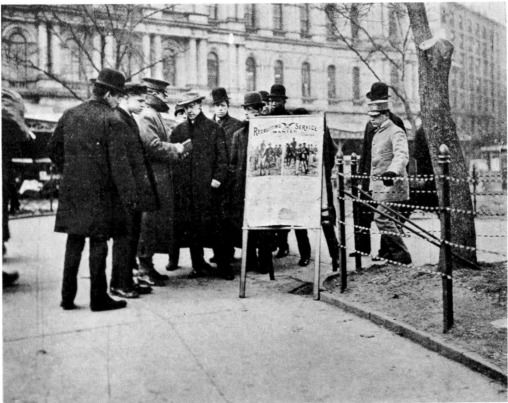

Fig. 4
Metropolitan Life Insurance Building, New York, 1910, postcard. Museum of the City of New York

Fig. 5
Metropolitan Life Insurance Co.'s Home Office Building, New York City. Glimpse of the Filing Section, undated, postcard. Museum of the City of New York, Gift of Donald Beggs

Fig. 6
A New Plan: Scouting for Recruits in City Hall Park, New York, from Victor Rousseau, "Wanted: Soldiers, An American Army Problem," *Harper's Weekly* 52 (21 March 1908): 10

When it opened in 1909, the Metropolitan Life Insurance Building was the tallest in the world, and its collection of steel filing cabinets was the largest anywhere. The filing system was part of the new bureaucratic organization of corporations headquartered in New York. Below the towering building was Madison Square Park, one of the city parks frequented by military recruiters. The enlistment benefits identified in the recruiting poster—"board, lodging, clothing, baths"—attracted men battered by poverty and economic insecurity.

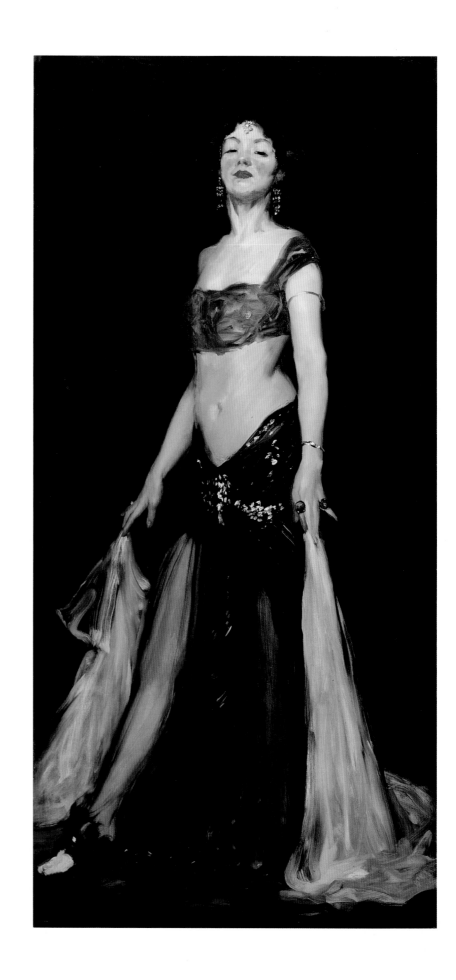

Fig. 7
Robert Henri, *Salome,* 1909, oil on
canvas, 195.6 x 94 cm (77 x 37 in.).
Mead Art Museum, Amherst College,
Massachusetts, Museum purchase,
1973.68

stop to read a garish recruitment poster, as their small dog pulls impatiently on his leash; farther up the path, three women in pastel-colored dresses and elaborate hats stand talking. One turns to look back at the recruit, who may return her glance from the corner of his eye. All around them, people on the benches are reading newspapers, chatting, or dozing, apparently oblivious to the efforts of the recruiter and his display. The Metropolitan Life tower is nowhere to be seen. Instead, the picture focuses on the varied stories of the people in Madison Square. Sloan's painting emphasizes the energy of human interaction in one of the public spaces of New York, not the muscle-bound strength of the city's gigantic buildings and corporate institutions. Rather than celebrating the Metropolitan Life Building, it examines metropolitan lives.

As Sloan was completing *Recruiting*, his friend Robert Henri was at work on a new painting, *Salome* (also known as *Salome Dancer*), that would jolt American conceptions of what fine art should be (fig. 7). This painting was also characteristic of the Ashcan School, with its combination of overt sensuality and traditional literary references mixing high and low culture, popular and refined tastes.

Henri had hired a professional dancer known as Mademoiselle Voclezca to pose as Salome performing the dance of the seven veils.[4] His painting presents the dancer just at the moment when she pauses to thrust her torso forward, grasping the veils at each side, and stares haughtily at her audience. In 1910 Henri submitted the painting to the spring annual exhibition of the National Academy of Design; the jury promptly rejected it, despite the fact that Henri was an academician of long standing. Sloan was not surprised. In his diary he noted "the Salome Dancer with naked legs. Of course the last was too much for them."[5]

What exactly was "too much" about this painting in 1909 and 1910? Probably not the "naked legs" alone, since the National Academy exhibitions had traditionally included full-length nudes. Richard Strauss's opera *Salome*, a portrayal of the biblical temptress who demanded the head of John the Baptist, had been banned several years earlier, but it had recently been staged in New York to critical acclaim. Within a few years Henri Regnault's painting of the biblical Salome, posed by a Mediterranean peasant girl, would be bought for a record sum by an American collector and donated, with great fanfare, to the Metropolitan Museum of Art (fig. 8). Could the jury have objected to a subject from the contemporary stage? Not if they compared the painting to John Singer Sargent's well-regarded portrait of the actress *Ellen Terry as Lady Macbeth*, done in 1889, which presents another full-length femme fatale who fixes the viewer with a provocative stare.[6]

But these were not the only associations that occurred to viewers around 1910. At the time Henri was painting his picture, at least a dozen other "Salome dancers" had recently performed in New York City (fig. 9). Their appeal extended to all social groups and provoked strong reactions. Uptown, "La Sylphe" danced "The Remorse of Salome." Downtown, Eva Tanguay writhed on the floor in the Ziegfeld Follies of 1909. Everywhere, New Yorkers enjoyed an Irving Berlin song about "Sadie Cohen, who left home" to reinvent herself as Sadie Salomey, exotic dancer.

Socialites hired the entire cast of another *Salome* to restage their production at a private estate on Pelham Bay and invited friends out for a "Salome party." Critics complained of a "Salome epidemic." In variety theaters across New York, it seemed, "half-dressed women" were dancing with veils and "joyfully receiving a human head (in papier maché) on a platter." The actress Marie Cahill petitioned President Theodore Roosevelt to stop "such theatrical offerings as clothe pernicious subjects in a boasted artistic atmosphere, but which are really an excuse for the most vulgar exhibition that this country has ever been called on to tolerate."[7] It seemed that Salomes were everywhere but at the National Academy of Design. In rejecting Henri's painting, the jury made a

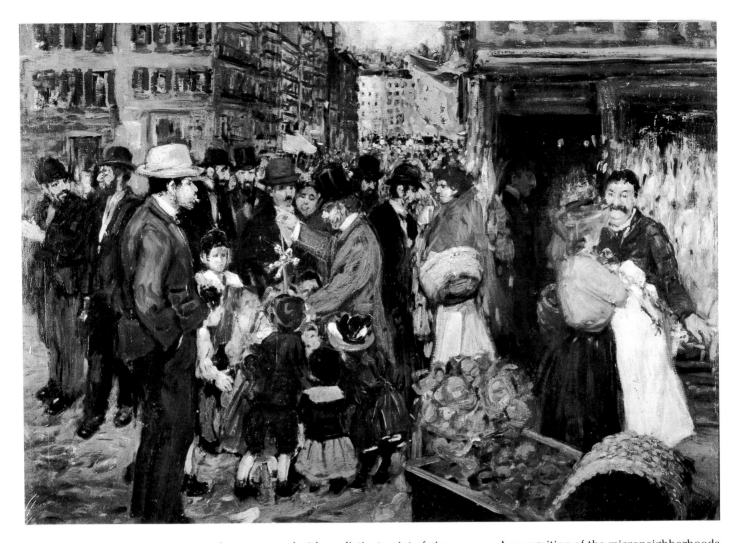

Fig. 10
George Luks, *Hester Street,* 1905,
oil on canvas, 66.3 x 91.8 cm (26 ⅛
x 36 ⅛ in.). The Brooklyn Museum,
New York, Dick S. Ramsay Fund

often composed with no distinct point of view
or emphasis; therefore, they render the urban
scene as much more chaotic than it appeared
to more directed observers, such as ordinary
pedestrians or artists, whose purposeful
activity compelled them to interpret and
order the urban scene around them. Byron
photographs of streets on the Lower East
Side document a wealth of information, from
the garbage on the pavement to the fashions
people wore. But the very abundance of de-
tail in these pictures can be confusing. Their
random compositions, in which views are
blocked and people walk out of the frame, can
make them almost illegible. Byron photo-
graphs depict the city as a place of random
chaos. Any urban dweller knows, however,
that the city has subtle and densely layered
systems of order and accommodation that
make it navigable and knowable.

A recognition of the microneighborhoods
and internal structures that define the city
was one of the distinguishing features of
Ashcan art, nowhere more evident than in
William Glackens's illustration *Far from the
Fresh Air Farm* (fig. 14). Glackens specialized
in taking crowd scenes that appeared in pho-
tographs as an undifferentiated blur and ren-
dering them in vivid detail. Many of his
drawings were made for general-interest mag-
azines; this one appeared in *Collier's* magazine
as a full-page illustration with the caption
"The crowded city street, with its dangers and
temptations, is a pitiful makeshift playground
for the children." The title makes an ironic
reference to turn-of-the-century social wel-
fare programs that provided rest and recuper-
ation for sickly slum dwellers and sponsored
rural vacations for inner-city children. Glack-
ens's drawing, however, presents its subject

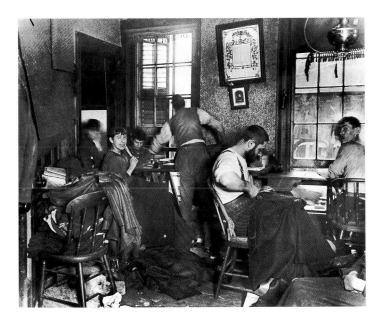

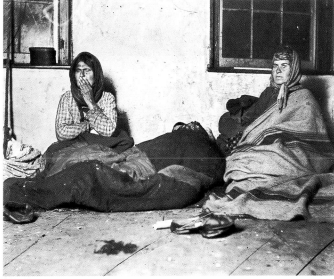

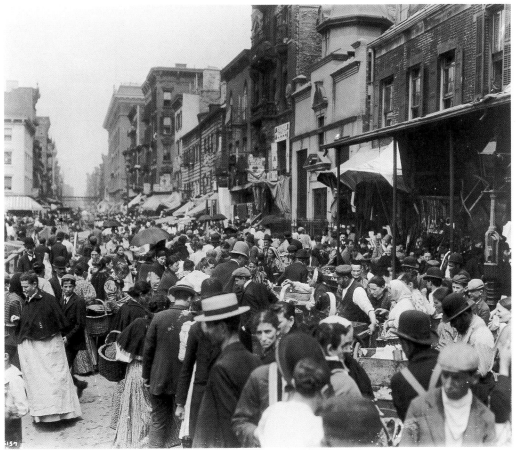

Fig. 11
Jacob Riis, *"Knee-Pants" at Forty-five cents a Dozen—A Ludlow Street Sweater's Shop*, ca. 1889. The Jacob A. Riis Collection, #149, Museum of the City of New York. Published in Jacob Riis, *How the Other Half Lives* (New York: Charles Scribner's Sons, 1891), 127

Fig. 12
Jacob Riis, *Police Station Lodging Room: two women*, ca. 1889, lantern slide. Museum of the City of New York

Jacob Riis's photographs of sweatshop labor in the tenements and makeshift accommodations for the homeless aroused criticism of poor working and living conditions in immigrant neighborhoods. His portraits of such communities also cast their inhabitants in a dubious light. Seeking to demonstrate that slum housing fostered a dangerous population whose disease and disorder could destroy the city, he executed his photographs to prove his point: some people were posed to look threatening; others were stiffly posed to make the subjects look passive or dull. Riis included these photographs in published books and articles and made some of them into lantern slides for use in public lectures.

Fig. 13
Hester Street, 1898. Museum of the City of New York, The Byron Collection

Fig. 14
William Glackens, *Far from the Fresh Air Farm,* 1911, carbon pencil and watercolor on paper, 64.8 x 43.2 cm (25 ½ x 17 in.). Museum of Art, Fort Lauderdale, Florida, Ira Glackens Bequest

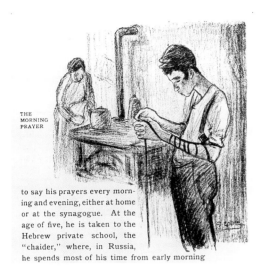

THE MORNING PRAYER

to say his prayers every morning and evening, either at home or at the synagogue. At the age of five, he is taken to the Hebrew private school, the "chaider," where, in Russia, he spends most of his time from early morning

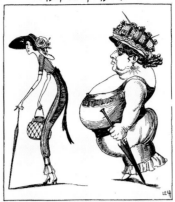

דער גרויסער קונדם

מאטקע חבר'ם קלייזעל

זיי פאהרען זיך "פיקסען"...

ביידע פאהרען זיי אין רערוועלכער קאונטרי זיך "פיקסען". אויב איינע וועט
געווינען דאס, וואס די צווייטע וועט פערלירען, וועלען זיי, מים גאט'ס הילף, ביידע
געהאלטען ווערען.

with an abundance of incident that strains the limits of a muckraking critique. His street on the Lower East Side is filled with figures, each of whom carries on a recognizable activity. The wealth of observed details in the architecture and signs synthesizes as much information as several photographs could show, including many things that Luks omitted from his street scene: we can read the slogans on the signboards and note the men carrying stacks of hats and bundles of clothing made in nearby sweatshops. Halfway up the street we see a reference to a common safety problem of the time: a pair of horses rears to avoid hitting children playing in the street. A look into the faces of the people in the picture, however, reveals schematic features and blank stares. Glackens's pictures remain distant from their subjects, showing little sympathy for people presented as foreign. Yet in the many little dramas depicted in these images Glackens does convey that New York is a city defined by multiple layers of human interaction, which no single narrative can adequately represent.

The sense of distance that is Glackens's weakness appeared in the work of other artists and observers of that era who might be expected to have closer ties to their immigrant subjects. The Jewish artist Jacob Epstein, who grew up on Hester Street, was praised for his "desire to paint his people

just as they are: to show them in their suffering picturesqueness."[12] His moving, solemn images of men praying and women working in factories suggest aspects of Lower East Side life unavailable in photographs and not evident in Ashcan School art (fig. 15). But they also play to preconceptions. Epstein's family prospered, and when he was fifteen his parents moved uptown to put as much distance as possible between themselves and the poverty of more recently arrived immigrants. When he revisited the Lower East Side as an art student, Epstein saw the area as a source of "artistic" material. His expressionistic drawings emphasize the difference between immigrants and assimilated Americans by stressing the pathos of the immigrants' lot.[13] For a more "indigenous" view we could look to the representations of Jews in the Yiddish-language press (fig. 16). These are often cartoons and present their subjects as caricatures, but they were thoroughly enjoyed by New York audiences. There was apparently no single, authentic insider's view of Hester Street, and none that could be called objective. Moreover, all of these images were produced by elites of a sort: individuals who chose to make art and to comment upon their peers.[14]

The social scientists who studied the Lower East Side at the turn of the century created another picture of the neighborhood with

Fig. 15
Jacob Epstein, *The Morning Prayer*, from Hutchins Hapgood, *The Spirit of the Ghetto* (New York: Funk & Wagnalls, 1902), 19

Fig. 16
Cartoon from *The Big Stick* 3 (23 June 1911): 11

This cartoon from a left-wing Yiddish satiric weekly shows one of the many ways that New York's Jewish immigrants caricatured each other. Ridiculing the latest American fashions and the women who presume to wear them, the cartoonist gives his subjects the same unflattering features found in other stereotyped images of Jews.

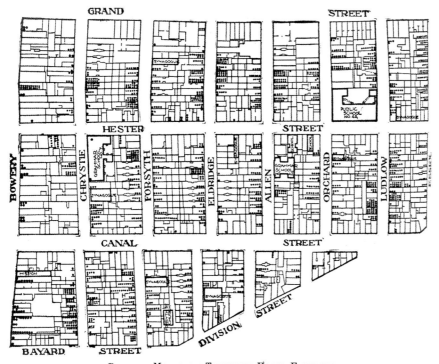

POVERTY MAP FROM TENEMENT HOUSE EXHIBITION.
Prepared by Lawrence Veiller.
Each dot represents 5 families who have applied for charity in 5 years, either to the Charity
Organization Society or to the United Hebrew Charities.

Fig. 17
Lawrence Veiller, Poverty Map from
Tenement House Exhibition, 1900.
Published in Robert W. DeForest and
Lawrence Veiller, *The Tenement House
Problem*, 2 vols. (New York: Macmillan,
1903), 1:114

graphs, charts, and statistics documenting lung disease and crowded living conditions. A map of Hester Street prepared in 1900 (fig. 17) indicates nine households per block receiving charity. Noting the correlation between poverty rates and tuberculosis, one report concluded that these figures "might well earn for New York City the title of City of Living Death."[15] Yet contemporary accounts and memoirs record not only illness, poverty, absent fathers, and overcrowded apartments but also play, community, childhood pranks, and proud parents.

This brief survey might tempt one to conclude that there was no objective representation of the Lower East Side, or perhaps no "real" Lower East Side at all. We would argue instead that there were many true versions of the place. Each of these representations reveals aspects of historical reality—the neighborhood's appearance as well as the artists' experience of it. The pictures in turn became part of the lived experience of the people who viewed them in their own time. Nor was there a single "artist's view": the six Ashcan School artists, although from similar ethnic and economic backgrounds, had at least six different ways of looking at the Lower East Side. In light of these observations, look again at Luks's *Hester Street*.

The painting emphasizes congestion. A row of buildings where the vanishing point should be blocks our view of the sky and pushes the crowd of people forward toward the viewer. Short, repeated brushstrokes suggest endless rows of windows and fire escapes and innumerable heads of people in the distance, packed together like the rows of chickens hanging in the shop window at the right.

Ranged across the middle ground are individual shoppers navigating through the crowd. Their faces are displayed in profile to emphasize the hooked noses that make all of them look alike. Yet within the group, some faces are ruddy, some sallow, some gaunt, some fleshy. The men strolling and talking and the group of children watching a peddler with a toy engage in leisure pursuits. But there are also signs of work in the activities of merchants selling and housewives buying groceries. In the foreground several full-length figures attract our attention and begin to suggest a story.

At left, a man stands smoking, his hands in his pockets. His white fedora and clean-shaven face set him apart from the other men, with dark hats and beards. He could be an outsider, or perhaps a resident—or former resident—who has taken on modern American ways: the younger brother who has changed his name and abandoned his mother tongue.[16] In the cluster of children gathered around the peddler we see a well-dressed boy in a black hat who has the traditional long sidelocks, standing opposite two shabbier children in knickers and straw hats. To the right, a woman in a pale blue blouse and fashionably trimmed hat is offset by a determined-looking woman in a red shawl who trudges in the opposite direction. The slender woman in blue bargains with the chicken seller, who looks at her with a proprietary air. The man in the white hat seems to take an interest in their negotiation. In each case a figure in American-

ized clothing is contrasted with people in traditional garb. In one concentrated image Luks suggests the dynamic process of social transformation and confrontation between old and new worlds that characterized New York's immigrant communities.

It would be difficult, and perhaps pointless, to label this image either optimistic or pessimistic, oppressive or carnival-like, nostalgic or forward-looking. It shows work *and* play, tradition *and* change, hardship *and* pleasure in tandem. In Ashcan School pictures, images of leisure are often set against a background of implied work, in recognition of the fact that recreation had to be carved out of the workweek and the space of the busy city. Parks are never separate from the urban fabric surrounding them; intimate conversations take place in the midst of a crowd.

Despite their informal appearance, Ashcan School pictures retain a sense of cautious distance from their subjects that seems different from the identification one might expect from an equal. As the novelist Toni Morrison has noted wryly, "Definitions belong to definers—not the defined."[17] Did the artists' projects create situations of unequal power that precluded a respectful understanding of the people in the pictures?[18] Before we decry Ashcan School art as objectifying, patronizing, or derogatory, or as a cynical attempt to play to a market, let us remember a few points. First, in New York at the turn of the century most people, including artists, were strangers to each other. In a way, Ashcan art repeats the experience of every urban dweller engaged in a constant process of defining or representing people he or she does not know. Second, the artists' curiosity about strangers had a tangible benefit: it forced the artists to meet real people whose humanity could, on occasion, confound their stereotypes.

Third, by translating these experiences into images, the artists called attention to subjects that had previously been overlooked or had never really been seen. The very act of making art could be a form of tribute to people whose lives had been hidden behind stereotypes or, even worse, ignored. At its best, Ashcan School art invites the viewer to be interested: to pay attention, to notice, and ultimately to acknowledge the people depicted. However limited and partial the view, the artists could be sharp-eyed observers of metropolitan lives.

Ashcan School pictures, so deeply embedded in the artists' experiences of a turn-of-the-century city, can help us think about the state of urban life today. As we watch Americans retreat from the public life of cities, we admire even more the vision of New York presented by the Ashcan School. It was shaped by the tensions of strangers from different social, economic, and ethnic groups trying to find a way to live together. At times the differences proved volatile or exploitative, but the mixture enriched all who participated by challenging them to create a polity where people from around the world could live, if not in harmony, at least in constructive toleration. Artists thrived in this environment, as ordinary but extraordinary citizens. Their view was not uncritical; they showed hardship, prejudice, and dislocation as well as exhilaration. But they regarded their fellow New Yorkers with curiosity rather than apprehension. Today their images of public spaces and chance encounters seem almost utopian. They can help us imagine a city in which people worked with great ingenuity to make themselves at home, a city where there was always something new to see and someone to see it with, a city where "What are you looking at?" did not always translate into fighting words.

ROBERT W. SNYDER

CITY IN TRANSITION

The greatest theater in New York has always been the theater of its streets, especially at the beginning of the twentieth century. The city that emerged was both coarse and inspiring. Tenements sprawled in the shadows of skyscrapers. Sidewalks rang with a symphony of languages. Street-corner socialists battled sweatshop tyrants. Bright lights illuminated nickelodeons and vaudeville theaters, the new temples of mass culture. Every age has, in the phrase of the British historian Asa Briggs, its "shock city"—the place that epitomizes the breaking trends of the era. As the twentieth century began, that city was New York. It was the country's biggest metropolis and capital of business, culture, and communication (fig. 18). Thanks to its dynamic economy and huge, polyglot population, transformations were bigger there than anywhere else. Thanks to its importance as a center for journalism, publishing, and entertainment, transformations in New York reverberated farther than those from anywhere else.

From the 1890s to the beginning of World War I, New Yorkers participated in a great drama: the creation of a city that would define urban life in America for the rest of the century. In their daily lives, all were part of the cast and part of the audience. These multitudes of people left a variety of written artifacts that record their perceptions of the time—newspaper and magazine articles, books, reports of social scientists, political speeches, poetry, plays, and more. Visual artifacts—photographs, films, illustrations, sheet music, and paintings—that capture how people saw the city are equally precious. Among the most memorable are the works of the artists

known as the Ashcan School—Robert Henri, William Glackens, George Bellows, George Luks, Everett Shinn, and John Sloan. These artists sought themes that mirrored their time and place: the creation of an urban ethnic culture in immigrant neighborhoods where a dozen languages were spoken, the glaring contrasts between the wealth of upper Fifth Avenue and the poverty of Cherry Street on the Lower East Side, the glitter of show business, the bustle of city streets, the construction of new public spaces, the encroachment of commerce into everyday life, and the ferment over the proper roles of men and women. When the Ashcan artists depicted twentieth-century New York in its formative years, they captured early expressions of themes that still define the city today.

If these artists achieved greatness, it was partly because they had a great subject to work with. The inescapable crosscurrents of culture, politics, and social change in New York City helped turn illustrators into artists. The highly public nature of life in the city—where everything from the rise of corporate headquarters to new roles for women could be observed on the streets—continually confronted them. If individuals define themselves through encounters with people who are different, then New York, in all its diversity, was the perfect city for the Ashcan artists, inspiring their visual representations of encounters with the city's complex humanity.

From 1890 to 1914 the city was a place of constant movement, but beneath a surface of seemingly random tumult surged two great currents: consolidation and diversification. Consolidation was strongest in the

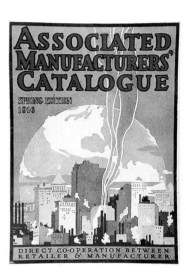

(opposite)
John Sloan, *Six O'Clock, Winter* (detail), 1912, oil on canvas, 66 x 81.3 cm (26 x 32 in.). The Phillips Collection, Washington, D.C., acquired 1922 (see fig. 91)

Fig. 18
Cover of the *Associated Manufacturers' Catalogue*, Spring 1916. Warshaw Collection of Business Americana, National Museum of American History, Smithsonian Institution

Illustrations like this one helped export to the rest of the nation an image of New York as a modern metropolis. New York City is presented as a world center of industry and merchandising.

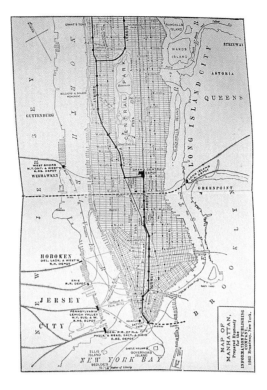

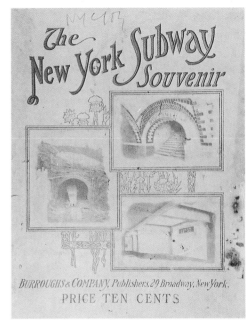

commanding heights of the city's economy, its transit system and buildings. The concentration of economic enterprises—particularly banks, factories, the stock market, and corporate headquarters—made major New York bankers, businessmen, and financiers uniquely powerful at national and international levels. In the wake of creating a city composed of five boroughs in 1898, New York constructed a mass-transit system that knit four of the boroughs into one functioning unit (figs. 19–21). Its built environment, the first skyscrapers and the expansion of apartment houses—as dwellings not just for the poor but also for the middle class and the rich—established patterns that would characterize the city for the rest of the century. The vertical city of the twentieth century replaced the horizontal city of the nineteenth, and New York became internationally recognized as the first great city to take on the physical form of a modern metropolis.

Diversification was strongest in the realms of culture. The throngs of immigrants were different from the city's natives as well as from each other. Despite efforts to "Americanize" them in schools and settlement houses,

they made New York a city where no one ethnic group could readily claim to represent the majority. Consumer culture created more leisure activities available to both men and women, which emphasized self-expression over self-control and eroded the rigidly defined gender roles of the nineteenth century. For natives and newcomers, as for men and women, identities were in a constant state of reformulation.

Yet the forces of consolidation and diversification spiraled back and forth in a fluid relationship, sometimes closely intersecting and sometimes far apart. The booking offices that managed New York's vaudeville houses and the editorial offices of New York's mass-circulation newspapers were clear examples of consolidation, concentrating cultural power and authority under one roof. They created cultural forms that could be shared by different elements of the population. But these vaudeville shows and newspapers, which sought to present something for everyone in a deeply divided city, unavoidably introduced new ways of thinking and feeling.

The subways linked the city's boroughs but at the same time spurred the construction

Fig. 19
Information Publishing Company, Map of Manhattan, from *The Week in New York* (8–14 January 1904). Library of Congress, Washington, D.C.

This map shows railroad and subway lines on the island of Manhattan in 1904, the year the Interborough Rapid Transit line opened. Railroads had long carried commuters, goods, and long-distance travelers to and from the city. The IRT enabled people to move quickly within the city itself, particularly to and from the commercial districts of Manhattan. By 1908 the system reached north to the Bronx and south to Brooklyn, where its arrival spurred residential and commercial development.

Fig. 20
Cover of *The New York Subway Souvenir* (New York: Burroughs and Company, 1904). Warshaw Collection of Business Americana, National Museum of American History, Smithsonian Institution

of neighborhoods that grew into distinct ethnic enclaves, perpetuating a polyglot cultural geography. Skyscrapers consolidated workers and managers in new bureaucratic offices to run modern corporations. The women employed in these offices as secretaries and clerical workers used their wages to develop a way of life different from that of their mothers; they anticipated more leisure, greater economic independence, and more time away from home and parental control. The city's working class—overwhelmingly immigrants separated by language and national origin— was a powerful source of diversity. But in arduous strikes, union organizers sought to consolidate workers from different parts of the world into a labor movement that could challenge the power of capital in New York City. The power, breadth, and contradictory nature of these trends produced a city where massive social and cultural changes were visible on the streets. From workmen erecting skyscrapers and immigrants in Old World dress to labor-union rallies and newly liberated couples enjoying street-corner flirtations without censure, the defining trends of New York were all open to public scrutiny, evaluation, and participation.

The city that the Ashcan artists encountered in the 1890s was heir to the Manhattan of journalist and poet Walt Whitman, "hemm'd thick all around with sailships and steamships,"[1] that emerged in the early nineteenth century. Between 1800 and 1850 the city's merchants assumed a commanding position in transatlantic trade, coastal shipping, and interior commerce on the Erie Canal. Complementary growth in finance and manufacturing made the city an economic powerhouse and a magnet for immigration. By 1855, fifty-two percent of the population was foreign-born; four-fifths of the immigrants were from Ireland or Germany.[2]

The new metropolis of the nineteenth century was a place of extremes. Its merchant princes were among the richest men in the nation, but the Five Points slums of lower

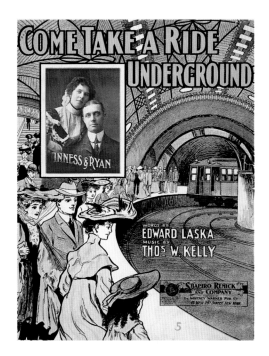

Manhattan sheltered some of the country's poorest immigrants. The difficulty of maintaining any kind of moral consensus in such a diverse city made New York the capital of both vice and moral reform. New York's ethnic animosities, particularly between native Protestants and immigrant Catholics, burst into violence that left the cobblestones marked with blood. The New York Draft Riot of 1863, which began as a protest against federal conscription policies biased against the poor during the Civil War, mutated into a race riot that took more than a hundred lives.

As the 1870s ended, the shock waves set off by events of the first half of the century were beginning to subside. Inequalities of wealth and power would prompt recurring action by the city's labor movement, but the conflicts between natives and immigrants, particularly the Irish and the native-born Protestants, no longer seemed to threaten the political order. The political ascendance of the Irish and "machine" politics meant that ballots, not bullets, would be used to settle ethnic and cultural disputes.[3]

In the aftermath of the Civil War, the United States emerged as an industrial nation of the first rank. New York financiers and industrialists consolidated their city's status as the

Fig. 21
"Come Take a Ride Underground,"
© 1904, sheet-music cover. Sam DeVincent Collection of Illustrated American Sheet Music, National Museum of American History, Smithsonian Institution

When the first subway opened in 1904, it attracted joyriding crowds in search of novelty and soon provided a subject for films and popular songs.

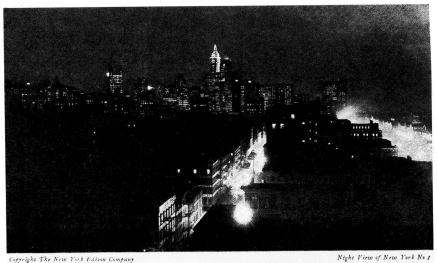

Copyright The New York Edison Company Night View of New York No 1

Lower New York looking South from Canal Street
Park Row Building Singer Tower West Street Building

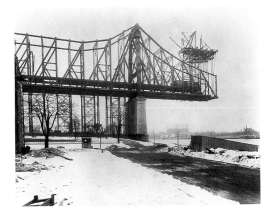

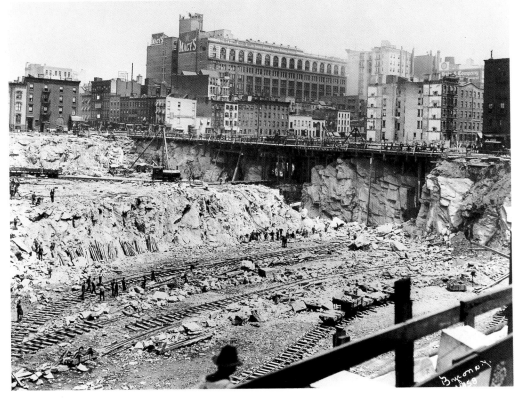

Fig. 22
Lower New York Looking South
from Canal Street, undated, postcard.
© The New York Edison Co., Museum
of the City of New York, Gift of M.
Matthilde Mourraille

*Electric lighting created the modern
image of the skyline at night. It made
possible the twenty-four-hour city, where
night turned into day and incredible
illuminated commercial displays
became part of everyday life.*

Fig. 23
*Blackwell's Island, Queensboro Bridge
under Construction,* 1907. Museum
of the City of New York, The Byron
Collection

*The construction of bridges and subway
lines made New York City look like a
work in progress. Once opened, they
gave the city a modern infrastructure
that fostered the movement of people
and goods around all five boroughs,
turning the metropolis that sprawled
around New York Harbor into one
functioning unit. The Queensboro
Bridge, depicted here under construc-
tion, joined Manhattan and Queens.
George Bellows painted the span when
it opened in 1909.*

Fig. 24
Excavation of Pennsylvania Station,
1906. Museum of the City of New York,
The Byron Collection, 93.1.1.7976

capital city of American capitalism, as banks and financial industries gained control of an ever-increasing portion of the nation's eco-nomic activity. New York was a great manufac-turing city, particularly for light industries like garment manufacturing. More and more mil-lionaires made New York their home and built elaborate mansions on upper Fifth Avenue.

Skyscrapers, made possible by the safety elevator and new construction techniques that placed the burden of a building on a steel skeleton instead of thick walls, sheltered new, bureaucratic corporations. The Woolworth Building on lower Broadway, opened in 1913, was the headquarters of an empire of retail stores and eclipsed the Metropolitan Life tower as the tallest building of its time. Its soar-ing tower, lit by what was then the new conve-nience of electric lights, dwarfed the church steeples that had defined the city's skyline in

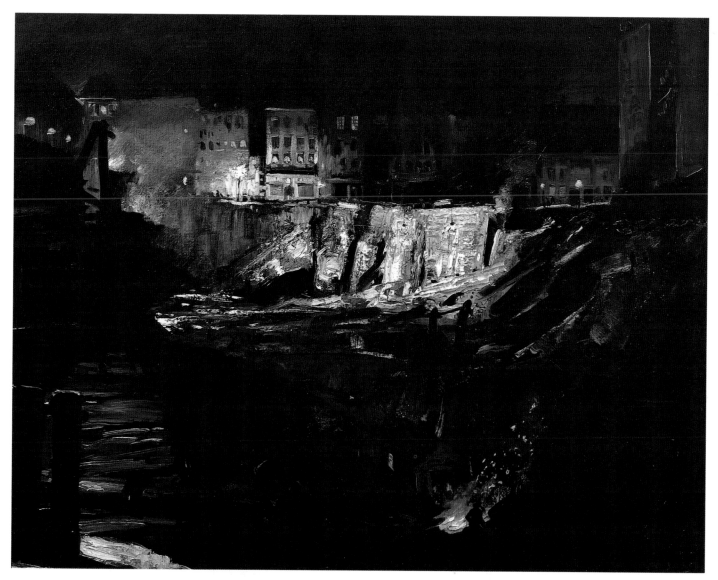

the nineteenth century. Inspired by skyscrapers illuminated against the night sky, Ezra Pound wrote, "Here is our poetry, for we have pulled down the stars to our will" (fig. 22).[4]

The construction of a great building was a dramatic event. New Yorkers routinely peered through the holes in fences surrounding construction sites to monitor the work in progress (fig. 23). However grand a spectacle for the observer, it was hard and dangerous work for the laborers on a construction project. In a poem titled "The Foundations of a Skyscraper," John Reed, a young journalist, wrote of how "blinded with sweat, men give a vision birth / Crawling and dim, men build a dreamer's dream."[5]

Among the city's best-known construction sites was the vast pit on the west side of Manhattan (fig. 24), which was to become a major

railroad terminal, Pennsylvania Station—the subject of a number of paintings by Bellows. Affirming New York's status as a major transportation center, the terminal also helped reconfigure the geography of the west side of Manhattan, pulling the center of gravity farther north. In order to be closer to Penn Station and the emerging entertainment district at Times Square—and to attract middle-class customers leery of the crowded immigrant neighborhoods below Fourteenth Street—the owners of department stores moved north from the Ladies' Mile on Sixth Avenue between Fourteenth and Twenty-third Streets (the probable setting of Shinn's pastel *Sixth Avenue Shoppers* [fig. 200]). They reestablished themselves in a new retail district in midtown between Thirty-fourth and Fifty-second Streets.[6]

Fig. 25
George Bellows, *Excavation at Night*, 1908, oil on canvas, 86.4 x 111.8 cm (34 x 44 in.). Berry-Hill Galleries, New York

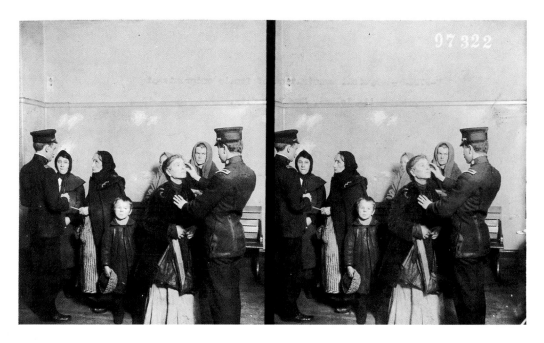

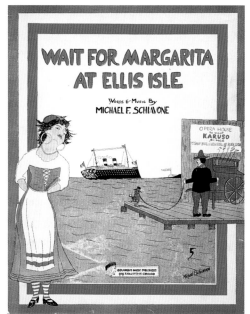

Fig. 26
Physical Examination of Female Emigrants at Ellis Island, New York City, 1911, stereograph. Prints and Photographs Division, Library of Congress, Washington, D.C.

Fig. 27
"Wait for Margarita at Ellis Isle," © 1909, sheet-music cover. Sam DeVincent Collection of Illustrated American Sheet Music, National Museum of American History, Smithsonian Institution

Bellows's *Excavation at Night* (fig. 25), which depicts the construction site at Pennsylvania Station, reminds us of the human labor that is the foundation of the most massive engineering projects. The painting juxtaposes idled machines with tiny figures of the people who operate them. From a distance the symbol of the city was its new skyline, the product of businessmen who directed the city's forces of consolidation. But at street level, New York was defined not by buildings but by people, whose diversity gave the city its vital polyglot culture. Some were native-born Americans from middle-class backgrounds (like the Ashcan artists) who came to the city because it was a magnet for the ambitious and the talented. But the most conspicuous people were newcomers—mostly Jews and Italians and a much smaller number of blacks from the South and the Caribbean. New York was their destination because it offered economic opportunity. Apartment buildings, skyscrapers, and mass-transit systems required everything from pick-and-shovel work to the laying of delicate mosaics. Clothing factories needed both skilled tailors and people to carry bundles of cloth to and from workshops. Ships moored on the waterfront of the nation's largest port needed longshoremen to stow and unload cargo.[7]

If the city offered obvious economic openings for newcomers, its cultural structure was, at first glance, less welcoming. The immigrant who stepped off a ship in New York entered a strange new world (figs. 26 and 27). "Until yesterday I was among folks who understand me," recalled Bartolomeo Vanzetti of his arrival in New York. "This morning I seemed to have awakened in a land where my language meant little more to the native (as far as meaning was concerned) than the pitiful noises of a dumb animal. Where was I to go? What was I to do? Here was the promised

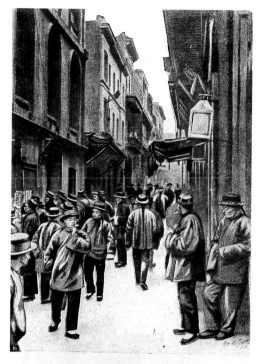

In Chinatown, New York.

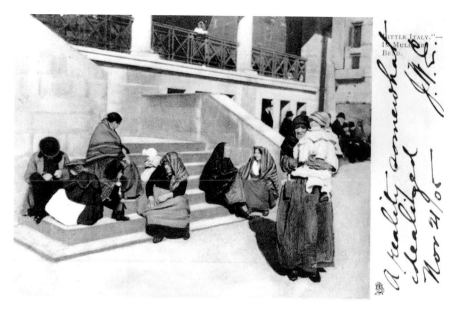

land. The elevated rattled by and did not answer me. The automobiles and trolley sped by, heedless of me."[8]

For many, the most prudent strategy for survival was to seek out fellow countrymen. The most popular destination for newly arrived immigrants was the Lower East Side in Manhattan, east of Broadway and south of Fourteenth Street, previously the home of Irish and German immigrants and, in its southern end, the site of Chinatown (fig. 28). By 1900 Jews were concentrated in the eastern end of the neighborhood on streets with dumbbell tenements stretching as far north as Fourteenth Street. Italians tended to settle on the western streets of the district, some of them moving north into Greenwich Village, in older housing located between large factories and warehouses (fig. 29). Both groups also established colonies in more distant areas of the city, such as Harlem in upper Manhattan and Williamsburg in Brooklyn.[9] African Americans, squeezed by a segregated housing market, clustered in the midtown Tenderloin, along Sixth Avenue from Twentieth to Fifty-third Streets, and in San Juan Hill (named for the

interracial fights that occurred up and down its slopes) along Tenth and Eleventh Avenues between Fifty-ninth and Sixty-fourth Streets.

The new immigrants of the Lower East Side provoked many different reactions. The Reverend Richard S. Storrs of the Church of the Pilgrims in Brooklyn assumed that a good city was one with a homogeneous Protestant, northern European population. He saw in Manhattan "an immense, shifting, heterogeneous population . . . with a large population of recent immigrants, and into which the political sewage of Europe is being dumped every week."[10] Storrs sought to isolate himself from the new immigrants by taking refuge in the island city of Brooklyn. Other New Yorkers were more generous and optimistic, viewing the immigrants as a source of invigoration for the metropolis. The essayist Randolph Bourne grew up in suburban New Jersey and studied at Columbia University. He looked forward to a "trans-national America," a cosmopolitan federation of cultures, native and immigrant, continually inspiring and invigorating each other, driving America toward a future as an international nation. Bourne hoped such a nation would save older Americans of Anglo-Saxon descent from their "old inbred morbid problems."[11]

Bourne was part of a generation of articulate writers who embraced the immigrants as

Fig. 28
In Chinatown, New York, undated, postcard. Museum of the City of New York

Fig. 29
"Little Italy" in Mulberry Bend, 1905, postcard. Museum of the City of New York, Gift of M. Matthilde Mourraille

After the turn of the century, New York's ethnic neighborhoods were documented in the newly popular form of postcards. Photographers tended to emphasize features that made the areas seem most exotic. The view of Chinatown shows an all-male population (few Chinese women were allowed to enter the United States in these years), some of whom wear the traditional queue. The scene in Little Italy shows women wearing shawls over their heads, a practice that distinguished them from native-born American women. They sit on steps leading up to a building in Columbus Park, an open space created when the city leveled the crowded Mulberry Bend slum district that Jacob Riis had denounced.

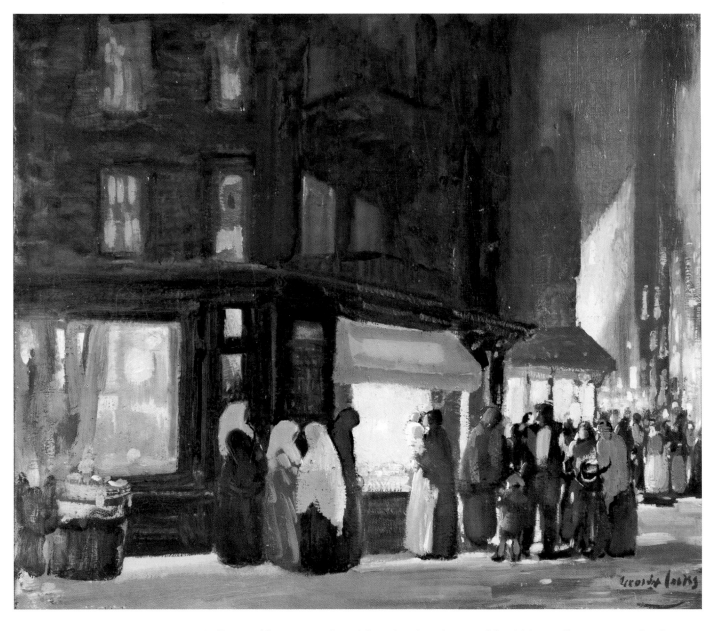

Fig. 30
George Luks, *Bleecker and Carmine Streets, New York*, ca. 1905, oil on canvas, 63.5 x 76.2 cm (25 x 30 in.). Milwaukee Art Museum, Gift of Mr. and Mrs. Donald B. Abert and Mrs. Barbara Abert Tooman

indispensable agents of social and cultural transformation. Like the Ashcan artists, many of these writers moved to New York as young adults and found their literary voices in the act of interpreting the city around them. California-born Lincoln Steffens arrived in New York to seek his fortune after years of study in Europe; he recalled in his *Autobiography* that he became "as infatuated with the Ghetto as eastern boys were with the Wild West."[12] The Oregonian John Reed, fresh out of Harvard and on the way to becoming one of the foremost radical journalists of his era, said of his dwelling near the Lower East Side, "Within a block of my house was all the adventure of the world; within a mile was every foreign country."[13] Bourne, Steffens, and Reed appreciated the immigrants because they paved the way for a more open culture in which no group or perspective automatically dominated. For radicals like Reed, that offered two benefits. In cultural realms, the arrival of the immigrants meant the end of the native-born gentry's dominance. In political terms, the immigrants, concentrated in the working class, formed a massive army of labor that could be recruited to the cause of socialism.

For the Ashcan artists, the act of drawing and painting the immigrants was part of the process of making sense of the newcomers

and interpreting their place in the metropolis. Although their art was less politically informed than the writings of Bourne and Reed, they shared an awareness of how the immigrants were changing the life of the city. They also shared a tendency to use stereotypes to identify the newcomers, reducing their complex humanity to a few recognizable types: the Irish tough, the Jewish street peddler. These stereotypes, a well-established device in American culture, dated from the first half of the nineteenth century and were widely used in journalism and theater to depict everyone from rural Yankees to African Americans and immigrants. The people whom Bourne described as "orderly Germans" and "turbulent Slavs" found their visual counterparts in the Ashcan artists' work. Yet in an era when nearly everyone used stereotypes to identify immigrants, the Ashcan artists were far more likely to be fascinated with foreigners, even friendly toward them, than they were to be hostile. Their reactions to the immigrants were far closer to Reed's views than to those of Storrs. Henri, their mentor, exhorted them to go out into the city streets and paint life as they found it. Of the six, Luks and Glackens were the most inclined to take his advice, repeatedly depicting the streets and markets of immigrant neighborhoods.

Luks's *Bleecker and Carmine Streets, New York* (fig. 30) depicts a corner in southwest Greenwich Village, an area inhabited by Italian immigrants. The shoppers on the street and the women clustered in the foreground establish the very public nature of life in this neighborhood. Socializing occurs not in the privacy of the parlor but on the sidewalk. Commerce draws people out of their apartments and into a wider community. Set at night, the scene is dramatized by the light spilling out of storefront windows into the darkness. Bleecker Street stretches off into the distance like the midway of a carnival, but one without grotesques; the people depicted are too distant to have recognizable features. Although the people gathered at Bleecker

and Carmine remain strangers to us, they do not appear threatening. The painter stands outside the community that he depicts, but from all appearances it is an inviting place, beckoning to him and drawing his attention further into its streets.

The real magnet for artists, photographers, and reporters looking for immigrants was the Lower East Side. The population density of the district was striking: the neighborhood's Tenth Ward had more than seven hundred people per acre in 1900, making it the most heavily populated in the city. More important was the diversity of its inhabitants and the intensity with which they crowded work, play, prayer, and politics into such a small area of the city.[14]

The Italians and Jews who settled on the Lower East Side were different from native-born New Yorkers, many of whom were of British, Irish, or German stock. But what gave the Italian and Jewish communities their complexity became apparent only with close knowledge: they were all deeply divided among themselves. Italians were more likely to think of themselves as Calabrians, Sicilians, or Basilicati. Jews had a more developed sense of themselves as a people sharing a faith, but still thought of themselves less as Jews than as Jews from Russia, Lithuania, Galicia, or Poland. Religion was also a source of division, not only between Jews and Catholics but also within religious groups. Jewish and Italian immigrant communities contained the highly devout as well as groups of anarchists who were contemptuous of religion. Politics also fostered ideological differences in immigrant communities, ranging from the enthusiastic embrace of capitalism to its condemnation. Life in an immigrant neighborhood required an adjustment not only to the world of native-born Americans but also to one's diverse fellow immigrants.

The Lower East Side, often mistaken for the eternal Old World, was in fact a place of change. Immigrants influenced each other and at the same time encountered American

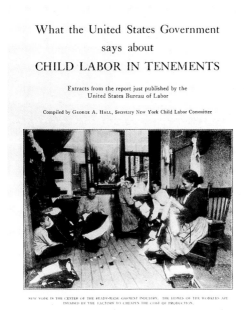

What the United States Government
says about
CHILD LABOR IN TENEMENTS

Extracts from the report just published by the
United States Bureau of Labor

Compiled by George A. Hall, Secretary New York Child Labor Committee

NEW YORK IS THE CENTER OF THE READY-MADE GARMENT INDUSTRY. THE HOMES OF THE WORKERS ARE
INVADED BY THE FACTORY TO CHEAPEN THE COST OF PRODUCTION.

Fig. 31
Cover of *What the United States
Government Says about Child Labor
in Tenements*, pamphlet (New York:
National Child Labor Committee,
March 1911). Robert F. Wagner Labor
Archives, Tamiment Institute Library,
New York University

*Progressives believed that scientific
investigations could identify social
wrongs and persuade authorities to
enact reforms. New York progressives
frequently assailed garment-industry
sweatshops, which were established
to hold down the costs of labor and over-
head in a fiercely competitive trade.
Lewis Hine, who took the photographs
in this pamphlet early in his career,
went on to win acclaim as a documen-
tary photographer for his depictions of
labor and industrial injustice.*

commercial and political culture. Abraham
Cahan, a Jewish immigrant who became one of
the most penetrating chroniclers of the immi-
grant experience, wrote that America (which
in his case meant New York) appeared to be a
land "of fantastic experiences, of marvelous
transformations" for the protagonist of his
novel *The Rise of David Levinsky*.[15]

In a city where the middle class still
believed in separating work and residence, in
which fathers left daily for the world of busi-
ness while mothers stayed home to run the
household, the Lower East Side violated basic
norms of respectability by flagrantly mixing
labor and home life. This phenomenon, which
originated with the German and Irish immi-
grants, was most vigorous east of the Bowery,
where Jewish and Italian immigrants used
their apartments as workshops for the cloth-
ing industry (fig. 31). Lillian Wald, a nurse and
a founder of the Henry Street Settlement
House, once visited some children who were
sick with scarlet fever. "The parents worked
as finishers of women's cloaks. . . . The gar-
ments covered the little patients, and the bed
on which they lay was practically used as a
work table."[16]

The bulk of New York's garment industry
in these years was concentrated in tiny firms
and sweatshops, and the immigrants pho-
tographed by Riis, bent over sewing machines
in their apartments, were at the bottom of an
industrial pyramid. At the top were large gar-
ment manufacturers, who farmed out orders
to subcontractors. They, in turn, parceled out
the work to small workshops or individuals
operating out of their own apartments for
long hours and small pay. "Among employ-
ers," charged Meyer London, an immigrant
Socialist lawyer who represented the Lower
East Side in the United States Congress, "the
manufacturer who is merciless in reducing
wages and in stretching the hours of labor, the
manufacturer who disregards in dealing with
his employees all laws human and divine is
most likely to succeed."[17]

To outsiders, immigrant streets could
appear alien, fascinating, or threatening.
Other than police officers, politicians, teach-
ers, fire fighters, and social workers, few had
reason to venture into them. Since the 1830s,
metropolitan newspapers had printed fea-
tures and human-interest stories about such
neighborhoods to satisfy readers' curiosity.
After the 1880s, articles were often accompa-
nied by illustrations.[18] Even a friendly observ-
er like Wald viewed the immigrant quarters as
places profoundly different from the rest of
the city because of their overcrowding and the
intensity of human activity. She wrote:

*One night during my first month on the East
Side, sleepless because of the heat, I leaned out
of the window and looked down on Rivington
Street. Life was in full course there. Some of the
pushcart vendors still sold their wares. Sitting
on the curb directly under my window, with
her feet in the gutter, was a woman, drooping
from exhaustion, a baby at her breast. The fire-
escapes, considered the most desirable sleep-
ing-places, were crowded with the youngest and
the oldest; children were asleep on the side-
walks, on the steps of houses and in the empty
push-carts; some of the more venturesome men*

and women with mattress or pillow staggered toward the river-front or the parks. I looked at my watch. It was two o'clock in the morning![19]

Glackens's *Far from the Fresh Air Farm* (fig. 14) addresses the curiosity about immigrant neighborhoods. The title calls attention to the crowded urban blocks where contagious diseases spread quickly through poorly ventilated tenements. The drawing shows many facets of tenement life simultaneously, rendered with more detail than any viewer could take in at once. Residents conduct their lives out in the open, with little concern for privacy. To native-born Americans, accustomed to seeing clean-shaven men and women in elaborate broad-brimmed hats, the men's heavy beards and the kerchiefs worn by the women struck a foreign note. At first glance, this street seems an outpost of the Old World in the heart of America. But on closer inspection, we see one signboard in Hebrew lettering, another in English. Kerchiefed women and bearded men share the street with boys playing baseball.

Glackens, a careful observer, recognizes that this street is not a piece of medieval Bialystok transplanted to New York but the scene of a powerful meeting between the cultures of Europe and America. The men carrying bundles of garments in the foreground are visible signs of the industry that goes on behind the scenes in the tenement buildings. This is not a place of timeless exoticism but one of rapid change that will transform the lives of both immigrants and native New Yorkers.[20] In a time when many observers saw immigrant neighborhoods as the homes of ancient and unchanged cultures, Glackens recognized the collision between old and new evident on a single block in New York.

The fascination with the immigrant poor that energized Glackens and photographers like Jacob Riis was one side of an equation that was well established in the minds of New Yorkers: their city was the scene of poverty, but it was also a showcase for the nation's rich, who built grand mansions like their counterparts in other cities (fig. 32). What

NEW YORK. Millionaires' Row.

made rich New Yorkers different was the nature of the city they lived in. As historian David Hammack has pointed out, the middle class and better-paid working class were numerically substantial and gave an identity to large sections of the city that were distinctly different from the abodes of both the rich and the immigrant poor. In a city of New York's scale, affluent neighborhoods had to be extraordinary to stand out—and they did. Yet even when they commanded attention, they were only one part of a city in which the neighborhoods of the poor, working class, and middle class were notable in their own right. The visual impression created by this phenomenon was of a city where the rich were powerful but not fully in command.[21]

Their hegemony was compromised partly by internal divisions within the upper class. The consolidation of capital in New York made the city a center of concentrated wealth, but the evolution of its economy—from merchant capitalism to industrial capitalism to finance capitalism—had created openings for successive layers of elites, with no single faction dominant. The old colonial "Knickerbocker" families were upstaged by the New England merchants who gravitated to the city in the first quarter of the nineteenth century. The Yankees were supplanted by the robber barons of railroading and banking in the years

Fig. 32
New York. Millionaires' Row, undated, postcard. Museum of the City of New York

In the last quarter of the nineteenth century the growth of banks, financial firms, and corporate headquarters in Manhattan spawned a new generation of millionaires. Many of them migrated to the city from other regions when their businesses opened New York offices. They preferred to live on upper Fifth Avenue, alongside Central Park, in a neighborhood that became known as Millionaires' Row. Their mansions were built to resemble European palaces in order to convey the sense of established wealth.

Fig. 33
Advertisement for the Hotel Knicker-
bocker on the back cover of *Town and
Country* 68 (3 January 1914). Warshaw
Collection of Business Americana,
National Museum of American His-
tory, Smithsonian Institution

*Town and Country magazine helped
consolidate an image of New York's
elites. Advertisements illustrated the
latest in luxury goods and glamorous
fashions, while articles reported on
social events. Features on New York's
leading families defined who was in
and who was out in high society.*

after the Civil War. In 1892, by one count the city had 1,368 millionaires.[22]

Generational differences within the city's elite were compounded by religion. By the beginning of the twentieth century the upper class, once strongly Protestant, also included Roman Catholics and a growing number of German Jews. This layering of elites created an upper class that lacked both cohesion and roots in the city. Uncertain of their social standing, rich New Yorkers imitated the elites of Europe in an attempt to wrap themselves in an aura of old wealth.[23] In a turbulent city that was always beyond their complete control, they tried to create an enclave of wealth and privilege. Industrial and maritime development along the East and Hudson Rivers had long pushed affluent Manhattan to the center of the island, and the northward growth of the business district had pushed moneyed seekers of quiet and exclusivity ever farther uptown.

The most striking visual expressions of this effort to construct an identity for the wealthy were the hotels and mansions on Fifth Avenue, dubbed the "billionaire district" of New York City in 1901 (fig. 33). The most famous hotel was the Waldorf-Astoria on Fifth

Avenue between Thirty-third and Thirty-fourth Streets, where millionaires promenaded in Peacock Alley and dined in the glass-walled Palm Garden, contemplating their dinner companions in floor-to-ceiling mirrors.[24] The Waldorf-Astoria anchored a district of hotels and restaurants that extended up Fifth Avenue to the vicinity of Forty-second Street, after which the avenue became the main artery of the elite residential district. The biggest mansions, like those of Vanderbilt, Carnegie, and Frick, covered entire blocks. To establish the appearance of old wealth, millionaires often ordered the construction of homes whose architecture recalled medieval France or Renaissance Italy.[25]

The architecture of upper Fifth Avenue from Fiftieth Street north for more than forty blocks marked it as an enclave for the privileged. Yet only three blocks east, at Lexington Avenue, was the beginning of Yorkville, a neighborhood of German and Eastern European immigrants, which sprawled from Fifty-ninth to Ninety-sixth Streets and from Lexington to the East River. Much of Yorkville was filled with tenements. Its social life was organized around immigrant institutions like the Turnverein, a German athletic association.[26]

The geographical proximity and cultural distance between Fifth Avenue and Yorkville spoke volumes about New York City. To walk from the Carnegie mansion to a street of walk-up tenements in less than ten minutes was to experience the density and complexity of an urban environment where change and diversity took physical form. Despite the social gulf between the rich and the immigrant working class, their worlds intersected in Central Park, with accompanying debates over the uses of public space and appropriate public behavior. From its opening in the 1850s to the 1870s, the park was the domain of the well-to-do. Poorer New Yorkers could not afford the time or carfare to go there during the week, and the presence of so many rich people must have proved daunting, if not alienating, for the less affluent. But at the end of the nineteenth century,

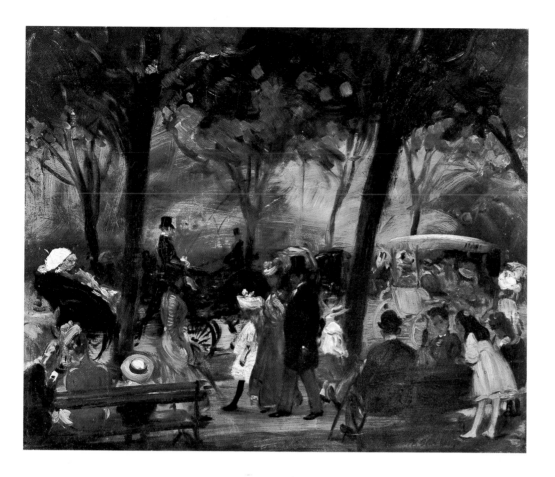

9322. AN AFTERNOON PROCESSION ON DRIVEWAY, CENTRAL PARK, NEW YORK.

Fig. 34
William Glackens, *The Drive, Central Park*, ca. 1905, oil on canvas, 64.5 x 81 cm (25 ¾ x 31 ⅜ in.). © The Cleveland Museum of Art, 1995, Purchase from the J. H. Wade Fund, 39.524

Fig. 35
An Afternoon Procession on the Driveway, Central Park, undated, postcard. Museum of the City of New York

The social tone established by the concentration of millionaires' mansions on upper Fifth Avenue could spill over into Central Park, especially during the daily procession of carriages. Glackens's painting presents a condensed version of what an English visitor termed "that impressive pageant which is put on each afternoon between the hours of four and seven. . . . All that is loveliest in womankind, all that men envy most in their fellowman, all that is best in horseflesh, is represented."

Just see the happy baby here,
So deftly bathed by sister dear!
Each time with care she quickly sees
If the water's 98 degrees.
Then lifts him in and holds him so,
And washes him from head to toe.
So gently rubs and pats him dry,

That not once does he squirm or cry.
Some powder sprinkled from the can
Makes baby comfy, spick and span.
His little eyes she cleanses next.
With boric acid pure.
Now baby's clean, outside and in,
Of that you may be sure.

Fig. 36
Little Mothers, undated, postcard (published by the Department of Health, City of New York, Bureau of Child Hygiene). Museum of the City of New York, Gift of Dr. J. Leon Blumenthal

Advice was given in the form of a postcard published by the Department of Health. Such efforts by Progressive Era reform organizations could seem paternalistic, if not naive, to mothers who struggled to raise children in crowded, disease-ridden tenements. Nevertheless, out of such efforts came modest improvements in the standard of living of the city's poor.

as working-class wages increased and work hours decreased, more and more of the struggling immigrants of lower Manhattan visited Central Park and found ways to make sections of the park their own.[27]

Central Park was the setting of several Ashcan works. Glackens's painting *The Drive, Central Park* (fig. 34) shows the persistence of a ritual that thrived from the 1860s to the era of World War I, in which the rich paraded in elegant carriages along the eastern side of the park on weekday afternoons (fig. 35). Nevertheless, by the time of Glackens's painting, thousands of working-class visitors were attending Sunday-afternoon concerts in the park, among them many Jewish and Italian immigrants.[28] As the historians Roy Rosenzweig and Elizabeth Blackmar have pointed out, Central Park was the scene of rich and poor engaging in activities to distinguish themselves and define their turf.[29] The park may have been New York City's great commons, but residents shared it partly by congregating there according to identity or interest in a kind of self-segregation.

The style wars of rich and poor in Central Park were the benign aspect of a social and political debate on wealth, poverty, and social justice that gripped New York around the turn of the century. The Ashcan artists encountered New York in the 1890s in the early years of a period of social and political ferment that became known as the Progressive Era. Three of them—Bellows, Henri, and Sloan—participated in its more radical activities.

New York already had a long tradition of political dissent. As early as the mid-nineteenth century, socialists, feminists, and labor unionists made the metropolis, in the words of Whitman, "the most radical city in America."[30] But the Progressive Era was distinct from earlier movements, whose zeal for reform had been deeply influenced by moralistic Protestant evangelicals. By the beginning of the twentieth century the Protestant strain of reformist thought was still strong, but it had evolved into the doctrine of "social gospel," which emphasized social causes of wrongdoing over the sinfulness of the individual. The heterogeneous activists of the Progressive Era—ranging from muckraking journalists to settlement-house workers and government reformers—were also moralistic, but their moralism was more secular and tended to be influenced by new notions of science and governmental efficiency. In their

THE NURSE IN THE TENEMENT
Ninety per cent. of the sick of the city remain at home

efforts to build a more just city, urban progressives addressed the metropolitan environment and its many institutions. In economic realms, they were concerned with the power of business trusts.

Broadly middle class in their leadership, New York progressives, like their counterparts in other American cities, tackled a wide range of problems. Their most visible creations in neighborhoods like the Lower East Side were the settlement houses, which provided education and social services for the immigrant poor. Settlement houses had an array of sponsors: university-educated social workers seeking practical applications for their academic training, Protestant reformers living out the Sermon on the Mount in inner-city slums, and assimilated German Jews seeking to educate Eastern European Jews in American ways. Many staff members were young, single, educated women (including Lillian Wald) who sought out such work as an alternative to conventional lives as wives and homemakers (figs. 36, 37, and 38).

Progressive reformers and radicals contributed to the political ferment that defined

their era, but the differences between them were significant. The growing power of international capitalism made radicals of the Progressive Era ever more receptive to Marxian forms of socialism and anarchism, whose emphasis on strategies for winning workers' control over massive industrial combinations seemed more suited to the demands of the twentieth century than the utopian socialism of the nineteenth century.

Bellows, Henri, and Sloan all attended the lectures of anarchist Emma Goldman. Henri and Bellows taught art classes at the anarchist Ferrer School. Bellows, Glackens, and Henri contributed drawings to the radical magazine *The Masses*. Sloan's political commitments led him to join the Socialist Party, contribute to the Socialist publication *The Call*, serve on the editorial board of *The Masses*, exhibit his etchings at the Socialists' Rand School, and run for office on the Socialist ticket.[31]

The Socialist Party that Sloan joined was an eclectic organization. Its critique of class-based inequalities was inspired not only by Karl Marx but also by Christian ideals and concepts of independent manhood and citizenship

Fig. 37
The Nurse in the Tenement, in Lillian D. Wald, *The House on Henry Street* (New York: Henry Holt, 1915), 29

Fig. 38
Headquarters of the Women's Trade Union League of New York Taken during the Shirtwaist Strike, 1910. Museum of the City of New York, The Byron Collection, #28515

In the early twentieth century, women inspired by progressivism, radicalism, and trade unionism were prominent in the fight against poverty in New York. The struggle changed their city and their own lives. Middle-class women who went to work in settlement houses found alternatives to the roles of wife and homemaker; working-class women who joined unions and went on strike found a political voice and economic sustenance unknown to their mothers.

leisure, of visits to a movie theater, amusement park, or vaudeville house.

During this era, a generation of entrepreneurs created a broad array of amusements to serve a population seeking to escape from tedious jobs and confining neighborhoods (fig. 42). Popular entertainment also played an important role in the breakdown of Victorianism, the ideology of rigorous self-control and self-improvement—strongest among the middle class but still influencing the working class—whose precepts dictated separate social lives for men and women. Several of the Ashcan artists recalled chafing under these constraints while growing up in conservative, provincial communities in the late nineteenth century. Bellows once remarked that the public library in his hometown of Columbus, Ohio, had banned the novels of Honoré de Balzac. By the time the Ashcan artists arrived in New York, Victorianism was crumbling but not yet gone, evolving into a new moral order that allowed men and women to experiment with a much wider range of self-expression and actions without fear of censure. Sex roles and the relations between men and women were being played out in a kind of interregnum, in which the old ways were fading but the new ways

were not entirely clear. Nowhere was this more apparent than in the realm of leisure, a subject that the Ashcan artists explored at great length.

In the nineteenth century many men sought their recreation largely outside the home in the company of other men. They patronized the barrooms, brothels, and prizefights that were pillars of the male "sporting culture." But by the end of the nineteenth century, the sporting scene was in a state of flux. Boxing was being divided into an amateur activity concentrated in elite schools and athletic clubs, where it was thought to build character, and a professional prizefighting industry, where fighters and promoters turned fisticuffs into a big business (fig. 43). The artists' enthusiasm spanned remnants of the old order and glimpses of the future.

In the first two decades of the twentieth century, New York State boxing laws seesawed between allowing boxing only in private clubs and allowing it in public under state supervision.[41] When Bellows painted *Both Members of This Club* (fig. 44) in 1909, the state law permitted fights in properly organized clubs but banned public prizefights, blurring the distinction between legal and illegal fights.

Fig. 42
"There's Always Something New on Dear Old Broadway," © 1914, sheet-music cover. Sam DeVincent Collection of Illustrated American Sheet Music, National Museum of American History, Smithsonian Institution

By 1914, when this song was published, Broadway had become the setting of a new world of urban pleasures that encouraged the social mingling of men and women.

Fig. 43
Hy Mayer, *A Knockout by the Police*, from Rupert Hughes, *The Real New York* (New York: Smart Set, 1904), 145

During the era of the Ashcan artists, boxing was evolving from a sporting men's pastime of dubious legality to a mass-market professional sport with a national audience. A Knockout by the Police *depicts a police raid on an illicit bout, prompting the flight of fans who include both top-hatted swells and coarsely dressed street toughs.*

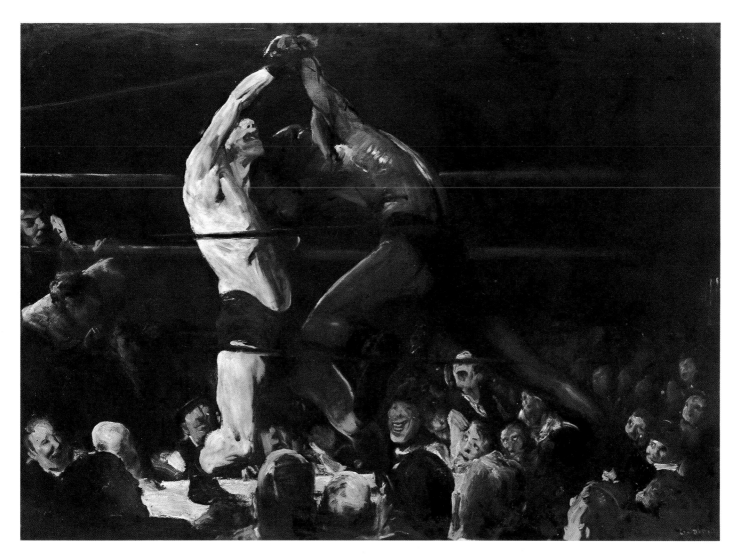

Bellows captured the all-male club fight scene that was soon to be superseded by more lucrative bouts marketed to bigger audiences in indoor arenas and outdoor stadiums. In this painting, the artist alluded to one of the most volatile issues in the world of boxing: the rise of the black fighter, personified by the heavyweight Jack Johnson. To many African Americans, Johnson was a hero. To many whites, he was a menace, the embodiment of all their fears and a living challenge to white supremacy. He won the title from Tommy Burns in Australia in 1908. When he defeated ex-champion James J. Jeffries in 1910, race riots broke out across the country. In New York, one African American was beaten to death and scores were injured. Yet when Johnson visited the city on a triumphal tour, thousands of African Americans gathered to welcome him.[42]

Both Members of This Club captures black and white fighters straining against each other in a clinch; the leg of the white man has buckled, as if he is about to collapse. The original title was *A Nigger and a White Man*, and it is possible to see the painting as the embodiment of many white fight fans' worst fears— the moment when a white boxer succumbs to a black boxer. Bellows later retitled the painting *Both Members of This Club*, and although the title might be ironic, it could also be an admission that both men are members of the boxing fraternity, entitled to respect according to its own bloody code.[43]

The enormous attention accorded Johnson and the search for a "white hope" who could defeat him testified to the lucrative market for prizefighting in the United States. But if boxing was in the process of becoming a

Fig. 44
George Bellows, *Both Members of This Club*, 1909, oil on canvas, 115 x 160.5 cm (45 ¼ x 63 ⅛ in.). © 1995 Board of Trustees, National Gallery of Art, Washington, D.C., Chester Dale Collection

Fig. 45
John Sloan, *Sixth Avenue and Thirtieth Street*, 1908, lithograph, 36.2 x 28.3 cm (14 ¼ x 11 ⅛ in.). National Museum of American Art, Smithsonian Institution, Gift of Mr. and Mrs. Harry Baum in memory of Edith Gregor Halpert

part of the legitimate entertainment industry, another aspect of the old male sporting scene, prostitution, was undergoing scrutiny and suppression by politicians and moral reformers—and receiving attention from the Ashcan artists. There was relatively little commercial sex in New York City at the beginning of the nineteenth century. Crowded living quarters and the watchful eyes of church and family tended to relegate what prostitution there was to the dockside areas. By the 1840s and 1850s, however, the growth in the city's population, size, and economic complexity created many more opportunities for prostitution. In George Foster's journalism, Ned Buntline's dime novels, and Walt Whitman's poetry, references to prostitution became a recognizable part of popular culture.[44] Women in the commercial-sex industry ranged from casual practitioners who exchanged sexual favors for treats to full-time prostitutes who commanded incomes far beyond those of the average domestic servant or seamstress.[45]

By the time the Ashcan artists were living in New York, the face of prostitution was changing. Public and private agencies suppressed brothels, driving them out of business and forcing the women to ply their trade in apartments, hotels, and saloons. Prostitution spread to midtown Manhattan and as far north as Harlem, and also, to a lesser extent, to Brooklyn, the Bronx, and Queens. This expansion made it difficult to distinguish between red-light districts and working-class or entertainment districts, all of which had their share of prostitutes.[46]

Sloan depicted prostitutes in many works, including the lithograph *Sixth Avenue and Thirtieth Street* (fig. 45), which were striking for their absence of any tone of moral disapproval. Since he portrayed working-class women as sexually expressive, but with consistent warmth and humanity, it is difficult to tell whether the women who prepare a late-night supper in *Three A.M.* or prepare for bed in *Turning Out the Light* (figs. 194 and 195) are prostitutes.[47] The ambiguous attitude pre-

Fig. 46
Program from *The Lure*, 1913.
Museum of the City of New York

sented in these images was related to a larger current in the Ashcan artists' New York. While moral reformers still condemned and attacked prostitution in repeated municipal investigations, they were growing more likely to emphasize its social causes. Instead of treating prostitution as sin pure and simple, they noted its links to police corruption and the protection provided by Tammany ward bosses. In this light the prostitute ceased to be the focus of all evil and became instead one of many characters enmeshed in a web of vice—perhaps not even the most culpable.[48] The stern and rigid judgments of previous generations were replaced by a more complex understanding of the issue, in which the moral judgments of crusading ministers shared the podium with the more clinical observations of social scientists (fig. 46).

The new perception of prostitution was part of a larger revision of the popular understanding of relations between men and women. At the turn of the century the power of domesticity—the view, strongest in the middle class, that women's primary task was

to direct and sanctify the home—began to give way to a moral order in which women would spend more of their lives outside of the home and beyond the constraints and supervision of their families.

One of the most powerful forces eroding this older conception of gender roles was consumer culture, particularly as it was expressed in retail stores in New York City—the setting of Glackens's painting *The Shoppers* (fig. 161). In the last quarter of the nineteenth century, the shopping district along Sixth Avenue between Fourteenth and Twenty-third Streets was defined by a new institution in New York, the department store, which catered primarily to a middle-class, female clientele (fig. 47). Women entered these stores in their traditional role as organizers and maintainers of family life but found in them—and the entire social experience of shopping—new experiences that increasingly distanced them from older conventions of domesticity.

In the stores, as historian Elaine S. Abelson has shown, women encountered an expanding array of ready-to-wear clothing and

Nineteenth-century critics blamed prostitution on the individual "fallen woman." By the twentieth century prostitution was more likely to be depicted as "white slavery," in which women were tricked or coerced into entering the sex trade and kept in a form of bondage. Although investigations failed to uncover the vast "white slavery" rings that existed in popular imagination, the theme was exploited by reformers, journalists, filmmakers, and dramatists. The 1913 drama The Lure *was acclaimed by a federal Department of Justice official for exposing the "facts" that would help girls and women "guard against the snares that are constantly being laid for them by white slave traffickers." In contrast to the tragic demeanor of the drama's heroine, Sloan depicted professional prostitutes as self-possessed women rather than as victims.*

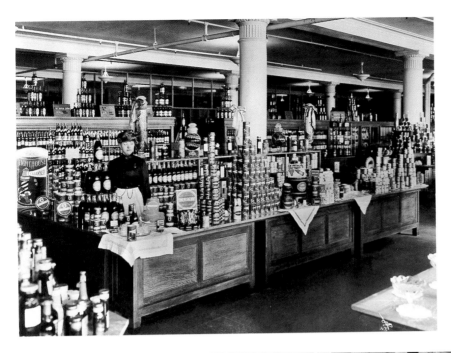

Fig. 47
R. H. Macy's Department Store Food Counter, 1902. Museum of the City of New York, The Byron Collection

During the Ashcan artists' years in New York, the heart of New York's shopping district was the Ladies' Mile at Sixth Avenue between Fourteenth and Twenty-third Streets. When Macy's department store moved to Herald Square at Thirty-fourth Street in 1902 to take advantage of emerging rail and subway lines and to cultivate more affluent clients, customers complained that it was too far uptown. But other stores followed, and Herald Square became the center for New York shopping. Macy's offered customers the pleasures of abundance in settings designed to encourage consumption. The store also served a broad range of customers, from shop girls to the upper-class carriage trade, but within such large stores, class distinctions shaped retail strategies.

Fig. 48
Advertisement for Siegel Cooper Company on the cover of a program for Wallach's Theatre, 1897. Warshaw Collection of Business Americana, National Museum of American History, Smithsonian Institution

household goods marketed through ever more dramatic and persuasive sales techniques and displays (figs. 48 and 49). These goods, which in earlier generations would have been made in the home, were now available for purchase. In shopping, women performed a delicate balancing act, providing for the needs of their families and at the same time enjoying the sumptuous atmosphere of the stores. Shopping became their work and their entertainment.[49] Even though the department stores they visited were dominated by other middle-class women shoppers, their forays into the busy streets bred in them an urban and urbane state of mind grounded in physical

mobility, consumerism, and an acceptance of heterogeneity.[50] All of this encouraged them to look beyond their homes and into the larger city for the framework of their lives.

Immigrant working-class women also shopped in stores on the Ladies' Mile, but they were more likely to visit the pushcarts and stores on the Lower East Side, which Glackens depicted in his magazine illustrations. Young, unmarried women often saw shopping as a form of recreation, a chance to experiment with new styles of clothing and fashion. They used wages earned in grinding garment-factory jobs to purchase cheaper versions of the fashionable clothing sold in

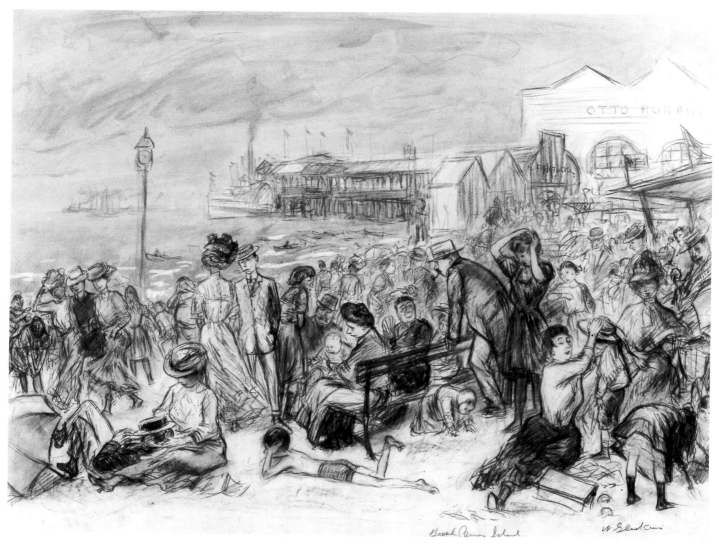

the uptown stores. At times, parents' need for their wages to supplement the family income conflicted with the women's personal desires for spending. Such conflicts sometimes encouraged the women to see themselves in more autonomous terms, as if—for better or worse—their own gratification was distinct from the good of their parents and families.[51]

Young working-class men and women, liberated from the worst ravages of poverty by higher wages and reduced working hours, began to spend large segments of their leisure time at Coney Island, dance halls, and nickelodeons. These offered abundant opportunities for men and women to meet outside the confines of family and neighborhood.[52] The Ashcan artists enthusiastically depicted these new institutions, where men and women experimented with newer, less constrained social mores. Sloan painted young, independent women going to the movies and also bathing at South Beach on Staten Island. Glackens captured the human density of the crowds on the beach at Coney Island (fig. 50).

Coney Island's stature as a resort for the urban multitudes dated to 1875, when the Prospect Park and Coney Island Railroad opened regular service to what was then a stretch of bathhouses and small inns on an Atlantic Ocean beach in Brooklyn. Hotels soon followed, and by the end of the nineteenth century, a stroller walking the island from east to west could observe a complete spectrum of American class and culture: at the east end, New York and Boston aristocrats; in the middle, at West Brighton, middle-class and working-class crowds enjoying arcades, dance halls, variety theaters, and sideshow attractions; at

Fig. 49 (opposite)
Division Street, June 29, 1910, 1910. Museum of the City of New York, The Wurts Collection

Despite the fame of the downtown retail district of Manhattan, other shopping centers could be found around the city. Downtown Brooklyn, home of Abraham and Straus, served people from the entire borough. Smaller commercial districts, like this one on Division Street on the Lower East Side, served the immediate neighborhood.

Fig. 50
William Glackens, *Beach, Coney Island,* 1902, crayon and chinese white, 195.6 x 94 cm (22 ¼ x 29 in.). Arkansas Arts Center Foundation

the far west end, crowds of rough men flocking to horse races, prizefights, and prostitutes.[53]

Coney's fame rested on three great amusement parks: Steeplechase Park, opened in 1897; Luna Park, opened in 1903; and Dreamland, opened in 1904. Luna Park and Dreamland offered spectacular atmospheres and amusements for a generally middle-class clientele (figs. 51 and 52). Steeplechase drew most of its patrons from the city's working class. Its free-and-easy atmosphere was a commercial adaptation of the mood of the Bowery, which so many of its patrons knew firsthand. Steeplechase also unabashedly tried hardest to take in money by "making sexuality and romance the focal point of amusement," as historian Kathy Peiss put it. The revolving "Barrel of Love" forced couples to collide and clutch at each other for balance. The compressed air jets of the "Blow Hole" blew off men's hats and lifted women's skirts.[54]

At Coney Island the amusements and resorts once scattered along the Bowery were combined in one vast pleasure ground and taken to an even more ecstatic state. Yet if Coney Island represented a consolidation of amusements, it also contributed to the fragmentation of the nineteenth-century cultural codes of restraint, propriety, and separate spheres for men and women. The old sporting scene had long provided men with their share of recreation outside the family. For women, there were comparatively few. The rise of resorts like Coney Island vastly expanded such opportunities for women and offered them the prospect of socializing with men— particularly appealing to working-class women whose apartments and neighborhoods were painfully overcrowded (figs. 53 and 54).

The movies were an important part of popular culture. Tenement dwellers found entertainment at cheap nickelodeons showing silent films that represented the city to its inhabitants in a new and compelling way. Films of subways and street scenes turned everyday experience into a new art form. The movies grew up in the city; their subjects and

Fig. 51
"Take a Trip Down to Luna with Me," © 1908, sheet-music cover. Sam DeVincent Collection of Illustrated American Sheet Music, National Museum of American History, Smithsonian Institution

Fig. 52
Witching Waves, Luna Park, Coney Island, N.Y., undated, postcard. Museum of the City of New York

What set Coney Island apart from earlier pleasure grounds were its rides and illuminations. Witching Waves, like many Coney Island rides, set men and women side by side and whirled them against each other to encourage a new kind of public physical intimacy. Luna Park took the bright lights of the city to new and fantastic dimensions.

the entrepreneurs of the new medium were inextricably part of the urban fabric. In their technology, the movies clearly looked to the twentieth century. Yet New York was a city poised between the nineteenth and the twentieth centuries. Even as it looked forward, it was defined partly by elements of its past—and nowhere more so than in vaudeville.

Entrepreneurs created vaudeville in the last quarter of the nineteenth century with the objective of forging a large, lucrative audience drawn from people who attended male-oriented concert saloons, melodramas, minstrel shows, and variety shows. Vaudeville was essentially a variety show organized around the premise of providing something for everyone. In New York, as in other large cities, theater managers learned to balance shows with acts that appealed to the native-born as well as immigrants, men and women, the working class and the middle class (fig. 55). They also learned to scrub away enough bawdry to satisfy proper middle-class families, but not so much that they lost the naughty spirits who were chafing at the restraints of Victorianism. The immigrant lured into the theater by a Yiddish-language singer also saw the costume drama designed to keep women up to date on the latest fashions. The proper middle-class couple attracted to the dramatic sketch also heard the sensual, expressive music of the ragtime piano player. Instead of forcing everyone into a bland conformity, vaudeville became an arena for cultural exchange that bred new forms of expression, from commercial ethnic songs to anti-Victorian comedy routines.

In its business organization vaudeville was theater gone industrial, with Manhattan booking offices that sent performers on tours of theater circuits throughout the city and across the country. Yet audiences were attracted by the promise of close interaction with performers. Shinn grasped this best in his painting *Footlight Flirtation* (fig. 56), in which a woman onstage looks directly into the eyes of a person in the audience, whose perspective is the same as that of the viewer of

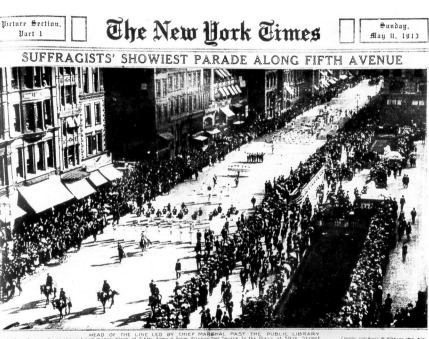

Fig. 53
Bathers and Iron Pier, Coney Island, New York, 1903, postcard. Museum of the City of New York, Gift of Leonard Lauder

Fig. 54
"Suffragists' Showiest Parade along Fifth Avenue," *New York Times*, 11 May 1913, pictorial section, sec. 1, 1

In pleasure grounds and public demonstrations, New York women challenged the belief that they should be passive and subservient to men. At seaside resorts such as Coney Island, women experimented with a new world of commercial leisure that endorsed the mingling of men and women rather than their separation, and self-expression rather than self-restraint. On the streets, suffragists demanded the vote for women.

B. F. KEITH'S

NEW UNION SQUARE THEATRE.

Performance Continuous from 1.30 to 10.30 P. M.
(Doors open at 1 o'clock P. M.)

598TH CONSECUTIVE WEEK
— OF —
Refined and High-Class Vaudeville,
COMMENCING MONDAY, AUGUST 28, 1905.

SPECIAL NOTICE.—Positively no fees of any kind are permitted in this theatre Patrons are respectfully requested not to disobey this rule, as we desire all our patrons treated alike, and this becomes an impossibility where fees are given for courtesies extended by our employees. Everything is free after you purchase your ticket, the encouragement of the fee-nuisance disorganizes our system of extending courtesies and makes it impossible for all of our patrons to receive the attentions which are due them.

Acts are run only in the order given when feasible to do so and are subject to change without notice It should also be noted that the order in which they are placed in the programme does not necessarily indicate the value of acts. SEE STAGE SIGNS.

A Overture KEITH'S ORCHESTRA—Emil Katzenstein, Director.
March—"The Girl from Boston"..................Ernest Hall

B Stereopticon Miscellaneous Subjects.

C Charles and Katherine Gibson Presenting their Serio-Comic Playlet, "THE BURGLAR'S KIT."

D Great Chick The Wizard of the Wheel.

E The Alpha Trio Comedy Hoop Jugglers.

F Jack and Bertha Rich Refined Talking and Dancing Duo.

G Charles Serra Creator of his Original and Unique Gymnastic Act on the White Column.

H Halladay and Leonard Kings of Irish Comedy.

I William Bonelli and Company
— IN —
"THE PINK WIDOW."
By Brandon Hurst.
CAST
Reginald Racket................................William Bonelli
Dolly Devereaux.................................Lonnie Deane
Holden Fast.....................................S. S. Willsie

J Klekko and Fravoli First Appearance in Vaudeville. Selections from "Trovatore."
(Late of Metropolitan Opera Company.)

K Ellis-Nowlan Trio Eccentric Comedy Acrobats.

L The Great Lafayette Innovations Extraordinary, In Remarkable and Astounding Protean Changes, Presenting a Series of Novelties New to the Theatre going Public

M Cliff Gordon The German Politician.

N The Great Lafayette AND HIS TRAVESTY BAND Presenting Humorous Impersonations of the World's Noted Musical Directors.

O Keith's Motion Pictures (The Kinetograph)
Showing an Excellent List of Interesting and Humorous Subjects.
MR. KANYOUSPELLIT AND HIS AIRSHIP.
PLAYMATES.
THE GAY WASHERWOMEN.
THE WONDERFUL ALBUM.
MODERN BRIGANDS.

ENTIRE CHANGE OF PROGRAMME WEEKLY

RED LIGHTS INDICATE EXITS.

Fig. 55
Vaudeville Program from B. F. Keith's New Union Square Theatre, 1905. Warshaw Collection of Business Americana, National Museum of American History, Smithsonian Institution

In a city of unprecedented diversity and energy, vaudeville successfully applied the forms and rhythms of urban life to theater. At B. F. Keith's New Union Square Theatre in 1905, continuous performances from 1:30 to 10:30 p.m. encouraged attendance during or after the workday. The variety of acts on the bill ensured that there would be something to please both men and women, immigrants and native-born Americans, working people and the elite. Vaudeville's popular appeal, and its need for many performers, made it a training ground for artists who later appeared in radio, television, and film.

the painting. Shinn's pictures of the world of vaudeville reveal both enjoyment of its dazzle and understanding of the performers' daily routine. Every vaudevillian, from aspiring amateur to seasoned professional, knew that the secret of success was pleasing the broad audience cultivated by the creators of these shows. The managerial end of vaudeville might be bureaucratic and heartless, but the relationship between artist and audience had to seem intimate and genuine.

The forces of consolidation and diversification that defined New York City at the turn of the century reached their peak in vaudeville. While its booking offices and star machinery represented consolidation of cultural power in a business headquartered on Times Square, its promotion of a more sensual, expressive culture contributed to the fragmentation of Victorianism. Its ethnic songs and comedy, instead of fostering simple assimilation, facilitated the construction of new American ethnic identities formed less from immigrant culture than from the commercial offerings of the entertainment industry. But by the teens, as Sloan's paintings reveal, movies were assuming an ever larger share of vaudeville's role in popular entertainment in New York. By the twenties, vaudeville was in a gradual decline. It died in the early thirties when the Great Depression made it economically untenable, and sound motion pictures captured what remained of its audience.

Vaudeville was only one of the elements of the city that underwent change by the end of the 1910s. Beginning in 1914, World War I drastically reduced immigration from Europe. After the war, during the 1920s, federal quotas severely limited immigration from southern and eastern Europe. African Americans from the South became the city's main source of cheap labor, crowding into Harlem in upper Manhattan and making it the capital of black America. The United States' entry into World War I had led to a wave of repression and superpatriotism that staggered American radicalism

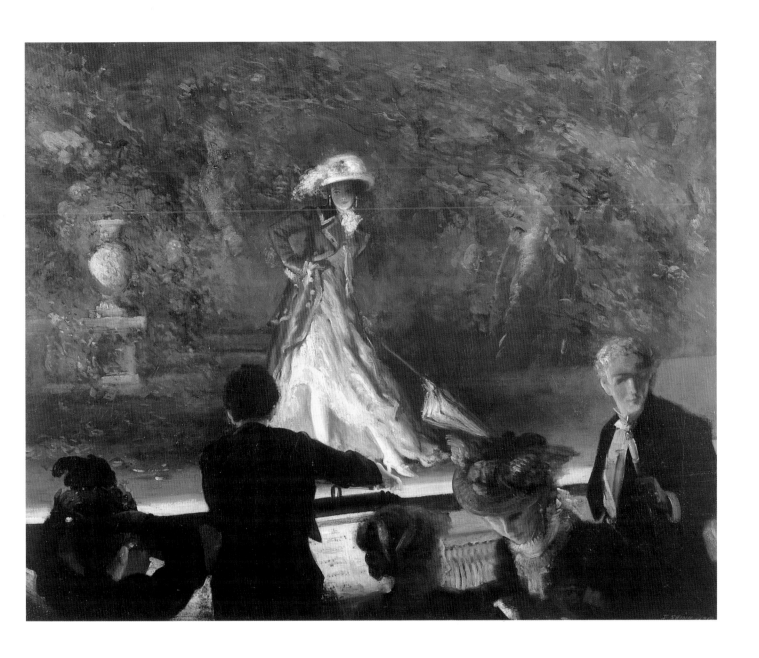

Fig. 56
Everett Shinn, *Footlight Flirtation*,
1912, oil on canvas, 75 x 92.7 cm
(29 ½ x 36 ½ in.). Collection of Mr.
Arthur G. Altschul

Fig. 57
Street Scene: Liberty Loan Posters for World War I, undated. Museum of the City of New York

Fig. 58
"It's a Long Way to Dear Old Broadway," © 1918, sheet-music cover. Sam DeVincent Collection of Illustrated American Sheet Music, National Museum of American History, Smithsonian Institution

World War I brought an ebbing of the spirit of change that defined the city at the turn of the century. Posters urging the purchase of war bonds appeared near Union Square, a well-known setting for radical rallies. The martial spirit that equated buying a war bond with fighting in the trenches made civilian dissent the equivalent of treason on the battlefield. The Masses, *with other radical publications, opposed the war and tried to expose its human cost. The federal government's response was to ban the magazine from the mails, driving it out of business in December 1917.*

The dominant atmosphere on the home front during World War I was fervently patriotic. Americans thought of the European battlefield and sang "It's a Long Way to Dear Old Broadway," but the hardships of the conflict seemed to be deemed worth the goal of a war to end all wars.

(figs. 57 and 58). Divisions over the Bolshevik Revolution and its meaning for American leftists fragmented the radical camp.

After the era of the Ashcan artists, much of what was once shocking and new would be absorbed into the New York City that thrived in the middle of the twentieth century. Women who grew up in the shadow of Coney Island and in the aftermath of the suffrage movement took for granted a world of greater equality where men and women mixed socially. The city's politics was defined by alumni of the Progressive movement such as Fiorello La Guardia, who left a legacy of urban liberalism that lasted into the 1990s. Popular culture was epitomized by street-smart alumni of the vaudeville stage like Jimmy Cagney. Italian and Jewish immigrants and their descendants settled into the city so completely that by the 1970s they were regarded as the Establishment, with the Statue of Liberty their Plymouth Rock and the dumbbell tenement their log cabin.

As the city of the Ashcan artists receded into the past, their works ceased to be contemporary records of daily events and became historical artifacts. In hindsight these pictures have acquired a patina of nostalgia

that obscures the turbulence of turn-of-the-century New York. Today their topical references are nearly inscrutable because, in some ways, the world that produced these works has changed. But in some important ways, it has not. In a nation growing increasingly suburban, New York is no longer the "shock city" that defines the emerging way of life for the majority of Americans. Much of the business and industrial power consolidated within its borders has migrated to other parts of the country. The "average American" is no longer a city dweller but a suburbanite, and much popular culture is now based in the private shopping mall rather than the city street.

But the issues of modernity and diversity that New York grappled with in the early years of this century, and that inspired Ashcan art, were not limited to one time and place. They heralded changes that Americans nationwide have encountered ever since. Once again

the arrival of immigrants is changing both city and suburb. The increasing presence of women in the work force again challenges traditional ideas of the proper roles of men and women. Sexual freedom, spurred on by a commercial culture that promises unlimited personal liberation and fun, continues to inspire debates about human conduct and relations.

Turn-of-the-century New Yorkers confronted these challenges, and in their responses fashioned a city that, despite its conflicts, seemed to offer a model for modern society. The New York that the Ashcan artists knew, at its best, tolerated differences, welcomed surprise, and rejected the idea that strangers were automatically threatening. As simple as this seems, the course of American life in the twentieth century—from long, hot summers to the flight to the suburbs to the omnipresent fear of crime—shows that the survival of that viewpoint cannot be taken for granted.

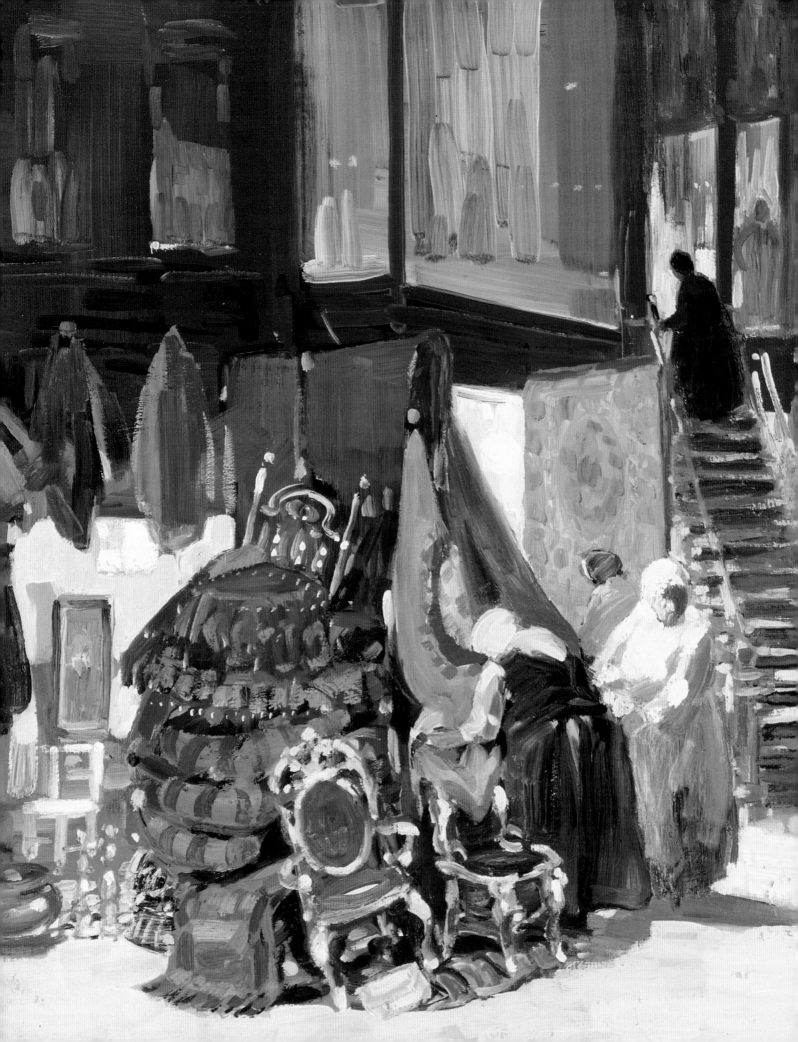

REBECCA ZURIER

THE MAKING OF SIX NEW YORK ARTISTS

None of the Ashcan artists were native New Yorkers, and only two set out to be painters. But what made them quintessential New York painters was that each learned to be an artist in New York under the inspiration of Robert Henri. Like millions of other Americans and immigrants from overseas, they responded to Manhattan's call as a magnet for talent—in their case, its unique position as capital of the nation's art world and its publishing industry. The six artists brought with them diverse experience as professional illustrators and teachers and a desire to make their mark on the national scene. All were inspired by Henri's ideas on the importance of making a vital, contemporary art based on the life around them. Out of these elements—journalism, Henri's teaching, and their experience as newcomers in the city—each artist eventually forged a distinctive vision and style that spoke to the relationship between art and "real life," as well as to the process of becoming a New Yorker.

PHILADELPHIA

Five of the six artists came of age in Philadelphia in the 1890s and owed their careers to the institutions and opportunities that city offered. Henri moved there in 1886 to study at the highly regarded Pennsylvania Academy of the Fine Arts. He had spent his childhood in the town of Cozad, Nebraska, founded as a real estate venture by his father, John Jackson Cozad, who claimed genteel southern roots. When the elder Cozad killed one of his employees in a dispute, the family fled east to Atlantic City and changed their names. Robert and his brother, now known as "Frank Southrn,"

moved to Philadelphia a few years later, Frank to pursue training at the Jefferson Medical College and Robert to study art. After a few years of advanced study and travel in Europe, Henri returned to Philadelphia in 1892 to continue classes at the Pennsylvania Academy and to teach at the School of Design for Women. At the academy he met a circle of newspaper artists and part-time students who began to convene at his studio for informal sketching, drinking, and discussion. These gatherings formed the nucleus of the Ashcan group.

For Shinn, Sloan, Glackens, and Luks, Philadelphia's institutions offered a different path to a career in art. Two of them grew up in Philadelphia; two came from small towns outside the city, moved to Philadelphia as teenagers, and found their first jobs there. Luks alone had the benefit of formal art training. As the son of a doctor, he grew up with some means and attended the Academy of Fine Arts in Düsseldorf for a few months before returning to Philadelphia to draw for newspapers. Shinn, Sloan, and Glackens, who came from more modest families of storekeepers and office clerks, received their early training in public high school drafting courses. They found work in Philadelphia as illustrators, and only later took night classes at the Pennsylvania Academy. Each eventually credited Henri with encouraging him to turn from news illustration to painting.

Philadelphia in the 1890s offered several opportunities to those who had a facility for drawing but might not have considered themselves fine artists. Newspapers, department stores, theaters, and publishing firms employed illustrators and designers for

George Luks, *Allen Street* (detail), ca. 1905, oil on canvas, 81.3 x 114.3 cm (32 x 45 in.). Hunter Museum of American Art, Chattanooga, Tennessee, Gift of Miss Inez Hyder (see fig. 125)

and repulsion coexist in uneasy balance. But to the artists who gathered in Philadelphia in the 1890s, Henri posed the challenge of seeking the beautiful by redefining it. Whether, or how, they would succeed in that challenge was another matter.

In later years Henri sent students out into the city to make *pochades* in restaurants, boxing rings, and neighborhoods in New York. His friends in Philadelphia needed a different sort of encouragement. As reporters, they had already mastered a routine of quickly translating observations of immediate experience into vivid images. Henri encouraged them to use these skills as the basis for ambitious paintings. To this end, he also recommended that they study graphic art of the past. Seasoned draftsmen like Glackens were well aware of cartoons in the British magazine *Punch*; now Henri showed them Rembrandt's etchings, Goya's prints, and Honoré Daumier's caricatures, arguing that drawings based on everyday mores could achieve the status of great art. He exhorted the Philadelphia news illustrators to think of art as a calling rather than a job and to transform their experience in black-and-white into a vital form of contemporary painting that would make a mark on the American art scene and stand with the great works of the past. By the mid-1890s several of the group had begun to experiment with making paintings of streets around Philadelphia or those seen on trips abroad. But to realize Henri's challenge fully, each of the artists, including Henri himself, would have to move to New York. On returning to Philadelphia after a trip to view art in Manhattan in 1897, Henri wrote, "New York is so different from here—one feels alive there."[8]

CITY OF AMBITION

New York was a logical place for both illustrators and painters to forge a career at the turn of the century, thanks to its consolidation of wealth, population, power, and the dominant institutions of culture. As Sloan remarked in 1898, "A good thing done in New York is heralded abroad—a good thing done in Philadelphia is well-done in Philadelphia."[9] By the mid-1890s New York had surpassed Boston as the center of American book publishing; its newspapers syndicated and distributed features throughout the country; it was becoming the headquarters for a new class of popular illustrated magazines with national circulation.[10] Readers from coast to coast now followed in words and pictures business news from Wall Street, New York's fashions, the doings of its high society, its literati, theater and entertainment, social problems, and day-to-day events. These changes created a growing demand for professional illustrators in the city.

The press also helped New York consolidate its position as capital of the American art world. Surveying the national art scene in 1902, the muralist Will Low observed that "the greater number of American artists of repute are to be found in New York City, thus making it, though so far apparently against its will, the metropolis of art in the United States in the same sense as are Paris and London in France and England."[11] Low noted that although Boston had venerable collections, Philadelphia claimed an older academy, and several other cities offered impressive museums and exhibition venues, New York had the largest concentration of art dealers, and its art institutions set the nation's standards. The New York-based National Academy of Design and the Society of American Artists created an identifiable Establishment both through their process of electing artists to membership and their highly publicized juried exhibitions; the Society of Illustrators, established in 1901, served a similar professional function. The city's art schools were feeders for these organizations. A network of New York dealers and auction houses with ties to Europe helped shape the American art market. New York galleries imported and displayed works from abroad, while a few dealers, including the enterprising William Macbeth, promoted the art of Americans (fig. 63). When artists protested this system by

establishing alternative schools and exhibitions, their protests took place in New York. All of these activities were chronicled in the press, piquing the interest of collectors and artists across the country.

New York's publishing industry also contributed to the city's intellectual life by helping to create a new culture of professional writers and artists who came to the city from the American provinces and forged their own networks among kindred spirits. Like the journalists Lincoln Steffens and John Reed, many of these people grew up in traditional communities and moved to New York as much to explore the freedom and variety of big-city life as to seek professional advancement or pursue creative art and writing. Newspapers and publishing firms offered steady employment to those skilled with pencil or typewriter, while the city's cosmopolitan atmosphere provided meeting places for exchanging ideas and encountering social mores that would have been frowned upon elsewhere. Leslie Fishbein has described how the culture of publishing helped contribute to the city's political radicalism.[12] Most of the Ashcan School artists were slightly older, and more concerned with their careers, than the college graduates and would-be bohemians who flocked to Greenwich Village in these years, but they forged friendships with writers and editors and participated in the city's political and cultural ferment.

Informal or unofficial ventures proved equally important in creating a viable art world in New York. Artists needed opportunities not only to sell their work and to see as much art as possible but also to discuss their work with others. Private clubs, professional organizations, and popular watering holes enabled groups of artists, from the genteel to the bohemian, to get together. (Sloan and Bellows paid tribute to the New York artists' life in a number of fond images of friends socializing [fig. 64].) These activities attracted coverage in the New York press and nationwide. By 1900 several art magazines were edited in New York, and dozens of other national publica-

tions based in New York featured articles on the local art scene. At least eight city newspapers employed their own art critics, who also freelanced for other publications. Here was a place where reputations could be made.

Luks moved to Manhattan and a job at the *New York World* in 1896; Glackens joined him later that year. They helped arrange a position for Shinn in 1897. Sloan came the following summer to work at the *New York Herald* but returned to Philadelphia after a few months. Despite impatience with his hometown's provincialism, he seems to have felt overwhelmed in New York and did not settle there permanently until 1904. As experienced news artists, the transplanted Philadelphians could take advantage of several professional tracks simultaneously. Their skills as sketch-reporters were still in demand at New York's major newspapers. Although photography had begun to replace some journalistic illustration, the illustrated Sunday supplements, particularly the comics, were booming. More flexible, interesting, and lucrative work came from the growing magazine market. Several of the artists had already sent cartoons to New York publishers when they lived in Philadelphia, but it proved more expedient to live in Manhattan, where they could establish

Fig. 63
John Sloan, *The Picture Buyer*, 1911, etching, 12.7 x 17.8 cm (5 x 7 in.). Delaware Art Museum, Gift of Helen Farr Sloan

William Macbeth, among the few art dealers in New York to promote the work of contemporary American painters, provided the gallery space for the exhibition of The Eight. Sloan depicted Macbeth (the standing figure with the dark goatee) in the process of making a sale. "He is shown purring into the ear of the victim."

Fig. 64
George Bellows, *Artists' Evening*, 1916,
lithograph, 22.23 x 31.11 cm (8 ¾ x
12 ¾₆ in.). Amon Carter Museum,
Fort Worth, Texas, 1985.41

Petitpas, a small French restaurant and
boardinghouse on West Twenty-ninth
Street, became a favorite gathering
place for Henri and his circle after the
Irish painter John Butler Yeats took up
residence there. The father of the poet
William Butler Yeats, the elder Yeats
was revered as a conversationalist. In
Bellows's print, Henri (gesticulating)
and the bearded Yeats engage in dis-
cussion, while Bellows stands behind
them; Bellows's wife, Emma (in the
black hat), is seated nearby; Marjorie
Henri sits at the next table and draws.

connections with art editors and pick up
assignments on the spur of the moment.
Because of their skills and prior experience on
metropolitan dailies, they were frequently
commissioned to draw incidents observed in
the city. Their work reveals the growing
national interest in all manner of information
about New York: Glackens made detailed pic-
tures for a nonfiction article on Wall Street
trading and also drew illustrations for humor-
ous short stories set on the Lower East Side;
Shinn produced lavish full-page "Midwinter
Scenes in New York" that were printed as inde-
pendent features in literary monthlies; Luks
drew hilarious tenement scenes for the pio-
neer Sunday comic, *Hogan's Alley*. Aspects of
all of these illustration assignments eventually
informed the artists' paintings.

Most important, magazine work left the

artists time and energy for other art. Rather
than submit to the daily grind of the newspa-
per artist, a free-lance illustrator had slightly
more control over his schedule. (A photo-
graph of Glackens at work in his New York stu-
dio shows a much more dignified setting
than that of the Philadelphia newsroom [fig.
65].) Sloan, for example, eventually settled
into a routine that allowed him to take on
enough commercial assignments to pay the
month's bills, then devote several weeks at a
time to his own painting. In New York the
former Philadelphians could live the life of
artists, with ready access to museum collec-
tions, changing exhibitions, the active group
of professional critics, and fellow painters.
Their letters (fig. 66) show that the social
networks established in Philadelphia flour-
ished in New York, as old friends gathered

for amateur theatricals at Shinn's studio in Greenwich Village or criticized each other's paintings in studio visits. Sloan's etching *Memory* (fig. 67) recalls evenings that he and his wife, Dolly, spent at the Henris' apartment. Under the intimate glow cast by a lamp, surrounded by studio clutter, the four friends gather around a table brought from Philadelphia. Linda Henri reads aloud to the group as the two men sketch and smoke, while Dolly Sloan listens pensively.

Henri was a driving force in maintaining ties among his friends from Philadelphia and encouraging them to venture into the New York art world. He arrived in New York in 1900 after several more years of study and teaching in Paris. By this time he had held one-man shows in New York and Philadelphia and was ready to make his name in a wider field. He secured teaching posts first at the Veltin School and then at the New York School of Art, where his classes soon rivaled in popularity those of the school's founder, William Merritt Chase. Here Henri developed his reputation as an inspiring teacher known for discoursing on literature in the classroom and sending students out into the city to make paintings of "life in the raw." Within a few years his students staged their own exhibitions, and critics began to refer to him as the "patriarch" of a "crowd" of "young painters, illustrators and *literati* who believe in the poetical and pictorial significance of the 'Elevated' and the skyscraper, of city crowds and rows of flat houses."[13]

George Bellows was one of many young artists who migrated from the American provinces to study in New York. Born and raised in a comfortable Methodist family in Columbus, Ohio, he left college after his junior year at Ohio State to pursue a career in art. He enrolled at the New York School in 1904 and gravitated toward Henri's class, rapidly becoming Henri's protégé and assistant and joining his circle of friends. By the time he was twenty-four, Bellows was showing regularly with other young artists as well as in major

juried exhibitions, winning acclaim for his powerful urban scenes.

Henri continued to hold forth to old friends and new associates at weekly open houses and at social events around the city. His circle expanded to include New York artists, journalists, and critics, especially those who embraced liberal politics. Their discussions ranged from current exhibitions, recent plays, and public lectures to philosophical ruminations on life, literature, and freedom. Henri also visited artists' studios and critiqued their work. He helped arrange for Sloan, Glackens, Luks, and later Bellows to exhibit in private galleries and encouraged them to submit their paintings to national exhibitions like the Carnegie annuals. With Henri's support, their work attracted sympathetic reviews, and eventually awards, from a number of critics who heralded a new tendency in American art, "full of the New York of today."[14]

Henri was developing a reputation as what we would now call a "player" on the national art scene. His paintings garnered awards in competitions and earned him prestigious portrait commissions. As his teaching continued to gain acclaim, he became a prominent advocate of "Progress in Our National Art" and received invitations to teach, lecture,

Fig. 65
"The Studio of Mr. Glackens Is in an Historic Old Building on Washington Square," from Grace Alexander Fowler, "Among the Illustrators," *Harper's Bazar* 39 (June 1905): 532

In an article on illustrators in New York, the author noted that Glackens's studio on Washington Square "suggests the artist rather than the illustrator.... With its great open fire, grand piano, and splendid rugs, Mr. Glackens' roomy studio is more than ordinarily attractive."

Fig. 66
John Sloan, *Eubetilebethare* [You
bet I'll be there], 1909, pen and black
ink on paper, 12.07 x 20.32 cm (4 ¾
x 8 in.). Museum of Art, Fort Laud-
erdale, Florida, Ira Glackens Bequest

*The Ashcan artists frequently ex-
changed illustrated letters. Sloan
drew this cartoon on the back of an
envelope in response to an invitation
to dinner at the home of Glackens and
his wife. Seated at the table (clockwise
from left) are William Glackens, Everett
Shinn, the café proprietor James B.
Moore, Edith Glackens, John Sloan,
and Florence Scovel Shinn.*

Fig. 67
John Sloan, *Memory*, 1906, etching,
19.1 x 22.7 cm (7 ½ x 9 in.).

*Sloan made this memorial, a tribute
to many evenings spent with old
friends, after the death of Henri's first
wife, Linda.*

and jury exhibitions in several states. The
National Institute of Arts and Letters invited
him to join. In articles, lectures, and inter-
views he discussed the need for institutions
that would encourage young artists to pursue
new directions. Elected to the Society of
American Artists in 1903 and the National
Academy of Design two years later, he soon
took part in the juries that selected works for
the annual exhibitions. When works by some
of the artists he admired most were rejected,
Henri released statements to the press in pro-
test of what he considered stultifyingly con-
servative tendencies in the art establishment.
What had been a matter of internal institution-
al politics now became national news.

Henri's protests, and the publicity they
generated, helped set the stage for the cele-
brated exhibition of "The Eight" in 1908. Henri,
Sloan, Luks, Glackens, and Shinn joined with
the Boston artist Maurice Prendergast, the
impressionist Ernest Lawson, and the symbol-
ist Arthur B. Davies to organize a show of their
work at the Macbeth Galleries. Unlike the
juried exhibitions, this show was sponsored
by the artists themselves and installed with-
out traditional hierarchies. Each artist
received a separate but equal amount of wall
space to arrange as he pleased. As Elizabeth
Milroy has pointed out, the exhibition was
probably more ground-breaking for the public-
ity it attracted as an event in art-world poli-

tics—a new, American Salon des Refusés—
than for the content of the pictures. The work
was hardly different from what these artists
and others had been exhibiting for some time,
but it was hailed as "revolutionary" because
the show challenged the selection and display
practices of the National Academy of Design.
The ensuing hoopla boosted the careers of the
artists involved and attracted thousands of
visitors. It was the first exhibition in New York
to be covered on the sports page as well as in
art reviews. An impressive number of pictures
sold, mainly to Gertrude Vanderbilt Whitney,
who made these acquisitions the core of her
growing collection of contemporary American
art. An expanded version of the exhibition
then embarked on a year-long tour of Ameri-
can cities and received much attention.[15]

Although the artists gained a certain
amount of notoriety from the exhibition, it did
not have much impact on their artistic devel-
opment. The grouping itself was temporary.
All of the artists involved knew and admired
each other and supported Henri's commit-
ment to promoting independent tendencies in
art, but only a few shared common artistic
concerns. In fact, as they explained to the
press, "we've come together because we're so
unlike." They never exhibited as a group
again. Instead, their work was juxtaposed in
larger exhibitions, including the Independents
exhibition in 1910 and the Armory Show of

1913. But within The Eight exhibition, the painters from Philadelphia formed a coherent subgroup that was clearly recognized for its distinctive images of "the real objects, the real people, and the real happenings of our everyday life." And as the exhibition toured, their work gained a national reputation for its "power to find grace in billboards, idylls in Sixth Avenue and beauty in everything." Over the next ten years these five artists would continue to exchange ideas and be described in terms of a movement, which often included Bellows, dedicated to a "New Art Realism" based on urban themes.[16]

SIX ARTISTS, SIX VOICES

The Eight exhibition proved to be a further step in the emergence of the Ashcan School as a group known for their "straightforward portrayal of visible things," especially things seen in New York. But though the artists were hailed for painting "life as they see it," each saw it differently.[17] By 1908 each had arrived at an independent voice that spoke distinctively about the city around him. A survey of their work in that year, at the Macbeth Galleries and elsewhere, shows how far each artist had come since arriving in Manhattan.

Strangely, while Henri had staked his reputation on promoting art that engaged the real life of modern New York, he displayed no recognizably New York subjects at the Macbeth Galleries exhibition. His pictures there consisted mainly of portraits or character studies, along with landscapes painted in Maine and Spain. These were a departure from the paintings he had made in the first few years of the century: a series of views of busy streets and rivers in which he enlarged the *pochade* format to treat the reportorial subject of daily commerce with symbolist suggestions of atmospheric "effect." In paintings such as *Snow in New York* (fig. 68) and *Cumulus Clouds, East River* (fig. 211), Henri's vigorous brushwork conveys a sense of energetic motion different from the street scenes he painted in Paris, or from Whistler's views along the Thames.[18] But he seems to have abandoned these subjects after a one-man show of city views in 1902, perhaps because they failed to sell. From then on, he concentrated on portraits, some commissioned, some posed by models, in which his rapid execution gave the sitters an air of alert activity. His full-length portraits of women, many posed by dancers, were especially effective in suggesting captured movement. Other portraits depicted people whom Henri found to be representative of modern national types. A few of these individuals whom he called "My People" were New Yorkers, notably the astonishing image of Willie Gee (fig. 138), but an increasing number were people the artist met during his summer trips to Europe, including the six portraits in the Macbeth exhibition.

What did these portraits have to do with Henri's philosophy of individualism, national art, and involvement with contemporary life? He argued that his paintings were consistent with an interest in progress, independence, and democracy. Progress could be expressed as the quality of movement and transition, whether of clouds in the sky, cars in the street, or the twist of a dancer's body, which gave his work its apparent spontaneity. Development and change could also be seen in the portraits of young people, whom Henri considered to be poised in a process of growth. Although some of these images now seem picturesque or nostalgic, they were meant to be dynamic examples of "humanity in the making, in the living." And while one observer dubbed the portraits formulaic "masks," Henri considered them expressions of individuality—his own and that of his sitters.[19] Each was supposed to reveal a distinctive character. Their range was to be all-encompassing, Whitman's democratic vision applied worldwide. The best of the portraits present subject, painter, and viewer as equals. Figures step forward to assert their presence; sitters interrogate the artist; women are not coy but rather confront the viewer directly. Other works tread dangerously close to cliché.

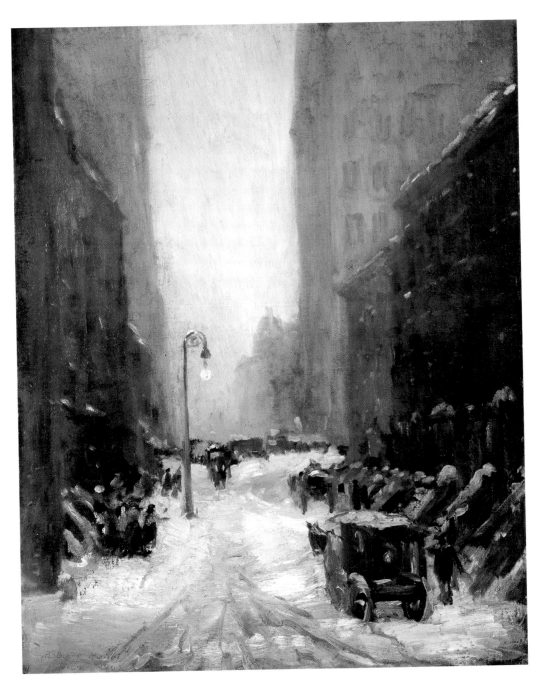

Fig. 68
Robert Henri, *Snow in New York*, 1902, oil on canvas, 81.3 x 65.5 cm (32 x 25 ¾ in.). © 1994 Board of Trustees, National Gallery of Art, Washington, D.C., Chester Dale Collection

In New York Henri adapted the pochade *format to energetic paintings of Manhattan streets and rivers. He included this picture in the one-man show in 1902 that proved to be his first and last major exhibition of city scenes.*

The success of The Eight exhibition enhanced Henri's role as a public spokesman for art, for the art spirit, and for principled "independence" in general. As his art moved away from local subjects, his public statements addressed more universal concerns. In the years following the show he became increasingly active in advanced intellectual circles and lent his support to a variety of causes, including the promotion of Irish theater in the United States, the Walt Whitman Fellowship, and Emma Goldman's campaigns for birth control. Goldman, the dancer Isadora Duncan, and the Irish painter and raconteur John Butler Yeats occasionally attended the weekly open house at Henri's apartment. At Goldman's invitation, he and Bellows taught art classes at the Ferrer School, where their students included Man Ray and Leon Trotsky, along with many young immigrants. In this way, Henri maintained contact with some of the forces transforming New York City while assuming the mantle of senior statesman in the arts.

By 1908 Everett Shinn, like Henri, was a cosmopolitan artist. In The Eight exhibition he showed oil paintings of theater scenes from London and Paris as well as New York. This exhibition marked his emergence as a full-fledged painter; in the past he had exhibited mainly pastels of city street scenes. The drawing *Night Life–Accident* (fig. 88), made in 1908, is more typical of Shinn's work up to that time. Although the moody, sketchlike image of an urban tragedy seems worlds away from the glamorous theater paintings, the two subjects were not unrelated. As Sylvia Yount has noted, Shinn's work demonstrates how popular media at the turn of the century helped equate theater, urban fashions, and sensational news by presenting all of them as spectacle. In an interview Shinn explained that he chose his subjects on the basis of drama and pictorial interest, and that tenement districts made for "effective" pictures.[20]

Using skills developed in news illustration, Shinn brought a new range of subject matter into the art gallery while endowing art with the immediacy of an on-the-scene report. He had come to New York to draw for newspapers but soon moved into the magazine market. In the late 1890s he began to augment his work in black-and-white by developing a technique of drawing in pastel on large sheets of dampened paper, then working over the images with ink and colored gouache. The resulting pictures combined the dexterity and shaggy line of drawing with lush splashes of color. Their distinctive technique conveyed with equal intensity the bustle of a fashionable crowd outside a restaurant or the decrepitude of a New York slum and suggested that the artist, like a reporter, had witnessed both. Shinn's pastel (combined with watercolor) titled *Cross Streets of New York* (fig. 69) carries over from his newspaper work a clear composition in which strong diagonals create a plunging perspective. Its drama is further heightened by the sketchlike line that makes buildings more tumbledown and gives the figures an air of strenuous activity. In other drawings, passersby struggle

against the wind as they trudge through snowy streets or hurry into cabs. Although *Cross Streets* was published as a small-format, black-and-white illustration accompanying a magazine article with the same title, in the original drawing the dark figures and dingy street and sky play off the brilliant orange of weathered brick buildings. The rich tonality of Shinn's drawings reproduced well in magazines while also giving them the impact of paintings when hung on the wall.

Shinn's big break in magazine work came in 1900 when *Harper's Weekly* published his drawing *A Winter's Night on Broadway* as its first full-color, large-scale centerfold illustration. (At thirteen by seventeen inches, the reproduction was nearly full size.) By the time the drawing appeared in print, Shinn had already been given one-man gallery shows of similar pictures, which sympathetic reviewers compared to the paintings of Parisian street people by the impressionist Jean-François Raffaëlli.[21] The drawings in these exhibitions included street views, news topics (*Fire on Twenty-fourth Street, New York City* and *The Docks, New York City* [figs. 89 and 93]), and pictures from the theater. Among Shinn's patrons were socially prominent theater people and collectors, including J. P. Morgan, William Merritt Chase, the director Clyde Fitch, and the designer Elsie DeWolfe. Another group of pastel drawings, in uniform format, were part of an unfinished project for a picture album to have been titled *New York by Night*. Designed to provide a tour of various aspects of the city, Shinn planned to juxtapose images of uptown fashion and downtown squalor (*Tenements at Hester Street* [fig. 102] was part of the set). *Park Row, Morning Papers* (fig. 70), a blue-toned scene that shows deliverymen dropping off newspapers before dawn, under the glare of streetlights, may have been made for this project.

The success of Shinn's early exhibitions in New York prompted his dealer, Boussod, Valadon, to send the artist to Europe, where he showed in the gallery's Paris branch and made notes for new drawings and paintings. Although

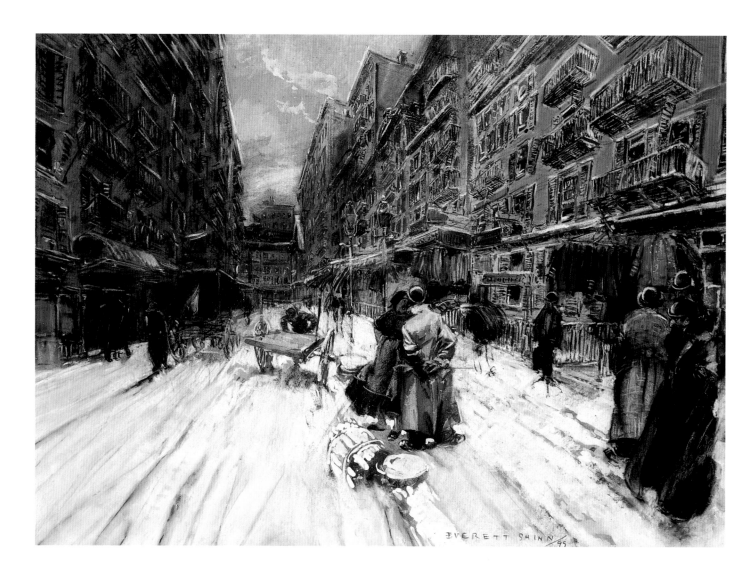

Fig. 69
Everett Shinn, *Cross Streets of New York,* 1899, charcoal, watercolor, pastel, white chalk, and chinese white on paper, 55.3 x 74.3 cm (21 ⅝ x 29 ¼ in.). In the Collection of the Corcoran Gallery of Art, Gift of Margaret M. Hitchcock by exchange

This drawing was made for an article that conducted readers on an imaginary tour of Manhattan organized on the basis of interesting views to be found away from the major avenues. The article indicates that Shinn's drawing represents a street on the Lower East Side. Here he adapted techniques learned from newspaper illustration to emphasize the dense, dilapidated buildings, the snow-rutted street, and the shabby clothes of the residents. Shinn included similar pastels in his gallery exhibitions.

Shinn had already seen the work of French artists in magazines and exhibitions at home, in Paris he seems to have looked more closely at paintings and prints by Degas, Édouard Vuillard, and Pierre Bonnard and may have encountered early work by the British painter Walter Richard Sickert. (Shinn's paintings of London music halls predate comparable pictures by the British Camden Town group.)[22]

When Shinn exhibited the results of his European travel alongside scenes from New York, some critics praised the theater paintings as ingenious interpretations of French themes, though one complained, "Surely it is not 'revolutionary' to follow in the footsteps of the men who were the rage in artistic Paris twenty years ago."[23] But, as Robert Snyder notes, Shinn's images of the stage often differ

from their European prototypes in their unusual viewpoints that call attention to the interaction between audience and performer so characteristic of American vaudeville. Shinn's ability to put the viewer in the performer's shoes may have been strengthened by his own involvement in the theater world. He built a backyard theater where he and his wife wrote, designed, and acted in informal plays with fellow artists, and he sold a number of scripts for vaudeville skits. His friendships with playwrights, directors, and actors, and support from the architect Stanford White, led to commissions to paint rococo-style murals that still can be seen today in the Belasco Theater near Broadway, along with other murals for private homes and many portraits. In his magazine illustrations Shinn returned to the

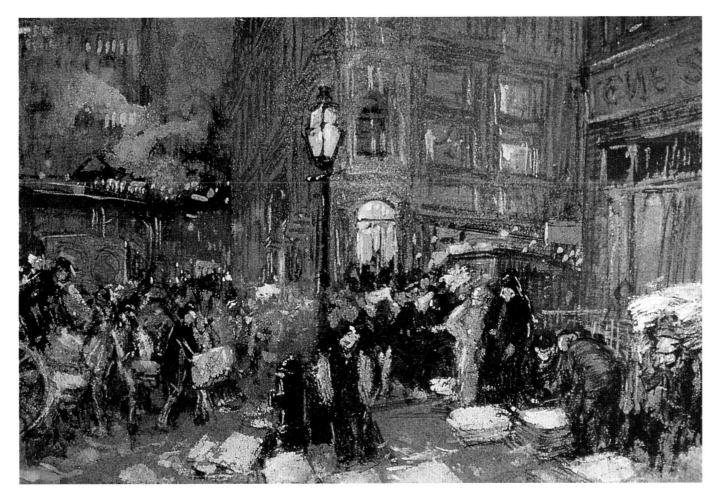

subject of physical labor, first treated in such pastels as *The Docks, New York City*. In 1911 he painted heroic working figures in a set of murals, *New Jersey Industry*, for the city hall in Trenton. In later years he focused almost exclusively on the realms of fashion and performance and worked for a time as an art director in the fledgling movie industry.

Two grand canvases dominated William Glackens's wall at The Eight exhibition: *The Shoppers* and *Chez Mouquin*, originally titled *At Mouquin's*. In both paintings friends posed as elegant New Yorkers engaged in fashionable contemporary pursuits. The compositional sophistication and psychological complexity of these paintings prompted comparisons with the work of Manet. Glackens's other paintings in the exhibition depicted busy urban parks in Madrid and New York, as well as the more proletarian crowds at Brighton Beach. Less intense than the two large-scale figure paintings, their dense and varied activity recalled

some of the magazine illustrations he was making at the time.

Glackens settled in New York after a trip to Europe with Henri in 1895–96. In Paris, with Henri's encouragement, he had sought out paintings by Manet (several of Glackens's paintings of parks seem to be based on Manet's *Concert in the Tuileries*) and had begun to make his own studies of streets, parks, and cafés. These informed the dark-hued views of parks and harbors that he painted in New York at the turn of the century. Like Shinn and Luks, Glackens moved from drawing for the *New York World* and *Herald* into magazine work, where his talents were much in demand. One of his first major assignments sent him to Cuba to cover the Spanish-American War for *McClure's*. (Unlike his friend Luks, Glackens really did travel with the troops, and contracted malaria for his troubles.) Although the articles Glackens illustrated ranged from tales of the Wild West and travelogues to

Fig. 70
Everett Shinn, *Park Row, Morning Papers*, undated, pencil, charcoal, watercolor, and gouache, 21.6 x 33 cm (8 ½ x 13 in.). Private collection

Shinn's pastels were known for capturing what one critic called "the real actualism of the street, of its scurry and bustle, of its rush and hustle . . . that tide of its life which makes those who both know and love the city feel that it is a sentient thing." Shinn may have planned to include this drawing in his unrealized project for a book to be titled New York by Night, *which would have presented a nocturnal view of the city that never sleeps—a popular conceit that continues into our own time.*

Park Row in lower Manhattan housed the headquarters of several of the city's newspapers. Turn-of-the-century visitors to Manhattan frequently remarked on the spectacle of busy deliverymen handling bundles of papers before dawn.

Fig. 71
William Glackens, *Curb Exchange*,
1907–10, gouache and conté crayon,
67.3 x 46 cm (26 ½ x 18 in.). Museum of
Art, Fort Lauderdale, Florida, Ira Glackens Bequest

Fig. 72
William Glackens, *Curb Exchange #1*,
ca. 1907–10, crayon and watercolor on
paper, 62.5 x 48.7 cm (24 ⅝ x 19 ³⁄₁₆ in.).
Georgia Museum of Art, The University
of Georgia, University Purchase 76.26

*The Roman-Corinthian style pediment
and columns of the New York Stock Exchange, erected in 1903, inspired favorable comment from design critics and
respectful depictions by architectural
illustrators. Glackens's eye was drawn
instead to the antics of the informal
"curb traders," a sight often noted in
guidebooks and depicted on postcards
at the time. Sloan, on a visit to Broad
Street in 1910, found the action rather
vulgar: "a crowd, mostly youths. Some
bare headed, some with red hats on,
some with caps and hats. Signalling and
shouting to other clerks in the windows
of the surrounding office buildings. . . .
Most of them are of a cheap looking
type of men."*

historical fiction, most of his drawings emphasized expressive human figures, and many were set in New York. Two unpublished drawings of the Wall Street *Curb Exchange* (figs. 71 and 72) show the artist's eye for detail and telling comic gesture, some of which he learned from studying British cartoons and some of which came from his remarkable imagination and visual memory. Working drawings show how Glackens made quick sketches on the street, then went through a painstaking process of compositional studies to arrive at a finished illustration, sometimes making several versions of the drawing before he was satisfied (figs. 73 and 74). The precision of the signage and architectural settings in these drawings suggests that Glackens may have used photographs for the background (fig. 75), but the variety, frenetic energy, and clever rendering that make the traders far more individualistic than they would appear to a camera are the artist's invention. A similar treatment of figures and incident informs paintings like *Skating in Central Park*.

At times Glackens's paintings were closely related to his illustration assignments. (The setting and overall mood of *Hammerstein's Roof Garden* [fig. 210] are quite similar to a drawing for an article published in *Harper's Bazar* the year before.) But at times there were differences. *Chez Mouquin* certainly achieves a different level of disquieting subtlety than any of the captioned illustrations Glackens drew for magazines. Magazine work, in turn, took him to a greater range of locales than he chose to treat in his own art. For example, as early as 1899 he illustrated Abraham Cahan's stories of Jewish life on the Lower East Side and developed a specialty in the subject; over the years he returned to the neighborhood to produce drawings for muckraking exposés as well as for humorous fiction. But Glackens seems to have ventured there only on assignment. For all of his knowledge of the area, he never depicted it in paintings. His drawings maintained a certain ambivalence or discomfort with the people there, who often appear forbidding, even grotesque, and always foreign. Glackens's paintings, filled with affectionate renditions of familiar foibles, stayed closer to the more respectable neighborhoods that the

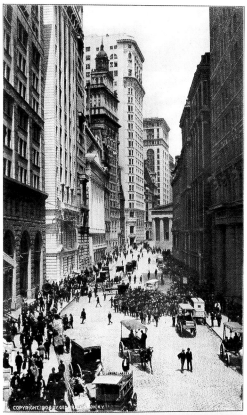

THE "CURB" MARKET, BROAD STREET

artist called home, including the park outside his studio on Washington Square. These works are often more decorative and slightly more decorous than his drawings.

After the Macbeth exhibition, Glackens moved away from making broadly brushed paintings in a dark-toned palette toward manipulating stitchlike strokes of paint in brilliantly vibrating hues. *Skating in Central Park* (fig. 76), with its choppy brushwork and blue shadows, could have been inspired by the painting technique of the impressionists Claude Monet and Pierre-Auguste Renoir, although the lively figures are distinctively Glackens's. His interest in modern art, deepened during a trip back to Europe in 1906, led him to return to France in 1912 to select paintings for the collector Albert Barnes and then to organize the American section of the Armory Show.[24] In the meantime, he continued to produce ingenious, stylized drawings of urban subjects for *Collier's* and other magazines; the most impressive of these were large drawings apparently made on his own initiative, which were published as magazine covers or full-page illustrations independent of text. Although the pictures seem to belie it, Glackens evidently came to loathe

Fig. 73
William Glackens, Sketch for *Curb Exchange*, undated, graphite and charcoal on paper, 20.59 x 13.97 cm (8 ½ x 5 ½ in.). In Glackens Sketchbook No. 709, Museum of Art, Fort Lauderdale, Florida, Ira Glackens Bequest

Fig. 74
William Glackens, Sketch for *Curb Exchange*, undated, graphite and charcoal on paper, 20.59 x 13.97 cm (8 ½ x 5 ½ in.). In Glackens Sketchbook No. 709, Museum of Art, Fort Lauderdale, Florida, Ira Glackens Bequest

A perfectionist, Glackens made extensive preparatory sketches and reworked his compositions until he was satisfied with them. He made at least three versions of this subject, but none were published. They depict the informal "curb market" on Broad Street, where unofficial brokers traded on the sidewalk outside the New York Stock Exchange.

Glackens filled a pocket sketchbook with notes he apparently made at the site: most of the firms whose names appear on the signboards were actually in business on Broad Street in 1908.

His finished drawings downplay the buildings and emphasize the chaotic activity of people in the street. All three versions use a similarly detailed architectural setting, possibly based on photographs, but vary their viewpoints and the figures in the crowd.

Fig. 75
George P. Hall and Son, *The "Curb" Market, Broad Street*, 1904. Museum of the City of New York

Fig. 76
William Glackens, *Skating in Central Park*, ca. 1910, oil on canvas, 63.5 x 76.2 cm (25 x 30 in.). Kraushaar Galleries, New York

his illustration assignments. By the late teens he was able to support his family with picture sales, augmented by his wife's inheritance, and stopped making illustrations altogether to spend more time painting at home and abroad.

George Luks's New York, like his public persona, was larger than life: a boisterous place where new arrivals—whether immigrants or modern technology—challenged older mores. His talent for conveying vigorous physical energy through bold brushwork can be seen in the virtuosic paintings *The Wrestlers* and *The Spielers* (fig. 176), both of which present figures lunging toward the viewer, and in his dramatic painting of trains entering the *Roundhouses at Highbridge*. At The Eight show,

however, he exhibited pictures in a quieter mood: barnyard scenes and a number of canvases depicting New York's diverse population. These included the market on *Hester Street* (fig. 10) and smaller portraits of urban characters, inspired by the old masters by way of Henri, which critics found quite poignant.

These paintings now look rather subdued in comparison with Luks's illustration work in the 1890s. Alongside his checkered career as a sketch-reporter, he produced forceful political cartoons and was best known for taking over the Sunday comic *Hogan's Alley* when the cartoon's originator, Richard Outcault, defected to the *New York Journal*. Set in a mythical downtown neighborhood, his drawings fea-

tured a wisecracking hero, Mickey Dugan
(known as the "Yellow Kid" because of the
smock he wore), and a gang of friends who
engaged in frenetic activity against a tenement
backdrop studded with humorous signboards
(fig. 77). A similar relish for the city's diversity
informs the portraits Luks made of people he
encountered on the street. Many of these
paintings are now either damaged or lost,
but their titles (*The Madonna of the Market
Place*, *The Pawnbroker's Daughter*, and *The Old
Cosmopolitan Chess Club*) suggest reportorial
rovings through immigrant neighborhoods.
Luks explained his predilection for painting
"the slums": "Down there people are what
they are." Like Henri, he claimed to emphasize
character rather than poverty; he told an
interviewer that he admired the energy of peo-
ple striving to improve their economic lot.[25]
There are connections between some of the
feisty urban types Luks painted and the char-
acters in his cartoons, but on the whole the
portraits are more restrained. In the 1920s
Luks painted several probing portraits of
miners and their families in Pennsylvania.

Scenes in New York's streets and parks
reveal yet another facet of Luks's career, that
of experimental painter. He made several trips
to Paris, and his later paintings of the Lower
East Side, including *Allen Street* (fig. 125),
downplay anecdote in favor of vivid, post-
impressionist color contrasts. He pursued
this interest in a series of striking outdoor
scenes, notably *Knitting for the Soldiers: High
Bridge Park* (fig. 78).

John Sloan's pictures in The Eight exhibi-
tion depicted working-class people in the West
Side neighborhood around Chelsea, the Ten-
derloin, and Madison Square, where the artist
lived (*Sixth Avenue and Thirtieth Street*, *Elec-
tion Night*, and *Hairdresser's Window* [figs. 147,
152, and 164]). He had moved to this area
shortly after arriving in New York in 1904 and
began keeping a diary at about the same time.
It describes his habit of noticing incidents on
his walks through the city, recording them in
his journal, then working them up into paint-

NEW YEAR'S CELEBRATION IN HOGAN'S ALLEY.

ings and prints in his studio. For example, the
painting *South Beach Bathers* (fig. 79) began
with one such observation on a Sunday outing
to Staten Island. The next day he "worked on a
picture, started to make a memory of South
Beach," and painted on and off for a few days
before putting the canvas aside; he took it
out again and finished it in 1908 in time for
The Eight's touring exhibition.[26] The paint-
ing's loose brushwork implies that the artist
preferred to work quickly. But instead of con-
veying the appearance of a rapid glimpse, as
Shinn's work does, Sloan's pictures are com-
posed with an illustrator's eye for narrative
content and telling detail. The crowd of people
on the sand in *South Beach Bathers* at first
appears random, but is actually arranged
around the central standing figure like spokes

Fig. 77
George Luks, *New Year's Celebration
in Hogan's Alley*, from *New York World*,
27 December 1896, comics page.
Collection of Clyde Singer

*Tenement districts provided the setting
for the raucous comic* Hogan's Alley,
*home of the celebrated Yellow Kid
(seen here ringing a bell). The rowdy
assortment of children on the street in
these cartoons recalls a contemporary
observer's description of "the 'Young
America' of all nationalities in the
city, shrill-voiced, disrespectful, easily
diverted, whether at work or at play,
shrewd, alert, and mischievous—the
New York Street Child."*

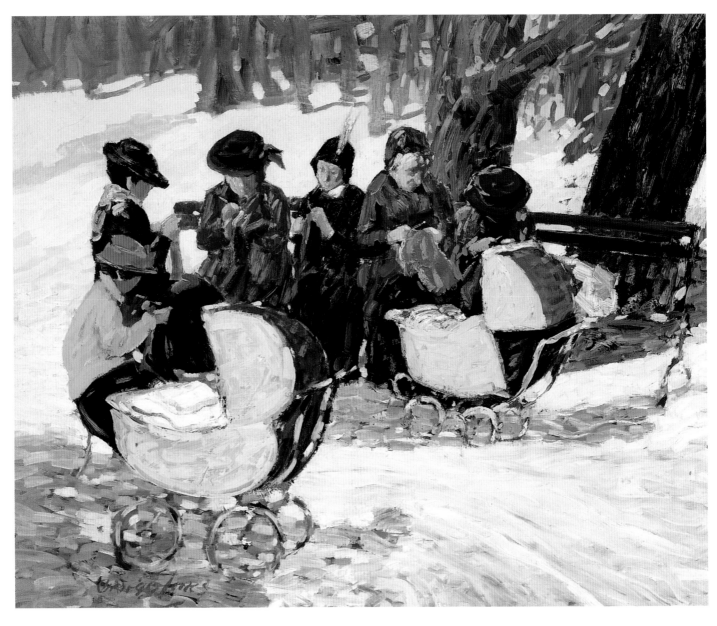

Fig. 78
George Luks, *Knitting for the Soldiers:
High Bridge Park*, ca. 1918, oil on can-
vas, 76.7 x 92 cm (30 3/16 x 36 1/8 in.).
Daniel J. Terra Collection, 2.1990.
Photograph © 1995, Courtesy of Terra
Museum of American Art, Chicago

*The brilliant color contrasts and the
purple shadows on the snow are evi-
dence of Luks's growing interest in post-
impressionist painting techniques. The
subject of this painting carried extra
meaning when it was shown in 1918.
Although exhibited simply as* Knitting,
High Bridge Park, *a number of critics
speculated that the women were "en-
gaged in patriotic service," knitting
for American soldiers overseas.*

of a wheel. Each person looks up at her, raising
the possibility of any number of relationships
among the figures, while a young girl in white
looks out at the viewer, in effect implicating us
as fellow observers. Details of costume, the
steamed crabs and hot dogs in the foreground,
and the title of the picture itself provide infor-
mation about the characters and situate them
in a particular time and place.

Many of Sloan's New York pictures sug-
gest stories that begin when one person (often
a man, and often the artist himself) looks at
another, often a woman. Women play several
roles at once in Sloan's art: beyond being
objects of desire, they record the new inde-

pendence of modern New Yorkers while also
presenting a variation on old ideals of beauty
in art. Charged paintings like *Sunday Afternoon
in Union Square* (fig. 80) bring to the fore the
sexual presence of city people in public, the
potential for flirtation and personal interac-
tion. Portraying working-class people as less
inhibited than the repressed bourgeoisie,
Sloan sought out scenes of camaraderie, from
the quiet communion of men at McSorley's
Bar to the bumptious conversation of women
walking arm in arm in *The Return from Toil*.
But he could also create contemplative, poetic
images of moments in the city, as in *The Wake
of the Ferry II* and *Pigeons* (figs. 98 and 129).

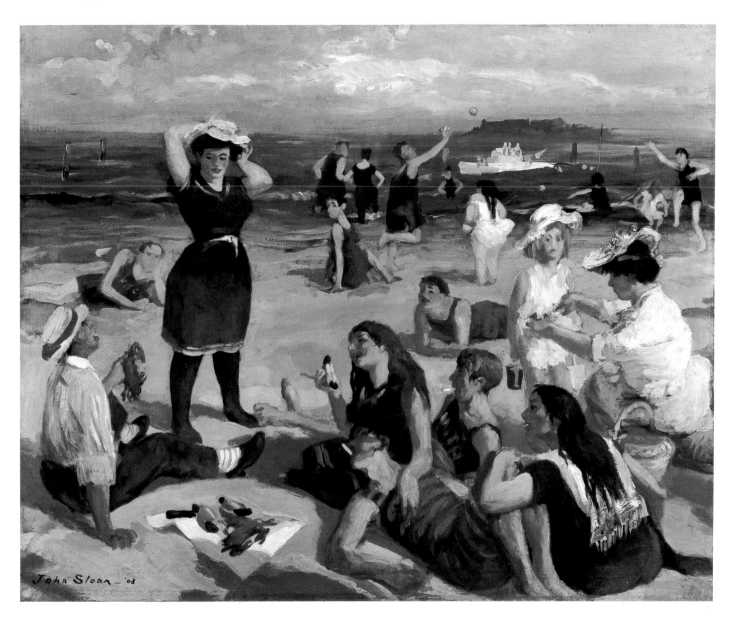

Because Sloan kept diaries, wrote and saved letters, and gave interviews during his long life, we know more about him than we do about his colleagues. We know that he was always bookish; that as a boy he enjoyed looking through albums of engravings by William Hogarth and bound volumes of illustrated magazines; that he read Dickens at an early age and Whitman, Balzac, and Joseph Conrad as an adult; that he quit high school to support his family by working in a bookstore, then moved into illustration work; that initially he was reluctant to leave Philadelphia but finally did so in 1904 when he lost his job at the *Philadelphia Press*. By that time his closest friends from Philadelphia had already moved to New York and were able to help him find book and magazine assignments; he specialized in illustrating fiction about immigrants and comic adventure stories. The Philadelphians also constituted a ready-made artistic and social circle. Sloan's diaries record many long nights (like those depicted in his etchings) spent drawing and talking, dining in restaurants, or attending lectures and plays with fellow artists and writers. We know of his admiration for Isadora Duncan and European drama, his jaunts to Coney Island and frequent visits to the movies, and his sense of humor. We know the unorthodox routine of the freelancer's day—sleeping late, spending afternoons scavenging for assignments—his

Fig. 79
John Sloan, *South Beach Bathers*, 1907–08, oil on canvas, 66.04 x 79.38 cm (26 x 31 ¾ in.). Walker Art Center, Minneapolis, Gift of the T. B. Walker Foundation, Gilbert M. Walker Fund, 1948

frustration at not selling his paintings, and the difficulties he faced balancing his budget.

Sloan's art changed when he moved to New York. In Philadelphia he had painted portraits and scenes of squares and streets viewed at a distance, but his New York work concentrated on human figures in situations that suggested narratives or made ironic comparisons, as in *The Woman's Page* (fig. 116). He first explored these themes in the "New York City Life" set of etchings, and by 1906 had carried them into oil paintings. His New York diaries record both his reading habits and the delight he took in observing incidents on walks through the city, which he occasionally compared to the realist fiction he admired. In fact, the social position of his neighbors on the West Side—mainly second-generation Irish-Americans—may have allowed him to see them as accessible literary characters in a way that he would not have regarded people in the more exotic districts that Luks chose to paint, or his own social peers. The diaries also indicate Sloan's continuing struggles to paint formal portraits and figure studies from the model. His city scenes were more successful; although they rarely sold, they were shown widely and reviewed favorably, with critics dubbing him "the American Hogarth."

Thanks to Sloan's diaries, we can also track his growing concern with politics in the years around The Eight exhibition. Always a reader and an argumentative talker, he became an organizer of the Macbeth Galleries show. Paralleling his fulminations against the New York art world, the diaries from 1907 through 1909 record increasingly frequent and fervent discussions about local elections, women's suffrage, and national labor problems with a new circle of associates. On reading of the general strike of fifty thousand workers in Philadelphia in 1910, he declared, "We are feeling the first throbs of the Great Revolution. I'm proud of my old home—cradling the newer greater Liberty for America!"[27] Sloan's general dissatisfaction with his own difficulties in making a living, coupled with an awareness of social inequalities, translated into an analysis of the injustices of the capitalist system and an interest in socialism as a potential solution. He and his wife, Dolly, became active Socialists and officially joined the party in 1910.

Sloan's diaries reveal some of the difficulties he faced in reconciling his art with his politics. He claimed that his painting was kept independent of the illustration work he donated to party publications and resisted any suggestion that he dedicate his art to propaganda. But for someone who agreed with Henri that art should treat the things in life that matter most, the two were rarely far apart. (For a few years, his involvement with the radical journal *The Masses* seemed to offer a way to bring his commitments together, although the drawings he published there usually remained separate from the subjects he treated in paint.) Around 1908 some of Sloan's paintings of city life began to reveal an increased attention to class distinctions, either by twitting the upper classes or by depicting his neighbors with warmth and respect. Emphasizing the pleasurable rather than the degrading aspects of working people's lives, Sloan portrayed them with a dignity that he did not grant the fatuous toffs in *Fifth Avenue, New York* and *Gray and Brass* (figs. 111 and 113). In contrast to upper-class alienation, pictures such as *Scrubwomen, Astor Library* and *Three A.M.* (figs. 193 and 194) depict their subjects in moments of relaxed fellowship that recall Sloan's rare images of his own friends, such as *Memory*. At times his pictures suggest that working people enjoy a physical spontaneity that he could only envy. Sloan seems to have considered himself an intellectual but not a man of property. He was well aware of having to work for a living, but he never identified with a proletariat. While his images of workers may have been idealized, his admiration was always from a distance.

The fruitful but difficult integration of art, work, daily life, and political conviction that Sloan achieved for several years eventually dissolved as his interests and circumstances changed. For a few years his political activities

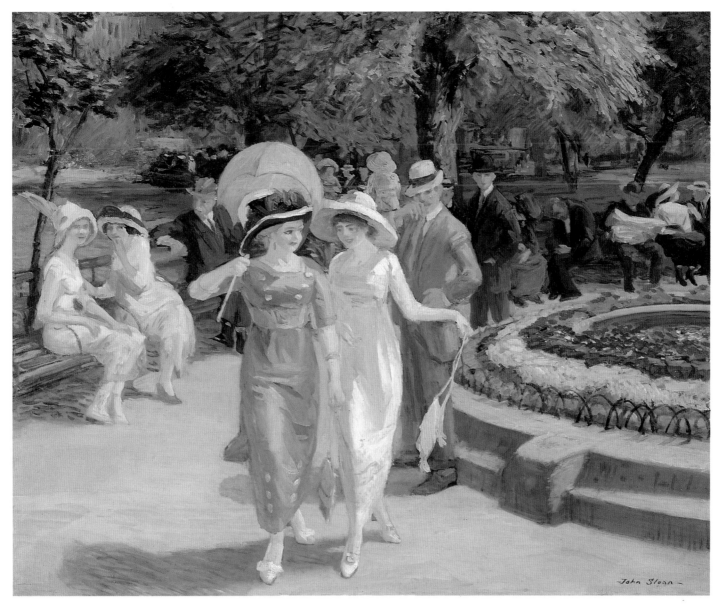

became all-absorbing, but he left the Socialist Party disillusioned at the outbreak of World War I. Teaching replaced illustration work as his main source of income at about the same time. Following the Armory Show, Sloan's art became increasingly concerned with formal properties of color and composition, which he explored more easily in the studio and at the seashore than on city streets. He spent more time away from the city—first on summer vacations in Gloucester, Massachusetts, then on extended stays in New Mexico. In New York Sloan's art and life had fed each other; neither was the same after he left.

Although George Bellows did not exhibit with The Eight, by the time of the exhibition his name was often linked with theirs as a follower of Robert Henri and one of the "youthful apostles of force, who express. . . the rush and crush of modern life, the contempt for authority."[28] For him, 1908 proved to be a banner year. In the wake of the Macbeth Galleries show, he participated in an exhibition that critics dubbed "The Eight out-Eighted." Organized by a group of Henri's pupils, it was distinguished by paintings of urban subjects rendered in an anti-academic technique that some found inept or deliberately crude but others considered audacious. Bellows showed a painting of the Pennsylvania Station excavation and the first of his boxing pictures, a pastel titled *The Knock-Out* (fig. 202). Critics either praised or

Fig. 80
John Sloan, *Sunday Afternoon in Union Square*, 1912, oil on canvas, 66.7 x 81.9 cm (26 ¼ x 32 in.). Bowdoin College Museum of Art, Brunswick, Maine, Bequest of George Otis Hamlin

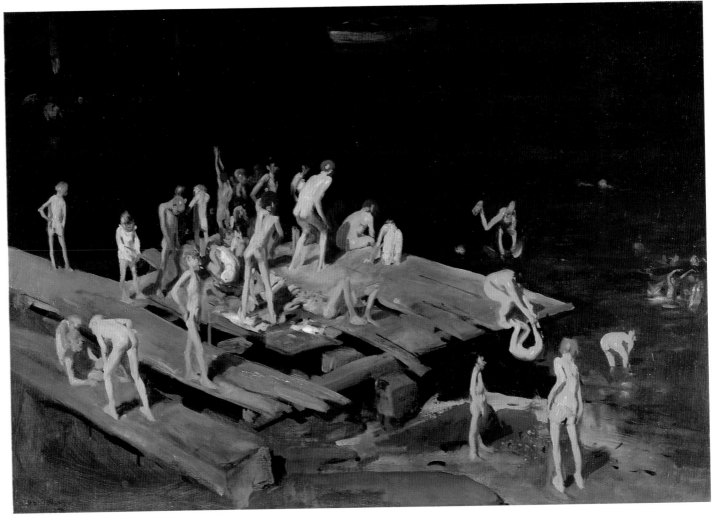

Fig. 81
George Bellows, *Forty-two Kids*, 1907,
oil on canvas, 107.63 x 153.04 cm
(42 ⅜ x 60 ¼ in.). In the Collection of
the Corcoran Gallery of Art, Washing-
ton, D.C., Museum Purchase, William
A. Clark Fund

*This work helped establish Bellows's
reputation for brashly rendered paint-
ings of the urban working class, "tagged
with the Gotham personality." The
slangy title suggested contemporary
street talk. The subject of tenement
youths diving off a broken pier was
unappealing to some critics, but others
praised the painting for its humor and
energy.*

damned the "frankly brushed" painting of "the Big Hole" and the "startling though brutal slice from life on the East Side," but all singled out Bellows as a young artist to watch.[29] He was not exactly an outsider at this point; the year before, he had exhibited *Pennsylvania Excavation* (fig. 96) and the boxing painting now titled *Club Night* at the National Academy of Design and had sent *Forty-two Kids* (fig. 81) to national juried exhibitions at the Carnegie Institute and the Pennsylvania Academy of the Fine Arts. At the same time that he was exhibiting with his fellow young Turks in rented rooms, his paintings *Forty-two Kids* and *North River*, an urban landscape, were attracting favorable notice at the National Academy's spring exhibition; the latter earned Bellows his first award and his first sale to a museum. The next year Bellows was elected to the National Academy of Design. All of this acclaim helped

establish his reputation as a painter of "passing phases of the town in a manly, uncompromising fashion," who found excitement where weaker souls saw only ugliness.[30]

Bellows had some experience with commercial illustration as a student in Ohio, and in the 1910s he occasionally picked up magazine assignments. But he came to New York primarily to study art, and achieved enough success through painting, printmaking, and teaching to be spared relying on illustration for his living. Instead, in Robert Henri's classes he developed a way of depicting the city. He eventually took the characteristics of rapid, vigorous execution of topical subject matter, and of exploring the extremes of New York life, even further than did the Philadelphia artists who had trained as news reporters. Bellows was a more ambitious painter than his older colleagues and more sophisticated in the way he

handled color and materials; his paintings show an expressionistic boldness and a willingness to take risks. In his art we see a power, and a fascination with violence, that makes Sloan and Luks seem warmhearted, Shinn refined, Glackens reticent—and that struck some of Bellows's contemporaries as empty, "noisy" bluster. Deliberately seamy images of working-class people are rendered with relish, so that while the ringside crowds and street children appear slightly grotesque, they are also indisputably alive. Boxing scenes and construction sites, polo matches and seascapes alike are marked by a sense of struggle and conflict. But in *Blue Snow, the Battery* Bellows achieves equally stark effects in a smoothly brushed expanse of empty space. His work in black-and-white—rough drawings in charcoal or crayon and later lithographs— was just as potent.

Bellows made some of his best large-scale drawings and prints for *The Masses*. In the teens he became a member of the editorial board and participated in the circles of artists and activists now termed the "Lyrical Left." Unlike Sloan, a committed Socialist, Bellows allied himself with the anarchist side of American radicalism. Like his mentor, Henri, he took a stand for individual freedom, admired Emma Goldman, and taught at the Ferrer School. Within *The Masses*' internal political debates, he expressed his convictions by arguing for artistic independence from any editorial policy. The pictures he published there included urban scenes (*Why don't they all go to the country for vacation?* [fig. 108]) as well as class-based social satire (*Business Men's Class* [fig. 199]) and some unforgettable political commentary. He differed from *The Masses*' editorial policy in his active support of American intervention in World War I. Always willing to use fame as a soapbox, he became a very public supporter of the war effort.

After 1908, Bellows's art explored several directions. He continued to depict fight scenes and other city subjects but also painted seascapes in Maine. With fame came prestige, portrait commissions, invitations to socialize with wealthy people, and some very interesting images of New York's elites at leisure. At the same time, he revisited the subjects of his early paintings in a series of large-scale prints that helped expand lithography's potential as a fine-art medium.

The war years proved to be a turning point for each of the Ashcan artists. After 1917, none of them devoted full attention to interpreting life in New York. They spent increasingly less time in the city and less time together as a group. Shinn moved to Hollywood, Glackens to France; Sloan, Bellows, and Henri divided their time between Manhattan and artists' colonies from Maine to New Mexico. Turning away from topical subjects observed on the street, most of these artists now concentrated on landscape, still life, portraiture, and figure studies that allowed them to investigate problems of design and color. Although none of them made the shift to abstraction, several moved toward more formal concerns in response to the modern art they saw at the Armory Show. Bellows became particularly concerned with imbuing his work with a timeless geometric structure based on principles of dynamic symmetry.

The artists retreated from a city where they and their work were no longer in the thick of things. The market for illustrations of urban subjects diminished as photography became the dominant medium for recording pictorial fact. With the waning of the Progressive Era and the advent of the free-spending 1920s, depictions of the urban working class receded from the forefront of public discussion. Instead, films, popular magazines such as *The New Yorker*, and modern artists presented a glossier, jazzy Manhattan, while Edward Hopper defined the city's bleaker side. Its population and social forces always in motion, New York after the war was no longer the same place that the artists had discovered at the turn of the century and where they had found their individual voices.

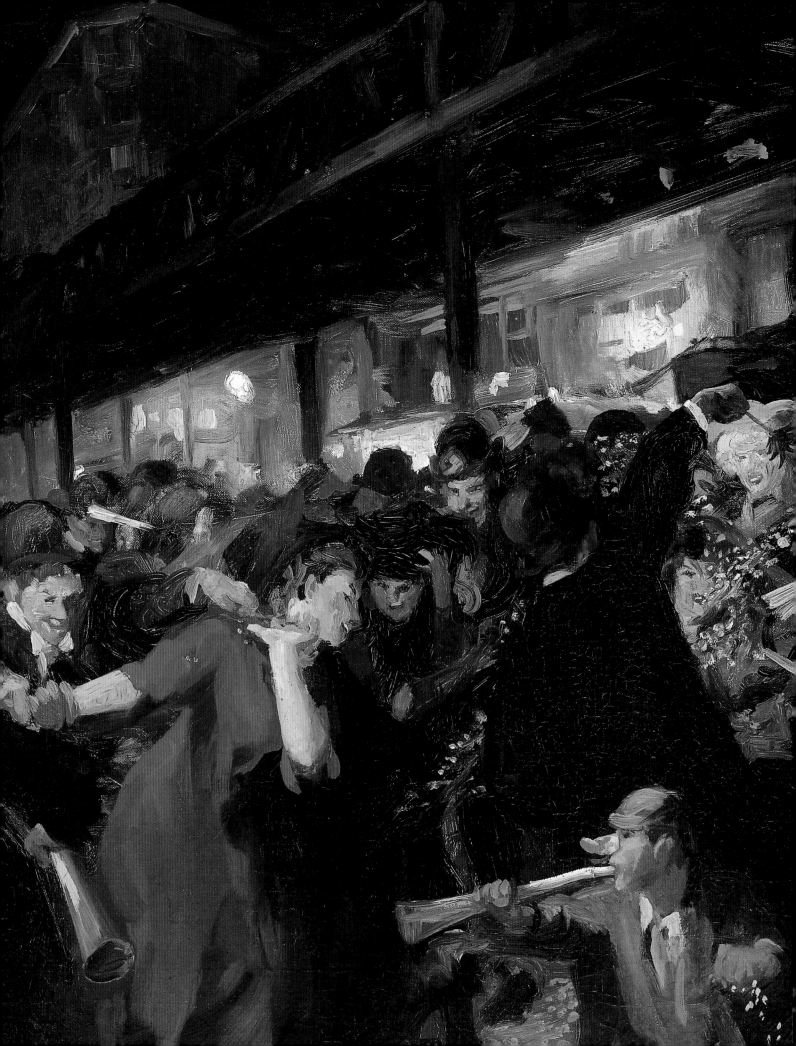

ROBERT W. SNYDER AND REBECCA ZURIER

PICTURING THE CITY

The Ashcan artists gave themselves an original challenge: to interpret and give visible form to the dynamic social forces that were shaping and reshaping New York City. There were few precedents for these subjects in American art, and depictions of European cities did not always translate directly. In many cases the artists sought new pictorial solutions to their dilemma. They looked to a variety of sources, both art historical and popular, for ways to characterize the city they lived in. Although their work shared concerns with images in newspapers, documentary photography, and entertainment, the artists often found new ways of representing their subjects and distinct ways of thinking about them. Their immersion in the issues of the day became the source of their originality.

In 1911 George Bellows met the challenge of picturing the city in a huge synoptic painting titled *New York* (fig. 82). Marianne Doezema has demonstrated that this image is actually a composite that juxtaposes the park and the confluence of streets and transit lines at Union Square with the canyonlike blocks of office and loft buildings located farther downtown; the rectangular format squeezes the architectural elements to heighten the "throbbing density, the magnificent heterogeneity of the scene."[1] The clusters of billboards and crowds of people and vehicles in the painting at first seem schematic, but actually are rendered with more variety and specific incident than is legible in contemporary black-and-white photographs. Strokes of color help the viewer single out shoppers buying vegetables at a pushcart and passengers boarding a streetcar, top-hatted gents and businessmen

in brown derbies, coachmen driving cabs and deliverymen on wagons, the green and yellow trolleys that ran along Broadway, the red and tan cars of the Third Avenue line, and the iron tracks of the Sixth Avenue elevated train. In the foreground, two uniformed city workers, a traffic officer and a street-sweeper, perform their duties. In one canvas Bellows has condensed the economic, commercial, and political activities that made the city function, juxtaposed them with elements of New York's characteristic architecture and public spaces, and filled the scene with a wide swath of the urban population going about their business.

This grand, generalized image that describes the city as a whole but no place in particular is atypical of the Ashcan School. More often the artists chose to represent individual moments or locales identified in the title by a specific address, activity, season, or personality (for example, *Christmas Shoppers, Madison Square*; *The Old Rosary Woman of Catherine Street, New York City*; and *Six O'Clock, Winter*). Their block-by-block, incident-by-incident approach has much in common with contemporary guidebooks and magazine articles that divided New York into a series of streets to be encountered successively on a "Walk Up-Town" or that described the city's activities at different times of the day. Shinn made many of his pastel drawings for this sort of publication.[2]

Yet despite the wealth of factual detail and the animated line that gives them their apparent spontaneity, these pictures are by no means literal slices of life captured at random on city streets. Each is a synthesis or construction that offers an artist's representation

John Sloan, *Election Night* (detail), 1907, oil on canvas, 67 x 82 cm (26 ⅜ x 32 ¼ in.). Memorial Art Gallery of the University of Rochester, Marion Stratton Gould Fund (see fig. 152)

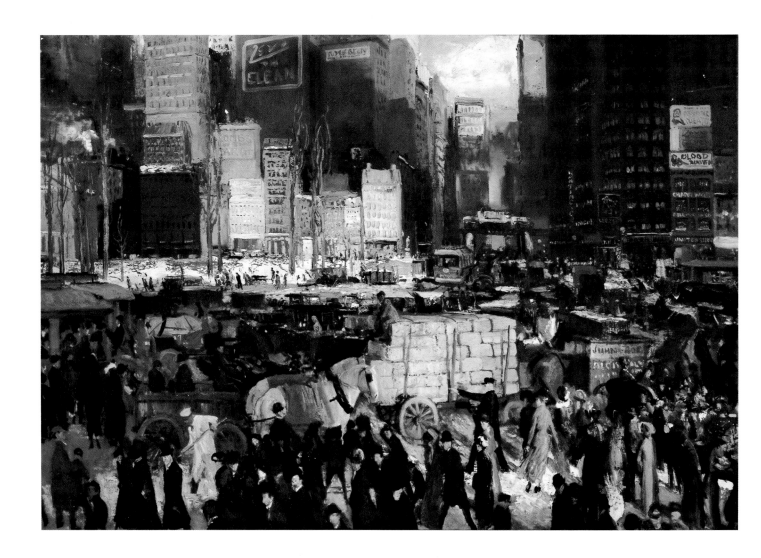

Fig. 82
George Bellows, *New York*, 1911, oil on
canvas, 106.7 x 152.4 cm (42 x 60 in.).
© 1995 Board of Trustees, National
Gallery of Art, Washington, D.C., Col-
lection of Mr. and Mrs. Paul Mellon

A startled critic wrote of this painting,
"When you first see it you are filled
with amazement, so full is it of motion,
of stirring existence. Trucks are darting
through the crowd. Men and women
are hurrying across the streets, trolleys
are clanging their way in and out, a
policeman is keeping people from
being run over, you feel the rush, you
hear the noise, and you wish you were
safely home."

of the people and places depicted. If they conveyed the ring of truth to viewers, it was due to the artist's skill at composing a picture and giving it the look of real life. The artists were never neutral and objective observers but interpreters who presented their distinctive visions of the urban scene.

This chapter examines some of the pictures they made, at times in comparison with other imagery from turn-of-the-century New York that helps provide a context for understanding their work. In compiling their record of the city, the artists followed familiar itineraries (fig. 83). Guidebooks and bus tours at the time recommended that any tour of the city include the waterfront, construction sites, immigrant neighborhoods, shopping districts, a visit to Wall Street, the public squares, Central Park, Coney Island, a vaudeville show, and so on; these were also the places recorded in the early "actuality" movies filmed in New York. Postcards and popular songs singled out the same subjects for comment. But the artists' images of these locales offered more than a breezy overview. Unlike the omniscient tour guide, they reveal that at times the artists were confused by, or even estranged from, the people they met on the street. Their pictures suggest some of the complexity of how people's lives were affected by developments in the "new New York."

In some sense the artists were sightseers who sought out the variety of the city's human spectacle and viewed it from a distance. Their work presents subjects as observed in public places or through a window, only rarely engaging them face to face. In that respect, the artists enacted the experience of most city people, constantly navigating new terrain and encountering strangers they would never see again. They were much like riders on a streetcar, who form a temporary association as they sit beside each other for a limited span of time.[3] As they watch and wonder about each other, they move through an urban landscape that appears as a series of glimpses through the windows into the lives of countless city dwellers. Although these contacts with strangers were momentary, the artists realized that their lives were intertwined: the newsboys that Shinn watched picking up bundles of morning papers were part of the same business that employed the artists themselves and that linked events, reporters, and readers in a dynamic conversation. Ashcan images present their subjects as fellow New Yorkers who all form part of the urban fabric. Unlike a guidebook's summary, these pictures rarely resort to a quick characterization or an ephemeral moment. Rather,

Fig. 83
Seeing New York, 1904, postcard. Museum of the City of New York, Gift of Adolph J. Brady

The standard routes of bus tours of the city featured the impressive architectural monuments of what commentators at the time dubbed "The New New York," but also included locales where characteristic urban activities could be observed. Many of these sites were depicted by the Ashcan artists. Barely three miles separated the Lower East Side of the immigrants from the Flatiron Building, but tour guides treated the excursion as a trip to another world. Sightseeing companies promised an authentic look at neighborhoods, including "the Bowery—with its endless procession of human wrecks."

N.Y. 11 Future New York
"The city of skyscrapers"

Fig. 84
Future New York: "The city of sky-scrapers," 1916, postcard based on a drawing by Harry M. Pettit, published in *King's View of New York,* 1908. Museum of the City of New York, Gift of M. Matthilde Mourraille

The rapid pace of construction in turn-of-the-century New York inspired science-fiction visions of a "city of sky-scrapers" and abstract interpretations of a mechanized metropolis devoid of people.

the artists composed their works to stop time and suggest some of the layers of meaning embedded in chance encounters. The stories they tell are rarely simple, since each is also shaped by the artist's relationship to the subjects represented. Although informed by shared artistic and social viewpoints, they do not form a unitary voice. In fact, some of the artists seem to have avoided people or parts of town that others found most intriguing, while certain pictures present contrasting interpretations of the same subject.

Like other New Yorkers, the Ashcan artists sought to understand the whirl of their city's streets. Unlike most of their neighbors, they made art out of their questions and their answers.

CHANGING CITY: THE URBAN INFRASTRUCTURE

Bellows's painting *Rain on the River* explores the mediation between man-made and natural landscapes in the city. In this view of Riverside Park and the rail yards along the upper Hudson, strollers on the pathways are never separated from the noise of the working water-front. Steam from ships' smokestacks merges with clouds and fog; trees and greenery are controlled in ordered plantings and crossed by paved sidewalks. The river is traversed by bridges and plied by ships. A damp gray sky marked by slanting strokes of rain unites both parts of the composition to convey the sensations of people walking in the park. The scene calls to mind a later tribute from the Manhattan poet Frank O'Hara: "One need never leave the confines of New York to get all the greenery one wishes—I can't even enjoy a blade of grass unless I know there's a subway handy."[4]

The Ashcan artists arrived in New York when the old nineteenth-century city of sailing ships, countinghouses, and horse-drawn wagons was giving way to a metropolis of steamships, skyscraper offices, and elevated trains. At first glance, this city seemed a juggernaut of terrible proportions. It threatened to become a place so large that it would have no human scale, so powerful that the work of individuals would seem puny, and so new that the past would be obliterated. In 1905 Henry James remarked with dismay on the rapidity of change and the disappearance of the old New York of his childhood. Others praised the technological breakthroughs. The spread of rapid transit, the booming bridges and mechanized rivers, and above all (literally) the relentless construction of skyscrapers were cited as signs of unstoppable progress (fig. 84). These motifs inspired modernist artists and writers to envision New York as the city of the future. "The skyscrapers are works of art," the visiting French painter Albert Gleizes told an interviewer in 1915. "Walking through the streets of this great city, I have, not infrequently, a feeling of being hemmed in and even crushed . . . the movement of humanity, streaming so steadily, so fixed of purpose, knowing so exactly where the goal lies New York is a very thrilling place."[5] Gleizes, Francis Picabia, and the American artists John Marin, Max Weber, and Joseph Stella responded with cubist paeans to throbbing avenues and the Brooklyn Bridge (fig. 85).

The Ashcan artists saw a richer and more subtle picture: not the unobstructed triumph of the modern but a dialogue between old and new, between man-made and natural landscape, that gave the city a complex and contradictory fabric, as when elevated trains loomed over horse-drawn carriages. In a city whose grandest work spaces were its harbor and construction sites, they saw how the labor of individuals—mariners, construction workers, longshoremen—made possible the new buildings and commerce that were growing toward an other-than-human scale. Their work does not show an inhuman city but rather one in motion, rebuilding itself through human effort—a city defined by the tension between its vast scale and the tiny, intimate yet significant enclaves that people created for themselves.

Nowhere was the tension between old and new more graphic than in transportation. At the turn of the century a growing network of commuter trains and mechanized elevated and underground lines allowed passengers to travel the length of Greater New York at unprecedented speed. But horses were still a common presence on the streets, hauling everything from freight to human passengers. The carts and carriages in Henri's *Snow in New York* (fig. 68) and Shinn's pastel *Fifth Avenue Coach, Winter* hark back to an older city dependent on animal power. Yet in none of these works is horse-drawn transport depicted as quaint or comfortable. Henri's street scenes appear in cold or gray weather on rutted streets flanked by dirty mounds of snow. The Fifth Avenue coach labors forward through a winter storm, its driver urging on the straining horses with a whip. The hapless pedestrian in the foreground confirms the cold; he trudges through the snow, his body bent forward by the wind, his hands covering his ears and holding down his hat.

There is little romance in these streets. In *Steaming Streets* (fig. 86), Bellows presents a collision between horse-drawn and newer modes of transport. A horse rears before a

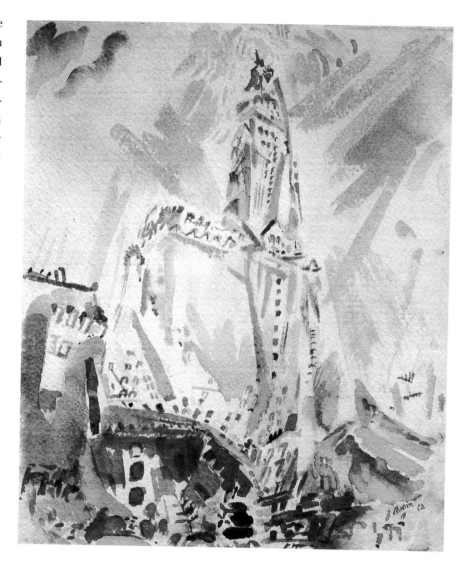

Fig. 85
John Marin, *Woolworth Building, No. 31*, 1912, watercolor over graphite. ©1994 Board of Trustees, National Gallery of Art, Washington, D.C., Gift of Eugene and Agnes E. Meyer

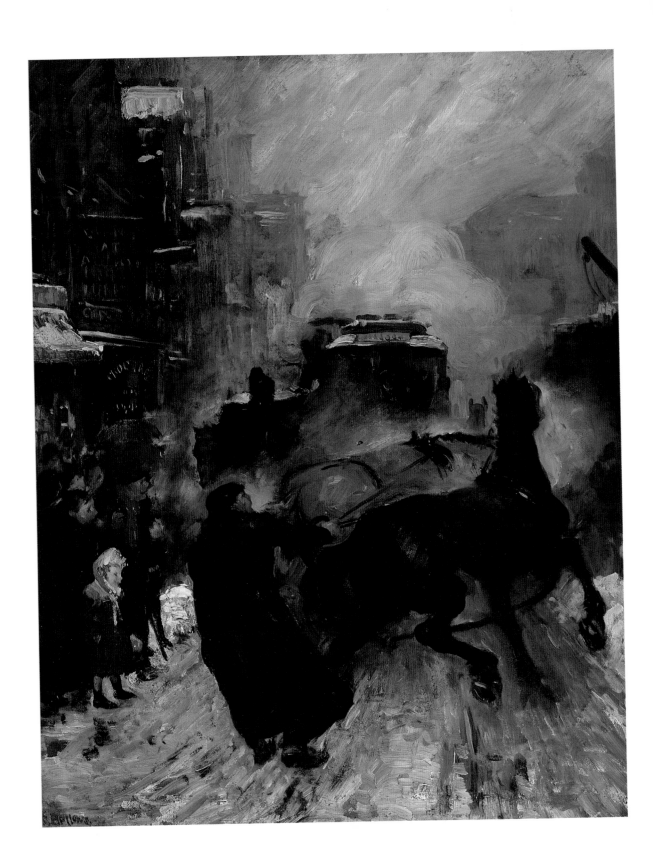

FIFTY PERSONS DEAD IN BROOKLYN ELEVATED WRECK

Photo shows a general view of the wreckage of the B. R. T. elevated train which jumped the tracks of the over head structure and dived to the streets below. It is feared that fifty persons died in the wreck.

Fig. 86 (opposite)
George Bellows, *Steaming Streets*, 1908, oil on canvas, 97.5 x 76.8 cm (38 ⅜ x 30 ¼ in.). Santa Barbara Museum of Art, Gift of Mrs. Sterling Morton for the Preston Morton Collection

Fig. 87
"Fifty Persons Dead in Brooklyn Elevated Wreck," undated, newspaper clipping. Warshaw Collection of Business Americana, National Museum of American History, Smithsonian Institution

In the New York City of the Ashcan artists, every disaster found its audience—first in the streets, then in the metropolitan press. Here a crowd gathers to look at the wreckage of an elevated train that jumped its track and crashed into a street in Brooklyn.

Fig. 88
Everett Shinn, *Night Life–Accident* 1908, pastel, watercolor, and gouache on paper, 33 x 43.8 cm (13 x 17 ¼ in.). Private collection

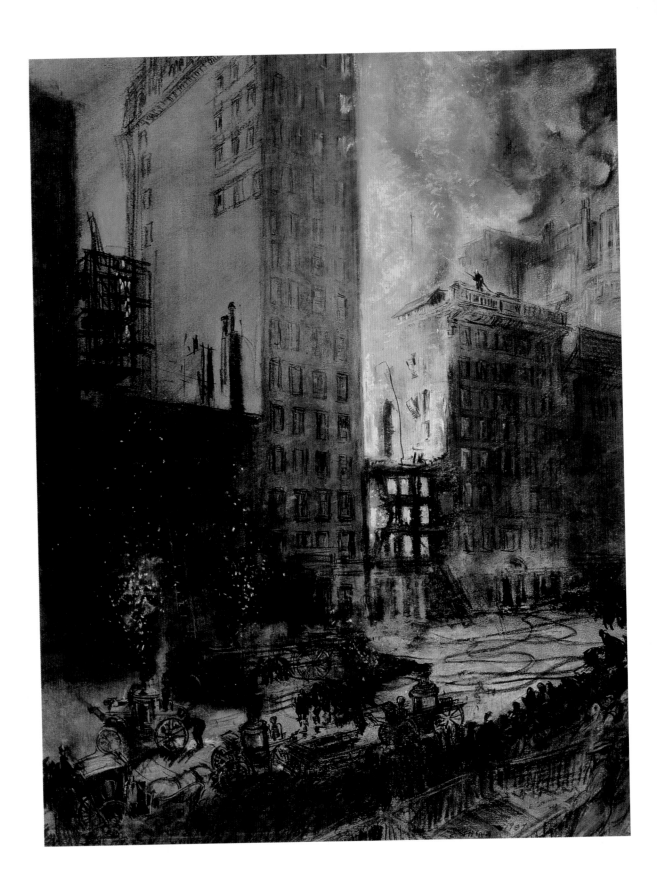

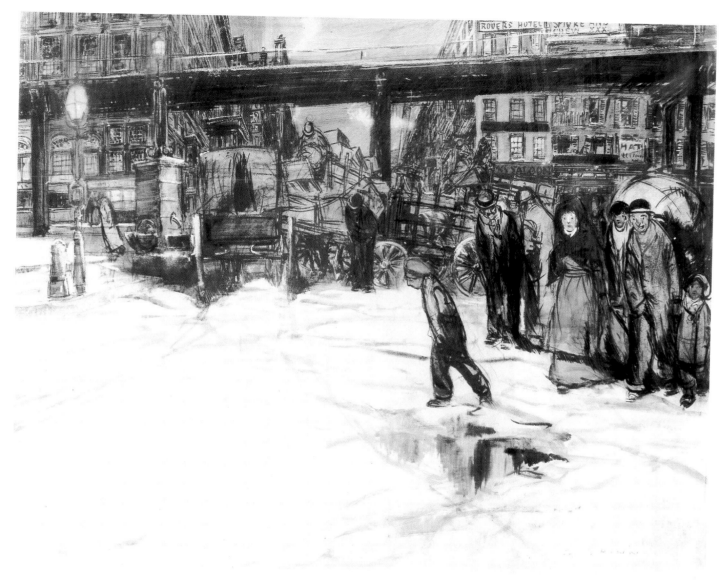

trolley car that looms out of the fog. The team-ster strains his back and digs in his heels to keep the animal under control. To the left, children and adults gasp and laugh at his predicament. We cannot tell whether the inci-dent in *Steaming Streets* will end in a wreck or a close escape. Shinn and Bellows knew the potential for trauma that was present on the pavements (fig. 87). *Steaming Streets* and Shinn's *Night Life–Accident* and *Fire on Twenty-fourth Street, New York City* (figs. 88 and 89) testify to the dangers of urban life. They also recognize a macabre aspect of urban disas-ters; thanks to the population density, acci-dents quickly acquire audiences. When that happens, only a thin line of chance separates sufferers from spectators.

As a newspaperman trained to cover ca-lamities, Shinn contributed to making urban accidents seem part of a show (indeed, simi-lar disasters are still a staple on television news).[6] His large-scale pastels brought these subjects from page one of the *Philadelphia Press* to the realms of high-class magazine illustration and Fifth Avenue art galleries, thus inviting art lovers to become part of the crowd of onlookers. The nighttime fire scenes use color to heighten the visual drama, as sparks fly from the eerie cauldron of burning buildings and fire fighters battle the flames. No heroes respond in *Night Life–Accident*. The light of a street lamp shines down over the shoulder of a woman gaping at an injured man lying in the street in pain, arm clutched across

Fig. 89 (opposite)
Everett Shinn, *Fire on Twenty-fourth Street, New York City*, 1907, pastel on paper, 59 x 45.7 cm (23 ¼ x 18 in.). Hirschl and Adler Galleries, New York

Shinn's pastel drawings of fire-fighting scenes present vivid, artistically daring variations on a popular subject. Shinn included this drawing in gallery exhibi-tions but also used it to illustrate a short story about a daring fireman. These sto-ries, like the movies made at the scenes of actual fires or studio reenactments, provided an exciting but safe, vicarious experience.

Fig. 90
Everett Shinn, *Under the Elevated*, undated, pastel and charcoal, 53.88 x 68.58 cm (21 ¼ x 27 in.). Whitney Museum of American Art, New York, Gift of Mr. and Mrs. Arthur G. Altschul

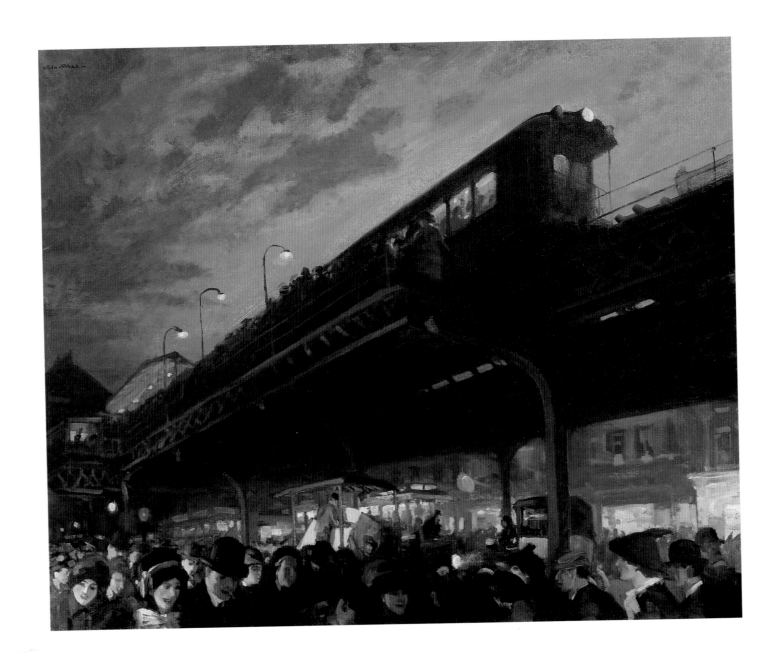

Fig. 91
John Sloan, *Six O'Clock, Winter*, 1912,
oil on canvas, 66 x 81.3 cm (26 x 32
in.). The Phillips Collection, Washing-
ton, D.C., acquired 1922

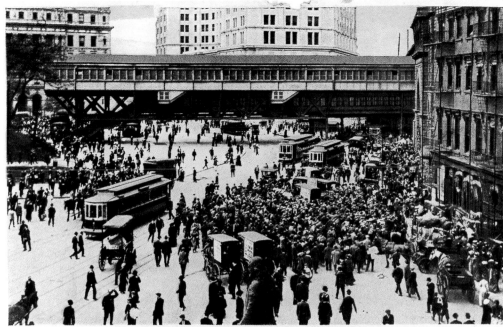

HOMEWARD BOUND, BROOKLYN BRIDGE, NEW YORK CITY.

his chest. Across from her, a man kneels, offering either a prayer for a departed soul or a plea for deliverance. To the rest of the spectators, the unfortunate man is an object. He can be stared at, as do the children; viewed at a distance, as do the men to the left of the light; or avoided, as does the man at the right in hurrying from the scene.

Both Shinn and Sloan show an awareness in their work of the interactions between people and machines. In Shinn's *Under the Elevated* (fig. 90), the rails of the elevated train form a dark horizontal bar across the top of the picture, pressing down on the wagons and people beneath. The track supersedes the ramshackle horse-drawn wagons beneath it and also delineates the horizon of the people who stand below, stoop-shouldered and shivering in the snow. In all likelihood they are working-class people, living in the shadows of the elevated train that makes their neighborhood a less than desirable place to live.

In Sloan's painting *Six O'Clock, Winter* (fig. 91), a crowded elevated train running at the height of the rush hour looms above a bustling street (fig. 92). The composition balances the architectural structure of the tracks with the faces of the people below who use

the train; color indicates transitional light at the end of the day and invites the viewer to consider the mood of commuters going home from work. Crowds of men and women pass before illuminated shop windows, but the real sense of motion is imparted by the train, painted so that it forms a sharp angle from the lower left corner of the painting toward the upper right. If Shinn's elevated train hems people in, Sloan's is taking them somewhere. The motion of *Six O'Clock, Winter* is vigorous, but not exactly purposeful.

A stronger sense of purposeful activity appears in the artists' paintings of New York's rivers, harbors, and construction sites. New York has always been a city of light industry, lacking the blast furnaces and smokestacks that made the mills of Pittsburgh so compelling to the artists Joseph Pennell and Joseph Stella. New York's heroic work spaces have long been its harbor and waterfront, the rivers that function as mechanized arteries, and those temporary spaces in the midst of the city where demolition and rebuilding offer the spectacle of the city remaking itself. The crowd of onlookers at a building site, peering through knotholes in the surrounding fence, has long been a staple New York scene. And

Fig. 92
Homeward Bound, Brooklyn Bridge, New York City, undated, postcard. Private collection

"Rush hour" had been a fixture since the nineteenth century, when commuters took the ferry from New York to Brooklyn. The construction of bridges spanning the Hudson and East Rivers, the incorporation of the five boroughs into Greater New York in 1898, and finally the spread of transit systems after the turn of the century moved people in and out of Manhattan in record numbers every day. Sloan's painting focuses on some of the faces in the evening crowd.

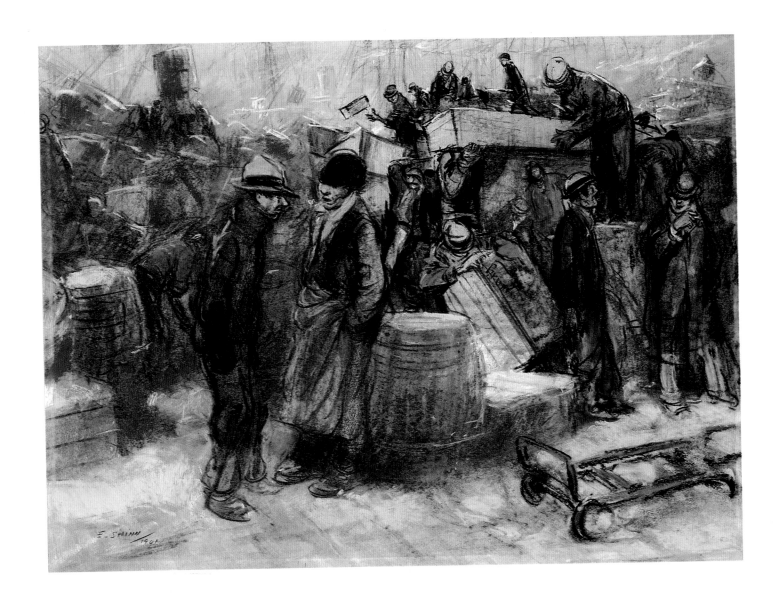

Fig. 93
Everett Shinn, *The Docks, New
York City,* 1901, pastel on paper, 39.4
x 55.9 cm (15 ½ x 22 in.). Munson-
Williams-Proctor Institute, Museum
of Art, Utica, New York

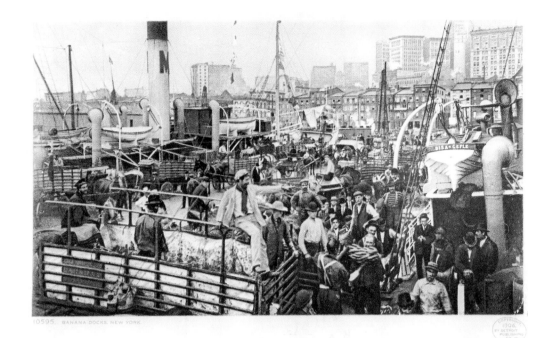

Herman Melville noted the men who stood on the waterfront, gazing out to sea. Ashcan images invited viewers to continue the tradition of watching the city at work.

New York had been the nation's leading port since the first quarter of the nineteenth century. The harbor paintings by the Ashcan artists show commerce and people in motion, expressed in the tugboats, barges, and ferries. These works are not idyllic representations of wind and sky but gritty evocations of rivers put to work, as in the powerful tugboat that steams past in Bellows's painting *The Bridge, Blackwell's Island* and the derricks and barges that mark Henri's views along the East River (fig. 211). Yet because there are no people visibly laboring in these harbor scenes, they are capable of sustaining a vision of maritime life that ignores the reality of hard work on the waterfront.

However, Shinn, in *The Docks, New York City* (fig. 93), and Bellows, in *Men of the Docks*, showed a real appreciation of the labor that produced so much of the city's wealth (fig. 94). To be sure, in Shinn's pastel the activities of dockworkers are not all toil. Two round-shouldered, weary-looking men in the foreground have paused to talk. A cigar-smoking man in a derby to the right, apparently a padrone who doles out jobs, is still. But all around them is the bustle of work, performed with basic equipment: a hand cart and a strong back. It took considerable skill to load ships so their cargo wouldn't break loose, and equal vigilance to avoid the accidents that frequently maimed longshoremen.[7] Shinn uses a coarse line to depict the docks as a place of raw energy, where goods are manhandled into position by work gangs. The cargo is menacing: it is piled more than shoulder high, threatening to bury the longshoremen who struggle with it.

Bellows's *Men of the Docks* (fig. 95) captures the reverse of Shinn's bustle by juxtaposing an active harbor with the stationary figures of men waiting for a job. Longshoremen's hours were dictated by the arrival and departure of ships. They might work twenty-four hours straight, then be unemployed for three days. Between shifts, they stood around in bars, on street corners, or on the docks waiting for work. Casual passersby saw them as idlers, but in reality they were always in a state of near-action, waiting for work that would provide the money to pay for rent and groceries. Bellows's painting emphasizes the precariousness of their livelihood. It manipulates the view to juxtapose Manhattan's impressive skyline with the busiest part of the

Fig. 94
Banana Docks, New York, 1906, postcard. Museum of the City of New York

In this 1906 view, past meets present on the waterfront of South Street, Manhattan's oldest maritime district: manual labor, masts, smokestacks, and nineteenth-century counting-houses, with high-rise office buildings looming in the background.

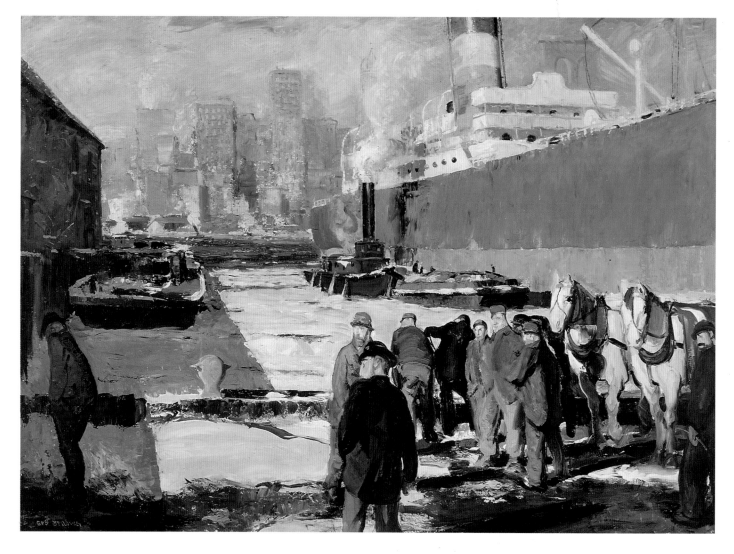

Fig. 95
George Bellows, *Men of the Docks*,
1912, oil on canvas, 114.3 x 161 cm
(45 x 63 ½ in.). Maier Museum of Art,
Randolph-Macon Woman's College,
Lynchburg, Virginia, First purchase
of the Randolph-Macon Art Associ-
ation, 1920

harbor, which is actually visible only from the other side of the Brooklyn Bridge. Huge boats loom in the foreground. Overshadowed by ships that can be loaded only by means of human strength, standing beside draft horses that recall the archaic physical nature of waterfront work in these years, the men of the docks all turn to watch something off to the left. Is it an offer of jobs for the day? A report that no work is available? The viewer is held in a state of uncertainty, as are the longshore-men who conduct their anxious vigil from one day to the next.

The tension between the workman and the potentially overwhelming nature of his work also appeared at construction sites, as seen in several paintings by Bellows of the building of the Pennsylvania Railroad Station. The excavation, which the contemporary press often reported as a feat of engineering, approaches the sublime in Bellows's paint-ings.[8] In this man-made canyon, depicted in *Pennsylvania Excavation* (fig. 96), billows of smoke may recall the crashing surf in Winslow Homer's views of the snowbound Maine coast, but here they emanate from machines. The flames flashing in the distance are not volca-noes but the glow of lanterns set up by work-ers to guard the site. Apart from the onlookers in the foreground, there is little human pres-ence in the painting; the individual workers deep in the pit are rendered as antlike specks of paint. The vast excavation is the result of their work, but they show no sign of mastery over a project so large that it dwarfs them and their efforts.

In *Excavation at Night* (fig. 25), the con-struction site is a grim cavern. On the far side

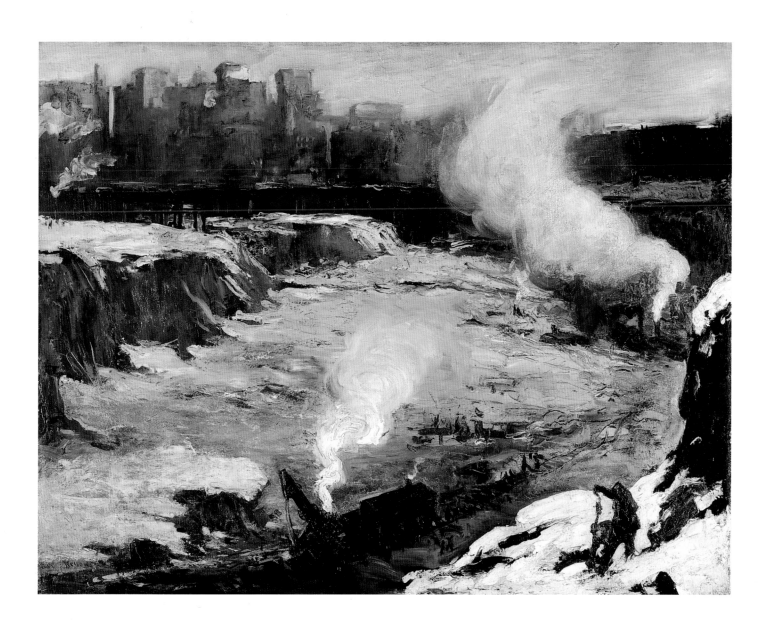

Fig. 96
George Bellows, *Pennsylvania
Excavation*, 1907, oil on canvas,
86.4 x 111.8 cm (34 x 44 in.).
Private collection

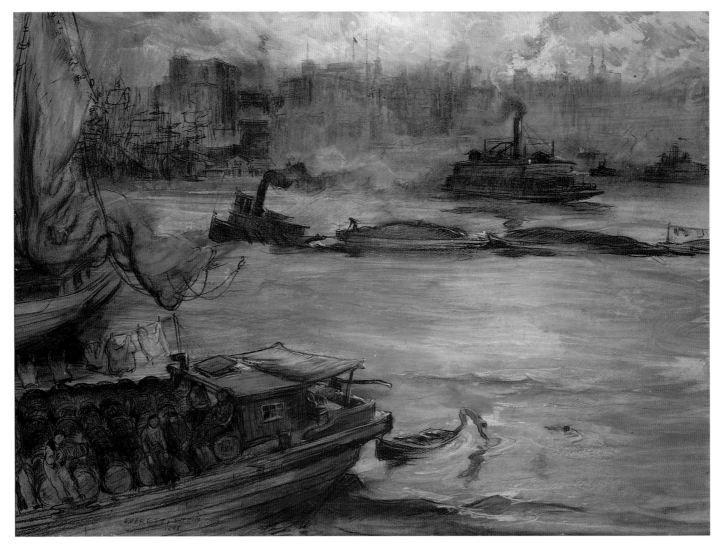

Fig. 97
Everett Shinn, *Barges on the East River,*
1898, charcoal and wash on paper,
50.8 x 68.6 cm (20 x 27 in.). Private
collection, New York, Photograph
courtesy of Adelson Galleries

of the pit, flames and lights give evidence of human activity, but no figures are visible. The center of the site is bleak. Only in the nearest depths of the pit is there any sign of life: seated workmen around a fire, which stands out as a mark of human presence in an otherwise inhuman setting.

The complexity of the environments in which people made places for themselves in the large and growing city is perceptively explored in Shinn's *Barges on the East River* (fig. 97). In the background are square-rigged sailing ships and towering buildings. In the middle distance are ferries and a tugboat pulling a string of barges. But the eye is drawn to a barge in the lower left-hand corner. Barges had a venerable history in New York; the first of them carried goods to and from the city on the Erie Canal in the 1820s, making New York

the transportation gateway to the American heartland. Here it is not tradition that makes the barge so interesting, but its multiple uses in the present. The cargo on the deck indicates this is a working barge, taking goods from one point to another. The laundry hanging on the clothesline reveals it is also the crew's home. And the presence of men lounging on the barrels, one playing a concertina while the other dives into the river for a swim, shows it to be their place of leisure and recreation.

While Bellows, Luks, and Shinn depicted a city in motion, Sloan found quiet poetry in the lives of its inhabitants. *The Wake of the Ferry II* (fig. 98) is set aboard one of the many commuter boats that crossed New York Harbor at the turn of the century. Ferries steamed through waters busy with all sorts of craft, but in Sloan's painting, movement is suspended; a

Fig. 98
John Sloan, *The Wake of the Ferry II*,
1907, oil on canvas, 66 x 81.3 cm
(26 x 32 in.). The Phillips Collection,
Washington, D.C., acquired 1922

ONE OF THE "AMERICAN" WAGONS DISTRIBUTING COFFEE AND SANDWICHES.

Fig. 99
One of the "American" Wagons
Distributing Coffee and Sandwiches,
from *New York American and Journal*,
6 March 1904, 42

*When the Ashcan artists arrived in New
York, the contrast between the city's
rich and poor was a common theme in
popular culture. Writers and illustrators
typically used a highly selective vision
that described the city only in terms of
its extremes. In an act of publicity as
much as charity, the* New York Ameri-
can and Journal *sent wagons to distrib-
ute coffee to homeless men in public
squares. Perhaps because the journal's
flamboyant editor, William Randolph
Hearst, championed the "common
man," this illustration plays on the
theme of contrast to condemn the
callous party-goers who drive past the
coffee line on a cold winter night.*

lone passenger leans against the frame formed
by the pillars at the stern of the boat and gazes
out into the fog. Seen from behind, the vaguely
identified figure—a woman, but it could easily
be a man—invites the viewer to stand in the
same place and look out over her shoulder. The
downward tilt of her head suggests contempla-
tion. Because we cannot know her thoughts,
we are free to imagine them and to empathize
with this stranger, as the daily routine of com-
muting offers a moment of solitary reflection.

RICH AND POOR

New York presented the Ashcan artists with
glaring contrasts between economic classes.
The city had a middle class, which was por-
trayed in some of their pictures. But the
artists were frequently drawn to the more dra-
matic and well-established convention of
showing the contrast between rich and poor,
so blatant in a city of grand mansions and
awful slums, ragpickers and millionaires.
Both luxury and penury were becoming
increasingly visible on the streets and in the
press. The doings of the elite "Four Hundred"
were chronicled avidly in newspaper society
pages, while visitors noted with amazement
or disgust the ostentation—social, sartorial,
and architectural—to be observed on Fifth
Avenue, in expensive shops, and in fashion-
able leisure spots. People came from all over
the country to spend money in New York.

At the same time a growing literature of re-
form and social protest called attention to the
presence of poverty in the city. Nineteenth-
century traditions of moral exhortation
against social evils gave way to the Progres-
sive Era's investigations, which used illustrat-
ed reports to expose conditions attributed to
systemic economic inequities. Images forced
comfortable New Yorkers to acknowledge the
presence of the "other half" (fig. 99).

The most striking thing about the rich
and the poor in New York City was their phy-
sical closeness and social distance. Guide-
books and illustrated articles took armchair
visitors past the mansions of upper Fifth
Avenue and the tenements of Italian Harlem,
the gritty Gashouse district and elegant
Gramercy Park: in areas that were only blocks
apart, the inhabitants lived profoundly differ-
ent lives. The social connecting points be-
tween them were few and episodic—politics,
with its occasional alliances of affluent lead-
ers and plebeian party members, and popular
entertainment, especially vaudeville, with its
performers from the city streets and its audi-
ence of "the classes and the masses."

The Ashcan artists carried this sense of
separation into their art, representing the rich
and the poor as if they inhabited entirely sepa-
rate realms. Rarely are they shown in proximi-
ty to each other, and never in overt conflict. As
painters who emphasized the public side of
life, they typically depicted people on streets
or in parks. This had profoundly different
implications for how they would represent the
two classes. For the rich, who by the 1890s
had created residential and social enclaves of
their own, the streets and public parks offered
places for promenading and display, but little
more. Large portions of their lives were spent
far from public scrutiny, especially that of
curbside painters. The poor had no such
shields against the artists' gaze. Given their
crowded housing, New York's poor made
the streets and parks the setting not only
for promenading and display but also for
quarreling, recreation, love, and family life. All

Fig. 100
Everett Shinn, *Eviction*, 1904, gouache
on paper mounted on board, 21.3
x 33.3 cm (8 ⅜ x 13 ⅛ in.). National
Museum of American Art, Smithsonian
Institution, Bequest of Henry Ward
Ranger through the National Academy
of Design

Fig. 101
Frontispiece to Helen C. Campbell,
Thomas W. Knox, and Thomas Byrnes,
*Darkness and Daylight: Lights and
Shadows of New York Life* (Hartford,
Conn.: A. D. Worthington and Com-
pany, 1899)

*Newspapers, books, plays, and songs
explored poor neighborhoods and vice
districts with words and images that
mixed moralism and titillation. Occa-
sionally they plagiarized one another
(the drawing of sleeping boys on this
title page is based on a photograph
used by Jacob Riis), but they always
claimed to present authentic views of
the city. They bragged of their ability to
go behind the barroom door or down
the dark alley to show the realities of
urban life, usually rendered as depravi-
ty. The neighborhoods of the rich were
as famous as those of the poor, but
the social lives of the rich, conducted
behind closed doors, were less open
to scrutiny than the lives of poor New
Yorkers.*

of these activities appeared in the artists'
works. As middle-class observers whose own
status placed them between the two extremes,
the Ashcan artists portrayed both rich and
poor with varying degrees of exoticism and
objectification.

Shinn included pastel drawings showing
the effects of poverty in several of his early
exhibitions. These lushly drawn images
repeated subjects usually presented in jour-
nalism and reformist photography as exam-
ples of extreme degradation. Evictions were a
common sight in tenement neighborhoods.
Memoirs of people who grew up in lower Man-
hattan in that era describe families who
moved several times a year in order to take
advantage of the free month's rent that came
with a new lease, then left without paying or
faced finding their household goods thrown
out on the sidewalk.[9] Shinn's *Eviction* (fig. 100)
presents people in a moment of total dissolu-
tion, their belongings piled in the street after
being driven out of their homes for failure to
pay the rent. The policeman who oversees the
process shows which side the law supports.

As Shinn portrayed them, the poor are
suffering and degraded to the point of face-
lessness. His eviction scenes feature mothers
holding children who are losing the roof over
their heads. The victims sit with shoulders
hunched over in despair, seemingly lacking
the strength to resist their fate. And their
predicament is worsened by being stared at
by curious spectators. But if it is clear that
Shinn thinks these people are suffering, his
view of what kind of people they are is less
certain. Their heads are bent, faces are avert-
ed. Of all the dispossessed, only one looks at
us, eyes wide with shock and mouth gaping.

Shinn's eviction images hark back to a
journalistic device that was old before the
Ashcan artists reached New York, that of
depicting the urban poor as debased crea-
tures of the abyss (fig. 101). Whether for titilla-
tion, as in the urban guidebooks that prolifer-
ated in the third quarter of the nineteenth
century, or for the purpose of goading the mid-
dle class into reform measures, as in the work
of Jacob Riis and Helen C. Campbell, chroni-
clers of the poor frequently depicted them in
the most negative light possible. Shinn stands
squarely in this tradition. Even when his sub-
jects have homes, as in *Tenements at Hester
Street* (fig. 102), they remain faceless. Here
Shinn depicts a common survival strategy of
tenement dwellers: sleeping on the roof or
fire escape in summer to avoid the stifling
heat of poorly ventilated apartments. The peo-
ple in the drawing—and they are barely recog-
nizable as such—appear strewn across the
composition like victims of a massacre.

Such weariness is not displayed in either
the rich or the poor painted by George Bel-
lows. In his paintings, both classes are animat-
ed, but their body language is profoundly
different. In *Luncheon in the Park* (fig. 103) and
A Day in June (fig. 104), Bellows portrays New
York's affluent at leisure in Central Park.
Crowd at Polo (fig. 105) shows them at play in
New Jersey. In all three works, the artist pays
little attention to the figures' faces, and more
attention to their forms: elegant, erect, and

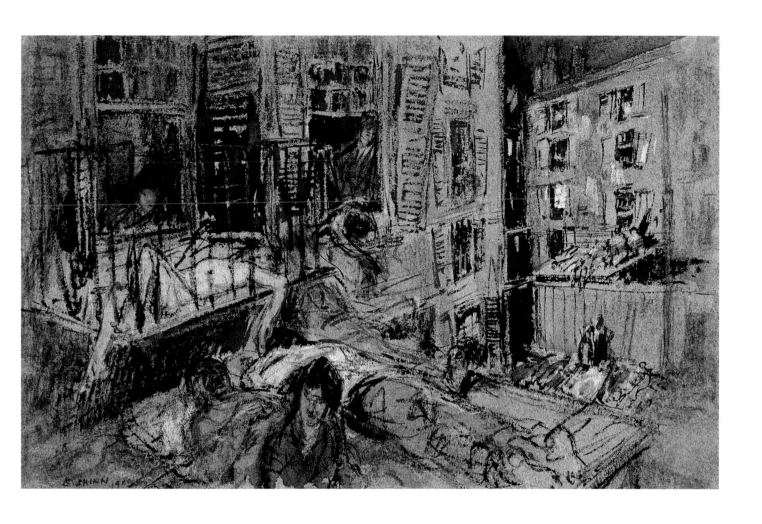

Fig. 102
Everett Shinn, *Tenements at Hester Street*, 1900, watercolor, gouache, and ink on paper, 21 x 33 cm (8 ¼ x 13 in.). The Phillips Collection, Washington, D.C., acquired 1943

A number of the pastels that Shinn made for exhibition treat the extremes of poverty depicted in reform literature and journalism. Shinn at one point planned to include these drawings in an album of nighttime scenes that would juxtapose images of "gaiety and drabness . . . a Bowery restaurant . . . old Delmonico's blazing facade—carriages, hansoms."

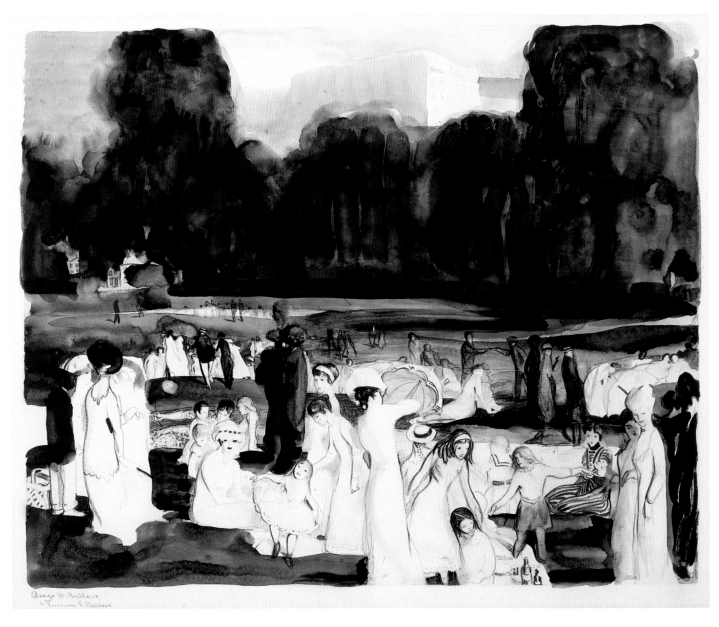

Fig. 103
George Bellows, *Luncheon in the
Park*, ca. 1913, ink wash on paper, 42.5
x 52.7 cm (16 ¾ x 20 ¾ in.). Albright-
Knox Art Gallery, Buffalo, New York

restrained in the park scenes, swirling in
action in *Crowd at Polo*. The latter shows Bel-
lows's awe for what he called "the wealthy
game of polo as played by the ultra rich." He
observed in a letter, "The players are nice
looking, moral looking. The horses are beauti-
ful. I believe they brush their teeth and bathe
them in goat's milk. It is a great subject to
draw, fortunately respectable."[10] A drawing
Bellows published in *Harper's Weekly* in 1914
exaggerates even further the stylish deport-
ment of the people in his paintings (fig. 106).
These figures do not admit scrutiny. Whether
from social intimidation, respect for their pri-
vacy, or a belief that they are more interesting

en masse than as individuals, Bellows does
not close in on his subjects. *Crowd at Polo*
shows a fascination with the rich as active
sportsmen, but the strong, graceful horses
command as much attention as the people do.

This attention to comportment—the idea
that the rich move differently from everyone
else—can also be seen in turn-of-the-century
entertainment. Movies preserve the dignified
bearing of actors playing well-to-do characters,
especially evident in women wearing corsets.
Their figures are often contrasted with the slap-
stick pratfalls and tattered dress of less proper
characters. In *The Clubman and the Tramp*
(D. W. Griffith, 1908), an enterprising vagrant

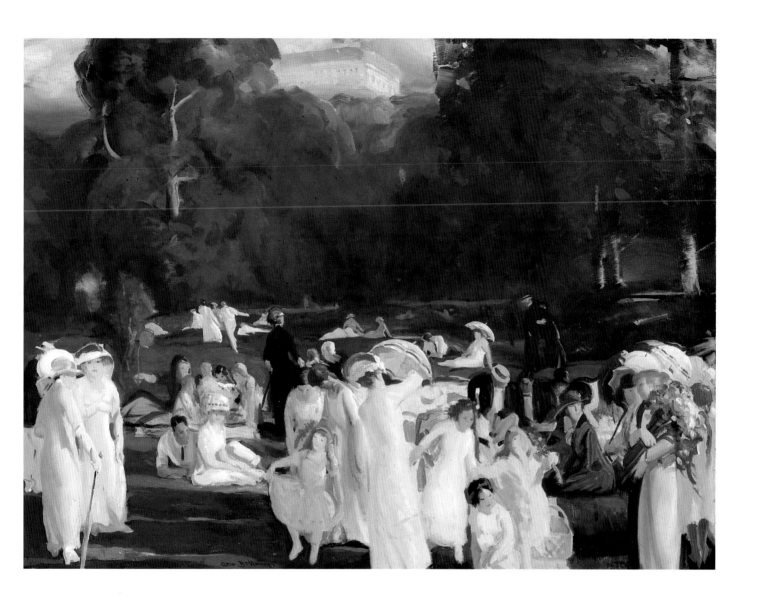

Fig. 104
George Bellows, *A Day in June*, 1913,
oil on canvas, 106.7 x 121.9 cm (42
x 48 in.). Detroit Museum of Art
Purchase, Lizzie Merrill Palmer
Fund, photograph © The Detroit
Institute of Arts, 1995

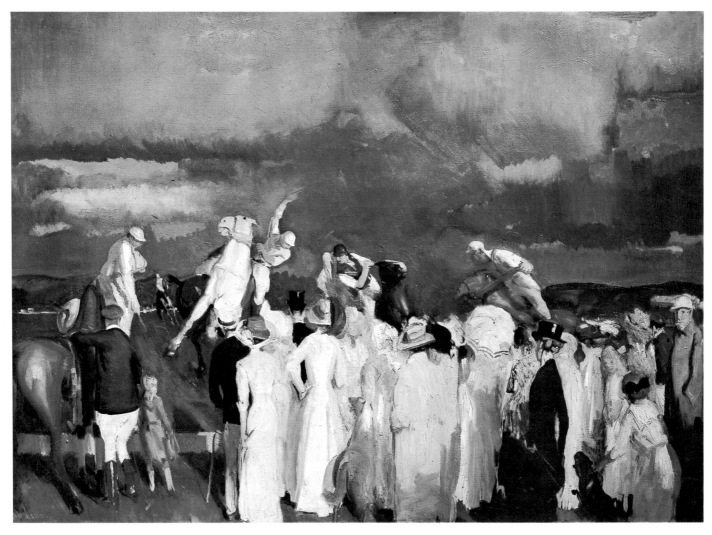

Fig. 105
George Bellows, *Crowd at Polo*, 1910, oil on canvas, 108 x 160 cm (42 ½ x 63 in.). Private collection

Although polo was regarded as an exclusive game played only by millionaires, press coverage increased after the American team won the International Cup from the English in 1909. The following year the financier George J. Gould opened the polo grounds on his New Jersey estate to the American team for pre-tournament practice, and Bellows secured an invitation to attend. Harry Payne Whitney, husband of artist and collector Gertrude Vanderbilt Whitney, was captain of the American team. A newspaper reported, "It is said that Mr. Whitney paid $4000 for one pony, which is another evidence that polo is no sport for the proletariat."

switches clothes with an unwitting look-alike gentleman, but is able to pull off his deception only when he learns the proper gestures.

Bellows shows no such restraint about getting physically close to his subjects in a large drawing in the collection of the Art Institute of Chicago (fig. 107). There is nothing about these people, living their lives out in the streets, unguarded by rank or privilege, to keep the artist at a distance. The drawing presents in detail a mother yelling at a bawling child, while two youngsters tangle in the left foreground. Their gestures are crabbed and angular, with none of the cool grace of the affluent people in the park. Their features are caricatured, cartoonlike—more recognizably human than those in Shinn's drawings, but still not real human beings. And as disturbing as the figures in the foreground appear, it is easy to see that they are but the most visible

part of a swarming crowd that fills an entire street. Like Shinn's characters, these are people of the abyss—except that they have come to life. Their numbers grow in the painting *Cliff Dwellers* and the full-page drawing *Why don't they all go to the country for vacation?* (fig. 108), both now at the Los Angeles County Museum of Art. These three works are variations on the same scene: a crowded street in front of a tenement stoop. As in his paintings of the wealthy in the park, Bellows is more interested in the aggregate than in individuals. Few faces are portrayed in identifiable detail.

Here, Bellows brilliantly captures the density of life and lack of privacy in tenement neighborhoods that drove people into the streets. We see pushcart peddlers, children playing leapfrog, a woman nursing an infant (recalling Lillian Wald's memory of a similar incident on Rivington Street), another woman

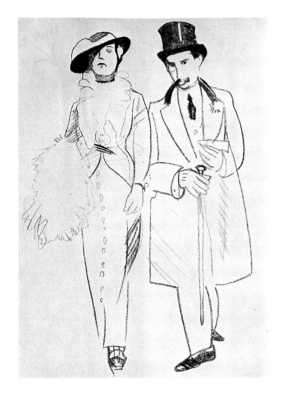

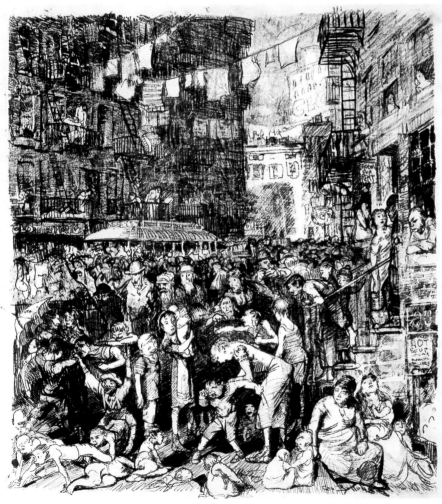

Fig. 106
George Bellows, *The Duke and the
Duchess*, from *Harper's Weekly* 58
(25 April 1914): 2

Fig. 107
George Bellows, *Why Don't They All
Go To The Country For a Vacation?*
(formerly *The Cliff Dwellers*), 1913,
charcoal, black crayon, india ink, and
watercolor, 53.5 x 68.4 cm (21 x 27 in.).
The Art Institute of Chicago, Olivia
Shaler Swan Memorial Collection,
1941.482, photograph © 1994, The
Art Institute of Chicago. All rights
reserved

*A version of this group appears in the
foreground of the 1913 painting* Cliff
Dwellers, *now in the Los Angeles
County Museum of Art. Although Bel-
lows made this drawing as a study, he
exhibited it as an independent work.*

Fig. 108
George Bellows, *Why don't they all
go to the country for vacation?*, 1913,
lithograph, pen, and crayon, 63.5 x
57.2 cm (25 x 22 ½ in.). Los Angeles
County Museum of Art, Los Angeles
County Fund

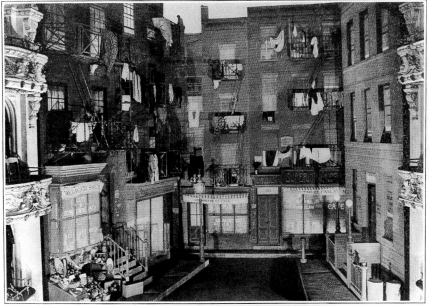

breaking up a fight, another putting out the wash, another coming home from work, and still others hanging out the windows and standing on the fire escapes. (The presence of so many women in the picture is an accurate recording of the important role they played as the eyes and ears of tenement neighborhoods.) To emphasize that these people have no secrets from us, their laundry and bedding flap in the breeze from a clothesline strung across the street between two buildings.

The Los Angeles drawing presents a scene that is similar to *Cliff Dwellers* in all essential details, but the drawing appeared in a different context. The title, when compared with that of the painting, suggests multiple ways of thinking, and perhaps Bellows's own divided mind, about his subjects. *Cliff Dwellers* refers to a popular novel about Chicago apartment life in the 1890s, which in turn evoked the habitats of ancient Pueblo Indians. As "cliff dwellers," the tenement's residents are not just inhabitants of vertical structures but, by implication, a primitive people; the effect is condescending. The painting was made for exhibition, whereas the drawing was published in the radical magazine *The Masses*; its cynical title may have been added by another member of the editorial board.[11] The title brings out other aspects of

the image by suggesting concern for the people in the picture. They don't go to the country for the same reason that they don't live in light, airy, spacious homes: they can't afford to. Instead, they do the best they can, stepping out-of-doors into the comparatively fresh air of the streets (fig. 109). The environment is made to look awful, but is undoubtedly better than the hot, airless rooms in dumbbell apartments.

The mixture of concern and condescension that distinguishes Bellows's images of tenement life and his unadulterated aesthetic admiration of the rich are different from John Sloan's approach to the same subjects. Sloan, a committed Socialist, always maintained that he confined his political art to political publications. A satiric cover for *The Masses*, titled *The Unemployed* (fig. 110), published in 1913 during a period when thousands were out of work, depicts the "idle rich" with unalloyed contempt.[12] Although Sloan claimed that he did not want to harness his art to political dogma, some of his ostensibly apolitical works show a distinct sympathy and respect for poor and working people and a hostility to the upper class. These are rarely, if ever, overtly propagandistic statements, but they do give a sense of Sloan's ultimate allegiances.

Fig. 109
Byron Company, *Stage Setting of the Last Act of "Salvation Nell" Representing a Street in the New York Slums*, in "Plays Worth Seeing—'Salvation Nell,'" *Theatre Magazine* 9 (February 1909): 55

Bellows made his pictures of tenement life at a time when social reform agencies were compiling pictorial evidence for investigations into "the congestion of population in New York." Set designers attempted to achieve a similar effect of human overload in the backdrop for "Salvation Nell, a drama of the slums."

Fig. 110
John Sloan, *The Unemployed*, cover illustration for *The Masses* 4 (March 1913). Maurice Becker Papers, Archives of American Art, Smithsonian Institution

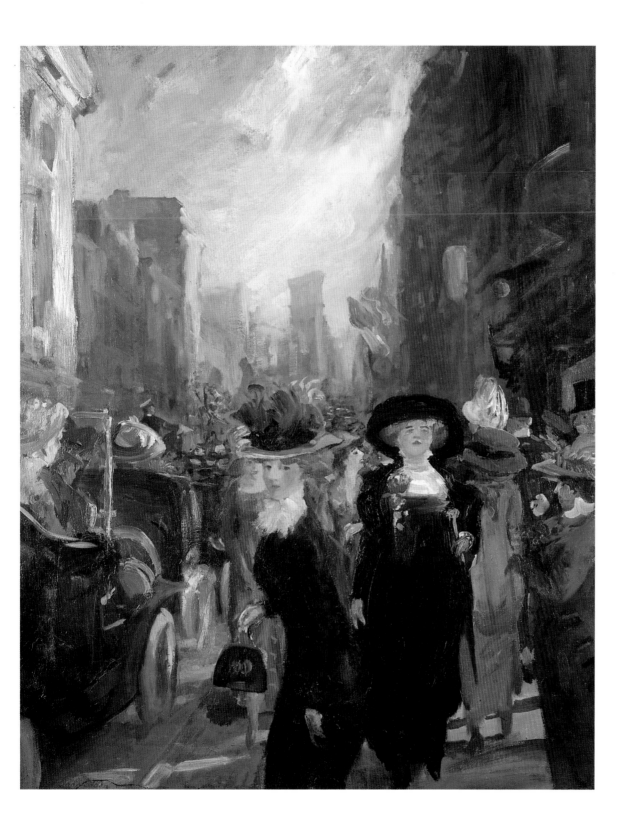

Fig. 111
John Sloan, *Fifth Avenue, New York*,
1909, 1911, oil on canvas, 81.3 x 66 cm
(32 x 26 in.). Private collection, Cour-
tesy of Kraushaar Galleries, New York

Fig. 112
John Sloan, *Fifth Avenue, New York*,
as reproduced in Frank Jewett Mather,
Jr., "Some American Realists," *Arts and
Decoration* 7 (November 1916): 16

worthy of more cutting criticism. The people out for a drive in *Gray and Brass* are smug and self-satisfied, oblivious to their surroundings. But Sloan, like Goya painting Spanish monarchs, suspects that their grandeur is all in their own minds. In *Fifth Avenue Critics*, Sloan contrasts the reactions of two elderly, affluent women as their carriage passes another with a young woman passenger, who is beautiful and elegantly dressed. One of the older women responds with a warm smile, which hints at reminiscence of her own youth. Her companion's reaction is stiff, upright, and disapproving. Its motivation is not clear—perhaps jealousy or suspicion, for unknown reasons. What is clear is her arrogance and mean-spiritedness.

Fifth Avenue Critics and *Gray and Brass* were designed to deflate. No such motivation appears in the etching *Roofs, Summer Night* (fig. 115). Sloan's subjects are the same sort of people that Shinn and Bellows depicted, in a situation often described in reform literature: tenement dwellers sleeping on their rooftops to escape the summer heat. The etching makes masterly use of shades of black to suggest a suffocating nighttime atmosphere. In the foreground lies a family—a mother, father, and daughter. The strap of the mother's garment has slipped off her shoulder. Potentially an erotic device, this detail functions instead to lead the eye to a fan, printed with an advertisement for a local dry-goods store, that is lying on her mattress. Across the roof to the right, a man lies awake. Like the artist observing the scene, he may be fantasizing about the woman with the bare arms, or he may be lost in his own thoughts. Wherever his state of mind, he is a much more fully realized person than any of the people depicted in similar circumstances by Shinn or Bellows.

Sloan displays a similarly nuanced, though not necessarily flattering, view of working-class life in *The Woman's Page* (fig. 116). The subject is a working-class woman at home. Her body is large and lumpy, presumably from a cheap, unhealthy diet. Her room is crowded with drying laundry, scrub board,

The painting *Fifth Avenue, New York* (fig. 111) shows affluent promenaders on the street that ran through the heart of Manhattan's wealthiest district. Sloan's diary records his wonder at seeing the exotic plumage of the "women in expensive gowns," and his painting is thoroughly consistent with Bellows's practice of treating wealthy subjects simply as beautiful figures.[13] Yet old photographs of the painting reveal that the haughty bearing and vacuous expressions of the central figures were once more obviously satiric (fig. 112). Sloan seems to have repainted the faces after 1930, but left behind an ambiguous hint of caricature.

In *Gray and Brass* (fig. 113) and *Fifth Avenue Critics* (fig. 114), Sloan found the rich

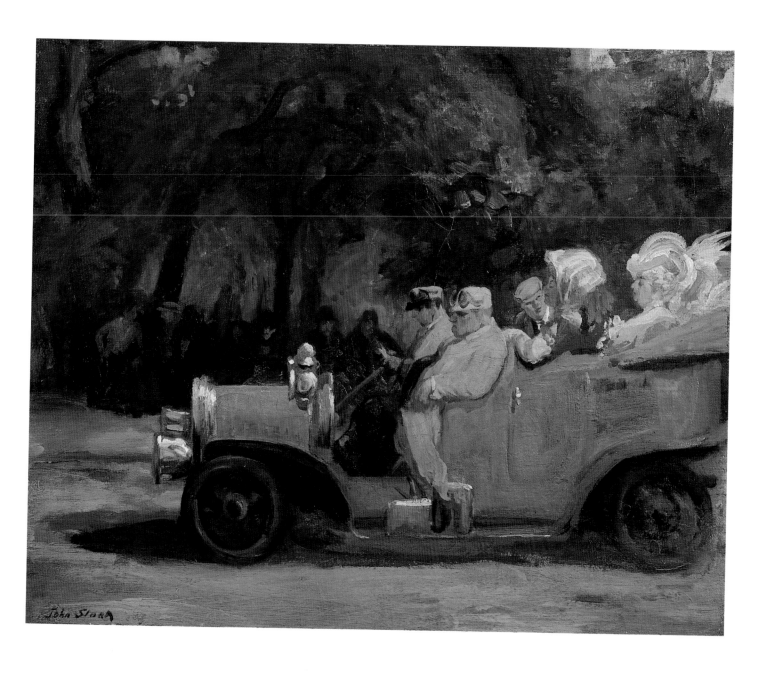

Fig. 113
John Sloan, *Gray and Brass*, 1907,
oil on canvas, 53.98 x 67.4 cm (21 ½
x 26 ⅝ in.). Private collection

*With unusual bite, Sloan described the
initial idea for this painting after a visit
to Fifth Avenue: "a brass-trimmed, snob,
cheap, 'nouveau riche' laden automo-
bile passing the park." The finished
picture, which contrasts the ostentatious
car with down-and-out men seated on
a park bench, is one of the few Ashcan
works to juxtapose wealth and poverty
in one image.*

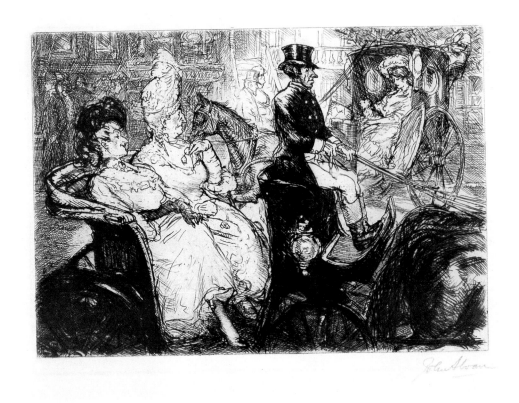

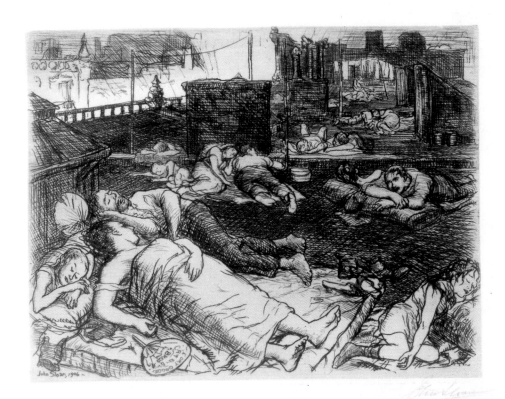

Fig. 114
John Sloan, *Fifth Avenue Critics*, 1905,
from the series "New York City Life,"
etching, 12.7 x 17.8 cm (5 x 7 in.).
Philadelphia Museum of Art, Given
by Mrs. Alice Newton Osborn

Fig. 115
John Sloan, *Roofs, Summer Night*, 1906,
from the series "New York City Life,"
etching, 13.3 x 17.8 cm (5 ¼ x 7 in.).
Philadelphia Museum of Art, Gift of
Mrs. Alice Newton Osborn

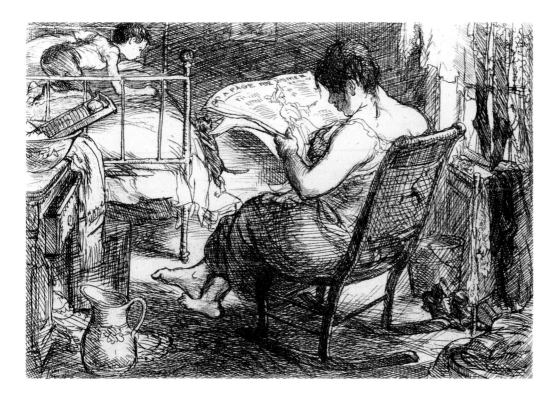

and basin. A small boy on a bed in the background plays with a cat. Ignoring her surroundings, the woman reads a newspaper opened to "A Page for Women," whose centerpiece is a tall, slender-waisted lady with an elaborate hat. Sloan, like Bellows, pays attention to body types to make an ironic contrast. The fleshy woman's reaction to the fashion plate is unclear because the expression on her face is masked by the tilt of her head and disheveled hair. Is she envious, sad, fascinated, or bored? Could the artist be ridiculing her or her situation? What was the response of the immigrant viewers who saw this print exhibited in a coffeehouse on the Lower East Side?[14] Any number of reactions would be plausible, depending in part on who looked at the picture.

Whether Sloan is satirizing the woman or the paper that she reads, his image points out the absurdity of mass culture: the incongruity between the fantasies that people read and the reality of their lives. The woman shown in the newspaper and the woman looking at her picture inhabit entirely different social worlds, a fact that no amount of glamorous illustration can bridge. In a city marked

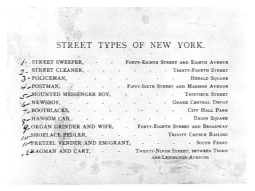

by cruel class distinctions and inequalities, *The Woman's Page* plays on longings that can never be fulfilled.

ETHNIC COMMUNITIES AND URBAN TYPES

The Ashcan artists, as products of their time and painters of a new style and sensibility, did make efforts to depict real life in New York City, although they frequently indulged in well-worn stereotypes. But in a few memorable works, they broke through conventions and depicted their subjects with depth and humanity. If the collective portrait that emerges is ambivalent, that is because the Ashcan artists, like many of their fellow New Yorkers, had mixed feelings about newcomers to the city.

Fig. 116
John Sloan, *The Woman's Page*, 1905, from the series "New York City Life," etching, 12.7 x 17.8 cm (5 x 7 in.). National Museum of American Art, Smithsonian Institution, Bequest of Frank McClure

Fig. 117
Table of contents, in Alice Austen *Street Types of New York*, 1906. Museum of the City of New York, 44.129.13

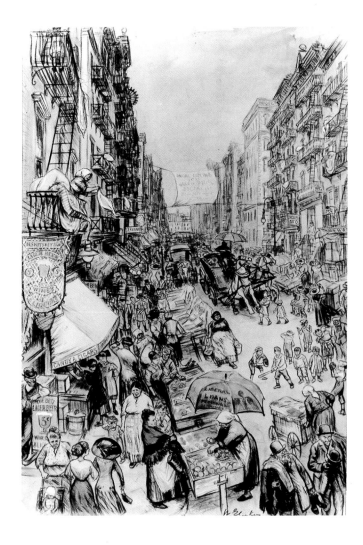

Fig. 122
William Glackens, *Far from the Fresh Air Farm*, 1911, carbon pencil and water-color on paper, 64.8 x 43.2 cm (25 ½ x 17 in.). Museum of Art, Fort Lauderdale, Florida, Ira Glackens Bequest

Fig. 123
William Glackens, *New York Street Scene with Vendors*, ca. 1913, pastel and charcoal on brown paper, 45.7 x 35.6 cm (18 x 14 in.). The Virginia Steele Scott Collection, Henry E. Huntington Library and Art Gallery

Fig. 124
William Glackens, *One Boy after Another Started Off with a Bundle under His Arm. They Ran As If for Their Life; As If a Kettleful of Boiling Water Had Been Emptied over Them*, from E. R. Lipsett, "Denny the Jew from Ballintemple," *Everybody's Magazine* 29 (July 1913): 91

This illustration brings out the difference between cultures when Denny Nolan, the son of Irish immigrants, ventures into "foreign" territory to earn extra cash by selling Yiddish newspapers on the Lower East Side.

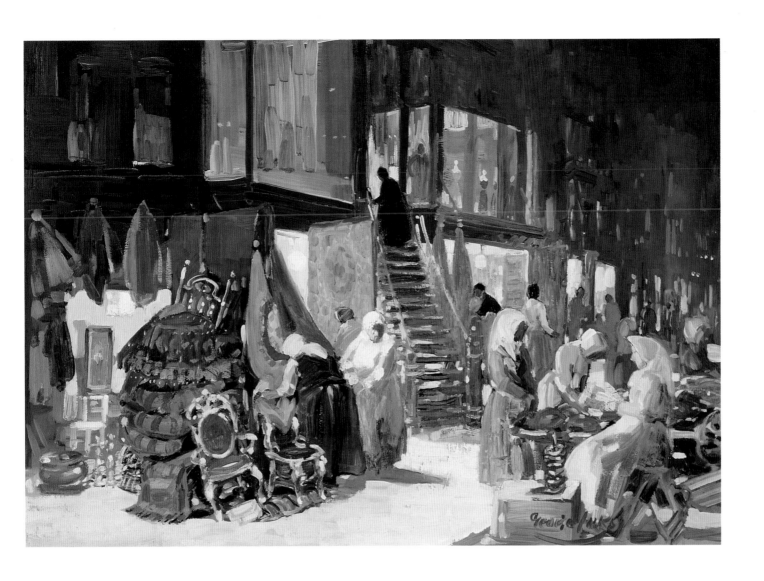

Fig. 125
George Luks, *Allen Street*, ca. 1905,
oil on canvas, 81.3 x 114.3 cm (32
x 45 in.). Hunter Museum of American
Art, Chattanooga, Tennessee, Gift of
Miss Inez Hyder

Fig. 126
John Sloan, *A Band in the Back Yard*,
1907, monotype, 13.7 x 17.5 cm (5 ⅜
x 6 ⅞ in.). Terra Foundation for the
Arts, Daniel J. Terra Collection,
1987.30. Photograph © 1995, Courtesy
of Terra Museum of American Art,
Chicago

arenas for recreation and self-expression from a crowded city (fig. 126). In *Forty-two Kids*, *Splinter Beach*, and *River Rats* (figs. 81, 127, and 215) Bellows depicts young boys swimming in the East River, using a pier as a diving platform. Their impromptu recreation contrasts with the official parks and playgrounds that municipal reformers were constructing at the time. In *Splinter Beach* the apartments on the far shore, the span of the bridge cutting across the top of the scene, and the tugboat passing in the channel severely limit the space open to the swimmers. Crowded together on the pier, they argue, frolic, and dive into the water.

Glackens's *Patriots in the Making* (fig. 128), published in the July 4, 1907, issue of *Collier's* magazine, has the same congested quality, although here the setting is a city street on Independence Day. A few girls and women are out and about, but, as in Bellows's two pictures of swimmers, the scene is dominated by males. The picture is hilarious: a raucous holiday, with flags and firecrackers present in equal numbers. The explosions intended to express patriotism injure one boy so badly that he is taken away in an ambulance, also frightening an older man and prompting one mother to administer a spanking.

Looking to the summit of this crowded neighborhood, Sloan finds the most secluded place available to the inhabitants—the rooftop, which is the setting of *Pigeons* (fig. 129). In a letter the artist told of observing this scene from the window of his studio on West Twenty-third Street; he returned to the canvas on several afternoons in order to capture the exact moment of fading light.[17] Illuminated by slanting rays of sun, a man and a boy race pigeons, the man guiding the birds with a long pole at the end of which is a rag. They communicate but do not speak, enjoying the stillness at the end of the day. The features of the man and boy are not fully developed, but alone with their birds they are far more distinct than the characters in Bellows's crowd scenes. Pigeon racing was a widely enjoyed sport in immigrant neighborhoods at the turn of the century (still practiced in New York City today), and the pigeon coop was a common fixture on tenement roofs. While the rooftops

Fig. 127
George Bellows, *Splinter Beach*, 1911,
pencil, black crayon, pen and ink, and
ink wash on wove paper, 43.7 x 58.3
cm (17 3/16 x 22 15/16 in.). Courtesy of
the Boston Public Library, Print
Department

Fig. 128

William Glackens, *Patriots in the Making*, 1907, charcoal and watercolor on paper, 81 x 64 cm (32 x 25 ⅛ in.). Collection of Mr. and Mrs. Thomas P. O'Donnell. Published in *Collier's* 39 (6 July 1907): 6

Under fire escapes bedecked with flags, neighborhood boys engage in pyrotechnic mischief, while their mothers attempt to discipline them. The comedian Jimmy Durante, son of an Italian immigrant, described a similar Fourth of July celebration in his old Lower East Side neighborhood ca. 1900: "The Fourth meant a big

bonfire, street fightin' and shootin' guns, and big parades. . . . [T]hese firecrackers the butcher gave me, I lit a big one and it wouldn't go off. So I blow on it, and bing! My brother took me to the hospital. It was a miracle I didn't go blind." At the time this drawing appeared in Collier's, *rowdy celebrations in immigrant and working-class communities, were coming in for criticism. Protesting "the madness of parents who place dangerous explosives in the hands of their little ones," the Society for the Suppression of Unnecessary Noise joined the campaign for a "Safe and Sane Fourth."*

often were crowded with sleepers on a hot summer night, at other times they could be quiet—above the noise of the street, relatively secluded from prying eyes, and offering a great vantage point for looking down to the streets and peering into others' apartments.

The Ashcan artists' closest encounters with the humanity of their subjects came in their portraits of individuals. Henri, Bellows, and Luks regularly asked children to pose whom they had spotted in New York or on their travels. Henri discussed some of these paintings in a conflicted essay titled "My People," which celebrated "this thing that I call *dignity* in a human being," yet sought to compile a catalogue of bust-length portraits—"the peon, a symbol of a destroyed civilization in Mexico . . . the bull-fighter in Spain . . . the Irish peasant"—in which "the race is reflected in the individual."[18] These portraits pay tribute to old-master traditions that bestowed dignity on their lowly sitters, yet also set them apart. Today we are reminded that Henri's heroes, Ribera and Velázquez, painted noble-looking beggars as well as the freaks kept by the Spanish court.

The New York painters were not alone in their interest, or in the bewilderment with which they confronted their subjects. Like their counterparts in journalism, photography, and the theater, the Ashcan artists depicted people as types, such as the newsboy or "street Arab." Luks frequently depicted urban characters—*Widow McGee* (fig. 130) or *The Sand Artist*—similar to those he had drawn in comic strips; *The Old Rosary Woman of Catherine Street, New York City* (fig. 131) maintains a strong sense of caricature. Oddly, though the artist was known for his theatrical flamboyance, the people he depicted often seem strangely vulnerable or even frightened—perhaps the source of their appeal to upper-class viewers. At its best, such stereotyping could only lead to two-dimensional representations of complex human beings. At its worst, it could be thoroughly racist and dehumanizing.

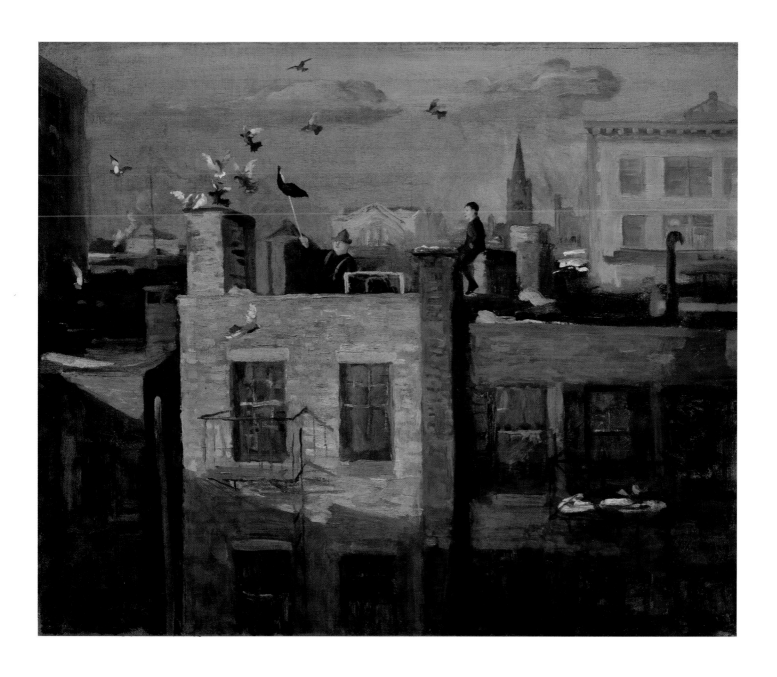

Fig. 129
John Sloan, *Pigeons*, 1910, oil on
canvas, 66 x 81.3 cm (26 x 32 in.). The
Hayden Collection, Courtesy, Museum
of Fine Arts, Boston

Bellows's *The Newsboy* (fig. 132) takes up an often-worked type, popular in sentimental Victorian paintings and also treated by photographers, from the sympathetic amateur Alice Austen to the reformer Lewis Hine, who included photographs of newsboys in reports on the dangers of child labor (figs. 133 and 134). Bellows's bust-length painting harks back to the format of old-master portraits by Frans Hals, yet has a grotesque element that also recalls Spanish images of beggars. Because the sitter's face is illuminated at an angle, one side is left in shadow, in privacy. Unlike the reformers' photographs, which claim to grasp the newsboy's essence in their gaze, Bellows's image implicitly admits that parts of the boy are beyond the artist's grasp.

Paddy Flannigan (fig. 135) also represents the kind of "street Arab" that New York photographers and guidebooks depicted. As a painting, Bellows's representation is as posed as Riis's photographs in *How the Other Half Lives*. But in Bellows's hands, Flannigan has real vigor. His open shirt reveals a wiry chest taut with muscle. The beginnings of a

cauliflower ear and the heaviness in his eyelids suggest skin thickened, like a boxer's, by absorbing too many punches. The high tilt of Flannigan's chin also indicates a cockiness and perhaps even disdain for those he meets. Reform-minded photographers rarely granted their subjects the right to express that emotion. Yet at the same time Bellows's portraits recall the comic, smart-aleck characters and sentimental singing newsboys popular on the New York stage and silent screen.[19] As an ethnic character, the Irish Flannigan is cousin to the Irish street lad in "Denny the Jew," drawn by Glackens. Both share the characteristic of scrappiness that was assigned to all young Irishmen in the conventions of the time; in the next generation Mickey Rooney exemplified the type. Both paintings offer fairly positive representations. They may be thin, but there is nothing cruel about them.

The negative stereotyping of European immigrants was still not as bad as that heaped upon African Americans. The Irish might be violent, but they were also characterized as bighearted. Jews were often credited with being smart, if conniving. The best that turn-of-the-century stereotypes could say about blacks was that they were childlike, and thus immune from the stern judgment that should be meted out to adults. Minstrel players in blackface portrayed vain dandies or ignorant fools who lived in rural areas and spoke an outlandish southern dialect; another strain of humor presented Sambo characters in an imaginary Africa. Almost all visual depictions of blacks in film and advertising, as well as cartoon and fine-art images, were caricatures.

The Ashcan artists' work shows a range of reactions to the African Americans who lived in New York City. Their published illustrations often conformed to the stereotypes of the era. Luks drew Sunday comics featuring grinning pickaninnies, while Sloan apparently saw no contradiction in depicting a goggle-eyed black boy eating watermelon in an antiracism cartoon for *The Masses*.[20] The faces of the children in Bellows's drawing of an African-

Fig. 130 (opposite)
George Luks, *Widow McGee*, 1902, oil on canvas, 61 x 45.7 cm (24 x 18 in.). Joslyn Art Museum, Omaha, Nebraska

Fig. 131
George Luks, *The Old Rosary Woman of Catherine Street, New York City*, 1915, ink on paper, 43.3 x 20.5 cm (17 ⅟₁₆ x 8 ⅟₁₆ in.). Munson-Williams-Proctor Institute, Museum of Art, Utica, New York

Luks's portraits of elderly women he encountered on the streets of New York repeated well-established formulas, with varying degrees of individuality. In a note he identified "the old rosary woman known as such in her neighborhood where she has been peddling rosaries for the past fifty years."

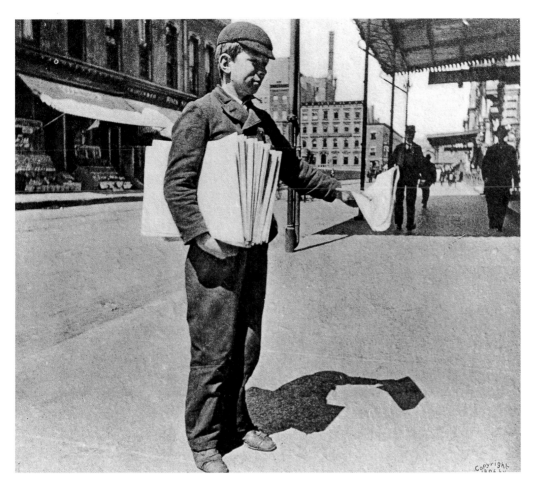

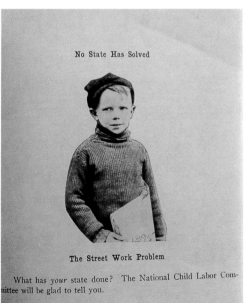

No State Has Solved

The Street Work Problem

What has *your* state done? The National Child Labor Committee will be glad to tell you.

Fig. 132 (opposite)
George Bellows, *The Newsboy*, 1916, oil on canvas, 76.5 x 56.2 cm (30 ⅛ x 22 ⅛ in.). The Brooklyn Museum, New York, Gift of Mr. and Mrs. Daniel Fraad, Jr.

Fig. 133
Alice Austen, *Newsboy*, from *Street Types of New York*, 1906. Museum of the City of New York

Fig. 134
Lewis Hine, "No State Has Solved the Street Work Problem," published in *Street-Workers*, pamphlet 246 (New York: National Child Labor Committee, 1915): 11

Bellows's record books indicate that he made a number of portraits of working-class children he observed in New York around 1908. The generic "newsboy" evoked a familiar urban type. Picture albums, news photographs, and reform literature presented newsboys and bootblacks either as picturesque characters or as examples of urban problems.

Fig. 135
George Bellows, *Paddy Flannigan*,
1908, oil on canvas, 76.2 x 63.5 cm
(30 x 25 in.). Erving and Joyce Wolf
Collection

Fig. 136
George Bellows, *Tin Can Battle, San Juan Hill, New York*, 1907, crayon, ink, and charcoal on paper, 53.3 x 61.6 cm (21 x 24 ¼ in.). Sheldon Memorial Art Gallery, University of Nebraska–Lincoln, UNL–F. M. Hall Collection, 1947.H-272

American neighborhood, *Tin Can Battle, San Juan Hill, New York* (fig. 136), are apelike.

Sloan's *Fishing for Lafayettes* (fig. 137), however, depicts a black man in a far more humane light. This small oil sketch was unusual for Sloan because he painted it outdoors, on the docks along the East River, while conversing with the people he shows in the picture. He probably never exhibited it. The black subject sits on a pier, derby on his head, pipe in his mouth, fishing rod in hand, as one man in a group of fishermen. He is the focal point of the painting, and there is nothing in the depiction that makes him any less than the white men nearby. Indeed, in its ordinariness, the image of the black man is unusually humane for its time.

Of all the Ashcan artists, it was Henri who produced the painting of an African American that departed furthest from stereotyping. Although he often chose his subjects to be representative of a type, his *Portrait of Willie Gee* (fig. 138) is free of the racist mask that white

Americans of that era so often placed over the faces of black Americans. Erect, composed, and dignified, with alert eyes, Willie Gee is a compelling individual. Whatever Henri's intention in executing the portrait, it is an implicit rebuke to the white American painters who depicted blacks in a racist manner. *Willie Gee* was one of the last portraits of "my people" that Henri made in New York; from then on, his letters record frustration at being unable to find "real" or unspoiled sitters. His attempt to isolate pure ethnic types was doomed in the end because nothing in New York remained pure for long. He had more success locating subjects in Europe and the Southwest.

Inhabitants of neighborhoods that visitors compared to foreign countries actually lived cheek by jowl with other nationalities; immigrants struggled so hard to maintain certain traditions precisely because they were constantly in contact with other cultures. The cacophony of products and

"San Juan Hill" was the nickname of a neighborhood west of Tenth Avenue from Fifty-ninth to Sixty-third Streets, where up to six thousand African Americans lived in one block of tenements. Like the artists who drew comic strips, Bellows made a brawl the center of attention in his drawing. The depiction of a dilapidated building (note the broken shutter) inhabited by idle people seems to confirm an investigator's report: "The people on the hill are known for their rough behavior, their readiness to fight, their coarse talk. . . . Boys play at craps unmolested, gambling is prevalent, and Negro loafers hang about the street corners." Yet the same writer observed the presence, on nearby blocks, of "many respectable families" and found the children there to be "devoid of the ingenious, exasperating deviltry of an Irish or German-American neighborhood." The year Bellows made his drawing, newspapers praised the efforts of a local pastor to organize revival meetings that freed the area from "the periodical outbreaks of lawless ruffianism that formerly kept the police force busy."

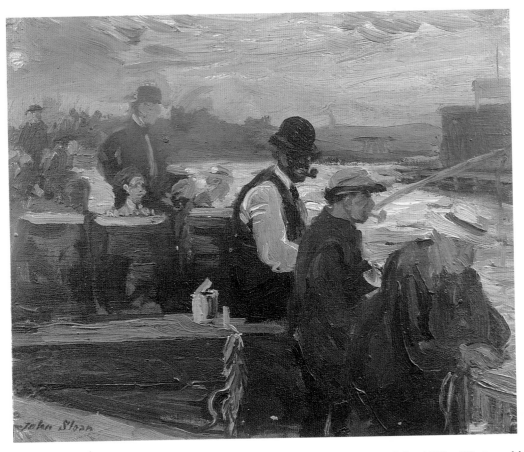

Fig. 137
John Sloan, *Fishing for Lafayettes*,
1908, oil on linen, 21.6 x 26.7 cm
(8 ½ x 10 ½ in.). Private collection

Fig. 138
Robert Henri, *Portrait of Willie Gee*,
1904, oil on canvas, 79.4 x 66.7 cm
(31 ¼ x 26 ¼ in.). Collection of The
Newark Museum, Purchase 1925

*At different times, Henri identified the
sitter as a bootblack or a newsboy, the
"son of a Virginia slave woman" who
moved north to New York.*

signboards displayed in Glackens's street
scenes were evidence of one aspect of the New
World predicament. The character of Denny
the Jew, the hero of the stories illustrated by
Glackens, was meant to typify another aspect
of cultural assimilation. The son of an Irish
immigrant who falls upon hard times, Denny
sets out to support his family by selling Yid-
dish newspapers and appealing to Jewish
charities. The stories themselves, written by a
Jewish author for publication in national mag-
azines, are filled with Yiddish dialect, yet were
aimed at a general readership. A similar mix-
ing occurred on the stage, with not just white
characters in blackface but Irishmen playing
Jews, Jews playing Germans, and countless
variations, while the idiomatic "New Yorkese"
that emerged in their speech combined traces
of several languages. While art critics be-
moaned the decline in picturesque or "gen-
uine" subjects, social commentators praised
the melting pot at work.[21] Even the logic of the
stereotype, based on the idea that a person is
either one thing or another, broke down in the

commercial culture of the 1920s. What could
be called native, what foreign, in "Alexander's
Ragtime Band"—a song based on an African-
American musical form, but adapted by a
Jewish immigrant who took the name "Irving
Berlin," and promoted as a national hit?

PUBLIC SPACES AND
PUBLIC BEHAVIOR

Glackens's figure sketches (fig. 139) are the
products of an artist doing what everyone
does when visiting New York City: people-
watching. From the vantage point of a park
bench, Glackens drew sketches of individual
pedestrians going about their business. These
notations, made on full pages in sketchbooks
or jotted down with a pencil stub on scraps of
paper concealed in his pocket (a trick he
learned in his newspaper days), later served
as source material for full-scale drawings, in-
cluding *Washington Square* (fig. 140). Today we
delight in the variety of New Yorkers in motion
that must have delighted the artist: the gait of
a girl balancing a bundle on her head, a man

Fig. 139
William Glackens, *Figure Sketches Number 2*, ca. 1907, chalk, 38.1 x 57.8 cm (15 x 22 ¾ in.). National Museum of American Art, Smithsonian Institution, Gift of Mr. and Mrs. Ira Glackens

Fig. 140 (opposite)
William Glackens, *Washington Square*, 1913, charcoal, pencil, colored pencil, gouache, and watercolor, 73.9 x 56.2 cm (29 x 22 in.). The Museum of Modern Art, New York, Gift of Abby Aldrich Rockefeller. Photograph © 1995 The Museum of Modern Art, New York. Published as *A White Christmas*, in *Collier's* 52 (13 December 1913): 8

Fig. 141
"City Parks Are Infested by Filthy and Vicious Hordes," *New York Herald*, 7 April 1907, sec. 3, 9

Where design and socially congenial visitors fostered a consensus on behavior, parks could be orderly places. But when visitors differed on who should be in a park and what they should do there, conflicts could erupt. The "idlers" and "riffraff of humanity" described in the New York Herald's article are presumably some of the same people who occupy the park benches in Sloan's paintings set in Madison and Union Squares.

taking off his coat, a woman adjusting her hat as she walks along. *Washington Square* is one of many Ashcan School images that connects public space with public behavior.

The greatest of New York's squares, parks, and avenues were municipal ornaments that offered citizens a wealth of amenities. But they also set the stage for an urban challenge, one that affected not only the Ashcan artists but every city dweller: sharing public spaces with strangers (fig. 141). By the 1880s, New York was already known for its public spaces such as Central Park and its public events such as ticker-tape parades. The variety of New York's people and public spaces grew even greater at the turn of the century. As the population became larger and more heterogeneous, new questions arose about the use of public space.

Progressive Era politics encouraged an activist role for government that included

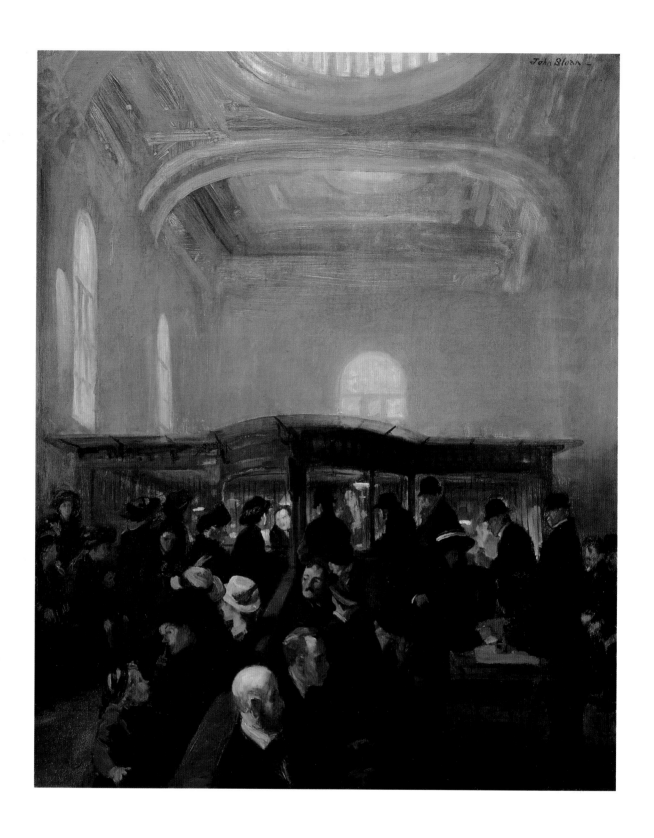

Fig. 145
John Sloan, *The Savings Bank*, 1911,
oil on canvas, 81.3 x 66 cm (32 x 26 in.).
Private collection, Washington, D.C.

Elsewhere the stories are more troubling. At *Sixth Avenue and Thirtieth Street* (fig. 147), an intersection in the red-light district known as the Tenderloin, a stream of passersby stops to stare at a woman dressed in white, who pauses before crossing the street. Her reddened nose, skimpy dress, and confused expression suggest that she has gone out abruptly to buy a pail of beer and now cannot find her way home. Sloan deploys details of setting (the Sixth Avenue elevated tracks and nearby saloons) to provide information about the neighborhood; the composition (strong diagonals formed by buildings, street, and sidewalk) links the figures in a narrative relationship; costume and gesture identify the people and set them apart from each other. Well-dressed men, and women who may be prostitutes, look scornfully at the woman, who clutches a hand to her chest as if for protection.[23] The vulnerable gesture of the woman, caught with her guard down, embodies the painful risk of being exposed in public and the cruelty of the fashionable urban crowd.

More typical images depict public encounters not as impositions or invasions of privacy but as a relatively benign condition of metropolitan life. They show city dwellers behaving as if they know they will be observed by strangers and at times positively enjoying it. How else can one explain the ostentation of fashionable ladies on *Fifth Avenue, New York* or the flamboyant gestures of the stockbrokers that Glackens depicted in *Curb Exchange* (fig. 71)? The latter drawing, of a scene frequently singled out in tourist literature and portrayed in photographs at the time, is a particularly vivid example of the artist's eye for what one might call "site-specific behavior" that could be observed in one locale but would be out of place in another.

This concern with public places as settings for human action carried over into the Ashcan artists' depictions of parks. Despite the greenery and open spaces, Luks, Shinn, Glackens, Sloan, and Bellows show scenes that are never really separate from the activity

on the streets around them. In *Blue Snow, the Battery*, Bellows revisited the intermediate zone between nature and working landscape that he treated so effectively in *Rain on the River*. This painting shows Battery Park at the southern tip of Manhattan as relatively empty but hardly a wilderness. The wide expanse of snow-covered ground under brilliant light and the river in the distance could almost be an icebound seacoast,[24] but barges, railings, and the shadow cast by a building to the left remind the viewer of the man-made setting that frames the park. More often, Ashcan artists reversed that relationship by depicting parks as architectural frames or stages for scenes of human activity.

Ashcan artists were not alone in their investigations of the relationship between

Fig. 146
John Sloan, *Greenwich Savings Bank*, undated, charcoal on paper, 19 x 22.9 cm (7 ½ x 9 in.). Collection of Oriana and Arnold McKinnon

The mix of people doing business in banks was a fairly new phenomenon when Sloan conceived this picture. A recent change in banking laws had spurred the opening of more branch offices where local residents from all walks of life could keep modest accounts. Sloan made an extra trip to the Greenwich Savings Bank on lower Sixth Avenue to deposit five dollars and make notes for this drawing. The railing dividing the room was a holdover from the nineteenth-century practice of providing separate waiting areas for men and women in public places. In the finished painting Sloan exaggerated the room's architecture in order to bring out the irony of the "poor thrifty [who] should stand and sit in awe of the columns and gold and glass which their own money builded."

Fig. 147
John Sloan, *Sixth Avenue and Thirtieth Street*, 1907, oil on canvas, 66.7 x 81.3 cm (26 ¼ x 32 in.). Collection of Mr. and Mrs. Meyer P. Potamkin

physical settings and the behavior of city dwellers. Similar interests inspired participants in the City Beautiful movement and other urban reformers who sought to analyze and improve urban life through the design of public spaces. This thinking originated in the mid-nineteenth century with the creation of Central Park, a massive municipal undertaking that was justified not simply as an amenity for local residents but as one that might improve people by putting them in contact with nature. Later in the century, as poverty became more visible and fear of crime increased, philanthropists promoted the construction of schools and model tenements whose very forms would educate the residents.[25] Their designs for urban facilities were more utilitarian than the bucolic parks of the nineteenth century, but they shared certain ideals of environmental uplift. For example, advocates of playground reform argued that supervised play, in an orderly environment (figs. 148 and 149), offered a safe alternative to the hazards of impromptu games on streets, docks, and alleys—exactly the kind of rough activity that Glackens depicted in *A Football Game* (fig. 150).

At the turn of the century such arguments about the need to improve city space and life were seconded by architects and planners who claimed that the creation of public works would not only beautify the city but Americanize a fragmented population by creating images of civic unity.[26] The World's Columbian Exposition of 1893 in Chicago inspired the creation of municipal commissions that produced plans for many American cities. The design of the exposition, with its symmetrical layout, clear vistas, and uniform architectural style, offered an aesthetic prototype of an ordered city, and the exposition's management was cited as an example of coordinated, rational planning under a centralized administration.

American advocates of "civic aesthetics" also looked to Paris as a model of urbanism, citing the work of Baron Haussmann,

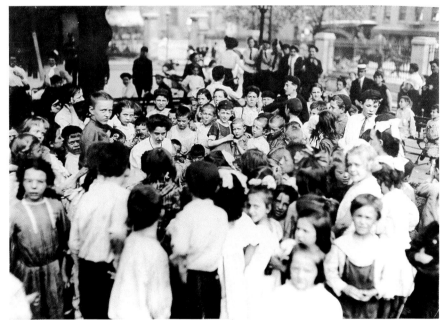

Fig. 148
Jacob Riis, *Athletic Meets in Crotona Park*, ca. 1902. Museum of the City of New York. Published in Jacob Riis, *The Battle with the Slum* (New York: Macmillan, 1902), 415

Fig. 149
Lewis Hine, *Children's Librarian Telling Stories to a Group of Children in the Hudson Park Playground during the Summer of 1910*, 1910, silver gelatin print. New York Public Library

Fig. 150
William Glackens, *A Football Game*,
1911, black ink, 61 x 45.7 cm (24 x 18
in.). Private collection. Published in
Collier's 48 (11 November 1911): 8,
as *For the Championship of the Back-
Lot League*

*Planners who argued for the construc-
tion of new parks and playgrounds
warned against the dangers of unsuper-
vised scrimmages in trash-strewn city
lots—a scene that Glackens depicted
with characteristic humor and violence.*

chief planner under Emperor Napoleon III.
"Haussmanization" was praised as much for
its efficiency (possible, noted the American
bureaucrats wistfully, only when the state
gives an administrator autocratic powers) as
for its aesthetic contributions. Tree-lined
Parisian avenues that separated strollers from
vehicular traffic were contrasted with "the
vexations of city pedestrians" on American
streets. In language that reads like a list of
Ashcan subjects, a writer for the professional
journal *Municipal Affairs* bemoaned

*noises which bewilder city visitors . . . the rattling
of cart wheels . . . voices of news vendors and
cab drivers whose clamor invades every nook
and corner creating an atmosphere of constant
excitement . . . merchandise [being] loaded and*

*unloaded . . . obnoxious pushcarts of hucksters
. . . especially on Fridays and Saturdays when
Jews and Gentiles buy supplies for the following
holidays . . . newspaper bulletins on sidewalks
increase the number of obstructionists. Disre-
garding the existence of passers, factory girls
on leaving their shops often barricade corners.
In the neighborhood of the Stock Exchange in
New York a promenader is apt to be hustled
[by] eager men, anxious to reach the field of
action. . . the reckless rapidity of passing trol-
leys . . . streets where unwashed foreigners
crowd into antiquated tenements . . . the Boul-
evards of Paris are in strange contrast with
such tumult.*[27]

In New York a group of architects, artists,
and civic leaders founded the private Munici-
pal Art Commission in 1898 and over the next
thirty years lobbied the city government to
adopt a master plan. Although its larger
dream of a rational city of boulevards and
plazas was never realized, the commission
sponsored public monuments and small-scale
improvements (lampposts and street fixtures
redesigned in classical style) and left its most
lasting mark on the city with the enactment of
zoning laws in 1916. Its advocacy of ordered,
classical architecture also inspired the design
of such large-scale commissions as the cam-
pus of Columbia University.[28]

Pictures played an important role in pro-
moting the vision of New York as a City Beauti-
ful. Reports illustrated with architectural
drawings presented ideal plans to govern-
ment commissions, while architectural and
popular magazines used similar drawings to
describe the latest municipal improvements
(fig. 151). Pictorial books like John C. Van
Dyke's *The New New York* helped readers visu-
alize the planners' precepts: symmetry, open
vistas punctuated by classical statuary, the
orderly separation of city functions to pro-
mote a smooth flow of traffic, the peaceful
conduct of citizens in public. Postcards pro-
duced at the time show similarly well-ordered,
spacious environments through which tiny
figures promenade. These "documentary"

images share a reciprocal relationship with
the fine-art paintings, prints, and photographs
produced in the same years by American
impressionists and tonalists.

Just as professional planners held up
Baron Haussmann's boulevards as a standard
for municipal design, these artists recast New
York according to a Parisian ideal by imitating
the paintings of Monet and Pissarro. But
unlike their French prototypes, city images by
American artists tended to avoid scenes of
crowded streets in favor of bird's-eye views or
depictions of parks and plazas as sparsely
inhabited spaces.[29] Architectural illustrators
used similar compositions and delicate tones
to depict a city of monuments and wide
avenues nearly devoid of people.

Yet what the planners viewed as chaos,
the Ashcan artists saw as dynamic human
interaction, as in Glackens's *Washington
Square*. The marble arch at the entrance to
Washington Square Park on Fifth Avenue,
inspired by the one on the Champs-Elysées,
was often cited as an example of municipal
architecture at its best. In Glackens's drawing,
however, the arch is hardly visible; the page is
given over instead to the hundreds of figures
who swarm over the railings, fill the patches of
lawn, and jostle each other on benches and

Fig. 151
Jules Guérin, *General Grant's Tomb
and Riverside Park*, from Randall
Blackshaw, "The New New York,"
Century 64 (August 1902): 506

Fig. 152
John Sloan, *Election Night*, 1907, oil
on canvas, 67 x 82 cm (26 ⅜ x 32 ¼
in.). Memorial Art Gallery of the
University of Rochester, Marion
Stratton Gould Fund

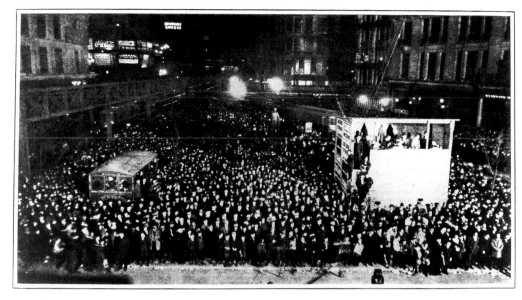

The massed thousands watching the bulletins in front of the "Herald" Building

paths. Glackens recombined drawings from his sketchbooks to create a heightened sense of density, yet each figure maintains its own personality. Unlike the isolated figures in an architect's drawing or an American impressionist painting, these people notice and are forced to interact with each other—sometimes violently. Boys pelt passersby with snowballs and are in turn scolded by adults or (upper left) apprehended by police. Seated on the benches are a mix of people from the different neighborhoods that surround the square: well-dressed children and top-hatted gents, rowdy boys in ragtag jackets, an immigrant mother wearing a babushka, nursemaids tending other people's babies. A swaddled woman slumps over as her neighbor tries to edge away.

Glackens's version of Washington Square contradicts the ordered uniformity of City Beautiful imagery. For all its exaggeration, in some ways it is truer to the nature of urban public space, where classes mix and people surprise each other. Architects can plan but not always control what will happen in a city square. That may not be such a bad thing.

Glackens's good-natured drawings make unpredictability an enjoyable part of the urban show by maintaining a comfortable distance between the viewer and the mayhem on the ground. Sloan's *Election Night* (fig. 152) surges directly into the crowd. The title refers to a public celebration that took place in Herald Square when crowds gathered to watch election results projected on the side of the *New York Herald*'s building at the intersection of Broadway and Sixth Avenue (fig. 153). Vendors sold tinhorns, confetti, and a feather-topped toy called a "tickler," with which friends or strangers could poke each other. The painting revels in the noise and physical abandon that breach all rules of correct decorum on city streets. It reveals another truth that most urban images concealed: in a city, especially during special moments of celebration, one can expect to be jostled and not mind it.

Debates over the uses of public space and appropriate public behavior played out most visibly in Central Park. Although the park was conceived in the 1860s as a bucolic haven, by the turn of the century it was crowded with activity. As previously discussed, diverse groups competed to define their own turf and styles of amusement in different sections of the park. The Ashcan artists

Fig. 153
How New York Watched the Returns, from William Cains, "Election Night in New York," *Harper's Weekly* 52 (7 November 1908): 9

In the early twentieth century the great squares traversed by Broadway—Printing House Square, Herald Square, and Times Square, all the sites of newspaper offices—were crowded with people celebrating on election night. Politics, with its rallies, oratory, and clubhouse festivities, was a participant sport for thousands of New Yorkers. Without radio or television, the fastest way to get the results of city, state, and national races was to gather outside newspaper offices. Learning the outcome of elections, however, was only part of the reason for gathering. Uptown crowds at Times and Herald Squares (perhaps less likely to be composed of political professionals tired from campaigning and ready to work the next morning) celebrated for hours after the winners were announced.

Sloan's painting recalls the comments of a reporter for Harper's Weekly *who noted the "remarkable number of young women.... [M]ost were polka-dotted from hat to skirt-hem with many-colored confetti and armed with raucous horns." The writer concluded, "Broadway on election night is no place for any one who is not prepared to be jostled about."*

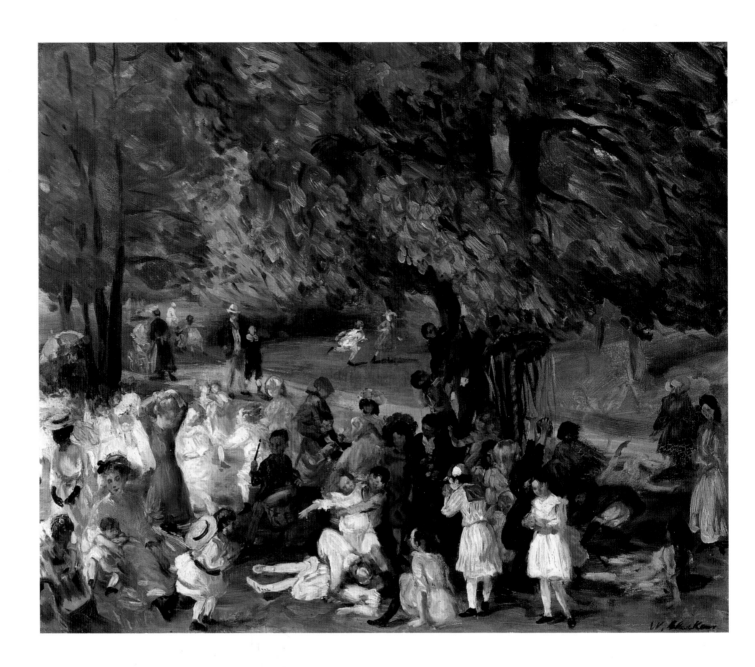

Fig. 154
William Glackens, *May Day, Central
Park*, ca. 1905, oil on canvas, 63.8
x 76.8 cm (25 ⅛ x 30 ¼ in.). The Fine
Arts Museums of San Francisco, Gift
of the Charles E. Merrill Trust with
matching funds from The de Young
Museum Society, 70.11

represented the park not as a retreat but as a space that was thoroughly integrated into the urban social fabric. By selective omission, their paintings confirmed but sometimes exaggerated its fragmented use.

In *The Drive, Central Park* (fig. 34), painted in 1905, Glackens showed the efforts of New York's elite to maintain rituals of decorum in one section of paths that bordered Fifth Avenue. Henry James, who visited the park that year, remarked on the "contrasts" that made it difficult to visit "the district abutting on the east side of the Park" (the setting of Glackens's painting) without immediately being reminded of "the social question." Within the park itself, James noted the "polyglot Hebraic crowd of pedestrians" and commented that "the alien was [now] truly in possession" of the park. The rectilinear formality of this painting seems worlds away from the scenes that troubled James, as if the artist, like the well-dressed coachmen in the picture, sought to ignore the mixture of people around him. Or could it be that some of the people on the benches, dressed in their best to observe the passing parade, are part of the "mingled medium" whom James noted for "the air of hard prosperity, the ruthlessly pushed-up and promoted look worn by men, women and children alike"?[30]

Glackens turned to a more rough-and-tumble form of leisure in *May Day, Central Park* (fig. 154), which explodes with the kind of disordered energy he would celebrate in his drawing of a backlot *Football Game*. But the spotless clothing of the children and the visible presence of nursemaids on the lawn suggest a more sanctioned kind of play.[31] The painting gives no indication that on the same day another seven hundred children gathered under a maypole (presumably in a different part of the park) as guests of Tammany Hall politicians and elected their own "colored" and "Italian" kings and queens of May. In a magazine illustration a few years later, Glackens depicted a more variegated group (figs. 155 and 156). In the illustration,

nursemaids are less evident than in his paintings, while the children seem more impudent and actively confront the few adults on the scene.

Bellows's park images seem even more anachronistic in their renditions of uniformly refined leisure. How do we reconcile the stately figures and immaculate clothing of the picnickers who fill *Luncheon in the Park* and *A Day in June* with a newspaper article

Fig. 155
Detroit Publishing Company, *May Pole Dance, Central Park*, 1905, photograph. Prints and Photographs Division, Library of Congress, Washington, D.C.

Fig. 156
William Glackens, *May Day in New York's Central Park*, from *Collier's* 39 (4 May 1907): 8

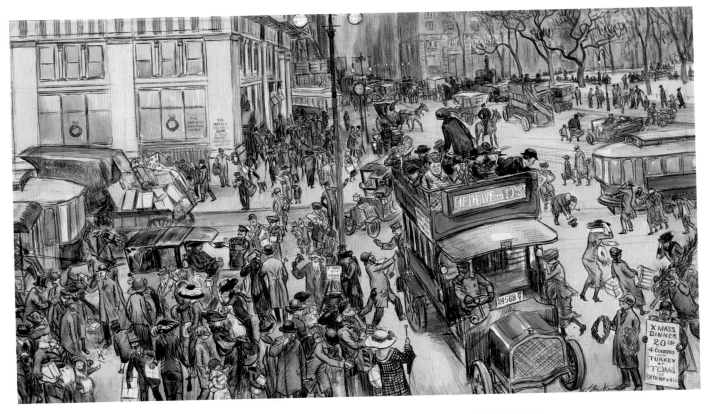

Fig. 157
William Glackens, *Christmas Shoppers, Madison Square*, 1912, crayon and watercolor on paper, 44.5 x 77 cm (17 ½ x 31 in.). Museum of Art, Fort Lauderdale, Florida, Ira Glackens Bequest. Published in *Collier's* 50 (13 December 1912): 22–23, as *The Day before Christmas on Madison Square*

By the early twentieth century, shopping and Christmas went hand in hand. Glackens's drawing shows a range of last-minute buying—from informal street peddlers hawking Christmas wreaths to wagons delivering purchases made uptown. New York's department stores also prepared Christmas mail-order catalogues that helped bring Manhattan shopping to the rest of the nation.

published in June 1913 complaining that the section of the park closest to a Jewish and Italian neighborhood resembled "a cheap picnic ground or the old Bowery or Coney Island because of the litter scattered about"?[32] Perhaps it was wishful thinking on the part of the artist or his intended audience. Or perhaps the genius of the park as public space was that many different realities could coexist there—and that in this case Bellows, like Glackens, chose to depict a reality that conformed to conventional expectations for genteel fine art.

Glackens's paintings of ice skating (fig. 76), a pastime enjoyed by almost everyone who could afford the price of skates, and the subject of several movies and stereopticon photographs made at the time, may be more typical of Central Park by 1912. In brushwork reminiscent of impressionist painting, the artist presents figures almost as varied but much less crowded and chaotic than those he depicted in drawings—or that appear in movies and photographs of the lake. Oddly isolated, each skater in this painting glides alone or in small clusters, suspended in momentary equilibrium.

SHOPPING

In Glackens's drawing *Christmas Shoppers, Madison Square* (fig. 157), a traffic-clogged intersection is a whirlwind of buying and selling. Men carrying sandwich boards compete with peddlers hawking Christmas wreaths; delivery trucks lumber by, laden with packages; shoppers juggle bundles as they try to cross the street. The commercial activity in the scene transforms the orderly public space desired by planners, much as the rise of consumer culture transformed the Christmas of the late nineteenth century into a holiday very different from that of a hundred years earlier. The third quarter of the nineteenth century in New York was the decisive phase in the growth of Christmas as a festival of consumption. The city's department stores were already nationally famous, and the possibilities of the Christmas trade were clear when R. H. Macy's set a record for one-day receipts by remaining open until midnight on December 24, 1867. In 1874 Macy's presented window displays decorated exclusively in Christmas themes. Within two decades

the shift to a consumer Christmas was complete. In 1891 F. W. Woolworth exhorted his store managers, "This is our harvest time. Make it pay."[33]

With New York's emergence as a national commercial center, the buying and selling of goods became central to the everyday life of the city. During the nineteenth century the shortage of space in urban living quarters accelerated the trend to purchase food and daily necessities in stores rather than growing or making them at home. What marked shopping at the turn of the century was how many things were available for sale and how much urban space and activity were dedicated to commercial exchange. Some of the grandest new city planning and construction projects highlighted not governmental but commercial office buildings, banks, hotels, and theaters; the public spaces at Times Square, Herald Square, and in the financial district showcased buildings for corporate headquarters, while older parks at Madison Square, Union Square, and City Hall were ringed with new commercial structures. Neighborhood shops were augmented by department stores clustered in newly created shopping districts.[34] On a day-to-day basis New Yorkers shopped not only for food, clothing, and furnishings but also for entertainment, while browsing and window shopping became pastimes in themselves.

The Ashcan School artists were among the first Americans to explore commercial themes in art. Many European painters had addressed the subject. When he visited America, Edgar Degas painted the New Orleans cotton exchange; several of his pastels of scenes in Parisian milliners' shops were purchased by the New York collector Mrs. H. O. Havemeyer at the turn of the century.[35] The topic of shopping was much discussed in American illustrated journals at the time. The shop girl, the salesman, and the department-store clerk became popular characters in fiction, theater, film, and song (fig. 158). In Theodore Dreiser's novel *Sister Carrie* (1900), the heroine pines for clothes displayed in department-store win-

dows, and it is the "drummer" (salesman) Drouet whose irresistible pitches eventually lead Carrie to her downfall. At the movies, *The Kleptomaniac* (Edison, 1905) offered a dramatic narrative set in a department store, while the actuality film *Bargain Day on 14th St.* (1905) consisted of one aerial shot of a horde of shoppers cramming through a door at opening time.

Pictures, in turn, played an important role in the emerging commercial culture. They appeared as illustrations in the advertisements that filled (and provided economic support for) the press, and on the billboards and posters that came to dominate the landscape in city and countryside alike. Yet while literature and popular culture at the turn of the century had found great interest in commerce, leading American painters avoided the subject. Perhaps artists shared the distaste for commercialism that led cultural critics to condemn obtrusive displays of advertising as vulgar and to consider financial concerns antithetical to the ideals of art. Open-air markets in Cairo or Normandy might offer appropriately charming subjects for painting, but modern American stores went unrecorded.

Comparisons with marketplaces in the Old World may have inspired Luks to devote

Fig. 158
Strobridge Lithographic Company, advertisement for *Only a Shop Girl*, 1908. Museum of the City of New York

The "low" but honest shop girl was a new heroine in popular songs and melodramas that recycled the theme of the contrast between rich and poor.

Fig. 161
William Glackens, *The Shoppers*, 1907,
oil on canvas, 152.4 x 152.4 cm (60
x 60 in.). The Chrysler Museum,
Norfolk, Virginia, Gift of Walter P.
Chrysler, Jr., 71.651

against the "pushcart evil" was hardly about a citizen's right to the street.[37] Rather, it was part of an effort to divide the heterogeneous city into identifiable zones, separate commercial from residential neighborhoods, limit the presence of "unsightly" billboard advertising on urban streets, and protect the interests of store owners. Planners hoped that the haphazard mix of business, residence, and local stores, seen in Glackens's drawing, would be replaced by centralized shopping districts with regulated signage along upper Sixth Avenue and Broadway.

Impressive new commercial buildings played an important role in plans for a more orderly New York. Madison Square Park boasted two skyscrapers: the Flatiron Building, erected in 1902, and the Metropolitan Life tower in 1909. Famous as the tallest

building in the world, the Metropolitan tower provided an architectural advertisement (or corporate identity) for its sponsor and thus functioned as both civic and commercial monument.

If the skyscraper served as a dignified symbol for business, the department store was the architectural monument to shopping. Glackens's magisterial painting *The Shoppers* (fig. 161) pays tribute to department stores and to the ladies who frequented them. By the turn of the century, New York department stores were known as "Adamless Edens" equipped with amenities—restaurants, reading rooms, and ladies' lounges—designed to turn shopping into a day-long activity especially appropriate for respectable women. Earlier shops had kept goods behind counters, so that every potential purchase required

negotiation with a clerk. The modern department store placed merchandise on display, with prices clearly labeled, along wide aisles that encouraged leisurely browsing and impulse buying. An army of assistants stood ready to complete the sale. *The Shoppers* depicts that moment of examination and deliberation at which the skilled shopper excels. Edith Glackens (in furs), Florence Scovel Shinn (on the far right), and the Glackenses' friend Lillian Travis posed for the picture amid an elegant selection of fashionable accessories.[38] Will she make a purchase, or is she "just looking"? As the saleswoman at left displays a garment with the anxious air of a lady in waiting, the shoppers' discerning expressions lend the process a sense of gravity and high drama.

Shinn's poignant pastel *Window Shopping* (fig. 162) presents a different psychological aspect of the romance between people and merchandise. The plate-glass window, developed in the late nineteenth century, made it possible to display goods to casual passersby on the sidewalk, turning the display into part of the urban streetscape. By the early 1900s, store-window design was a growing profession, with journals devoted to tactics for manipulating shoppers' desires with eye-catching displays (fig. 163). In contrast to the fashionable trio in Glackens's interior scene, Shinn's shopper is depicted as a drab woman who pauses in midstride on a rainy night, transfixed before the elegant mannequins in a department-store window. As in his theater

Fig. 162
Everett Shinn, *Window Shopping*, 1903, pastel, 38 x 48.3 cm (15 x 19 in.). Collection of Arthur and Holly Magill. Photograph courtesy of Kennedy Galleries, Inc., New York

Fig. 163
Simpson-Crawford Department Store,
1905, photograph. Museum of the City
of New York, The Byron Collection,
#19358

*Plate-glass windows made displays
of goods a part of the streetscape in
shopping districts. Intended to entice
customers inside to make purchases,
the lavish displays also enlivened the
sidewalks of New York and provided
an enjoyable aesthetic experience
for those who were just window shop-
ping. The Simpson-Crawford store
was located on Sixth Avenue between
Nineteenth and Twentieth Streets, a
few blocks from Sloan's apartment.*

Fig. 164
John Sloan, *Hairdresser's Window,*
1907, oil on canvas, 81 x 66 cm (31 ⅞
x 26 in.). Wadsworth Atheneum, Hart-
ford, Connecticut, The Ella Gallup
Sumner and Mary Catlin Sumner
Collection Fund

*In diary entries for June 1907, Sloan
described the genesis of this painting
(sometimes called* Hairdresser's Win-
dow—Sixth Avenue*): "Walked up to
Henri's studio. On the way saw a hu-
morous sight of interest. A window,
low, second story, bleached blond hair
dresser bleaching the hair of a client.
A small interested crowd about. . . .
Walked out to take another look at
the Hair Restorer's Window. Came
back and started to paint it." Sloan
apparently finished the picture after
three more sessions of work. An artful
arrangement of rectangular shapes
focuses attention on the hairdresser,
whose rubber gloves indicate the use of
harsh chemicals to bleach her client's
hair. The surrounding signboards are
full of puns, including "Madame Mal-
comb," the name of the hair salon. The
witty references to advertising appealed
to the Pop artist Andy Warhol, who
acknowledged Sloan as one of the few
historical artists who inspired him.*

images, Shinn's composition maintains an equilibrium between the figure of the real woman in the foreground and the haughty show-window models, who are illuminated like actresses on a stage. The glow from the window reflects like footlights on the wet pavement. The viewer is invited to imagine the dreams of the humble window-shopper looking at this display of glamour, color, and fantasy.

Characteristically, Sloan's scenes of shopping are set in less refined parts of town, where commerce, street life, sex, and humor cohabit at random. *Hairdresser's Window* (fig. 164) depicts a stretch of lower Sixth Avenue as a noisy, bustling environment whose flashy billboards and placards announce a variety of businesses: a chop-suey restaurant, where Chinese immigrants purveyed an American-ized, mixed hash of a cuisine to non-Chinese customers, provides an apt metaphor. A ground-floor showcase displays wigs on man-nequins, but the main focus is on the second-story window, which frames the scene of a hairdresser at work; a crowd gathers on the sidewalk to watch. Sloan went out of his way to render legible lettering that comments on the

scene. A witty arrangement makes visual equa-tions between the rectangular window, the placards that punningly advertise hair prod-ucts, and the flat, frontal canvas itself. The painting, in effect, becomes an advertisement for Madame Malcomb's salon.

Could this picture invite comparison be-tween a work of art and a billboard, each with its own pitch to make? How different, really, is the viewing that goes on in this scene from that depicted in *Picture Shop Window* (fig. 165)? Here Sloan shows a cluster of window-shop-pers marveling at a display of prints for sale; their gestures reveal naive delight, perhaps awe, at the powers of art. The scene suggests that the shoppers' activity—strolling, pausing to inspect a display, deciding whether to look more closely or move on to view the next item—is not all that different from the activity of visitors at an art exhibition. The possibility of a sale increases both the drama of the encounter and the artist's stake in its outcome.

Sloan made explicit the analogy between shopping and viewing art in a series of prints he planned to entitle *Connoisseurs.*[39] In *The Show Case* (also called *Critics on Form*) (fig.

Fig. 165
John Sloan, *Picture Shop Window*,
1907–08, oil on canvas, 81.3 x 63.8 cm
(32 x 25 ⅛ in.). Collection of The
Newark Museum, Gift of Mrs. Felix
Fuld, 1925

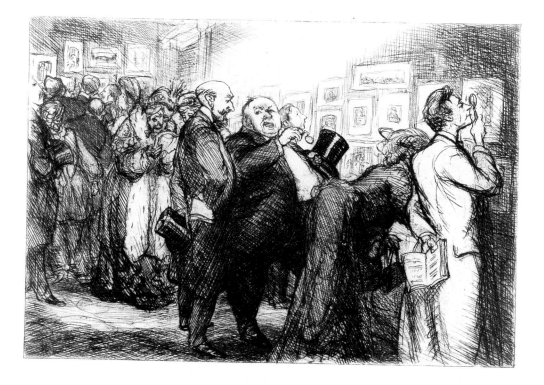

Fig. 166
John Sloan, *The Show Case*, 1905, from the series "New York City Life," etching, 11.43 x 17.15 cm (4 ½ x 6 ¾ in.). Delaware Art Museum, Gift of Helen Farr Sloan

Madame Ryanne's corset shop, like Madame Malcomb's hairdressing salon, appears to have been one of Sloan's inventions. This pseudo-French name may be a humorous rendition of Margaret Ryan, whose corset establishment, according to city directories, was located in Sloan's neighborhood near Sixth Avenue, a few blocks from the art gallery depicted in Connoisseurs of Prints.

Fig. 167
John Sloan, *Connoisseurs of Prints*, 1905, from the series "New York City Life," etching, 11 x 17 cm (4 ½ x 6 ¾ in.). Delaware Art Museum, Gift of Helen Farr Sloan

Sloan later identified the setting of this image as "the Old American Art Galleries on 23rd Street."

166), a group of girls make a humorous comparison between a corset on display in a showcase and the statuesque, well-dressed woman walking by. The educated art lovers in *Connoisseurs of Prints* (fig. 167) exercise similar scrutiny and judgment—but rather more restrained behavior—as they compare works for sale at an auction-house gallery. Whose experience is more ennobling or artistic? As an artist who constantly placed his work before the public yet rarely made a sale, Sloan had mixed feelings about the art market and made disparaging comments about artists who achieved commercial success. His skepticism of market

Fig. 168
John Sloan, *Fun, One Cent*, 1905, from the series "New York City Life," etching, 12.5 x 17.6 cm (4 15/16 x 6 15/16 in.). National Museum of American Art, Smithsonian Institution, Gift of Ann Kraft

competition in all forms eventually led him to embrace the socialist ideals of cooperation promoted in *The Masses*. He had firsthand experience with the world of advertising both in his free-lance work as a commercial illustrator and in his role as publicity coordinator for the exhibition of The Eight. After spending weeks arranging for press releases and promotional pamphlets and courting journalists to review the exhibition, Sloan no doubt appreciated the wry comparison between art and advertising in a cartoon that Everett Shinn sent him. It depicted eight artists carrying paintings on enormous placards with the query "Dear Sloan—why not go up Fifth Avenue like this?" The images of shopping that eventually went on display in The Eight exhibition (including *The Shoppers*, *Hairdresser's Window*, and *Hester Street*) showed closely commerce, advertising, and the art world were intertwined.

COMMERCIAL LEISURE

In Sloan's etching *Fun, One Cent*, executed in 1905 (fig. 168), three young women stand in a penny arcade (figs. 169 and 170), about to put a penny in a slot, turn a crank, and glimpse "Those Naughty Chorus Girls." They are adolescents; the girls next to them are so young that they wear short skirts and stand on a stool to peer into the viewer. Their leader is a young woman who wears a long dark skirt cut to reveal a considerable glimpse of her ankle, a daring proposition in 1905.

The scene is deeply ambiguous. Are these young girls exercising naughty independence from their fathers and mothers? Or are they learning how to be the sexual playthings of men? Who, if anyone, is in charge—the girl leading them on, the man who runs the penny arcade, or the man who made the films? Whatever the ultimate meaning of the situation, two conclusions are possible. This

could happen only in a world where—for good or ill—women have opportunities to experiment with behavior outside the control of neighborhood and family. And because they live in a time when moral standards are in flux, there is no clear moral meaning to their actions (fig. 171).

It is all very much a part of turn-of-the-century New York when the city became the capital of a new business—the leisure industry. Gradual decreases in working hours, the loosening of Victorian restraints, and the need for recreation among people crowded into tenements and sweatshops fueled a growing demand for leisure. A generation of entrepreneurs, many of them immigrants, provided the public with vaudeville shows, professional sports, movies, and amusement parks.

The Ashcan artists, like alert journalists covering a breaking story, captured the birth of the new world of commercial leisure. Like other aspects of the making of the new city, it was a messy process. Older neighborhood forms of popular culture (fig. 172) gave way to a new national mass culture (figs. 173 and 174). People's free time was turned into a commodity, something to be "spent." Men and women left the nineteenth-century world of separate spheres and mingled in a realm of

leisure defined by intimacy, sensuality, and sexual exploitation. Immigrants used careers in popular entertainment to move from the margins into the mainstream.

Luks, Glackens, and Shinn focused special attention on vaudeville, where virtually all of these trends coalesced to shape the era's most popular form of theater. The world of saloon entertainers and street-corner hoofers spawned much of the talent on the vaudeville stage, and both are captured in Glackens's *A Headache in Every Glass* and Luks's *The Spielers*.

Fig. 169
Automatic Vaudeville (exterior), 1904. Museum of the City of New York, The Byron Collection, #18039

Fig. 170
Automatic Vaudeville (interior), 1904. Museum of the City of New York, The Byron Collection

The "Automatic Vaudeville" penny arcade offered naughtiness, such as "Peeping Jimmie" and "French High Kickers," at affordable prices.

Fig. 171
Cartoon from *The Big Stick* 3 (17 November 1911): 4

New forms of entertainment offered many new opportunities for transgression. In this cartoon from a Yiddish humor weekly, an old-fashioned wife tries to pull her husband (wearing the traditional attire of an Orthodox Jew) away from a kinetoscope machine, while he exclaims in fascination, "Oy-oy . . . Oy!"

Fig. 172
John Sloan, *Man Monkey*, 1905, from
the series "New York City Life," etch-
ing, 11.4 x 17.1 cm (4 ½ x 6 ¾ in.).
© 1994 Board of Trustees, National
Gallery of Art, Washington, D.C., Gift
of Mrs. Peter D'Albert

Fig. 173
George Luks, *Cake Walk*, 1907, mono-
type, 12.7 x 17.8 cm (5 x 7 in.). Dela-
ware Art Museum, Gift of Helen Farr
Sloan

of prostitution, and at first glance this one might be: men and women are seated together at tables, and from all appearances the men are being plied with drinks. But seated at a table facing the piano player is a family: mustachioed father in derby, plump and stolid mother in a bonnet, and a small girl in a ribboned hat.[40]

The presence of the family conveys to us that Glackens has noticed two things that many of the reformers missed: this ostensibly licentious concert saloon might be less immoral than it seems at first glance. Sometimes rough and respectable people mixed in the same settings. And among some ethnic groups, particularly Germans, the presence of men and women drinking in the same concert hall was not considered an invitation to immorality. In fact, German immigrants considered this recreation quite normal and respectable. Only among the native-born middle class was it treated as incipient moral disaster.

The founders of vaudeville transformed the concert saloon from a questionable hangout into an inclusive theater that attracted middle-class families. If *A Headache in Every Glass* looks at this setting on the eve of great changes, *The Spielers* (fig. 176) looks at the people whose talents would be shaped into vaudeville acts. The movements of the two girls dancing together are less than perfectly coordinated, but the grins on their faces are the focal point. They are the kind of people who were both the source and the consumers of the energy of vaudeville. The key to vaudeville was that its entrepreneurs took such talent off street corners and put it onstage. If the performers were good enough, they could wind up touring the entire country. Groucho Marx and George Burns are among the many entertainers who developed their wisecracking stage personalities as child performers on the streets of early twentieth-century New York.

Whether the performers in Luks's *The Amateurs* (fig. 177) will make it to the top of big-time vaudeville is not clear. What is obvious is that they take very seriously their opportunity at an amateur night, most likely

A Headache in Every Glass (fig. 175) refers to the cheap alcohol that was a staple of the concert saloon, where the picture is set. Onstage are two of the types of performers that would become vaudeville staples: the ethnic comic (in this case probably Irish, with his muttonchop whiskers) and the scantily clad (for the time) women in the chorus. The composition of the audience raises the morally ambiguous status of the concert saloon. Progressive Era reformers who investigated "commercialized vice" correctly called many of them dens

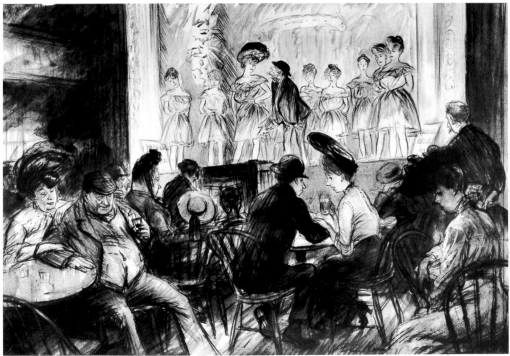

Fig. 174
John Sloan, *The Theater*, 1909, mono-
type, 19.1 x 22.8 cm (7 ½ x 9 in.).
© The Cleveland Museum of Art,
Gift of Mr. and Mrs. Ralph L. Wilson
in memory of Anna Elizabeth Wilson,
61.162

*Figs. 173 and 174 suggest some of the
excitement, and the range, of commer-
cial entertainment in New York. The
cakewalk was invented by slaves on
southern plantations and parodied in
blackface minstrel shows, but by the
late nineteenth century it was being
performed with great style by African-
American entertainers before mixed
audiences in vaudeville and eventu-
ally on film. Sloan's print suggests the
glamour of ornate theater interiors
and the elaborately dressed people
in the audience.*

Fig. 175
William Glackens, *A Headache in
Every Glass*, 1903–04, charcoal and
watercolor on paper, 33.66 x 49.53
cm (13 ¼ x 19 ½ in.). Terra Foundation
for the Arts, Daniel J. Terra Collection,
1992.170. Photograph © 1995, Cour-
tesy of Terra Museum of American
Art, Chicago. Published in James L.
Ford, "Our Melancholy Pastimes,"
Leslie's Monthly Magazine 57 (April
1904): 608

Fig. 176 (opposite)
George Luks, *The Spielers*, 1905, oil
on canvas, 92 x 66.7 cm (36 ⅛ x 26 ¼
in.). Addison Gallery of American Art,
Phillips Academy, Gift of anonymous
donor, 1931.9. © Addison Gallery of
American Art, Phillips Academy,
Andover, Massachusetts. All rights
reserved

*The term "spieler" sometimes referred
to a "tough girl" of "New York's worst
district . . . bent on amusing herself" by
dancing on the sidewalk—with or with-
out a partner—or in the city's seedier
dance halls. Luks's painting, however,
was extolled as an image of youthful
innocence, represented by "the little
tousled Irish girl with her red locks who
dances with the pretty flaxen-haired
German child, surely a baker's daughter
of Avenue B." Viewers imagined the
sound of an organ grinder in the back-
ground. Perhaps these exuberant chil-
dren were also performers making their
way into the city's entertainment busi-
ness by dancing on the street for money.*

Fig. 177
George Luks, *The Amateurs*, 1899, oil
on canvas, 61 x 45.7 cm (24 x 18 in.).
Private collection

*In contrast to the professional glitz that
Shinn's theater scenes evoke, Luks's
stiffly brushed painting captures the
awkwardness of two young people
facing the footlights in an attempt to
break into vaudeville at one of the
amateur nights staged weekly at the-
aters throughout the city. Success was
measured in cheers and a cash prize
from the management; failure brought
catcalls or the indignity of being yanked
offstage with the infamous "hook." A
critic described this painting apprecia-
tively in 1910: "a bright and snappy
sketch called 'The Amateurs'. . . will
appeal to any one who has seen the
'hook' wielded at the Friday soirees at
Miner's." Miner's Bowery Theater was
the launching pad for many a career,
including that of Eddie Cantor, who
made his debut there at an amateur
night in 1908.*

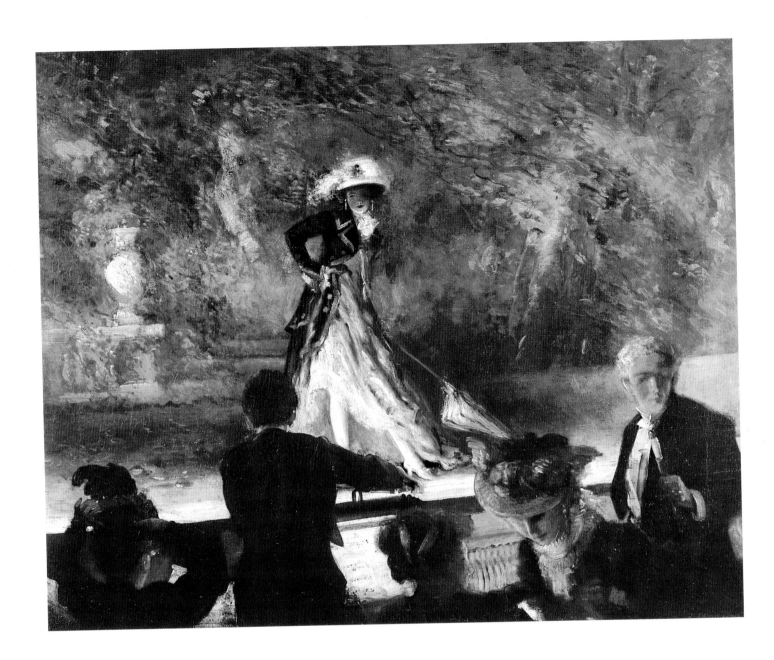

Fig. 178
Everett Shinn, *Footlight Flirtation*,
1912, oil on canvas, 75 x 92.7 cm (29 ½
x 36 ½ in.). Collection of Mr. Arthur G.
Altschul

held at their neighborhood vaudeville house. They are singers who have performed before appreciative friends, family, and mirrors but are now entering the world of show business. Their clothing is simple but formal. What distinguishes them is their body language: stiff and erect, with hands at sides and mouths open wide, they are the antithesis of *The Spielers*. The difference lies in the audience. *The Spielers* are performing for themselves and for the artist. The audience before *The Amateurs* is the gatekeeper to the world of vaudeville, a hierarchical and competitive entertainment industry that offers riches and fame to the successful few and the grind of underemployment to its less than stellar performers. The audience will destroy *The Amateurs* with boos if they fail to please, but will cheer them on toward stardom if they do well. This pressure weighs heavily on the two performers.

The Amateurs depicts the popular base of the vaudeville industry, whereas Shinn's *Footlight Flirtation* (fig. 178) explores a revealing moment in the life of one of its professionals. Critics in Shinn's day compared his pictures of entertainment to French paintings, but they differ from the work of Degas, Georges Seurat, and Henri de Toulouse-Lautrec in that his theater images take the viewer into the life of the actor by exploring the interplay between performers and their audience. Judging from the movement of the crowd in *Footlight Flirtation*, it is either the beginning or the end of the show—a difficult time for holding the attention of the audience, which is not fully settled into its seats. The woman onstage is trying to capture the attention of one spectator with a coquettish glance across the footlights. Like a good vaudevillian, she plays directly to her audience, reaching out to them to give the impression that the show is being performed just for them, collectively and individually.

The woman in *Footlight Flirtation* risks her reputation onstage, facing boos, rejection, and unhappiness if she fails to put across her act. The boxers painted by Bellows risk far more, and that is what gives his paintings of fight scenes such terrible power. Although the artist obviously found boxing compelling, his reactions to it in his paintings reveal a combination of respect for the fighters and ambivalence about boxing as a sport. The fans in *Stag at Sharkey's* (fig. 179) are part of the bout. Two fighters strain mightily against each other, one lunging forward to land a punch to the midsection while the other buckles from the blow and winds up to strike a blow of his own. Their faces are invisible; they are defined only by their powerful physical presence.

If the fighters were the only people in the painting, it would be a dehumanizing image: boxers reduced to bone and muscle in violent collision. But Bellows's attention to the faces in the audience makes the painting a far more humane exercise, an exploration of the range of reactions to the fight. In the foreground, a man with a cigar in his mouth looks back at us enthusiastically and gestures toward the ring. Across the ring, another man, with a cigar in his mouth, looks at the fight with an expression of skepticism and concern. Other men in the painting show enthusiasm, involvement, exhilaration—and a grotesque frenzy.

The sum of the fans' reactions to the fighters, and the portrayal of the fighters themselves, is an exercise in ambivalence. The boxers' physicality makes them palpably alive, but the emphasis on their bodies and the avoidance of their faces limit the fullness of Bellows's portrayal of their humanity. The wide range of reactions to the boxers at Sharkey's suggests that Bellows was of two minds about pugilism. As an artist, Bellows suggests that he is a fight fan with a bad conscience because he is acutely aware of two things that are disturbing about boxing: the violence that the fighters inflict upon each other and the blood lust that a fight generates in the audience. The difference between the violent mood of the crowd and the purposeful and disciplined violence of the boxers may explain Bellows's remark that he found the atmosphere at ringside "a lot more immoral than the fighters themselves."

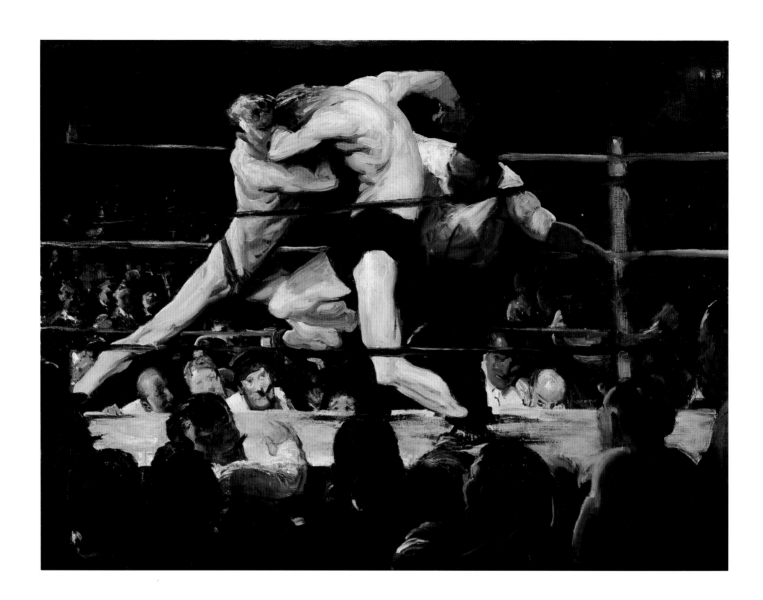

Fig. 179
George Bellows, *Stag at Sharkey's*,
1909, oil on canvas, 92 x 122.6 cm
(36 ¼ x 48 ¼ in.). © The Cleveland
Museum of Art, 1995, Hinman B.
Hurlbut Collection

Bellows began to frequent the "regular
Weekly Stag of the Sharkey Athletic
Club, Sixty-Fifth Street and Broadway"
at a time when public prizefighting was
still illegal in New York City. Visitors
bought a five-dollar monthly member-
ship pass, but the fights, which attracted
up to three thousand spectators, were
occasionally shut down by the police.
Bellows's painting conveys some of the
roar of the crowd and the illicit atmos-
phere at ringside.

Fig. 180
George Bellows, *Preliminaries to the Big Bout*, 1916, lithograph, 40 x 49.8 cm (15 ¾ x 19 ⅝ in.). © 1994 Board of Trustees, National Gallery of Art, Washington, D.C., Andrew W. Mellon Fund

Fig. 181
John Sloan, *Haymarket*, 1907, oil on
canvas, 66.7 x 81.6 cm (26 ¼ x 32 ⅛
in.). The Brooklyn Museum, New York,
Gift of Mrs. Harry Payne Whitney

Preliminaries to the Big Bout (fig. 180) shows the vast change that had taken place in professional boxing by 1916, illuminating both the entry of women into the audience and the growing gulf between the experience of the boxer and that of the spectator.[41] In the background, two boxers slug it out head to head. The entire strength of their bodies goes into every punch. The referee, bent at the waist, leans in to monitor the action. Does this impress the fans in the foreground? Apparently not. Men and women in formal dress, most conspicuous among them a jowly old gentleman, move toward their seats without a glance at the ring. This is, after all, a preliminary bout. The boxers are merely low-level gladiators, not big-money prizewinners whose earning capacity commands notice. The fighters will remember the match, but these fans will not.

According to the earlier middle-class ideal of women as agents of morality and purity, their presence in the audience should moderate the violence of the scene. But these women show neither shock nor interest nor compassion. Their social distance from the fighters anesthetizes them against the boxers' suffering.

Although German immigrants had enjoyed leisure activities in which men and women mixed freely without the stigma of vice, such encounters were frowned upon by most native-born, middle-class New Yorkers at the turn of the century (and by those from the working class who aspired to their standards of respectability). Sloan's *Haymarket*, painted in 1907 (fig. 181), captures the lingering aura of this world. Two fancily dressed women, most likely prostitutes, enter the Haymarket concert saloon unescorted. Their appearance elicits the stare of a young girl walking with her mother, who tries to distract the child's attention from such unsavory characters. The light from the Haymarket's open door draws us toward the interior of the hall. Though described by some as a palace of sin, the Haymarket imposed rules of decorum on its patrons, forbade overtly erotic dancing, and

thus managed to preserve a veneer of propriety that kept the institution open for many years. The entrepreneurs who created the new institutions of commercial leisure appropriated such tactics; they typically insisted on paying homage to middle-class standards of behavior, if only to slyly violate them.

The achievement of these entrepreneurs was to create places for unsupervised encounters between men and women that had no taint of vice. In *Movies, 5 Cents* (fig. 182), Sloan depicts an audience of men and women, alone and in pairs (including a black woman in the back row), who are watching a movie about a park-bench romance. The picture on the screen seems to be fraught with sexual possibilities, but the mood of the audience appears to be controlled and devoid of impropriety. The atmosphere suggests that the social mixing of men and women has been accomplished not by expanding old haunts of vice but by developing new standards of behavior that let them mix freely without supervision. Nevertheless, that accommodation did not happen easily. The informality of the audience in the painting—people talking to each other and coming and going throughout the performance—and the love scene on the screen would soon come in for censure. By 1909 the New York–based National Board of Review had imposed unofficial codes on movies, and uptown theaters required audiences to behave themselves more formally (fig. 183).

One of the first places where the sexes mingled was at the seaside resort. Glackens's early painting of Coney Island, ca. 1898 (fig. 184), presents an image of decorum that contrasts with the much more liberated behavior that prevailed after the turn of the century, as depicted in his own *Beach, Coney Island* (fig. 50), Sloan's *South Beach Bathers* (fig. 79), and Bellows's *Beach at Coney Island*. South Beach was an amusement park on Staten Island that attracted a primarily working-class clientele. The men and women in Sloan's painting enjoy a physical familiarity that the artist would not have expected from bathers

Fig. 182
John Sloan, *Movies, 5 Cents*, 1907,
oil on canvas, 59.7 x 80 cm (23 ½
x 31 ½ in.). Collection of Mr. and
Mrs. Herbert A. Goldstone

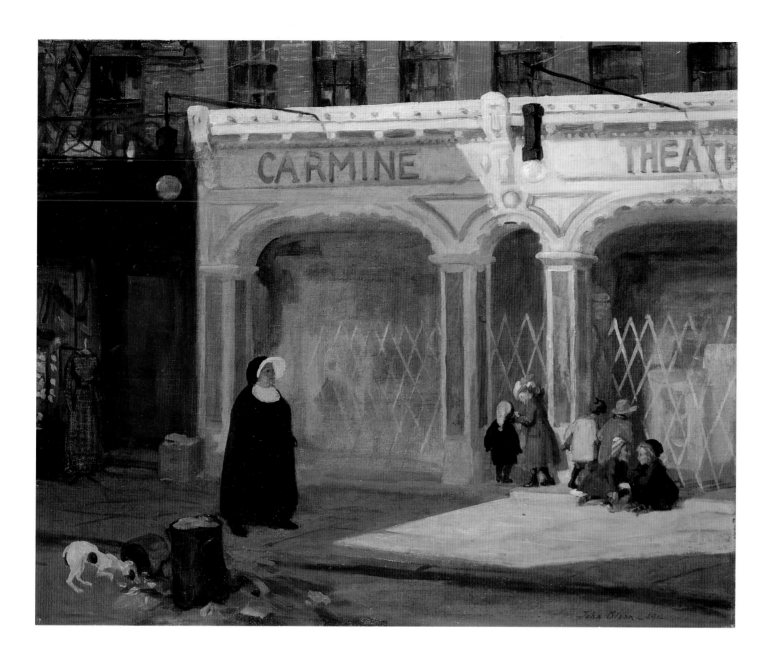

Fig. 183
John Sloan, *Carmine Theatre*, 1912, oil on canvas, 66.4 x 81.3 cm (26 ⅛ x 32 in.). Hirshhorn Museum and Sculpture Garden, Smithsonian Institution, Gift of Joseph H. Hirshhorn Foundation, 1966

Many early movie theaters were informal storefronts in neighborhoods where immigrant audiences who spoke little English could enjoy silent films. Sloan's painting shows children peering into a theater on Carmine Street in the Italian district. The nun walking past subtly reminds us of the concerns expressed at the time that movies would lull audiences into moral vice—at a time when unaccompanied children were not officially allowed in theaters.

Fig. 184
William Glackens, *Fruit Stand, Coney Island*, ca. 1898, oil on canvas, 64.8 x 80.6 cm (25 ½ x 31 ¾ in.). Kraushaar Galleries, New York

at a more proper resort. In the foreground, a man and two women, all clad in bathing suits, sprawl against each other. To their left, a woman adjusting her hat is eyed appreciatively from behind by men lounging on the sand. At the right, a mother adjusts a child's diapers in full view. In the background, a man and woman walk arm in arm toward the water's edge.

Bellows's *Beach at Coney Island* (fig. 185) shows both newer and older kinds of public behavior while once again using awkward body language and an edge of caricature to depict the working-class subjects. A bright blond palette suggests their exposure to the hot sun. The center of the painting is taken up by a group of children supervised by two adults, who seem to be settling a quarrel that has ended in tears. Behind them to the right,

in the distance, bathers leap exultantly in the breaking waves. To the left, people relax around a table in the shade of a canopy. In the corner are two sweethearts, oblivious to everyone and virtually ignored by all around them. He sits upright, braced by his right hand. His left arm encircles her as she sprawls across her lap on her back. The opportunity for such intimate conduct is created, ironically, by the crowd they are part of. Among strangers, none of whom is responsible for their behavior, they are free to do as they please. The fact that no one reproaches them is further evidence that by the turn of the century the moral code of New York was fragmenting, with no one standard deemed appropriate for all. They have achieved what only city dwellers know is possible: the pleasure of being alone in a crowd.

Fig. 185
George Bellows, *Beach at Coney Island*, 1908–10, oil on canvas, 106.7 x 152.4 cm (42 x 60 in.). Private collection

Fig. 186
John Sloan, *Movies*, 1913, oil on
canvas, 50.5 x 61 cm (19 ⅞ x 24 in.).
Toledo Museum of Art, Museum
Purchase Fund

MEN AND WOMEN

In Sloan's painting *Movies* (fig. 186), the illu-
minated storefront of a neighborhood thea-
ter tempts passersby with promises of an
evening's excitement. Acid colors convey
the glare of newly installed electric lights.
Posters advertise *A Romance of the Harem*,
a title recalling the exotic locales and lurid
stories that thrilled, delighted, and sometimes
shocked New York's varied audiences. But in
Movies the real romantic interest is on the
sidewalk in front of the theater. Various
groups respond with interest: a woman
marshals her husband; two girls look on in
wonder and restrain a younger child. At

the right, two single women and three men
enact a complicated flirtation: will the men
treat the women to the movie? What will
happen afterward? The scene is rich in
dramatic possibilities.

Turn-of-the-century entertainment made
sex part of its appeal, and the Ashcan artists
reflected this in their work. Sensuality onstage
inspired Henri's *Salome*, while the girls crank-
ing the mutoscope in Sloan's etching *Fun, One
Cent* indulged in cheaper thrills. The rapt audi-
ence in Sloan's *Movies, 5 Cents* watches the
scene of a couple kissing on a park bench, an
image that recalls actual movies like *Love by
the Light of the Moon* (Edison, 1901). Other

films made at the time dispensed with the park bench and simply filled the screen with long kisses—to the consternation of critics who decried the lack of artistic content and warned of the movies' damaging effect on the morals of adults and children.[42]

An anxious response to these shifting standards could be observed in frequent discussions of the scandalous independence of the "new woman" and in corresponding attempts to control licentious images. During these years the New York Society for the Suppression of Vice worked to censor literature it deemed indecent, to remove paintings of nudes from art exhibitions,[43] and to ban the distribution of information on "family limitation." With their support, the city enacted laws to bar unaccompanied children from theaters, and in 1909 established a board to review and regulate movies.

Single men, always plentiful in cities, were now joined by an unprecedented number of "bachelor girls" living independently and often supporting themselves (fig. 187). Every age and social group had its liberated women: upper-class matrons asserted a new independence in social affairs, while educated young women moved to New York in search of freedom to study, to become artists, or to pursue altruistic careers in social work. In the bohemian enclave of Greenwich Village, married women now kept their maiden names, and free love and unconventional living arrangements became the norm. Many more newcomers joined the ranks of the growing pink-collar clerical and sales forces. Farther down the economic ladder, women worked as waitresses, laundresses, servants, and scrubwomen. Women's labor formed the mainstay of New York's garment industry, and working women were the principal market for the low-cost, ready-to-wear fashions available for the first time. For the daughters of immigrants, the weekly paychecks offered a small measure of independence and access to a consumer culture that their mothers had never imagined.

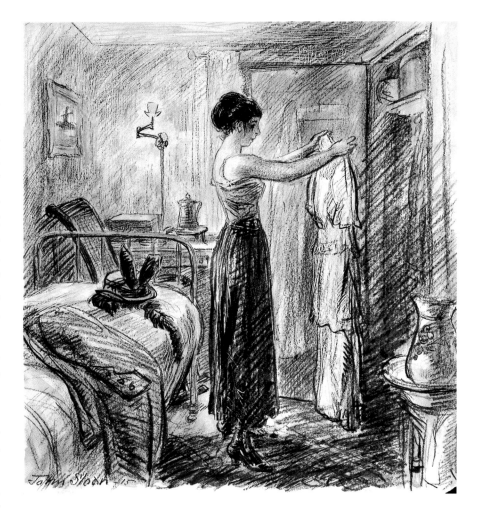

Political activists argued that unequal wages and working conditions ensured not freedom but real hardship for many working women. The feminist Rheta Childe Dorr's popular treatise *What Eight Million Women Want* cited statistics to demonstrate that women were delaying marriage and childbearing and linked an increase in the divorce rate to the fact that more women were working and achieving financial independence. The book concluded with a plea for female activism and referred to the public spectacle of massive suffrage parades in New York.[44]

The ferment accompanying these changes was a difficult subject, and not all of the Ashcan artists addressed it directly. Luks, for example, was known among friends for his ribald humor, but most of his figure painting was limited to depictions of children and elderly people. Of the six artists, Sloan and Bellows, who tended to seek more socially

Fig. 187
John Sloan, *Bachelor Girl*, 1915, charcoal and wash, 33.7 x 32.8 cm (13 ¼ x 13 in.). The Art Institute of Chicago, Olivia Shaler Swan Memorial Fund, 1941.826, photograph © 1994, The Art Institute of Chicago. All rights reserved. Published in *The Masses* 6 (February 1915): 7

Since the 1890s reformers had called attention to the inadequately paid single woman living alone in a meagerly furnished "hall room." To the radicals of The Masses, *her plight characterized the exploitation of working women. Sloan's drawing humanizes this topical subject.*

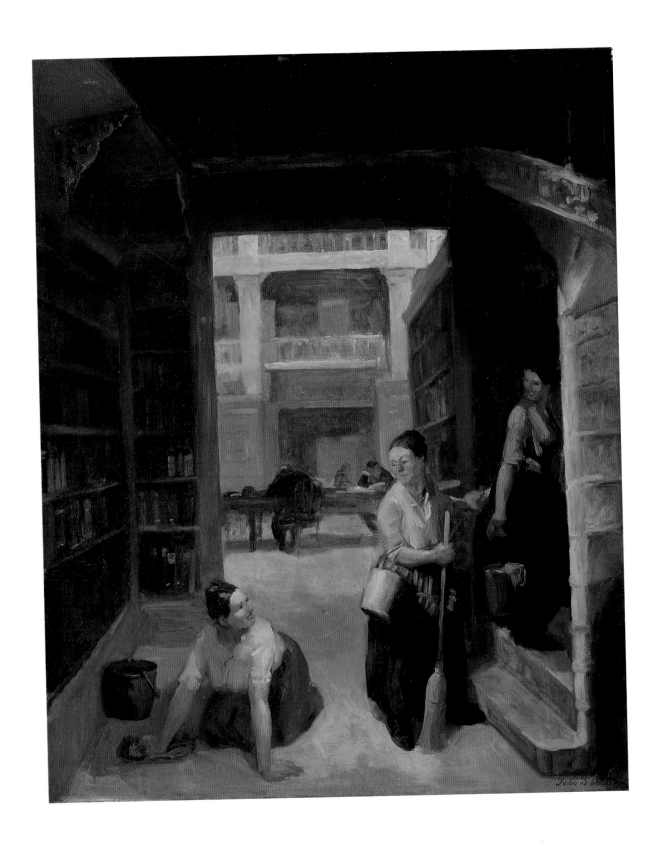

Fig. 193
John Sloan, *Scrubwomen, Astor
Library*, 1910–11, oil on canvas, 81.3
x 66 cm (32 x 26 ¼ in.). Munson-
Williams-Proctor Institute, Museum
of Art, Utica, New York

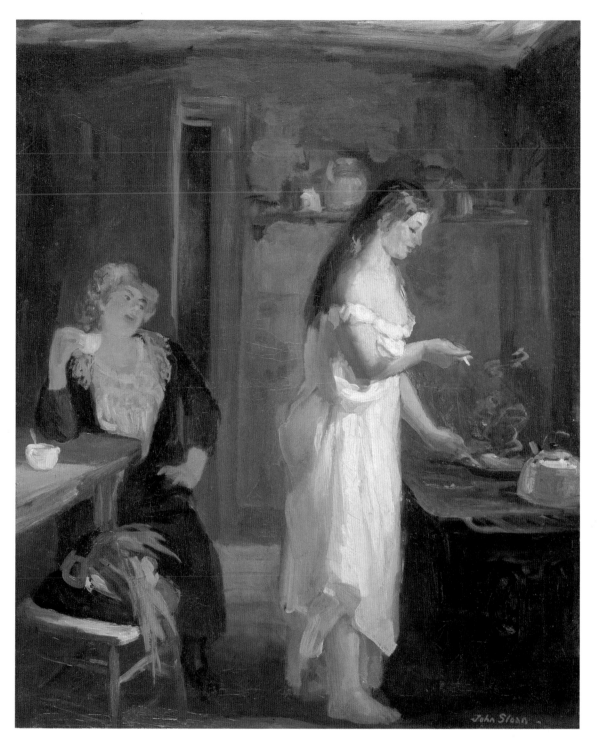

Fig. 194
John Sloan, *Three A.M.*, 1909, oil on
canvas, 81.3 x 66.7 cm (32 x 26 ¼ in.).
Philadelphia Museum of Art, Given
by Mrs. Cyrus McCormick

*Sloan based this painting on a household
he observed through his studio window
while working late at night. Whether or
not he intended these women to be prosti-
tutes has engendered a scholarly debate
that the early criticism does little to eluci-
date. Although the painting was rejected
for a National Academy of Design exhi-
bition, at least one critic found that this
"picture with its common city subject, the
kind of thing one can see from one's back
window of a Winter night if one lives in
any of the more bohemian quarters of
the town, possessed merit of a peculiarly
classic sort." Others were unimpressed
with the artist's propensity for "character-
istic bits of the underworld, and even of
the lower class of women in that world."*

Fig. 199
George Bellows, *Business Men's Class*, 1913, monotype with ink, crayon, graphite, and collage, 41.9 x 65.4 cm (16 ½ x 25 ¾ in.). Courtesy of the Boston Public Library, Print Department, Gift of Albert H. Wiggin. Published in *The Masses* 4 (April 1913): 10–11

sap life of all its vitality, writer Jack London offered a vision of authentic masculinity expressed in a struggle against the elements, animals, and other human beings. London was a socialist, but Theodore Roosevelt, a Republican, also concluded that modern civilization would deplete men unless they deliberately embraced a strenuous life. The cult of the fit male body also made celebrities of professional boxers and helped the career of Sandow (Eugene Sandow), a former wrestler who displayed his muscular build on stage and screen. Bellows mocked these concerns in *Business Men's Class* (fig. 199), in which flabby athletes attempt to rescue the race via calisthenics at the local YMCA. Working-class men were seen as more vital, which may explain the appeal of Shinn's pastel drawings of men watching a cockfight and toughs brawling on a New York City dock (figs. 200 and 201), included in the same gallery exhibitions as his stage scenes, and Bellows's fight scenes.

The image of an all-male world that Bellows created in *The Knock-Out* (fig. 202) was brought to new heights of violence in *Stag at Sharkey's*, in which the audience was transformed into a mass of howling grotesques. The brushwork creates a titanic collision of smears

of blood-red paint. Sloan's *McSorley's Back Room* (fig. 203) presents an alternative masculinity in the hushed, all-male world of a tavern that banned women until the 1970s. Sloan effectively conveyed his impression of McSorley's as "a place where the world seems shut out—where there is no time, no turmoil."[50]

Yet for all their disturbing noise and brutality, Bellows's boxing images also convey an exciting, even erotic appeal. Jack London evoked similar sensations in his novel *The Game*, whose heroine, a boxer's fiancée, is appalled by "that brutal surging and straining of bodies, those fierce clutches, fiercer blows, and terrible hurts," yet stares in fascination and "shame at [the] sight of the beautiful nakedness of her lover."[51] Perhaps these conflicting emotions explain the public response to Bellows's paintings: horror, disapproval, and endorsement, if only for the undeniable brilliance of the artist's technique. Sloan's paintings of McSorley's failed to sell, but despite some criticism, all of Bellows's boxing pictures were exhibited and reproduced widely, and most found buyers. Odder yet was the language used by art critics to praise not just the image and the brushwork but Bellows himself as a paragon of virility: "Take any of the Parisian chaps, beginning with Henri Matisse,

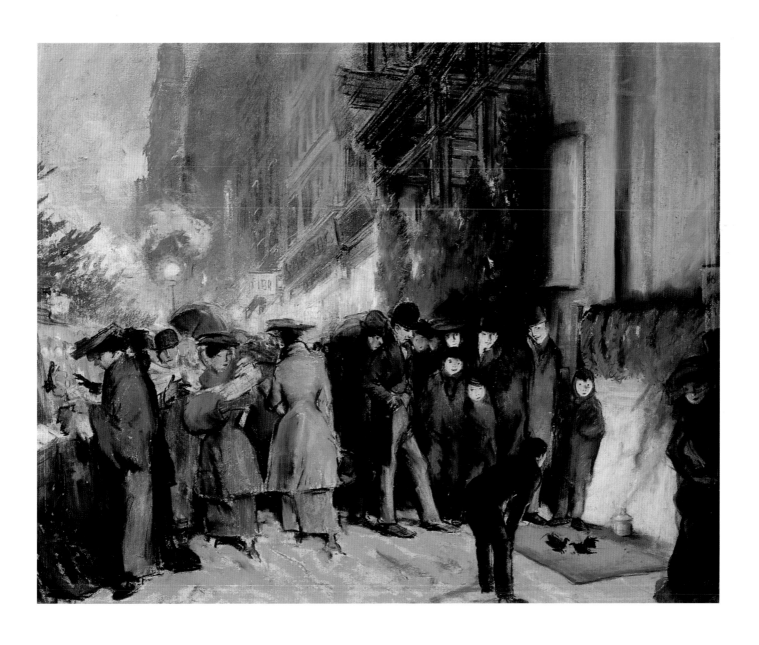

Fig. 200
Everett Shinn, *Sixth Avenue Shoppers*, undated, pastel and watercolor on board, 53.3 x 67.3 cm (21 x 26 ½ in.). Santa Barbara Museum of Art, Gift of Mrs. Sterling Morton for the Preston Morton Collection

Shinn's drawing exemplifies the differing interests of men and women, even in a time of more fluid gender roles. On a sidewalk in the shopping district, he separates women clustered around the stalls at left from the group of men who gather to watch a cockfight at the right.

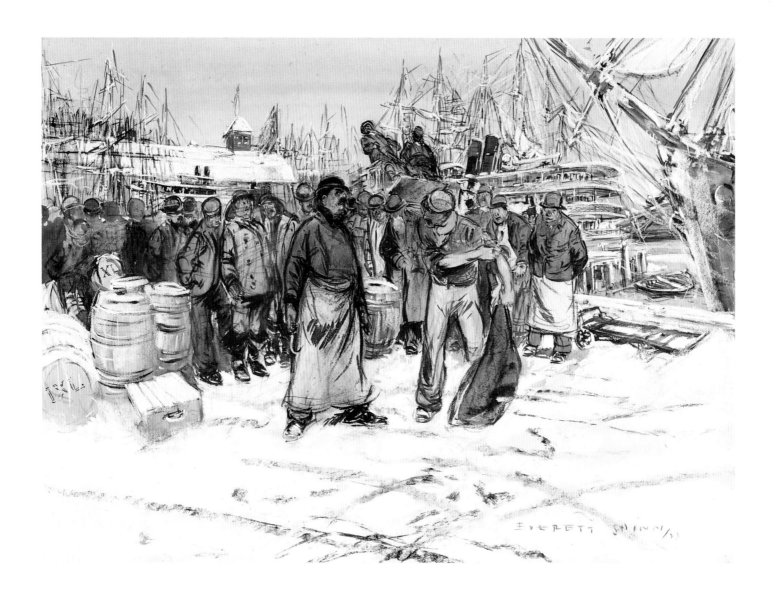

Fig. 201
Everett Shinn, *Spoiling for a Fight,
New York Docks*, 1899, pastel and
watercolor on board, 55.9 x 74.9 cm
(22 x 29 ½ in.). Milwaukee Art Muse-
um, Gift of Mr. and Mrs. Donald B.
Abert and Mrs. Barbara Abert Tooman

*The docks and surrounding saloons and
boardinghouses were frequently de-
scribed as an all-male world marked by
fights over who would get work and of
attacks on strikebreakers by stevedores
and longshoremen. Certain New York-
ers also recognized the waterfront as a
place frequented by men in search of
"rough trade" in male sexual partners.*

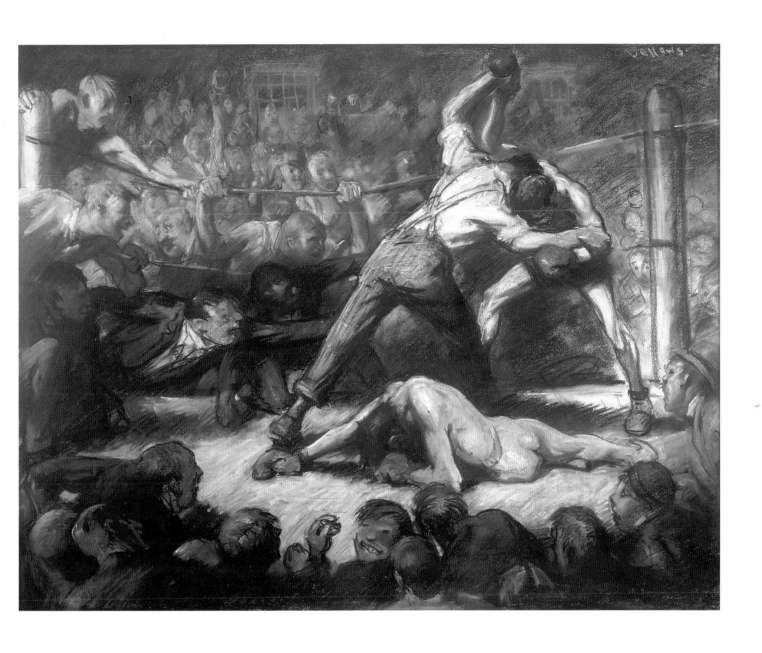

Fig. 202
George Bellows, *The Knock-Out*, ca. 1907, pastel and india ink on paper, 53 x 70 cm (21 x 27 ½ in.). Collection of Rita and Daniel Fraad

The strain of the battling fighters' bodies and the mood of the jeering crowd in Bellows's boxing scenes create a sense of violence missing from other depictions of prizefighting at that time, including the stiffly staged fights recorded on film and even the illustrations for Jack London stories. The Knock-Out *was one of the drawings removed from an exhibition of contemporary art held in 1911 at the public library in Bellows's hometown of Columbus, Ohio.*

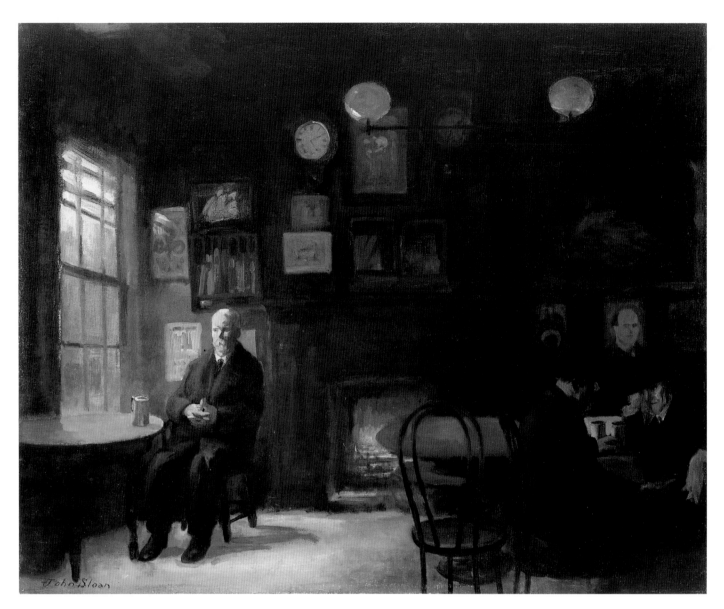

Fig. 203
John Sloan, *McSorley's Back Room*,
1912, oil on canvas, 66.04 x 81.28 cm
(26 x 32 in.). Hood Museum of Art,
Dartmouth College, Hanover, New
Hampshire, Purchased through the
Julia L. Whittier Fund

*Sloan's painting conveys some of the
dignity and reverence for tradition that
he admired in this tavern on East Sev-
enth Street, founded by John McSorley
in 1854 and still in business today. By
the time Sloan painted this work, certain
fixtures had long been in place: the idio-
syncratic collection of clocks, portraits,
and other artifacts behind the bar; the
loyal clientele of "quiet working men
who sip their ale and look as if they are
philosophizing"; the family recipe for
ale (John McSorley frowned upon hard
liquor); the familiar brood of cats; and
the absence of women, a prohibition
that remained in place for many years.*

who make a specialty of movements—well, their work is ladylike in comparison with the red blood of Bellows." Doezema notes that Bellows's supporters described him as the great white hope who would reinvigorate American art. With Bellows's example in mind, Henri told an Ohio audience in 1911 that "painting is a good deal like prize fighting."[52]

The open sensuality offered in commercial amusement caused anxiety to feminists like Dorr. Discussing the dangers of dance halls in *What Eight Million Women Want*, she acknowledged a "universal" and "innocent" human need to dance, as implied in images like Luks's *The Spielers*. (Similar ideas were expressed by Isadora Duncan in these years.) But Dorr feared the dangers young women were exposed to when they dressed up in unsuitable finery to frequent unchaperoned dance halls: liquor, bad company, and the unwanted attentions of men. In one anecdote Dorr recounts, a young woman's "natural" enjoyment of a commercial dance hall proves the first step down the slippery slope toward prostitution—a fear reflected in Sloan's *Haymarket*, in which a mother tries to shield her daughter from that way of life. Dorr's Progressive Era solution to the problem was to propose municipally supervised dances for young people.[53]

The discussion of prostitution during the Progressive Era was characterized by arguments that the problem was less a matter of personal sin than of societal forces requiring systemic legislation. But reformers' analyses did little to abate the intensity of public hysteria over the "white slave trade," manifest in the establishment of several government investigatory commissions and the popularity of the subject in film and the press. In New York the Chamber of Commerce commissioned an investigation into "the social evil" in 1900, and efforts to survey and control prostitution continued to occupy the Committee of Fourteen and other reform groups throughout the first two decades of the century.[54]

In part, the early twentieth-century campaigns against prostitution were responses to a system that, as middlemen became more involved, was taking on characteristics of the same organized economic and political corruption that progressives sought to eliminate from government. Part of the new fear of prostitution revealed a concern with the unboundedness and unpredictability that characterized much sexual behavior at this time. Movies, including *The Traffic in Souls* (1913), showed innocent women abducted on the street and forced into brothels. The titles of some of Sloan's pictures identify prostitutes with particular locales (*Sixth Avenue and Thirtieth Street*; *Chinese Restaurant*), but such activity could not be isolated geographically; the fear was that prostitutes could no longer be differentiated from respectable people. Peiss has documented some of the absurd efforts of vice squads to identify loose women (including a stakeout in a Chinese restaurant) and their frustration that good girls could no longer be distinguished from bad.[55]

In Sloan's paintings it is sometimes difficult to tell whether the women who assert such a strong sensual presence are meant to be seen as prostitutes. The powerful figures in *Three A.M.* continue to confound modern scholars, who debate whether the title and the plumed hat conspicuously displayed on a chair in the foreground were intended as hidden clues to the women's profession. Or could these two people sharing a meal and conversation in the warm glow of their kitchen simply be, as critics at the time assumed, "bohemians" or "sisters," perhaps waitresses or actresses, who have returned from work late at night?[56] Sloan's painting deliberately obscures the issue by refusing to convey any hint of depravity. The story is a bit more obvious in *Sixth Avenue and Thirtieth Street* (fig. 45), whose title refers to a well-known red-light district. Here a woman who appears to be a madam or a streetwalker stands haughty and erect, the focus of attention of all on the sidewalk. She is pulling on a glove, and the

gesture creates an enigma: are we—and the people in the illustration—really witnesses to a prostitute adjusting her garments after an assignation? If so, what does the artist want us to make of this? Ashcan images present prostitutes as human beings who work hard for their money. John Reed's story "A Daughter of the Revolution" presented its prostitute heroine as a liberated woman who makes independent choices.[57]

Although in some ways Ashcan images made behavior others considered troubling seem appealing, they still maintained the power to provoke censorship. Sloan and Henri were accustomed to seeing their work rejected for exhibitions (the fate of Henri's *Salome* at the National Academy of Design was neither the first nor the last case). The most dramatic example of their art's provoking moral disapproval occurred at a 1911 exhibition of 135 works by "New York Independents" held at the public library in Columbus, Ohio. Details of the incident remain murky, but apparently after the exhibition was hung, a number of pictures, including Bellows's drawing *The Knock-Out*, four etchings by Sloan, and nudes by Rockwell Kent and Arthur B. Davies, were placed in a separate room accessible only to adults (or possibly men). According to an outraged article that Henri's ally Guy Pène du Bois published in the *New York American*, the chief librarian, in consultation with the supervisor of art in the Columbus public schools, removed the pictures to a "room of immorality." Sloan and Henri responded indignantly to news of the dispute, and Henri threatened to cancel a lecture in Columbus unless several works were restored to the exhibition. Since both prizefighting and movies showing prizefighting were illegal in Ohio at that time, the images were apparently considered to be as dangerous as the sport itself. Local papers were less explicit about the details of the incident but yield other clues. The censors' response to the art exhibition seems to have been part of larger concerns in the community over regulating sex, violence,

and challenges to authority in general. That same month municipal officials in Columbus banned Emma Goldman from speaking at a labor rally because she was "not a proper person," and charged a "negro doctor" with "performing an unlawful operation"; the Ohio papers also reported a "Bill for Women's Votes" in Arkansas. Meanwhile, in Pennsylvania regulators blocked the performance of a play in Philadelphia and ordered the nude statues designed for the State Capitol to be covered with plaster drapery.[58]

Although the Ashcan School offered fresh perspectives on the changing relations between men and women in New York City, the fact remains that this subject was viewed through the eyes of men. A number of female artists—most of them younger, some of them Henri's students—treated New York's street life in these years, but they were regarded as anomalies and had little lasting success.[59] Very few maintained a commitment to serious careers or produced mature, complex, and forceful images comparable to the work of the older men, nor were they able to attract sustained critical attention.

The dynamics of the original Ashcan group, and the ethos of their vision, made it difficult for women to be members of this club. The artists' personal lives provide instructive examples. Although most of the wives were known as active, articulate women, five of whom had been art students, they either gave up ambitions for a career in art when they married (as did Emma Bellows, Edith Glackens, and Henri's first wife, Linda) or limited their activity to the less prestigious professions of cartooning and illustration of specialized subjects considered feminine. In their early years together Florence Scovel Shinn enjoyed a greater reputation than her husband, Everett, and supported him financially, yet her popular drawings of children never garnered the fame that he eventually achieved as a fine artist. Marjorie Organ was already well known as the sole female cartoonist on the *New York Journal* when she met

Robert Henri in 1908, and she continued to work after their marriage; Edith Glackens's "amateur" efforts included eight drawings that were exhibited in the Armory Show,[60] and she marched with the contingent of professional women artists in the great suffrage parade of 1913. Yet both posed for portraits by their husbands that confirmed existing conventions for women and art: Edith Glackens with her children, Marjorie Henri in an evening gown.

Those women who did achieve fame as fine artists in the early twentieth century worked in genres more conventional than the Ashcan School's. Cecilia Beaux and the photographer Gertrude Kasebier commanded high prices as society portraitists; Gertrude Vanderbilt Whitney won several commissions for grand allegorical sculpture; Alice Beach Winter and Bessie Potter Vonnoh specialized in images of children. A younger group of modernist artists, including Georgia O'Keeffe and Marguerite Thompson Zorach, attracted interest in their lyrical nature abstractions. Another generation would have to pass before Isabel Bishop, Alice Neel, the photographers Berenice Abbott and Helen Levitt, and a host of female printmakers associated with the Works Progress Administration (WPA) would fulfill the promise of the female urban artist and present the experience of exploring New York's streets from a woman's point of view.[61]

The Ashcan artists left an important record of the challenges and benefits of life in a city of strangers. Their art celebrated the city, observes Roy Rosenzweig, "as a place in which people of different backgrounds, interests, predilections can mingle in mutual tolerance if not necessarily mutual comprehension."[62] The pictures they made form a collective portrait of the city as a complex mosaic of different spaces, communities, and subcultures, a liberating place where individuals could create new identities and communities for themselves.[63] Their art distills for viewers the process of living in changing times, the moments of accommodation to the modernizing trends that made city life rich and perplexing.

These pictures are filled with details and incident: light on a tenement wall at the end of a day, the energetic choreography of children playing in a park, the confident gestures of single women enjoying a night on the town. But for all their insights, the pictures also show us that there are things we cannot see: the inner thoughts of people on the street. They present a city of infinite stories whose endings we will never know. Ninety years later the stories still engage us.

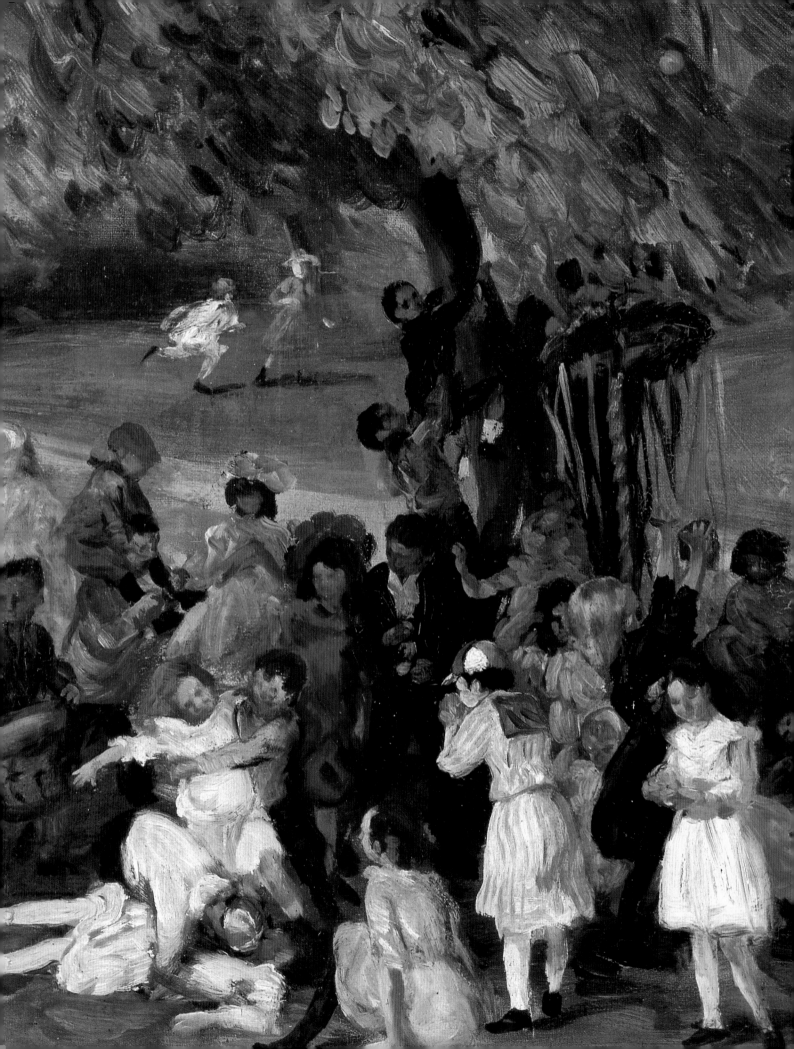

VIRGINIA M. MECKLENBURG

MANUFACTURING REBELLION
THE ASHCAN ARTISTS AND THE PRESS

Almost a century has passed since the Ashcan artists first began to exhibit in New York. Since then we have come to understand The Eight exhibition at Macbeth Galleries in 1908, which featured the work of five of the six artists considered here, as a moment of artistic revolution. The terms "radical" and "revolutionary black gang" have become catchwords to support the belief that the artists' subject matter—the street life and people of New York—marked a break with the values that characterized American art during the late nineteenth century. In *Art and Life in America*, a 1949 survey of the history of art in the United States, Oliver Larkin wrote:

What shocked the world of art was a preoccupation with types, localities, and incidents to which Americans were conveniently deaf and blind. A degree of strenuousness could be forgiven in the days of Teddy Roosevelt; but to paint drunks and slatterns, pushcart peddlers and coal mines, bedrooms and barrooms was somehow to be classed among the socialists, anarchists, and other disturbers of the prosperous equilibrium.[1]

Despite Larkin's conviction that the art world was shocked by the images of "drunks and slatterns" and "pushcart peddlers"—a belief that has prevailed for more than fifty years—Everett Shinn sold fourteen works from his show of New York street scenes at Boussod, Valadon Gallery in 1900 and received remarkably good reviews from no fewer than twelve New York newspapers.[2]

If the Ashcan artists' work was revolutionary, it was so only in terms of the art world. They approached their work according to traditional ways of handling paint and composing scenes, but used their skills to depict subjects that were intimately entwined with contemporary popular culture. Certainly they had a more conflicted understanding of who the public was than did their nineteenth-century predecessors. Except for Henri, they were both illustrators and painters, whose early work for daily newspapers and national magazines had taught them to appeal to the broadest range of the American public. Although they actively sought to participate in the annual exhibitions of the National Academy of Design and the Society of American Artists—New York's two major art organizations—they constructed a body of work that spoke to general audiences rather than solely to the collectors and art lovers who frequented those shows. Since their subjects dovetailed closely with the issues being addressed by writers for popular magazines, sociologists, and reformers, their themes were familiar territory to vast numbers of Americans.

A reading of the reviews of the Ashcan artists' exhibitions during the first decade of the century makes it clear that perceptions of their work underwent considerable revision. In 1900 Shinn's New York street scenes received widespread positive attention. In 1907, a year before The Eight exhibition opened, the work of these artists was

William Glackens, *May Day, Central Park* (detail), ca. 1905, oil on canvas, 63.8 x 76.8 cm (25 ⅛ x 30 ¼ in.). The Fine Arts Museums of San Francisco, Gift of the Charles E. Merrill Trust with matching funds from The de Young Museum Society, 70.11 (see fig. 154)

repeatedly presented as conflicting with the intellectual and aesthetic values of the last quarter of the nineteenth century. By 1910, however, they were perceived as key players in the Progressive Era's effort to redefine social and moral values in ways that could accommodate early-twentieth-century life. The story of how this transformation took place and how the terms used to describe their work evolved reveals as much about the changing values of the society at large as it does about the artists themselves.

In 1907 Robert Henri resigned in protest from the jury for the 82nd annual exhibition of the National Academy of Design because paintings by several of his friends had been rejected. The spokesman for a group of young men struggling to make their way in an unfriendly art world, he was universally viewed as an artistic rebel. The incident was widely reported in the press, and the academy was portrayed as a bastion of cultural and artistic obsolescence, where artists who had a stake in limiting change fought off challengers to the artistic mainstream. Ironically, Henri was not the first to resign from such a jury. As Kenyon Cox, one of the National Academy's more conservative members, noted, J. Alden Weir and Ben Foster had resigned in previous years. The difference, however, was Henri's willingness, even eagerness, to take his case to the press.

That a heated debate was always newsworthy was lost on neither Henri nor the reviewers who carried the story of his dispute with the academy to their New York readers. As Elizabeth Milroy has pointed out, the Ashcan artists, especially Henri, understood and used the power of the press.[3] Whether premeditated or circumstantial, the publicity campaign was highly successful. The Eight exhibition in New York the following year was thronged with people. The attention it received during its tour to Philadelphia, Chicago, Toledo, Detroit, Indianapolis, Cincinnati, Pittsburgh, Bridgeport, and Newark testifies to the effectiveness of a press campaign that had begun several years earlier.

At the outset of their New York careers, the Ashcan artists were viewed as young practitioners of older art forms. Marianne Doezema's studies of Bellows, the exhibition catalogues *American Impressionism and Realism: The Painting of Modern Life, 1885–1915*; *Painters of a New Century: The Eight & American Art*; and *The Paintings of George Bellows*, and other recent publications have discussed the stylistic similarities between the work of the Ashcan painters and that of the American impressionists and Munich school painters.[4] The Ashcan artists' contemporaries also recognized their sympathy for earlier art. Henri's preference for the techniques of Manet, Hals, and Velázquez was repeatedly noted in the press, and the parallels between Sloan's prints and those of Hogarth, Daumier, and George Cruikshank placed him squarely within the traditions of art. Shinn shared two shows with prominent impressionist William Merritt Chase. Occasionally critics quibbled with the way Henri handled paint or mentioned the messiness of Shinn's pastels. But they also praised the work for its fresh insights, strength, and virility—popular and loaded words used by turn-of-the-century reviewers to describe the new work in positive and distinctly "American" terms. The fact that Sloan painted shop girls, Henri depicted lower-class "types," Luks chose the streets and people of immigrant neighborhoods, and Shinn preferred derelicts, tenements, and vaudeville stages was always noted by reviewers. Yet they seldom reproached the artists for depicting inappropriate subjects. Instead, critics generally commented on compositional concerns and paint handling and identified the artists as well-known illustrators.

But competition among New York newspapers was lively, so critics sought the newsworthy. The annual exhibitions of the National Academy of Design and the Society of American Artists seemed increasingly repetitive. Huge exhibitions featuring work by members, they also included paintings and sculpture submitted by nonmembers, using a jury sys-

tem to make selections from the hundreds of entries. As a result, many of the same artists were featured year after year. (Facing the same problem, the Pennsylvania Academy of the Fine Arts in Philadelphia solicited works by Whistler, Winslow Homer, and other prominent painters to spice up its shows, get better press coverage, and attract visitors.) Astute newspaper critics quickly recognized that descriptive prose week after week promised little excitement for readers, so they created conflicts, exaggerated situations, and embellished details to add drama to their stories. An art-world revolution was certain to stir up debate, and given Henri's outspoken views on democracy in art, Luks's boisterous and colorful personality, and the public's familiarity with the illustrations of Shinn, Glackens, and Sloan, the Ashcan artists offered real possibilities.

It was not surprising, given their prior careers as newspaper sketch artists and illustrators, that they had supportive friends among the critics. Mary Fanton Roberts, editor and columnist at *The Craftsman*, and her husband were friends of the Sloans, Henris, and Glackenses and frequent guests at their apartments. Under Roberts's leadership, *The Craftsman* published articles on almost all the Ashcan artists and took an editorial stance that closely resembled Henri's own writings. Henri Pène du Bois, critic for the *New York American*, was the father of the group's young friend Guy Pène du Bois, who also wrote for the paper after his father's death. The Ashcan artists enjoyed support from critics for many of the city's daily newspapers, including Charles de Kay of the *New York Times* and later the *New York Post* and critics for the *New York Mail and Express*, the *New York Press*, and the *New York World*.

The idea that their art was revolutionary seems to have been at least partly the creation of a group of friends who wrote for the *New York Sun* and *Evening Sun* and most consistently supported the group. Charles FitzGerald, art critic for the *New York Evening Sun*, was William Glackens's brother-in-law and a regular at the group's gatherings at Mouquin's, the Café Francis, and other night spots. After emigrating from Ireland in the late 1890s, FitzGerald had lived in Boston, where he knew and greatly admired Maurice Prendergast, one of the Ashcan group's close friends and a participant in The Eight exhibition. In 1901 he went to work for William J. Laffan at the *New York Sun* newspapers. Laffan, who had begun his own career as an art critic, was a collector and a trustee of the Metropolitan Museum of Art. By the late 1890s Laffan had recognized the appeal of lively arts coverage for his middle- and upper-class readers and insisted on employing knowledgeable critics rather than general-assignment reporters. At the turn of the century the *Sun* company devoted more space than any other paper to covering New York's active art, music, theater, and literary scene.[5]

FitzGerald was an outspoken man with a feisty writing style, an eye for new talent, and an abiding disrespect for the conventional. He had little sympathy for the National Academy of Design and the Society of American Artists and consistently attacked their annual exhibitions. Although he expressed "general sympathy" for the society because it had originated as a protest movement with a "healthy disgust of officialdom and trades-unionism in art," by 1902 he was writing that the society was no longer a progressive force in American art. After its promising early years, he said, "the Society began to follow meekly in the footsteps of the decrepit Academy, and every year its exhibitions grew more and more like the Academy's." The 1902 exhibition, he concluded, was "a great acknowledgement of failure, a frank confession of incompetence."[6]

Frederick James Gregg, another young writer for the *Evening Sun*, also became friendly with the Ashcan artists just after the turn of the century. Another Irishman, Gregg had gone to school with the group's friend John Butler Yeats (this friendship is celebrated in Sloan's painting *Yeats at Petitpas'*). Gregg

Both Gregg and FitzGerald articulated a philosophy of contemporaneity in their writings. (Since articles were unsigned, it is difficult to pinpoint who wrote which reviews, although Charles FitzGerald kept a scrapbook of clippings that presumably includes his own writings.) Philosophically progressive, they believed that art should be responsive to the issues of modern life and employed the language of progressivism—words such as aggressiveness, masculinity, and vitality—that denoted new approaches to social and political issues as well as art. Gregg and FitzGerald also consistently identified the Ashcan artists as illustrators, alerting readers that they were already familiar with the artists' magazine and newspaper work.

American illustration was undergoing dramatic changes, and to be progressive in that field meant employing a realistic rather than a sentimental or melodramatic approach. By linking the realism of the Ashcan artists' paintings with the field of illustration, Gregg and FitzGerald argued that they were radicals.

EARLY REVIEWS

When Shinn moved to New York in 1897, he joined Glackens and Luks in the art department of the *New York World*, a crusading paper for which Theodore Dreiser also worked. Shinn's illustrations for *Ainslee's Magazine*, *The Critic*, and *Harper's Weekly* also brought him increasing notice, and in 1900 a solo exhibition of his pastels opened at Boussod, Valadon Gallery. Already friendly with theater personalities, Shinn included in the show portraits of popular actress Julia Marlowe costumed as Viola in Shakespeare's *Twelfth Night* and as the star of *Barbara Frietchie*, in addition to a portrait of director Clyde Fitch in his study (fig. 204), which were guaranteed to attract the public's attention.[7] The works of greatest interest to the press, however, were thirty-one New York street scenes ranging from impressionistic, snowy landscapes to depictions of the less attractive aspects of tenement neighborhoods. *Broadway and Twenty-*

joined the *Evening Sun* in the late 1890s as an editorial writer and several years later turned his talents to art criticism. A man of catholic tastes who supported impressionism as well as the Ashcan artists and the Stieglitz circle, Gregg was a great admirer of George Luks and bought many of Sloan's etchings. Better known now as publicist for the Armory Show, Gregg was also a frequent participant in the artists' evenings at local night spots. He wrote in opposition to the academy and, along with FitzGerald, worked to "market" the Ashcan artists as radical figures on the New York art scene.

third Street, Madison Square, The Docks, and other images featured, in the words of the *New York Commercial Advertiser*, "shoppers, workmen or the usual city idlers."[8] The *New York Evening Post* critic wrote that Shinn's

themes are chiefly found in the streets and places of amusement of this city and are put down on paper with a spirited and personal style quite refreshing. With a grim humor akin to that of Daumier, he tells the tale of toil along the river front, in the suburbs where gangs of men dig ditches and cut streets through hills, or singly ply their grimy trade of rag-picking. Once he shows a poor "drab" lurking for shelter in a doorway, and again in a very dramatic way, he depicts a solitary figure on the stage, with a vast empty background, and a darkened house, whose only illumination is from the footlights. Rickety rows of old buildings, yet more rickety Fifth avenue stages, snowy streets and a few impressions of actresses in different plays make up the rest of the display of this little known worker who must now, unless all signs fail, emerge from obscurity.[9]

The exhibition was reviewed by more than a dozen New York papers as well as dailies in Philadelphia and Pittsburgh. Rather than being appalled by his images, several of which had been (or, in the case of the portrait of Clyde Fitch, would be) published as magazine illustrations, most critics described Shinn's street scenes in terms of a picturesque mode popularized in France but well known in the United States through paintings and illustrations. He was called an "American Raffaëlli," referring to the French realist Jean-François Raffaëlli (1850–1924), whose work ranged from scenic views of the Place de la Concorde to depictions of the vagabonds, absinthe drinkers, and other derelict inhabitants of industrial Paris, which were already well known in New York. The show was a financial as well as a critical success.[10] The gallery offered to fund a trip abroad for Shinn and promised him another show following his return.[11]

The Boussod, Valadon exhibition and the publicity and sales it generated launched Shinn's career overnight. In July 1900, during his stay in Paris, he had an exhibition of pastels at Goupil's gallery. By the spring of 1905 he had five more solo shows at four different New York galleries.[12] He was also increasingly acclaimed as an illustrator. In 1899 he did illustrations for several magazine covers, as well as a number of articles and short stories for *Ainslee's Magazine*, and contributed to *Harper's Weekly*, *Truth*, *The Critic*, and other popular periodicals.

Shinn's illustrations ranged from saccharine, picturesque images of well-dressed, attractive women in street scenes of unidentifiable location (fig. 205) to portraits of popular figures such as *Clyde Fitch in His Study* and street scenes depicting "rickety rows of old buildings" (fig. 206). Certainly the demands of each magazine and story dictated in part the kind of image that was appropriate, but editors hired artists based on the kind of work for which they were particularly suited. Shinn's versatility as a draftsman of street life determined his selection for these commissions.

His friends Glackens and Luks were also receiving significant attention for their

Fig. 205
Everett Shinn, cover illustration for *Ainslee's Magazine* 3 (March 1899)

THE CRITIC

CHRISTMAS NUMBER

During the first several years of the century Luks exhibited his paintings less frequently than did the other Ashcan artists. In May 1902 several of his canvases were on view at Frederick Chapman's gallery, along with works by Jean Baptiste Camille Corot and other European masters. This opportunity for the public to see some of Luks's work prompted FitzGerald to publish a long article arguing that the well-known cartoonist George Luks should also be considered a serious painter.

Contrasting Luks's subjects with the often genteel images shown in academy exhibitions, FitzGerald wrote that the artist specialized in gritty, lower-class subjects but employed the devices and subjects typical of illustration to probe themes with high moral purpose. *Boy with Shovel*, he noted, depicted a street urchin posed with a spade over his shoulder; *Butcher Boy* was "grimy" and "snuffling"; *Prizefighter* had a "terrible battered head."[16] Luks's special power, FitzGerald said, was his willingness to grapple with whatever was most fundamental in his subject, whether lovely or brutal.[17] Armstrong also argued Luks's seriousness. In her article on the new leaders in illustration, she reproduced two street scenes (*East Side* and *South Ferry Morning Scene*) that contrasted sharply with the satiric tone of the cartoons for which Luks was best known to readers of the *New York World*.

Like Luks, Glackens began drawing comics for the *New York World* in 1896. He soon moved to the staff of the *New York Herald* and was increasingly successful as a magazine illustrator. In 1902, when the Frederick J. Quinby Company commissioned him to illustrate an edition of Charles Paul de Kock's novels, Glackens enlisted Sloan, Luks, James Preston, and several other friends from Philadelphia to work on the project (the company ran out of funds before completing the edition, anticipated to include more than fifty volumes). Juggling book illustration with work for *Collier's*, *McClure's*, *Saturday Evening Post*, *Frank Leslie's Illustrated Weekly*, and other

illustrations. In 1900, along with F. C. Yohn and Henry McCarter, Glackens, Luks, and Shinn were celebrated as the "new leaders" of American illustration.[13] Although neither Glackens nor Luks had yet made a mark in the New York art world, they were acclaimed for portraying the "essential" aspects of their street scenes and character types and for capturing the "vibrant expositions of the masses of life."[14]

Luks had shown paintings occasionally at the Pennsylvania Academy of the Fine Arts, but he was known in New York primarily as an illustrator and cartoonist. He had come to New York in 1896 and immediately went to work for the *New York World*, where he illustrated articles on subjects ranging from murder trials to proposed new laws (fig. 207). He became particularly well known after taking over the *Hogan's Alley* comic strip when its originator defected to another newspaper. His barbed wit also brought him work for *The Verdict*, a weekly magazine of political satire (fig. 208). By 1900 he was reportedly earning enough money selling paintings to enable him to abandon cartooning for the rest of his life, although he taught and did occasional illustration work.[15]

popular magazines was a challenge; nonetheless, Glackens produced dozens of drawings, ranging from neighborhood street scenes that accompanied stories on the plight of the lower classes to depictions of well-dressed heroines whose independence and intelligence saved the day, and also character sketches of eccentric old men.[18] At the same time, he completed some of his finest paintings. If less frequently than Shinn, he occasionally merged his illustrations with his art. *A Summer-Night Relaxation* (fig. 209), which accompanied a story in *Harper's Bazar*, served as a preliminary version of *Hammerstein's Roof Garden* (fig. 210).[19]

When Robert Henri came back to New York after a two-year stay in Europe in August 1900 and moved to a house overlooking the East River, his return was noted in the press.[20] A year and a half later he had a solo exhibition at Macbeth Galleries, one of the few commercial enterprises in New York that was emerging as a showcase for American paintings.[21] To introduce Henri to the New York public, William Macbeth (who had handled the artist's work during his stay in Europe) outlined the high points of his career in the exhibition brochure, noting that Henri's success in the French art world had culminated in the government's purchase of one of his paintings (*La Neige*) for the gallery of the Luxembourg Palace.

Of the fourteen landscapes and three portraits in the show, *Cumulus Clouds, East River* (fig. 211) and *Portrait of a Young Woman* were singled out for special mention in the press. The *New York Sun* critic called Henri a painter with "character and force" and urged readers "on no account [to] miss this exhibition."[22] Although heralded as a triumphant expression of Henri's individuality, the show contained nothing that marked the emergence of a radical artist. *Cumulus Clouds, East River* fit comfortably within the context of New York scenes by Childe Hassam, Paul Cornoyer, Guy Wiggins, and other artists whose pictorial views of the city's squares and skyscrapers used atmo-

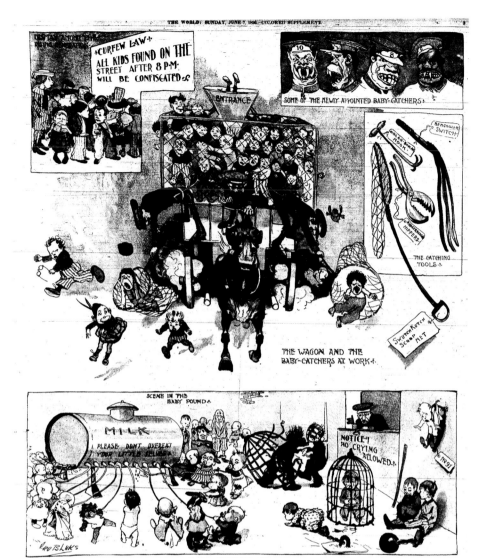

BABY CATCHERS AT WORK.

spheric effects to establish mood. Reviewers commended the painting in terms that could just as easily have described an impressionist canvas.[23] If Henri departed from the impressionists' typical choice of city subjects by selecting a dock scene, neither the small scale of the laborers and team in the right middle ground nor their treatment as minor figures seems to have evoked even passing mention of recent labor problems on the waterfront. Henri's placement of a man holding a child's hand at the center of the scene is a more primary pictorial element and one that alludes to the closeness of family ties of lower- or middle-class life, even on the New York docks.

Portrait of a Young Woman was recognized as a character type. The sitter's "impertinent self-assertion" marked her as a new or

Fig. 207
George Luks, *Baby Catchers at Work*, from *New York World*, 7 June 1896, 3

Luks's Baby Catchers at Work *was drawn in response to proposed curfew laws that would have allowed authorities to pick up children found unsupervised in the streets after 8 p.m. From the various "catching tools" to the child labeled No. 91 hanging on a nail on the wall and the gruesome heads of the "newly-appointed baby-catchers," Luks points out the difficulties in implementing such a law. By envisioning the situation in terms of a dog pound, he emphasized the absurdity of the proposed law.*

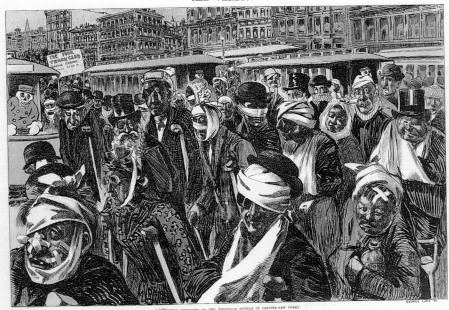

(HUMOROUSLY DEDICATED TO THE STREET-CAR SYSTEMS OF GREATER NEW YORK)
ANNUAL PARADE OF THE CABLE-TROLLEY CRIPPLE CLUB.

Fig. 208
George Luks, *Annual Parade of the Cable-Trolley Cripple Club*, from *The Verdict* 1 (20 March 1899): 10–11

Fig. 209
William Glackens, *A Summer-Night Relaxation*, from Ada Sterling, "New York's Charm in Summer," *Harper's Bazar* 33 (18 August 1900): 972

"modern" woman, a thoroughly familiar subject in stereo cards, magazine articles, advertisements, illustrations, and cartoons.[24] More respectful than the many satiric images depicting women's newly emerging independence, Henri's painting nonetheless conformed to a well-established pattern in the field of illustration.

In contrast to Macbeth, who emphasized Henri's success within official French circles, FitzGerald's review of the show built a case for Henri as the prime exponent of a new Ameri-

can painting characterized by energy and movement. He described Henri's work as aggressive and masculine, filled with the vigor that characterized contemporary life. In a thinly veiled gibe at the academy, FitzGerald contrasted Henri with "all the hands that ever niggled over a surface for the sake of explaining and polishing what from the first conception was meaningless and worthless."[25] In attacking the academy, FitzGerald constantly lumped together the work of those who frequently showed at annuals of the National Academy and the Society of American Artists as though they were a homogeneous rather than a disparate group of artists. This verbal assault, and his use of Henri as a vehicle for criticizing their work, marked the beginning of an ongoing effort to polarize the Henri group and those who exhibited at the National Academy of Design.

As Henri was not an illustrator, he could become known to the public only through exhibitions of his paintings. Fortunately he continued to have a busy solo exhibition schedule. In November 1902 he showed forty-two paintings at the Pennsylvania Academy, which were exhibited the following month at Pratt Institute in Brooklyn. The exhibition presented landscapes as well as his characteristic

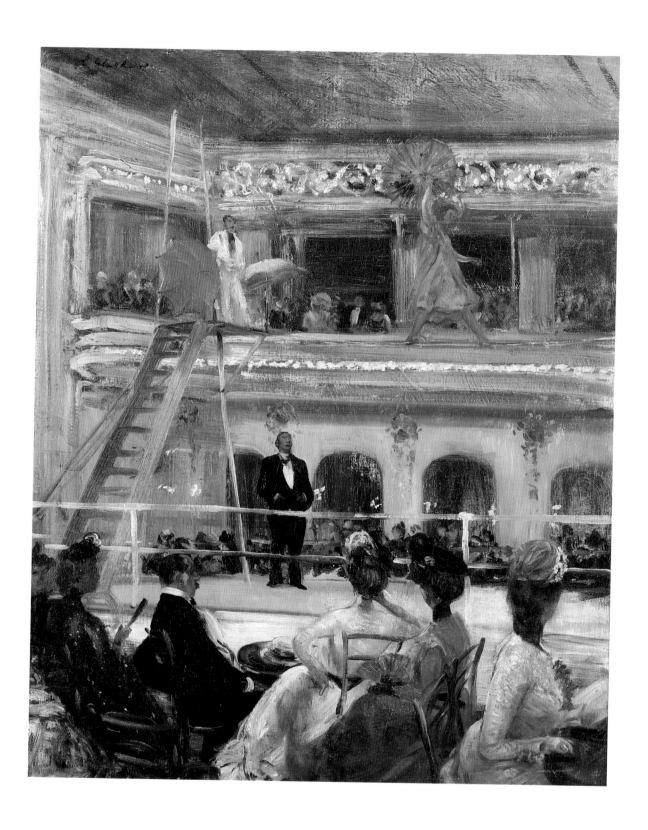

Fig. 210
William Glackens, *Hammerstein's Roof Garden*, 1901, oil on canvas, 76.2 x 63.5 cm (30 x 25 in.). Whitney Museum of American Art, New York, Purchase 53.46. © 1995 Whitney Museum of American Art

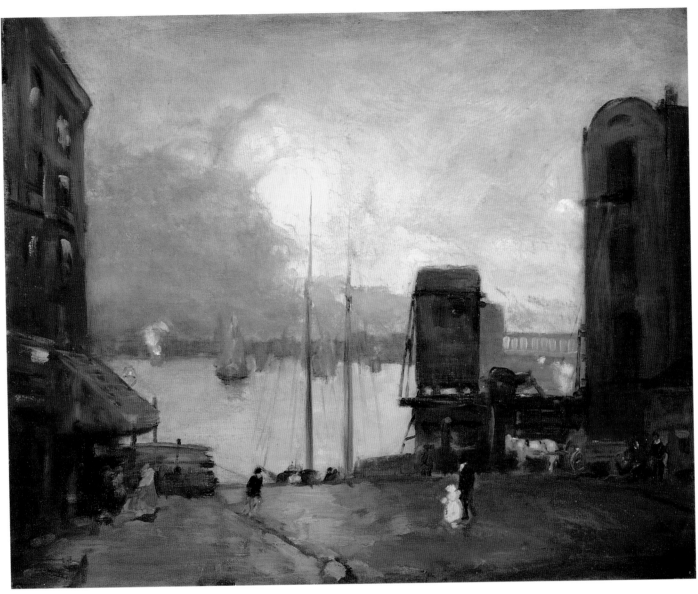

Fig. 211
Robert Henri, *Cumulus Clouds, East River*, 1901–02, oil on canvas, 63.5 x 80.6 cm (25 x 31 ¾ in.). Collection of Rita and Daniel Fraad

In the early years of the century, Henri often painted views of traffic on the East River from the window of his house at 512 East 58th Street. In a letter he described the location as "not the most fashionable quarter I'll admit but with such a view of the river from both ends of the house that I shall never be in want for something magnificent and ever-changing to paint." His gray-toned paintings emphasize the unglamorous activities of a busy working waterfront.

portraits. With each show, Henri's reputation for individuality grew, as did his ability to find the universal in the topical. His landscapes were "full of . . . the great struggle of nature . . . the power of moving forces . . . the eternal truths of existence."[26] His portraits, too, were praised for their clarity of vision, and those presented not as depictions of specific individuals but with generic titles, such as *Portrait of a Young Woman*, were consistently understood to represent a more universal idea or type.

Henri's enterprising personality and his success as a teacher and painter led to his inclusion in exhibitions at the National Academy of Design and the Society of American Artists, which he was invited to join in 1903. He participated in the academy's annual

shows from 1903 through 1910 and became an associate member in 1905. In 1906 he was elected a full academician, signaling that he had clearly achieved success in Establishment terms.

Although Sloan did not come to New York until 1904, he had already submitted work to the academy shows and was featured from time to time in exhibitions at the National Arts Club and other alternative spaces, where his paintings were associated with those of Henri, Glackens, and Luks. Compared with the others, Sloan was a latecomer in depicting New York street scenes. His newspaper work in Philadelphia and other illustrations he published around the turn of the century more closely resembled the French art nouveau

style than they did the gritty street scenes his friends preferred. With his illustrations for Charles Paul de Kock's novels, however, and the success of his 1905 painting *Coffee Line*, his conversion to urban realism was complete, and in 1906 *Dust Storm, Fifth Avenue* and *Spring, Madison Square* were accepted by the National Academy of Design. Perhaps his most provocative early works were the series of etchings he began in 1905, transcribing views such as *Night Windows* (fig. 212), which he saw from the window of his studio on the edge of the Tenderloin district. His images of lower-class New Yorkers sleeping on rooftops on hot summer nights, prostitutes, and young girls enjoying naughty nickelodeon images were nonetheless enthusiastically received by New York critics.[27]

George Bellows came to New York the same year that Sloan arrived. He became friendly with Henri after enrolling at the New York School of Art, where Henri taught. Too young to have been included in the early discussions of the Ashcan artists' work, Bellows emerged in 1907 as a brilliant young painter and a close associate of the other five. *River Rats*, which was included in the spring 1907 annual at the National Academy, established his credentials as a painter of New York street life.

When Henri resigned from the jury of the National Academy's 82nd annual in 1907, the press reported that his friends had been almost systematically rejected by the institution. But a quick review of the annuals contradicts this perception. Although Luks and Shinn were not included, Henri's work was exhibited each year from 1903 through 1910; Bellows was represented annually from 1907 through 1918. In 1905 Glackens's *East River Park* was accepted; 1906 brought Sloan's *Spring, Madison Square* and *Dust Storm, Fifth Avenue*. In 1907 Sloan's *Picnic Grounds*, a lively scene set in a Bayonne, New Jersey, park, and Glackens's *The Sixth Bull* were featured.

The exhibitions of the Society of American Artists (until it merged with the National Academy in April 1906) also frequently included work by the Ashcan artists. According to the society's catalogues, Glackens showed *Portrait of a Young Woman* in 1900; in 1901 Sloan exhibited *Independence Square,*

Fig. 212
John Sloan, *Night Windows*, 1910, etching, 13.6 x 17.9 cm (5 ¼ x 7 in.). ©1994 Board of Trustees, National Gallery of Art, Washington, D.C., Rosenwald Collection

Based on scenes that Sloan observed from his studio, Night Windows *places the viewer, like the artist, in a situation characteristic of life in a crowded urban neighborhood. Like the man on the roof (scarcely visible in the upper left corner), we watch the neighbors with interest but are ourselves part of the scene. The urban artist, like the city dweller, learns to live with such displays—at once intimate and anonymous.*

Philadelphia, and Henri showed *The River-bank* and *A Café, Night*. Glackens was the only one of the group featured in 1902, when *Hammerstein's Roof Garden* was exhibited, although in 1903 Luks's *East Side, New York City*, a portrait by Henri, and Glackens's *Lunch Counter* and *Ballet Girl in Pink* were included. Sloan, Shinn, Henri, and Glackens were all represented in 1904. Visitors to the 1905 exhibition could see Sloan's *Coffee Line*, Luks's *The Spielers* (fig. 176), Henri's *Portrait of Willie Gee* (fig. 138), Shinn's *French Music Hall*, and Glackens's *May Day, Central Park* (fig. 154). The Ashcan artists were clearly not ostracized, and the society's juries accepted both portraits and the New York scenes that the press considered their more progressive accomplishments. They also frequently participated in large-scale exhibitions at the Pennsylvania Academy of the Fine Arts, the Carnegie Institute in Pittsburgh, and the Art Institute of Chicago.[28]

The Ashcan artists' annoyance with the academy partly stemmed from their dependence on its annuals to present their work to the public. Apart from Henri's 1902 exhibition at Macbeth's and Shinn's several solo shows, the prospects for exhibiting in commercial galleries were limited. The participation by Henri, Glackens, and Sloan in a group show at the Allan Gallery in April 1901 represented rare commercial-gallery exposure.[29] Instead, actively seeking alternative opportunities to present their work to the public, they turned to gallery spaces in the city's private clubs.

One of the first such venues came in the spring of 1903, when Henri, Luks, and Glackens were featured in a group exhibition at the Colonial Club. Henri sent two landscapes and a portrait of a man; Luks showed *Whiskey Bill* and three city scenes, two of which depicted Gansevoort Dock; Glackens was represented by a Coney Island scene and *Paris Fête*.[30] The Colonial Club show offered an opportunity to assess their work together, and the fact that the Colonial Club show coincided with the Society of American Artists' annual made com-

parisons inevitable. In neither show were their works well hung. Poor lighting at the Colonial Club made it difficult to see the paintings, and the society's hanging committee had skied the pictures by Luks and Glackens. Henri Pène du Bois of the *New York American* criticized the society's annual for featuring work that, except for the Ashcan paintings, was as "old in fashion as hoops, puffed sleeves and turbans." He identified Henri's *Young Woman in Black* as the exhibition's masterpiece and praised Glackens's *Lunch Counter* and Luks's *East Side, New York City*. He observed that several of Luks's pictures at the Colonial Club had been rejected by the society and suggested that despite the "acute characterization, the fine drawing and sensitive modeling" of *Whiskey Bill*, its title had offended those with delicate sensibilities.[31]

With rave reviews in the *New York Sun*, the *New York American*, *Town Topics*, and several other papers, the Colonial Club exhibition proved a critical success.[32] Predictably supportive, FitzGerald praised the high moral tone Luks brought to his wretched subjects in terms customarily employed by conservative academicians like Kenyon Cox, who spoke of the elevated motivations of their allegorical and idealized subjects. Luks, wrote FitzGerald, was

a painter of corner boys and "toughs," street urchins, ragamuffins, and all kinds of low types, employed with a subject that cannot by any possibility be called low, unless indeed we may apply that term to the works of God—to the waters, the clouded stormy sky of a winter's day, the drifting snow, the eternal struggle of man with the elements.[33]

He identified Glackens as an illustrator, but one who went beyond mere illustration: "Where else shall we look for another who has given us what he gives us here? The children at play in the park, the bourgeois out for a holiday, the crowds at Coney Island. . . . " Here, he wrote, "is the life revealed to us already in his illustrations; it is the life that all of

us have seen but to which he sends us back again with renewed understanding, with keener insight. So with Mr. Luks, who shares with him the skyline at the Society and darkness at the Colonial Club."

In January 1904 the National Arts Club hosted a "Loan Exhibition of Pictures by Robert Henri, William Glackens, George Luks, Arthur B. Davies, Maurice Prendergast, and John Sloan." Although Ernest Lawson and Everett Shinn were absent, the list was identical to the roster of artists included in The Eight exhibition four years later. Reviews of the show stressed the vernacular character of the subjects and their connection with popular illustration. The artists were variously described as "forceful and vigorous" and "robust and emphatic." Luks, however, who showed *Snow Dumpers, Whiskey Bill,* and *Prizefighter,* was "the real newcomer." The *New York Evening Mail and Express* critic described *Prizefighter* as "a veritable masterpiece," noting that Luks had "qualities of seeing and recording that cannot be praised too highly. The subject has been absolutely understood, and it is presented with a conviction that bites and insists."[34] The same opinion was expressed of works by Glackens and Sloan.[35] The author concluded by stating that they were a group of young men "about whom the prison house of convention has not yet begun to close."[36] Increasingly, FitzGerald and Gregg were attracting allies in their campaign against the society and the academy.

During the previous several years, Gregg and FitzGerald had emphasized the virility and masculinity of Ashcan art and, along with Pène du Bois, contrasted this work with the "delicate sensibilities" characteristic of the society and academy artists. By discussing the Ashcan artists in terms of a conflict between the "feminine" sentimentality of the era of gentility and the "masculine" aggressiveness of the new age, these critics reinforced the idea that the artists were working in opposition to the academy.[37] If the words "virility" and "masculinity" seem antifeminist

HOLIDAY SHOPPERS ON AVENUE A.

for a time when debate over women's rights was in the news almost daily, they also described Teddy Roosevelt, the hunter, trustbuster, and intrepid adventurer whose audacity captured the public's attention, as did the adventure stories of Bret Harte and Jack London. Masculinity signified a freewheeling, aggressive, and independent attitude that distinguished the Progressive Era from the nineteenth century.

When FitzGerald and Gregg stressed the artists' importance as illustrators, they were attempting to locate their work in the forefront of change. In 1900, when Regina Armstrong called Shinn, Glackens, and Luks leaders of a new movement in illustration, she was alluding to the realism they brought to their subjects and signaling a shift from the picturesque, sentimentalized portrayals typical of American illustration during the previous decades. Jay Hambidge—now better known for his theories of dynamic symmetry and their later impact on vanguard artists— was one of the most effective of the new realists (fig. 213). Also contributing significantly

Fig. 213
Jay Hambidge, *Holiday Shoppers on Avenue A*, from Jacob A. Riis, "Merry Christmas in the Tenements," *Century* 55 (December 1897): 165

In "Merry Christmas in the Tenements," Riis's compassionate portrayal of tenement life during a joyous holiday season was paired with "realistic" illustrations to support the truth of his narrative. Jay Hambidge's Holiday Shoppers on Avenue A *was just such a "realistic" scene. The cropped and overlapping figures broke with the conventions of the sentimental picturesque and added a note of urgency to the illustration.*

to this realistic vein were W. A. Rogers, May Wilson Preston and her husband, James, Florence Scovel Shinn, Frederick J. Gruger, and later Stuart Davis and Glenn O. Coleman. However, most of these artists, including Shinn and Glackens, moved comfortably between the new realism and more sentimental images when the latter were called for by their editors or commissions.

For newspaper critics whose audiences consisted of a large and diverse public, it made perfect sense to explain the artists' work by relating it to familiar images. Even Henri's portraits could be made to fit. Direct and uncompromising, *Portrait of Willie Gee*, like Luks's *Widow McGee* (fig. 130) and Bellows's *Paddy Flannigan* (fig. 135), was close kin to the depictions of character types that visually expressed the ideas conveyed in the many human-interest stories that filled illustrated newspapers and magazines. The critic who had described Henri's *Portrait of a Young Woman* as a "modern woman" placed the painting in the well-recognized genre of types.

Despite the artists' increasing success within and outside the academy and society shows, FitzGerald continued to argue the opposition he had so carefully constructed over the previous several years. In his review of the 1905 Society of American Artists exhibition, he grudgingly noted, "The artists have persevered without encouragement and even in spite of rebuffs, and now that their standing is well established outside of Fifty-seventh street, is it any wonder that the Society is pleased to take some sort of notice of their existence?"[38]

The following year, Henri, Luks, Glackens, and Sloan showed at Sigmund Pisinger's Modern Art Gallery in a group exhibition that also included work by Charles Hawthorne, Ernest Lawson, and Leon Dabo and his brother. Among the thematically most provocative works were Sloan's New York etchings. In a feature article the *New York Herald* critic extolled their humor. *The Woman's Page* (fig. 116), he said, "shows a slatternly woman seated in an untidy room, with an unkempt child creeping about and a bed that is still unmade. The woman is eagerly devouring the woman's page of a magazine containing hints for beautifying the home."[39] FitzGerald called the etchings "astonishing . . . unequalled by any work of the kind that has been exhibited here."[40]

THE BATTLE WITH THE ACADEMY

It was against this backdrop that the furor erupted over the 1907 National Academy show. Having been elected a full academician the previous year, Henri was invited to serve on the thirty-member selection jury for the 82nd annual, which was scheduled to open in March. He seemed finally positioned to enhance his friends' chances of acceptance and to initiate change from within. Although Bellows's *River Rats*, Sloan's *Picnic Grounds*, and Glackens's *The Sixth Bull* were accepted by the jury, a second canvas by Glackens and paintings by Luks, Shinn, and several former Henri students were rejected. Henri tried to arrange for them to be reconsidered, but most of the other jurors failed to give them a second viewing. On the second round of review, when Henri's portrait of Spanish bullfighter Felix Asiego (one of three paintings Henri submitted that year) was demoted from first to second rank, Henri responded by withdrawing two of the three pictures he had submitted.[41]

The event proved a field day for the press when accounts of the jury's deliberations were leaked to them. The academy's reluctance to respond to inquiries led critics to interview Henri, whose articulate discussion of artistic independence won him the support of the daily papers.[42] In articles and follow-up stories, he was championed as the defender of the *refusés*. What had been a quiet disagreement among the jurors was transformed into a wide-ranging discussion of the state of American art and the National Academy's role in determining what could be seen. Throughout the stories Henri was characterized as a reasonable man whose support for highly accomplished artists was foiled by entrenched conservatism.

In retrospect, it is clear that this proved a pivotal event for the Ashcan artists. In the weeks surrounding the opening of the show, Henri was frequently in the news, as were the actions of the National Academy of Design. In mid-April the academy announced the names of newly elected members. The merger with the Society of American Artists in 1906 had significantly increased membership. Yet this was not mentioned in the press, which emphasized that of the thirty-six artists proposed that year, thirty-three were rejected. Headlines announcing "The Academy and Its Slaughter of Candidates" and "Doors Slammed on Painters" seemed to confirm the institution's reluctance to open its doors to progressive artists.[43] Again the press turned for comment to Henri, who continued to speak out for democracy in art and to call for more open exhibitions.[44]

In the ensuing weeks, Henri often made news. In late April, one Charles Vezin, described by the New York Herald as a businessman who painted in his spare time (his painting On the Aqueduct was included in the 82nd annual), wrote a scathing letter to the editor of the Herald protesting the art movement "in which Mr. Luks is one of the most virile, or shall I say virulent, factors." Although not critical of everything the Ashcan artists had painted, Vezin lambasted their tendency to celebrate the sordid: "Let us paint the slums and beggars and landscapes that are cheerless and bleak, but in doing so let us reveal their hidden beauty. . . . There is no hidden beauty to reveal in the degenerate." When Vezin encountered Henri in the gallery of the New York School of Art on April 26, Henri called him a liar and a "dirty cur." In response, Vezin, by his own account, "opened his right hand wide and brought it into prompt and forcible connection with Mr. Henri's cheek."[45] Again, Henri emerged the innocent victim of academic malice, and his stock with the press soared further.

After this humiliating experience, Henri must have felt a sense of poetic justice when Samuel Swift declared in the April issue of Harper's Weekly that Henri and his friends were "prophets" of a new, "more direct and more democratic" spirit in American art. Swift identified them as a group of artists "chiefly concerned, not with the figure as such, but with actual human beings, their emotional life, and the material environment that helps to determine their character." Swift's suggestion that material environment was a determinant in defining the character of their subjects now seems almost a premonition of a changing perspective on the Ashcan artists' work that would evolve over the next several years. He also recognized the enormous variation in their subjects:

The School of Robert Henri, George Luks, William Glackens, Jerome Myers, John Sloan— to name only some of its strongest members— presents phases of life extending from eminent bishops to half-stripped prize-fighters, from men and women of prestige to the latest batch of newly landed immigrants, from the work and the play of rich and poor, young and old, down to the worn human aspect of decrepit houses on New York's crumbling East Side. . . . These painters convince us of their democratic outlook. They seek what is significant, what is real, no matter whither the quest may lead them. . . . This is an attitude healthily American, and so is the optimism that all of them disclose in their pictures. . . . There is virility in what they have done, but virility without loss of tenderness; a manly strength that worships beauty, and art that is conceivably a true echo of the significant American life about them.[46]

Having talked for several years about holding their own show, Henri and his friends recognized the value of capitalizing on recent publicity. On May 14, 1907, they announced that eight painters (Henri, Luks, Glackens, Sloan, Shinn, Davies, Prendergast, and Lawson) would exhibit together the following year. The next day the New York press was filled with stories heralding the formation of The Eight.[47] Not surprisingly, the New York

Sun published a long article stating that the artists had organized because "their pictures in many instances have been rejected by the staid jury of selection of the National Academy of Design." Although the artists denied that rejection from academy shows had prompted their decision to hold an independent exhibition, the timing of the announcement, just following the National Academy furor, seemed to indicate otherwise.

The announcement of The Eight exhibition was received with enthusiasm. The *Sun* critic reminded readers of the 1904 National Arts Club show in which, he said, "the mark of individuality, the virile departure from the plumb line pictures of newsboys with prettily polished and academically pathetic patches on their knickers, was so noticeable that everybody flocked to the show. New York is talking about that show even yet."[48]

The artists were primed to provide quotable responses when the press requested comment, although they declined to be identified by name. One reportedly said they were a group of men "who think, who are not academic in the hard unfeeling sense of the word, and who believe above all that art of any kind is an expression of individual ideas of life." Another remarked:

[T]he trouble with a lot of artists, so called, is that they draw an arbitrary line across God's works and say: "In this half of His works He has been successful, but over here in the shadows and the misery of life, the seamy side, He has failed." We mustn't paint that seamy side. It's vulgar. Your portraits, for instance, must be only of the rich, and always see to it the lady is seated on a gold chair. Ever notice the gold chair in those pretty portraits? That's part of the formula.[49]

Although the press again raised the specter of academy rejection, when The Eight exhibition opened the following year, critical discussion was beginning to shift. By the spring of 1907 the academy debate had reached a climax. With its winter exhibition more than six months away, further discussion promised only to rehash old news.

"A LITTLE GROUP OF PHILOSOPHERS"

At this point James Gibbons Huneker entered the critical arena. Huneker had been a music and drama critic for the *New York Sun* in 1901 and 1902.[50] In 1906 he returned to write art criticism. Never trained in art, he described himself as an impressionistic critic who responded at times to the surfaces and formal characteristics of the artwork and at others to a painting's subject matter. An instant success, Huneker's art criticism was conversational in tone and often witty. He was less a partisan of the Ashcan artists than were Gregg and FitzGerald, and he chastised them when they showed inferior work as often as he praised their successes. Huneker was also less obsessed with attacking the academic world. Drawing on his deep knowledge of all the arts, he punctuated his reviews with references to music, drama, and literature. Better than FitzGerald and Gregg, he understood the Ashcan artists in terms of a broader cultural debate and related their work to naturalistic fiction to distinguish them from the purveyors of the picturesque who depicted similar themes in sentimentalized or nostalgic ways. He called Luks the "Dickens of the East Side" and linked the Ashcan artists with writers Maxim Gorky, Frank Norris, Theodore Dreiser, and Stephen Crane, whose "realistic" accounts of lower-class life were gaining substantial popular visibility. Although it was unlikely that Huneker's readers knew that Glackens, Shinn, and Dreiser were friends, they may have been familiar with the illustrations Glackens drew for several of Dreiser's many magazine stories.

Naturalistic fiction had begun to reach broader audiences by the middle of the first decade of the twentieth century. Crane, who died in 1900, had been unable to find a publisher for *Maggie, A Girl of the Streets* in 1893, when he first wrote it, so he published the book himself. In 1906, however, Gorky was sufficiently

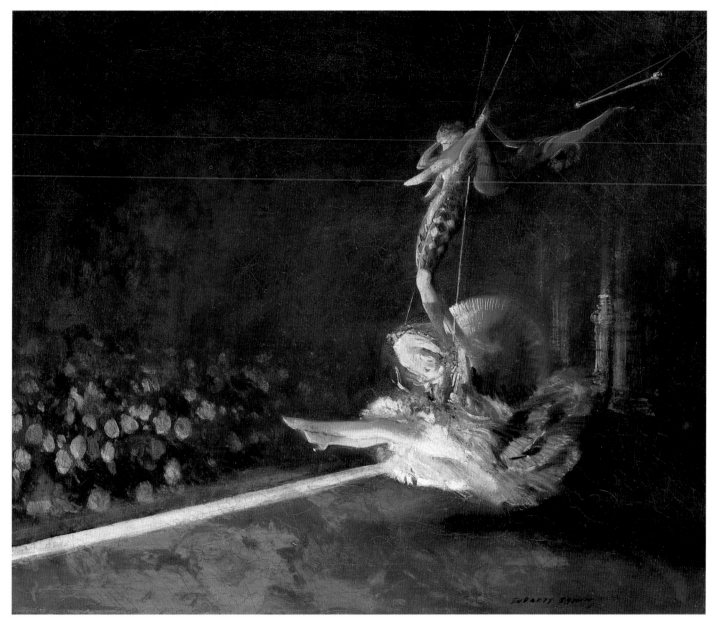

well known to schedule a lecture tour in the United States. Although the tour was canceled after his arrival when it was discovered that Gorky was not married to his female traveling companion, the plans for the tour had increased the visibility of his writings and social philosophy in the United States. Dreiser's first novel, *Sister Carrie*, was originally published in 1900, but in a very small edition due to concern about its subject matter. In 1907, however, the book was reissued in large enough numbers to be widely read.

Huneker, back on the staff of the *Sun* by the time the 82nd academy jury met, was drawn into the debate, but he was less inter-

ested in the politics of the art world than in lively discussions about the art itself. Luks's work offered Huneker perhaps the best opportunity to incorporate his appreciation for naturalistic fiction into his evolving beliefs about what was significant in art.

Rejection by the academy jury had made Luks especially newsworthy. Although his work had been rejected before, the press coverage attendant on Henri's resignation from the jury had catapulted Luks into the limelight. (Shinn might have been a good candidate for press attention, too, but his preoccupation with theater subjects such as *Trapeze, Winter Garden* [fig. 214] and mural

Fig. 214
Everett Shinn, *Trapeze, Winter Garden*, 1903, oil on canvas, 49.5 x 58.8 cm (19 ½ x 23 ⅛ in.). Private collection, Washington, D.C.

commissions made him less newsworthy.) Paradoxically, Bellows's acceptance by the academy won him attention. *River Rats*, his first submission, was not only accepted but also celebrated as the work of a brilliant young painter. However, it was Luks who initially attracted the attention of the press. Huneker wrote an article about him in March 1907, as did the critic for the *New York Herald*. Huneker did another story in April. In July *The Spielers* received attention in the *New York Sun*, and *The Craftsman* did a feature article on his work in September.

Initially Huneker followed the lead of the other *Sun* critics in calling Luks a "revolutionist." However, he spoke of Luks's lower-class subjects not as an affront to academic art, as had FitzGerald in earlier years, but as a link with literary figures whose writings had philosophical depth.

The East Side is his happy hunting ground. In the Second avenue Yiddish restaurants where old men with Biblical heads drink coffee and slowly converse; on Houston street when, apparently, the entire East Side is buying fish Shabbas abend; in vile corners where the refuse of humanity drift, hopeless, helpless; there Luks catches some gleam of humor or pathos, some touch that, Gorkylike, brings before us . . . a human trait that emerges to the surface of this vast boiling kettle.[51]

Although the word "democratic" had occasionally been used to describe the Ashcan artists' work, for most critics it increasingly became the hallmark of their images of New York. In his September 1907 *Craftsman* article, John Spargo celebrated Luks as a painter of democracy: "Above all," he wrote, "Luks is an American." He also noted the similarity between Luks's work and the realism of Charles Dickens and Maxim Gorky, saying, "Who among the painters of our time has more surely caught, and faithfully recorded, the heights and depths, vices and virtues, tragedies and comedies, passions and foibles of humanity?"[52] What constituted democracy or Am-

ericanism was less easy to define, however, especially when such a term was used to describe art. Whether it denoted an emphasis on American subject matter, as Spargo and Mary Fanton Roberts argued in articles in *The Craftsman* in 1907, or reflected some atavistic quality that determined the way an artist painted independent of theme, as was Henri's conviction, was the subject of considerable discussion. In either case, by 1907, with Huneker writing for the *New York Sun* and *The Craftsman* taking up the gauntlet for the democracy of American art that depicted contemporary life, it was increasingly difficult to argue against the significance of the Ashcan artists' work. At best, denigrating their work suggested a return to outworn art-making practices; at worst, it revealed a latent lack of patriotism.

Bellows, too, emerged on the scene in 1907. When *River Rats* (fig. 215) was featured in the spring National Academy show, Huneker called it a "capital" picture, and the *New York Globe* critic described it as a "delightful impression . . . with its lads bathing, the city being seen above the high ground."[53] Even the relatively conservative magazine *The Nation* described Bellows's remarkable ability to transform a humble scene into art:

[I]t proves afresh that the artist and not the subject makes the work. Given a muddy, rock embankment rising in the mutilated ugliness of transitional city improvements to the height of a third of the canvas, and above this unsightly bulk, unlovely buildings of factory-like character blocking all but a patch of perfectly toned sky, and you have the general structure out of which the painter has created a work of art. But he has done this by placing close to the heavy waters of the river a congregation of slender street arabs, nude, and panting for the cool but uncleanly stream. This aggregation of fragile and active forms, relieved by the massive and rugged formation of disrupted earth behind, sets on the imagination much as would some delicate conception of Cellini, in which his

Fig. 215
George Bellows, *River Rats*, 1906,
oil on canvas, 77.5 x 97.8 cm (30 ½
x 38 ½ in.). Private collection, Wash-
ington, D.C.

Metropolitan Museum of Art in New York and the Toledo Museum. "One wonders when looking at the canvases by this vigorous young painter if the word 'art' should be used in connection with his work, it is so full of vitality and the actual life of the times."[68]

By focusing on the human dimension of Luks's paintings and the gutsiness of Bellows's work and connecting them with naturalistic writers, critics had shifted the discussion of the Ashcan artists' New York images to a more serious and universal realm. The question of beauty—the key to critical success in the late nineteenth century—was no longer relevant. Words like "sordid" and "ugly" became compliments, not epithets, signaling the breadth and depth of the artists' understanding of contemporary life. "Realism" offered new possibilities for understanding it, too. By realism, critics did not mean the transcription of some aspect of nature or urban life. Rather, the term signified a willingness to examine selectively the motivations, psychology, and appearances of a world in which beauty and ugliness coexisted in order to arrive at a more fundamental understanding of the human condition. The reviewers echoed the statement of turn-of-the-century philosopher William James, who felt claustrophobic when surrounded by middle-class values: "Let me take my chances again in the big outside worldly wilderness with all its sins and sufferings."[69] According to these critics, the Ashcan artists were not simply reporters of contemporary life; they were philosophers of their age.

In the ensuing years—from The Eight exhibition until the beginning of World War I—the artists continued to grow in popularity. The Independents' exhibition in 1910 prompted considerable press, but the focus was as much on the idea of the show (everyone willing to pay the modest fee to exhibit was included) and the chaotic nature of the installation (works were hung alphabetically by artist's last name) as on the quality of the work. Henri's resignation from the academy jury in 1907 had provided the angle for critics to look

closely at Luks, and The Eight exhibition a year later placed a number of his works before the public. Luks's 1910 exhibition at Macbeth's and solo exhibitions at Kraushaar Galleries in the years following ensured his establishment as a mainstream realist. By 1911 the *New York Post* critic could easily say that "to call George Luks an 'insurgent' seems rather far-fetched."[70] Sloan, too, was widely recognized for his wit, masterly draftsmanship, and ability to reveal the mysteries of life. Although his first solo exhibition was not held until January 1915, at Gertrude Vanderbilt Whitney's studio, the following year he began a long relationship with Kraushaar Galleries. With an increasing number of alternative exhibition spaces—from the Church of St. Mark's in the Bouwerie to John Weichsel's People's Art Guild and the Ferrer School—showing work was no longer contingent on an association with the National Academy.

By 1910 the Ashcan artists' reputations had been made by the press, and their illustrations continued to capture the public's imagination, although the work done by Sloan and others for the socialist magazine *The Masses* raised eyebrows. However, the role of rebel was to fall to other artists. Even in 1911 a reviewer remarked that Luks and the others looked sane compared with such paintings as Max Weber's 1909 *Summer* and other "grotesqueries" that distorted the human form. When the Armory Show opened in 1913, it was clear that the Ashcan artists were not practitioners of artistic radicalism (fig. 216). Although flurries of debate related to both their art and their illustrations continued to erupt from time to time, by 1916 the artists were considered historians of their age. Their urban street scenes had become documents of a bygone era in New York life.

But the Ashcan artists also left behind a legacy that allowed the American Scene painters and social realists of the 1930s to work in a neutral critical environment. The notion that artistic conventions and imaginary scenes could constitute important art

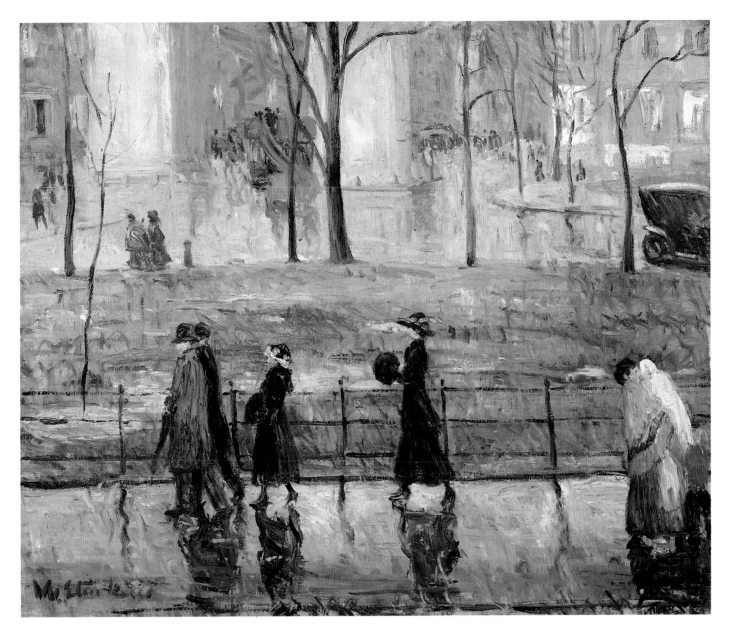

had given way to the conviction that an American philosophy was deeply rooted in the American public. For Stuart Davis and Edward Hopper, whose early careers were significantly influenced by the Ashcan artists; for Reginald Marsh, Isabel Bishop, the Soyer brothers, and the hundreds of other painters who depicted New York life with the financial support of the Works Progress Administration, the question was not whether to paint contemporary life, but how best to express the special circumstances of their times.

Fig. 216
William Glackens, *March Day–
Washington Square*, 1912, oil on
canvas, 63.5 x 76.2 cm (25 x 30 in.).
Private collection, Washington, D.C.

NOTES

INTRODUCTION

1. On the origins of the term Ashcan School, see Elizabeth Milroy, *Painters of a New Century: The Eight & American Art*, exh. cat. (Milwaukee: Milwaukee Art Museum, 1991); and Robert Hunter, "The Rewards and Disappointments of the Ashcan School," in Lowery Stokes Sims, *Stuart Davis: American Painter*, exh. cat. (New York: Metropolitan Museum of Art, 1992), 35–41.

2. American impressionists who painted New York City tended to follow the example of Claude Monet in depicting urban landscapes rather than concentrating on human activity. William H. Gerdts, *Impressionist New York* (New York: Abbeville Press, 1994), 34, makes the point that, among American art critics and collectors, Monet's art was much more popular than that of the figurative painters Degas and Manet.

3. Olivier Zunz discusses the Metropolitan Life tower in *Making America Corporate, 1870–1920* (Chicago: University of Chicago Press, 1990), chap. 4. Thanks to William R. Taylor for recommending this source.

4. In his pocket diary entry for 1 May 1909, Henri records painting Mademoiselle Voclezca. Robert Henri Papers, Archives of American Art, Smithsonian Institution, courtesy of Mrs. John C. LeClair.

5. See diary entry, 9 March 1910, in Bruce St. John, ed., *John Sloan's New York Scene: From the Diaries, Notes, and Correspondence 1906–1913* (New York: Harper & Row, 1965).

6. The Strauss opera was scheduled to be performed at the Metropolitan in 1907 but was canceled after one performance "on purely moral grounds" ("New Pictures of Salome, The Most Notorious Opera," *New York World*, 3 February 1907, pictorial section, 1). It was revived successfully at Hammerstein's Manhattan Opera House in 1909 and reviewed by Lawrence Gilman, "The World of Music," *Harper's Weekly* 53 (6 February 1909): 27. On Salome and the opera, see Nancy L. Pressly, *Salome: La Belle Dame Sans Merci*, exh. cat. (San Antonio: San Antonio Museum of Art, 1983) and "No More 'Salome' Here," *New York Evening Post*, 30 January 1907, 1. Henri Regnault's painting *Salome* (1870) was donated by George F. Baker to the Metropolitan Museum in 1916; see Bryson Burroughs, "Regnault's Salome," *Bulletin of the Metropolitan Museum of Art* 11 (August 1916): 164–66, and "The 'Salome' of Henri Regnault," *Vanity Fair* 6 (August 1916): 47. (Henri clipped a copy of the illustration that accompanied this article for his scrapbook.) Sargent's portrait (now in the Tate Gallery) was well known, having been included in the prestigious exhibition of American painting at the 1893 World's Columbian Exposition in Chicago and reproduced widely. Henri himself

had admired the painting at an exhibition in Paris in 1889; see Bennard Perlman, *Robert Henri: His Life and Art* (New York: Dover, 1991), 18.

7. "Comstock Shocked at Fifth Avenue," *Variety* 14 (17 April 1909): 6. When the French star Odette Valéry performed as Salome at the Fifth Avenue Theatre, the management displayed a painting of the actress that had previously been shown at the Paris Salon. Despite these credentials, Anthony Comstock of the New York Society for the Suppression of Vice demanded that the *Fantasie Egyptienne* be removed. See entry for Charles Allan Winter's *Fantasie Egyptienne* in Rowland and Betty Elzea, *The Pre-Raphaelite Era, 1848–1914*, exh. cat. (Wilmington: Delaware Art Museum, 1976); "To Give 'Salome Party,'" *New York Times*, 26 August 1908; "The Salome Pestilence," *New York Times*, 13 September 1908; "The 'Salome' Dance Gets into Politics," *New York Times*, 24 August 1908.

8. F. J. M. [Frank Jewett Mather?], "The Independent Artists," *Nation* 90 (7 April 1910): 360.

9. Most recently in H. Barbara Weinberg, Doreen Bolger, and David Park Curry, *American Impressionism and Realism: The Painting of Modern Life, 1885–1915*, exh. cat. (New York: Metropolitan Museum of Art/Harry N. Abrams, 1994).

10. Luks's painting is discussed in Weinberg et al., *American Impressionism*, 191–95. Labels to that exhibition described Riis as a "more candid observer," as quoted by John Updike, "Beyond the Picturesque," *New York Review of Books* 41 (23 June 1994): 21.

11. On Riis, see Maren Stange, *Symbols of Ideal Life: Social Documentary Photography in America, 1890–1950* (Cambridge, England: Cambridge University Press, 1989), chap. 1.

12. Hutchins Hapgood, *The Spirit of the Ghetto: Studies in the Jewish Quarter in New York* (New York: Funk & Wagnalls, 1902), 259.

13. On Epstein and other Jewish artists on the Lower East Side, see *Painting a Place in America: Jewish Artists in New York, 1900–1950*, exh. cat. (New York: Jewish Museum, 1991).

14. Arguing that "certainly not all [Jewish] artists knew [the Jewish] community in the same way," Matthew Baigell has noted that New York's Jewish artists came from diverse economic and religious backgrounds, and that most eventually left the Lower East Side (*Painting a Place in America*, 29–32). The Gentile Luks did participate in an exhibition sponsored by the Madison House Settlement on the Lower East Side; see Henry Moscowitz, "The East Side in Oil and Crayon," *Survey* 28 (11 May 1912): 272–73.

15. Robert W. DeForest and Lawrence Veiller, eds., *The Tenement House Problem*, 2 vols. (New York: Macmillan, 1903), 1: 201–02. Quotation is from pp. 114–15. Compare Veiller's description with the memoirs of the Lower East Side collected by Jeff Kisseloff, *You Must Remember This: An Oral History of Manhattan from the 1890s to World War II* (New York: Harcourt Brace, 1989), 3–81.

16. Abraham Cahan describes such a character as the protagonist of *The Rise of David Levinsky* (New York: Harper & Brothers, 1917).

17. Toni Morrison, *Beloved* (New York: Alfred A. Knopf, 1987), 190.

18. The philosopher Michel Foucault has argued that visual knowledge is a form of domination, and in recent years several historians have used Foucault's insights to analyze the way pictorial surveys of nineteenth-century cities worked as instruments of social control over the urban poor. We prefer to reformulate this assessment of knowledge and power by arguing that *all* residents of a big city seek knowledge and devise systems of ordering (through stereotypes, images, or "mental maps") in order to exercise some form of control over their surroundings. See Michel Foucault, "The Eye of Power," in Foucault, *Power/Knowledge: Selected Interviews and Other Writings, 1972–77* (New York: Pantheon, 1980), 146–65, and John Tagg, *The Burden of Representation: Essays on Photographies and Histories* (Amherst: University of Massachusetts Press, 1988).

CITY IN TRANSITION

1. Walt Whitman, *Leaves of Grass* (New York: W. W. Norton, 1973), 474.

2. Edward K. Spann, *The New Metropolis: New York City, 1840–1857* (New York: Columbia University Press, 1981); Sean Wilentz, *Chants Democratic: New York City and the Rise of the American Working Class, 1788–1850* (New York: Oxford University Press, 1984), 110; and Robert Ernst, *Immigrant Life in New York City, 1825–1863* (Port Washington, N.Y.: Ira J. Friedman, 1965; orig. pub. 1949), 193.

3. See Adrian Cook, *The Armies of the Streets: The New York City Draft Riots of 1863* (Lexington: University Press of Kentucky, 1974), 209.

4. The line was written in 1913 and published in Ezra Pound, *Patria Mia* (London: Peter Ewen, 1962), 19.

5. John Reed, "The Foundations of a Skyscraper," in *American Magazine* (October 1911), reprinted in Jack Alan Robins, ed., *The Complete Poetry of John Reed* (Washington, D.C.: University Press of America, 1983), 32.

6. On the reconfiguration of the department-store district, see William Leach, *Land of Desire: Merchants, Power, and the Rise of a New American Culture* (New York: Pantheon, 1993), 31–32.

7. Thomas Kessner, *Golden Door: Italian and Jewish Immigrant Mobility in New York City, 1880–1915* (New York: Oxford University Press, 1977), 167–68.

8. Cited in Jerre Gerlando Mangione and Ben Morreale, *La Storia: Five Centuries of the Italian American Experience* (New York: HarperCollins, 1992), 109.

9. Jacob Riis, *How the Other Half Lives*, 1890 (reprint, New York: Dover, 1971), 20–22; *The WPA Guide to New York: The Federal Writers Project Guide to 1930s New York* (New York: Pantheon, 1982), 113–14; Ira Rosenwaike, *Population History of New York City* (Syracuse: Syracuse University Press, 1972), 82–85; and Kessner, *Golden Door*, 132.

10. Quoted in David C. Hammack, *Power and Society: Greater New York at the Turn of the Century* (New York: Russell Sage Foundation, 1982), 211.

11. Randolph S. Bourne, "Trans-national America," in Olaf Hansen, ed., *The Radical Will: Randolph Bourne Selected Writings 1911–1918* (New York: Urizen Books, 1977), 248–64.

12. Joseph Lincoln Steffens, *The Autobiography of Lincoln Steffens* (New York: Harcourt Brace, 1931), 244.

13. Cited in Martin Burgess Green, *New York 1913: The Armory Show and the Paterson Strike Pageant* (New York: Scribner's, 1988), 5.

14. Moses Rischin, *The Promised City: New York's Jews, 1870–1914* (Cambridge: Harvard University Press, 1977; orig. pub. 1962), 79.

15. Abraham Cahan, *The Rise of David Levinsky* (New York: Harper & Brothers, 1917), 61.

16. Lillian Wald, *The House on Henry Street* (New York: Henry Holt, 1915), 153.

17. Meyer London, cited in Leon Stein, ed., *Out of the Sweatshop: The Struggle for Industrial Democracy* (New York: Quadrangle/New York Times Book Company, 1977), 98.

18. See Frank Luther Mott, *American Journalism: A History of Newspapers in the United States Through 260 Years: 1690 to 1950*, rev. ed. (New York: Macmillan, 1950).

19. Wald, *The House on Henry Street*, 69–70.

20. Abraham Cahan, *The Rise of David Levinsky*, 93–103.

21. See Robert W. Snyder, *The Voice of the City: Vaudeville and Popular Culture in New York* (New York: Oxford University Press, 1989), 16; also Hammack, *Power and Society*, 62.

22. On the waves of elites, see Frederic Cople Jaher, "Style and Status: High Society in Late Nineteenth Century New York," in Jaher, *The Rich, the Well Born and the Powerful: Elites and Upper Classes in History* (Urbana: University of Illinois Press, 1973), 258; on the calculation of millionaires, see Lewis A. Erenberg, *Steppin' Out: New York Nightlife and the Transformation of American Culture* (Westport, Conn.: Greenwood Press, 1981), 36.

23. Jaher, "Style and Status," 280. On the socially elite known as the "Four Hundred," see Frederic Cople Jaher, *The Urban Establishment: Upper Strata in Boston, New York, Charleston, Chicago and Los Angeles* (Urbana: University of Illinois Press, 1982), 269–70.

24. On the "billionaire district," see Franz K. Winkler, "The Architecture in the Billionaire District of New York City," *Architectural Record* 11 (October 1901): 679, cited in Robert A. M. Stern et al., *New York 1900: Architecture and Urbanism, 1890–1915* (New York: Rizzoli, 1983), 307; also Erenberg, *Steppin' Out*, 35.

25. Stern, *New York 1900*, 315–16, 329.

26. On Yorkville, see *The WPA Guide to New York*, 243–52; also Stanley Nadel, *Little Germany: Ethnicity, Religion and Class in New York City, 1845–1880* (Urbana: University of Illinois Press, 1990), 161–62.

27. Roy Rosenzweig and Elizabeth Blackmar, *The Park and the People: A History of Central Park* (New York: Henry Holt, 1992), 211–18, 222–29, 308–09, 332–39.

28. See Henry James, *The American Scene*, 1907 (reprint, Bloomington: University of Indiana Press, 1968), 114, 117, 174, 178.

29. Rosenzweig and Blackmar, *The Park and the People*, 336–38.

30. Edward Haviland Miller, ed., *The Correspondence of Walt Whitman* (New York, 1861–69), I, 46, cited in Wilentz, *Chants Democratic*, 389.

31. Sean Wilentz, "Low Life, High Art," *The New Republic* 207 (28 September 1992): 42; also Rebecca Zurier, *Art for The Masses: A Radical Magazine and Its Graphics, 1911–1917* (Philadelphia: Temple University Press, 1988), 4, 32, 56–57.

32. Nick Salvatore, *Eugene V. Debs: Citizen and Socialist* (Urbana: University of Illinois Press, 1982), 192, 229, 311.

33. On Socialist Party activity in New York during these years, see James Weinstein, *The Decline of Socialism in America, 1912–1925* (New York: Monthly Review Press, 1967), 57, 58, 61; also *Encyclopedia of the American Left* (New York: Garland, 1990), 233, 640, 651, 724; also Irving Howe, *World of Our Fathers* (New York: Harcourt Brace Jovanovich, 1976), 310–23.

34. See Robert A. Rosenstone, *Romantic Revolutionary: A Biography of John Reed* (New York: Alfred A. Knopf, 1975), 117–32, 135–36; also Steve Golin, *The Fragile Bridge: Paterson Silk Strike, 1913* (Philadelphia: Temple University Press, 1988), 170–78, 187–88.

35. See *Encyclopedia of the American Left*, 275–76, 283–84.

36. Bruce St. John, *John Sloan* (New York: Praeger, 1971), 570.

37. Howe, *World of Our Fathers*, 297–98.

38. Ibid., 299–30; on the assistance of the Women's Trade Union League, see Golin, *Fragile Bridge*, 122.

39. Leon Stein, *The Triangle Fire* (Philadelphia: J. B. Lippincott, 1962).

40. Cited in Zurier, *Art for The Masses*, 56.

41. Jeffrey T. Sammons, *Beyond the Ring: The Role of Boxing in American Society* (Urbana: University of Illinois Press, 1988), 62–63; also Randy Roberts, *Jack Dempsey, the Manassa Mauler* (Baton Rouge: Louisiana State University Press, 1979), 92–94.

42. Randy Roberts, *Papa Jack: Jack Johnson and the Era of White Hopes* (New York: Free Press, 1983), 85–107, 108–10, 115; Roberts, *Jack Dempsey*, 21, 24–25, 29–31.

43. My ideas here are influenced by Wilentz, "Low Life, High Art," 43.

44. Timothy J. Gilfoyle, *City of Eros: New York City, Prostitution, and the Commercialization of Sex, 1790–1920* (New York: Norton, 1992), 74–75, 119, 141, 147.

45. Ibid., 288–93; on an earlier period, see Christine Stansell, *City of Women: Sex and Class in New York, 1789–1860* (New York: Alfred A. Knopf, 1986), 175–85. The cost of living and economic options available to women in New York City received close attention in the early twentieth century. See the discussion, with reference to surveys conducted in 1917 by the U.S. Department of Labor, in Ruth Rosen, *The Lost Sisterhood: Prostitution in America, 1900–1918* (Baltimore: Johns Hopkins University Press, 1982), 137–68.

46. Gilfoyle, *City of Eros*, 222–23.

47. Ibid., 279–80.

48. Ibid., 304–06.

49. See Elaine S. Abelson, *When Ladies Go A-Thieving: Middle-Class Shoplifters in the Victorian Department Store* (New York: Oxford, 1989), 13, 18–22, 25–31.

50. Ibid., 20.

51. See Kathy Peiss, *Cheap Amusements: Working Women and Leisure in Turn-of-the-Century New York City* (Philadelphia: Temple University Press, 1986), 62–72.

52. On the general improvement in working-class standards of living in New York between 1880 and 1920, see Peiss, *Cheap Amusements*, 11–12.

53. See Judith A. Adams, *The American Amusement Park Industry: A History of Technology and Thrills* (Boston: Twayne, 1991), 42; and Peiss, *Cheap Amusements*, 123.

54. Peiss, *Cheap Amusements*, 134–36.

THE MAKING OF SIX NEW YORK ARTISTS

1. Will Jenkins, "Illustration of the Daily Press in America," *International Studio* 16 (June 1902): 255.

2. Quotations are from Everett Shinn, "Life on the Press," in "Artists of the Philadelphia Press," *Philadelphia Museum of Art Bulletin* 41 (November 1945): 9–12 passim.

3. John Sloan, quoted in "Artists of the Philadelphia Press," n.p.; see also Shinn, "Life on the Press" and the photograph of Shinn in the newsroom (Archives of American Art, Smithsonian Institution), reprinted in *City Life Illustrated, 1890–1940: Sloan, Glackens, Luks, Shinn—Their Friends and Followers*, exh. cat. (Wilmington: Delaware Art Museum, 1980), 15.

4. Robert Darnton, "Writing News and Telling Stories," *Daedalus* 104 (Spring 1975): 188–93.

5. Stuart Davis, interview conducted by the Archives of American Art, 1962, quoted in Garnett McCoy, "Reaction and Revolution, 1900–1930," *Art in America* 53 (August–September 1965): 69.

6. Song with lyrics from a popular vaudeville tune called "I Am a Voo-Doo Man," cited by Walter Pach, interviewed by Bennard B. Perlman, 5 September 1952, quoted in Perlman, *Robert Henri: His Life and Work* (New York: Dover, 1991), 63 and n. 53. Keith Haring recalled, "*The Art Spirit* was almost like a Bible to me for a while. . . . I still read it sometimes." Haring, interview with Vince Aletti (1981), in *Keith Haring: Future Primeval*, exh. cat. (Normal, Ill.: University Galleries, Illinois State University, 1990), 95. The New York journalist Pete Hamill cites Henri's book *The Art Spirit* as an inspiration to art students in the 1950s, in *A Drinking Life: A Memoir* (New York: Little, Brown, 1994), 168–70.

7. Robert Henri, *The Art Spirit* (Philadelphia: J. B. Lippincott, 1923), 141. In an interview with Bennard B. Perlman on 11 November 1956, Mrs. John Sloan stated that Sloan presented Henri with *Leaves of Grass*; see Perlman, *The Immortal Eight: American Painting from Eakins to the Armory Show, 1870–1913* (Westport, Conn.: North Light, 1979), 40 and n. 20. Robert Hunter discusses the difference in generations of Henri students in "The Rewards and Disappointments of the Ashcan School: The Early Career of Stuart Davis," in Lowery Stokes Sims, *Stuart Davis: American Painter*, exh. cat. (New York: Metropolitan Museum of Art, 1991), 31–44.

8. Diary entry cited in William Innes Homer, *Robert Henri and His Circle*, 1969 (rev. ed. New York: Hacker, 1988), 90.

9. Sloan to Henri, 1 October 1898, Henri Papers, Beinecke Library, Yale University, New Haven.

10. The consolidation of the national press in New York eventually cost Sloan his job as an illustrator on the *Philadelphia Press*, which dropped its Sunday feature section in favor of a syndicated supplement.

11. Will H. Low, "National Art in a National Metropolis," *International Quarterly* 6 (September–December 1902): 109.

12. Leslie Fishbein, *Rebels in Bohemia: The Radicals of The Masses, 1911–1917* (Chapel Hill: University of North Carolina Press, 1982), chaps. 1 and 4.

13. Sadakichi Hartmann, "Studio-Talk," *International Studio* 30 (December 1906): 183.

14. Mary Fanton Roberts [Giles Edgerton, pseud.], "Notes and Reviews," *The Craftsman* 14 (April 1908): 345.

15. Much of this account is taken from the best recent publication on The Eight, Elizabeth Milroy, *Painters of a New Century: The Eight & American Art*, exh. cat. (Milwaukee: Milwaukee Art Museum, 1991). In addition to the excellent bibliography, see Judith Zilczer, "The Eight on Tour, 1908–1909," *American Art Journal* 16 (Summer 1984): 20–48.

16. "Eight Independent Painters," *New York Sun*, 15 May 1907; "'The Eight' Exhibit New Art Realism," *New York American*, 4 February 1908; unidentified clipping from *Chicago Post*, 29 September 1908, Art Institute of Chicago scrapbooks.

17. Quotations are from James Gibbons Huneker, cited in Milroy, *Painters of a New Century*, 48 n. 115, and an unknown writer for the *New York Times*, cited in Milroy, ibid., 24 n. 14.

18. See Bruce Chambers, "*Street Scene with Snow (57th Street, N.Y.C.)*: An Idea of City 'In Snow Effect,'" *Yale University Art Gallery Bulletin* 39 (Winter 1986): 30–39.

19. Robert Henri, "My People," *The Craftsman* 27 (February 1915): 469; Arthur Hoeber, "Work of Robert Henri," *New York Commercial Advertiser* (4 April 1902).

20. See Sylvia Yount, "Consuming Drama: Everett Shinn and the Spectacular City," *American Art* 6 (Fall 1992): 87–109; Deborah Fairman, "The Landscape of Display: The Ashcan School, Spectacle, and the Staging of Everyday Life," *Prospects* 18 (1993): 205–36; and H. Barbara Weinberg, Doreen Bolger, and David Park Curry, *American Impressionism and Realism: The Painting of Modern Life, 1885–1915* (New York: Metropolitan Museum of Art/Harry N. Abrams, 1994), 201–13. Shinn, quoted in Louis Baury, "The Message of Manhattan," *Bookman* 33 (August 1911): 592–94.

21. I am grateful to seminar papers by Catherine Herbert (University of Pennsylvania, 1988) and Anita Gonzalez (University of Michigan, 1992) for information on connections between Shinn's work and that of Raffaëlli. The French artist's work was exhibited in Philadelphia in 1899 and written about frequently in *The Studio* and other journals at the turn of the century.

22. Sickert had an exhibition at the Durand-Ruel Gallery in Paris in 1900 while Shinn was there.

23. William B. McCormick, "Art Notes of the Week," *New York Press*, 9 February 1908, quoted in Milroy, *Painters of a New Century*, 48.

24. Glackens and Barnes had known each other since they were high-school classmates in Philadelphia. Richard J. Wattenmaker discusses their relationship in his essay "Dr. Albert C. Barnes and the Barnes Foundation," in *Great French Paintings from the Barnes Foundation: Impressionist, Post-impressionist, and Early Modern* (New York: Alfred A. Knopf in association with Lincoln University Press, 1993): 3–7.

25. Louis Baury, "The Message of Proletaire," *Bookman* 34 (December 1911): 403.

26. See diary entries for 23, 24, 26 June 1907; 27, 29, 30, 31 July 1908, in Bruce St. John, ed., *John Sloan's New York Scene: From the Diaries, Notes and Correspondence 1906–1913* (New York: Harper & Row, 1965).

27. *John Sloan's New York Scene*, 6 March 1910.

28. Charles de Kay, "Academy of Design," *New York Post*, 14 March 1908.

29. Arthur Hoeber, "Art and Artists," *New York Globe and Commercial Advertiser*, 21 March 1908; Mary Fanton Roberts [Giles Edgerton, pseud.], "Notes and Reviews," 345.

30. J. Nilsen Laurvik, "The Winter Exhibition of the National Academy of Design," *International Studio* 33 (February 1908): CXLII.

PICTURING THE CITY

1. Marianne Doezema, "The Real New York," in Michael Quick et al., *The Paintings of George Bellows*, exh. cat. (Fort Worth: Amon Carter Museum, 1992), 111–14.

2. See, for example, two articles by Jesse Lynch Williams: "The Walk Up-Town in New York," *Scribner's* 27 (January 1900): 44–59 (illustrated with photographs); and "Cross-Streets of New York," *Scribner's* 28 (November 1900): 571–87 (illustrated with drawings by Shinn and Glackens, among others). Both articles were reprinted as a book, *New York Sketches* (New York: Charles Scribner's Sons, 1902). Shinn made many of his pastel drawings for an album, never published, to be titled *New York by Night*. Although the exact content of the book is unknown, Shinn later identified several drawings as part of the project, and others appear to have been made in the same format. A mock-up of the cover and several of these drawings are now in the Saint Louis Art Museum.

3. Robin D. G. Kelley makes a similar point in describing the interior spaces on public transport as "moving theaters" and notes that "the design of streetcars and buses—enclosed spaces with seats facing forward or toward the center aisle" gives everyday encounters a "dramaturgical quality." ("'We Are Not What We Seem': Rethinking Black Working-Class Opposition in the Jim Crow South," *Journal of American History* 80 [June 1993]: 103). Rebecca Zurier is currently working on a study of looking and visuality in the turn-of-the-century city, with particular reference to the Ashcan artists.

4. Frank O'Hara, "Meditations in an Emergency" (1957), in Donald Allen, ed., *The Selected Poems of Frank O'Hara* (New York: Alfred A. Knopf, 1974), 87.

5. Gleizes, quoted in "French Artists Spur on an American Art," *New York Tribune*, 24 October 1915. See also Merrill Schleier, *The Skyscraper in American Art, 1890–1931* (Ann Arbor: UMI Research Press, 1986).

6. Many thanks to Sylvia Yount, who developed this interpretation in her fine article, "Consuming Drama: Everett Shinn and the Spectacular City," *American Art* 6 (Fall 1992): 87–109.

7. David Montgomery, *The Fall of the House of Labor: The Workplace, the State, and American Labor Activism, 1865–1925* (Cambridge, England: Cambridge University Press, 1987), 97–99.

8. Marianne Doezema discusses this series in *George Bellows and Urban America* (New Haven: Yale University Press, 1992), chap. 1.

9. Jeff Kisseloff, *You Must Remember This: An Oral History of Manhattan from the 1890s to World War II* (New York: Harcourt Brace Jovanovich, 1989).

10. George Bellows to Joseph Taylor, 21 April 1910, Bellows Papers, Special Collections Department, Amherst College Library. Quoted with the permission of Jean Bellows Booth and the Library.

11. See the discussion of these two images in Doezema, *George Bellows and Urban America*, 188–96, and Rebecca Zurier, *Art for The Masses: A Radical Magazine and Its Graphics, 1911–1917* (Philadelphia: Temple University Press, 1988), 148.

12. The relationship between Sloan's art and his politics is discussed in detail in Zurier, *Art for The Masses*, 55–57.

13. See diary entry, 20 November 1908, in Bruce St. John, ed., *John Sloan's New York Scene: From the Diaries, Notes, and Correspondence 1906–1913* (New York: Harper & Row, 1965).

14. *The Woman's Page* appears on a list labeled "Exhibition at Centre Coffee House November 1915," which was written in Hebrew and English on the back of a kosher-restaurant menu, apparently in conjunction with an event sponsored by the People's Art Guild (John Weichsel Papers, Archives of American Art, Smithsonian Institution). The guild's activities are described in *Painting a Place in America: Jewish Artists in New York, 1900–1950*, exh. cat. (New York: Jewish Museum, 1991), 104–17.

15. Hutchins Hapgood, *The Spirit of the Ghetto: Studies in the Jewish Quarter of New York* (New York: Funk & Wagnalls, 1902); James Gibbons Huneker, *New Cosmopolis: A Book of Images* (New York: Charles Scribner's Sons, 1915), 68; Rupert Hughes, *The Real New York* (London: Smart Set, 1904), 240.

16. See the film *New York City "Ghetto" Fish Market* (Edison, 1903).

17. Letter from Sloan to G. H. Edgell, 9 February 1935, in the curatorial files of the Museum of Fine Arts, Boston.

18. Quotations are from Henri, "My People," *The Craftsman* 27 (February 1915): 459–69.

19. See the films *The Sandwich Man* (Biograph, 1902) and *A Street Arab* (Edison, 1898).

20. Leslie Fishbein discusses the problem of *The Masses'* treatment of African Americans in her introduction to Zurier, *Art for The Masses*, 15–20. For Luks, see the cartoon "Mose's Incubator," *New York World*, 30 January 1898, comics section, p. 5. For overviews of the depiction of African Americans in turn-of-the-century visual art and popular culture, see Guy C. McElroy et al., *Facing History: The Black Image in American Art*, exh. cat. (Washington, D.C.: Corcoran Gallery of Art, 1990); Jan Nederveen Pieterse, *White on Black: Images of Africa and Blacks in Western Popular Culture* (New Haven: Yale University Press, 1992); Robert Toll, *Blacking Up: The Minstrel Show in Nineteenth Century America* (New York: Oxford University Press, 1974).

21. Jerome Myers, quoted in Louis Baury, "The Message of Proletaire," *Bookman* 34 (December 1911): 404–09.

22. "Holiday Hoodlums," *New York Times*, 2 May 1905.

23. Suzanne Kinser, "Prostitutes in the Art of John Sloan," *Prospects* 9 (1984): 241–42, identified the women as prostitutes. Such an identification is questioned by Timothy Gilfoyle in *City of Eros: New York City, Prostitution, and the Commercialization of Sex, 1790–1920* (New York: Norton, 1992), 412.

24. Bruce Robertson illustrates this picture and compares it to Winslow Homer's paintings of the Maine coast in *Reckoning with Winslow Homer: His Late Paintings and Their Influence*, exh. cat. (Cleveland: Cleveland Museum of Art in cooperation with Indiana University Press, 1990).

25. Paul Boyer discusses "positive environmentalism" in *Urban Masses and Moral Order in America, 1820–1920* (Cambridge: Harvard University Press, 1978), chaps. 15–18.

26. See Michele H. Bogart, *Public Sculpture and the Civic Ideal in New York City, 1890–1930* (Chicago: University of Chicago Press, 1989).

27. Louis Windmuller, "Vexations of City Pedestrians," *Municipal Affairs* 6 (March 1902): 129–32. See also Charles Mulford Robinson, "Civic Improvements," and Edward R. Smith, "Baron Haussmann and the Topographical Transformation of Paris under Napoleon III," *Architectural Record* 22 (August 1907): 117–19, 120–33; Herbert Croly, however, criticized the "monotonous machine-made regularity of the newer Paris" ("What Is Civic Art?" *Architectural Record* 16 [July 1904]: 48).

28. The Municipal Art Commission and New York's zoning laws are discussed in Robert A. M. Stern et al., *New York 1900: Metropolitan Architecture and Urbanism, 1890–1915* (New York: Rizzoli, 1983); Giorgio Ciucci et al., *The American City: From the Civil War to the New Deal* (Cambridge: MIT Press, 1979); and Bogart, *Public Sculpture*.

29. Hubert Beck makes this point in "Urban Iconography in Nineteenth-Century American Painting: From Impressionism to the Ash Can School," in Thomas W. Gaehtgens and Heinz Ickstadt, eds., *American Icons: Transatlantic Perspectives on Eighteenth- and Nineteenth-Century American Art* (Santa Monica, Calif.: Getty Center for the History of Art and the Humanities, 1992), 319–48. His interpretation has been challenged (but not disproven) in William Gerdts, *Impressionist New York* (New York: Abbeville Press, 1994), and H. Barbara Weinberg, Doreen Bolger, and David Park Curry, *American Impressionism and Realism: The Painting of Modern Life, 1885–1915*, exh. cat. (New York: Metropolitan Museum of Art/Harry N. Abrams, 1994), 174. See also Wanda Corn, "The New New York," *Art in America* 61 (July–August 1973): 58–65.

30. Henry James, *The American Scene* (1907, repr. Bloomington: Indiana University Press, 1968): 114, 174, 117, 178. James visited New York in spring 1905.

31. "Presently the grass was so strewn with white frocks that at a little distance it looked as if household linen laid out to bleach had suddenly taken to skipping about." "Happy Youngsters Celebrate May Day," *New York World*, 2 May 1903, as cited in Sally Mills's entry for this painting in Marc Simpson, Sally Mills, and Jennifer Saville, *The American Canvas: Paintings from the Collection of the Fine Arts Museums of San Francisco* (New York: Hudson Hills Press, 1989), 204; see also her entry for the related painting *Little May Day Procession*, in *American Paintings from the Manoogian Collection*, exh. cat. (Washington, D.C.: National Gallery of Art, 1989), 180. On Central Park, see Roy Rosenzweig and Elizabeth Blackmar, *The Park and the People: A History of Central Park* (New York: Henry Holt, 1992).

32. *New York Times*, 30 June 1913, as cited in Rosenzweig and Blackmar, *The Park and Its People*, 407.

33. For the history of the growth of Christmas as a consumer festival, see Daniel J. Boorstin, *The Americans: The Democratic Experience* (New York: Random House, 1973), 158–62.

34. William Taylor discusses the impact of commercial culture on turn-of-the-century building in *In Pursuit of Gotham: Culture and Commerce in New York* (New York: Oxford University Press, 1992).

35. Mrs. Havemeyer bought *At the Milliner's* in 1899 and *Little Milliners* in 1911. In 1915 these pictures and Degas's *The Laundress* were included in a loan exhibition at Knoedler's gallery in New York. See Alice Cooney Frelinghuysen, *Splendid Legacy: The Havemeyer Collection*, exh. cat. (New York: Metropolitan Museum of Art, 1992).

36. David Nasaw, *Children of the City: At Work and at Play* (New York: Anchor, 1985), 11–16.

37. See Daniel Bluestone, "The Pushcart Evil," in David Ward and Olivier Zunz, eds., *The Landscape of Modernity: Essays on New York City, 1900–1940* (New York: Russell Sage Foundation, 1992), 287–312.

38. Glackens's son Ira described the making of the picture in his book *William Glackens and The Eight: The Artists Who Freed American Art* (New York: Horizon Press, 1957), 84–85, 170.

39. Peter Morse discusses the series in *John Sloan's Prints: A Catalogue Raisonné of the Etchings, Lithographs and Posters* (New Haven: Yale University Press, 1969), 134–38.

40. On ethnic enjoyment of entertainment, see Robert W. Snyder, *The Voice of the City: Vaudeville and Popular Culture in New York* (New York: Oxford University Press, 1989). Glackens's illustration depicts a concert saloon on Coney Island; Jimmy Durante described playing the piano in a similar establishment ca. 1906 in his memoir, *Schnozzola*. Suspected links with prostitution investigated by the American Vigilance Association are discussed in James Bronson Reynolds, "Commercialized Vice," *Survey* 31 (21 December 1913): 354.

41. Sean Wilentz, "Low Life, High Art," *The New Republic* 207 (28 September 1992): 41–44.

42. *A Bench in the Park* (Biograph, 1904); *Teasing* (Biograph, 1905).

43. On censorship in New York City in these years, see Frances Oppenheimer, "New York City's Censorship of Plays," *Theatre Magazine* 8 (May 1908): 134–36, and Daniel Czitrom, "The Politics of Performance: From Theater Licensing to Movie Censorship in Turn-of-the-Century New York," *American Quarterly* 44 (December 1992): 525–53. The Society for the Suppression of Vice, under the direction of Anthony Comstock, had been active in New York since the nineteenth century; among its targets were articles in *The Masses* and the painting *Fantasie Egyptienne*, which is discussed in the Introduction, note 7.

44. Rheta Childe Dorr, *What Eight Million Women Want* (Boston: Small Maynard, 1910); Barbara Meil Hobson, *Uneasy Virtue: The Politics of Prostitution and the American Reform Tradition* (Chicago: University of Chicago Press, 1990); statistics on working women in Margaret Gibbons Wilson, *The American Woman in Transition: The Urban Influence, 1870–1920* (Westport, Conn.: Greenwood Press, 1979).

45. I am indebted to Lisa Tickner's observation that "'Art' was itself complicit in the regulation of sexualities" and her stimulating discussion of art in the British suffrage movement of this period, in *The Spectacle of Women: Imagery of the Suffrage Campaign, 1907–1914* (Chicago: University of Chicago Press, 1988): 14 and passim.

46. Bernice Kramer Leader made this point in "The Boston Lady as a Work of Art," *Arts* 56 (January 1982): 112–19. See also Leila Bailey Van Hook, "Decorative Images of American Women: The Aristocratic Aesthetic of the Late Nineteenth Century," *Smithsonian Studies in American Art* 4 (Winter 1990): 45–69.

47. See Patricia Hills's important article, "John Sloan's Images of Working-Class Women," *Prospects* 5 (1980): 157–96.

48. Kathy Peiss, *Cheap Amusements: Working Women and Leisure in Turn-of-the-Century New York City* (Philadelphia: Temple University Press, 1986).

49. See Michael Kimmel on turn-of-the-century masculinity, in Harry Brod, ed., *The Making of Masculinities: The New Men's Studies* (Boston: Allen & Unwin, 1987).

50. Letter from Sloan to Clyde Burroughs, 15 April 1924, curatorial files, Detroit Institute of Arts. See also Hutchins Hapgood, "McSorley's Saloon," *Harper's Weekly* 58 (25 October 1913): 15; Grant Holcomb, "John Sloan and 'McSorley's Wonderful Saloon,'" *American Art Journal* 15 (Spring 1983): 5–20.

51. Jack London, *The Game* (New York: Macmillan, 1905), 150, 111.

52. Quotations are from "The Pennsylvania Academy," *New York Sun*, 5 February 1910, and "Auditors Held by Henri Two Hours," *Ohio State Journal*, 27 January 1911. See also Doezema, *Bellows*, 89–121.

53. Dorr, *What Eight Million Women Want*, 201–49.

54. See *The Social Evil with Special Reference to Conditions Existing in the City of New York* (New York: Putnam, 1902) and the review by Josephine Shaw Lowell in *Municipal Affairs* 6 (March 1902): 141–44; George Kneeland, *Commercialized Prostitution in New York City* (New York: Putnam, 1913); and Mark T. Connelly, *The Response to Prostitution in the Progressive Era* (Chapel Hill: University of North Carolina Press, 1980), 12–16.

55. Timothy Gilfoyle provides extensive discussion of the difference between perception and reality of the geographical distribution of prostitutes in *City of Eros*. In *Cheap Amusements*, Peiss cites the reports of vice squads in New York and the Boston *Report of the Massachusetts Commission for the Investigation of White Slavery* (1914): 15, 16; see also Kinser, "Prostitutes in the Art of John Sloan," 242–43.

56. Patricia Hills presents this interpretation in "John Sloan's Images," 174. See also Louis Baury, "The Message of Bohemia," *Bookman* 34 (November 1911): 261, 265.

57. See the discussion of Sloan's work in Gilfoyle, *City of Eros*, and Kinser, "Prostitutes in the Art of John Sloan." Kinser cites John Reed's story, "A Daughter of the Revolution," *The Masses* 6 (February 1915): 5–8.

58. "Barred from Memorial Hall," *Ohio State Journal*, 20 January 1911; "Negro Doctor Accused of Illegal Operation," *Ohio State Journal*, 21 January 1911; "Philadelphia Bars La Samaritaine," *New York American*, 1 February 1911; "Drape Statue with Plaster of Paris," *New York Evening Journal*, 25 January 1911; "Bill for Women's Votes," *Ohio State Journal*, 22 January 1911.

59. The illustrator Cornelia Barns, Abastenia Eberle (sculptor of street children), and painters Theresa Bernstein and Elizabeth Sparhawk-Jones are perhaps the best known. Henri had many female students, including Bessie Marsh and Amy Londoner; several contributed street images to an exhibition that attracted some press attention in 1906, but little is known of their work after that time.

60. She sold two of the drawings to the well-known collector John Quinn, an accomplishment Sloan pursued but was never able to achieve. Edith's suffragist activities are described in Glackens, *William Glackens and The Eight*, 184–86.

61. See Pamela Allara, *Alice Neel: Exterior/Interior*, exh. cat. (Medford, Mass.: Tufts University Art Gallery, 1991); on Bishop, see Ellen Todd, *The New Woman Revised: Painting and Gender Politics on Fourteenth Street* (Berkeley: University of California Press, 1993). Among the women who studied with Ashcan artists at the Art Students League were Elizabeth Olds and Peggy Bacon, who both became well-known printmakers.

62. Roy Rosenzweig, private communication with the authors, 22 October 1994; see also Iris Marion Young, "The Ideal of Community and the Politics of Difference," in Linda J. Nicholson, ed., *Feminism/Postmodernism* (New York: Routledge, 1990).

63. George Chauncey, *Gay New York: Gender, Urban Culture, and the Making of the Gay Male World 1890–1940* (New York: Basic, 1994), 131–34.

MANUFACTURING REBELLION

1. Oliver Larkin, *Art and Life in America* (New York: Rinehart, 1949), 336.

2. The *Philadelphia Press* (29 March 1900) reported that Shinn had sold fourteen works and had offers for several more. See Everett Shinn Papers, Archives of American Art, microfilm roll D179: 7. Shinn himself said later that twenty-two works were sold "to Mrs. Gould and Mrs. Astor and Mrs. Vanderbilt—everybody social. I don't know if they liked 'em, but they'd do anything [Stanford] White—that red-headed wild man—told 'em to." Shinn, quoted in Aline Loucheim, "Last of 'The Eight' Looks Back," *New York Times*, 2 November 1952, Shinn Papers, D179: 180.

3. Elizabeth Milroy, *Painters of a New Century: The Eight & American Art*, exh. cat. (Milwaukee: Milwaukee Art Museum, 1991), 17.

4. See Marianne Doezema, *George Bellows and Urban America* (New Haven: Yale University Press, 1992); H. Barbara Weinberg, Doreen Bolger, and David Park Curry, *American Impressionism and Realism: The Painting of Modern Life, 1885–1915* (New York: Metropolitan Museum of Art/Harry N. Abrams, 1994); and Michael Quick, Jane Myers, Marianne Doezema, and Frank Kelly, *The Paintings of George Bellows* (New York: Harry N. Abrams, 1992).

5. For a fascinating discussion of the background of the *New York Sun* papers, see John Loughery, "The *New York Sun* and Modern Art in America: Charles FitzGerald, Frederick James Gregg, James Gibbons Huneker, Henry McBride," *Arts Magazine* 59 (December 1984): 77–82.

6. Charles FitzGerald, "Society of American Artists.—I," *New York Evening Sun*, 29 March 1901, in Charles FitzGerald scrapbooks, Archives of American Art, 30–31.

7. Edith DeShazo reports that Shinn's first show at Boussod, Valadon & Company ran from 17 November through 15 December 1899 and that the show in late February through early April was his second. See Edith DeShazo, *Everett Shinn, 1876–1953: A Figure in His Time* (New York: Clarkson N. Potter, 1974), 213.

8. *New York Commercial Advertiser*, 26 February 1900, in Shinn Papers, D179: 7.

9. *New York Evening Post*, 24 February 1900, Shinn Papers, D179: 7.

10. According to an article in Shinn's scrapbook, buyers included Miss Gilder, William Merritt Chase, Mr. C. B. Alexander, Mr. B. F. Perkins, and "many others." See "The Heart of the Town," apparently clipped from *Notes on Art*, 16 March 1900, Shinn Papers, D179: 10.

11. After his return from Europe, Shinn's next exhibition at Boussod, Valadon featured "Paris and New York Types," which was almost as well received as his 1900 show. Reviewers were generally less enthusiastic about the Paris subjects than the American scenes, although his ability to capture moving crowds of people and life in Paris "dives" continued to mark him as a young artist of great promise, even if his drawing and handling of color still needed improvement.

12. In the next several years Shinn had two more exhibitions at Boussod, Valadon; a show at M. Knoedler & Company; one at Durand Ruel's New York gallery; and another at E. Gimpel and Wildenstein. Reviews continued to commend his growing talent and ability. He also regularly sent work to the annuals and fellowship exhibitions at the Pennsylvania Academy of the Fine Arts and other museums around the country. His early commercial success was short-lived, however. After 1905, and until 1943, he had only one other solo show, at the Union League Club in 1911.

13. Regina Armstrong, "The New Leaders in American Illustration," *The Bookman* (May 1900): 244–51. Armstrong emphasized the "radical" nature of the art of Shinn, Luks, Glackens, F. C. Yohn, and Henry McCarter. She stated that Glackens set out early to be a "revolutionist in art" because he rejected the idea of art schools. The same idea was repeated in her discussion of Luks and Shinn, but did not suggest that the subject matter of their work was out of the ordinary, except in its "sincerity and simplicity."

14. Armstrong, "The New Leaders in American Illustration," 251.

15. P. M. D., "George Luks, 1866–1933," in *City Life Illustrated, 1890–1940: Sloan, Glackens, Luks, Shinn—Their Friends and Followers*, exh. cat. (Wilmington: Delaware Art Museum, 1980), 65.

16. Charles de Kay identified *Prizefighter* as a portrait of boxer Yank Sullivan. See Charles de Kay, "George Benjamin Luks, Arch Impressionist," *New York Times*, 4 June 1905, sec. 10, 6.

17. Charles FitzGerald, "George B. Luks, Painter," *New York Evening Sun*, 10 May 1902.

18. See Nancy E. Allyn and Elizabeth H. Hawkes, *William Glackens: A Catalogue of His Book and Magazine Illustrations* (Wilmington: Delaware Art Museum, 1987).

19. For a fascinating discussion of turn-of-the-century magazines, including their focus and readership, see Rebecca Zurier, *Picturing the City: New York in the Press and the Art of the Ashcan School, 1890–1917*, Ph.D. diss., Yale University, 1988, chap. 2.

20. An unidentified clipping noted Henri's return to New York and described him as a "regular exhibitor at the salon" who was known in France equally well for figure painting and street scenes. See "Studies of Street Scenes. Robert Henri Will Portray Life in This City," in Henri vertical file, National Museum of American Art (hereafter NMAA) library.

21. For an extended discussion of the history of Macbeth Galleries, see Gwendolyn Owens, "Art and Commerce: William Macbeth, The Eight and the Popularization of American Art," in Milroy, *Painters of a New Century*, 61–84.

22. "Around the Galleries, Pictures by Robert Henri at Macbeth's," *New York Sun*, 6 April 1902, 8.

23. When *Cumulus Clouds, East River* was shown in Henri's solo exhibition in Philadelphia later in the year, a reviewer wrote that "the noteworthy feature [of the painting] is the poetic appreciation of the scene's real beauty of color and arrangement. The sky is flooded with sunlight and each cloud is transparent." See "Notable Specimens of Robert Henri's Brush on Exhibition. Brilliant Exhibition of Modern Art, Work of a Philadelphian, Shown at Academy of the Fine Arts," *Philadelphia North American*, 16 November 1902, Robert Henri Papers, Archives of American Art, 887: 114, courtesy of Mrs. John C. Leclair.

24. "An Exhibition of Fine Paintings," *Great Round World, New York*, 12 April 1902, in Henri vertical file, NMAA library.

25. Charles FitzGerald, "Mr. Robert Henri and Some 'Translators,'" *New York Evening Sun*, 2 April 1902, in Henri vertical file, NMAA library.

26. Unidentified author and title, *New York Globe and Commercial Advertiser*, 19 December 1902, in Henri Papers, 887: 131.

27. Although the press celebrated Sloan's etchings of New York City life, the American Water Color Society returned four of the images he submitted to the May 1906 exhibition as being too vulgar to exhibit. See David W. Scott and E. John Bullard, *John Sloan, 1871–1951* (Washington, D.C.: National Gallery of Art, 1971), 87.

28. For exhibition histories, see Rowland Elzea, *John Sloan's Oil Paintings, A Catalogue Raisonné*, part 2 (Newark: University of Delaware Press, 1991), 445ff; Valerie Ann Leeds, *My People: The Portraits of Robert Henri*, exh. cat. (Orlando: Orlando Museum of Art, 1994), 113–14; DeShazo, *Everett Shinn*; Peter Hastings Falk, *The Annual Exhibitions of the National Academy of Design, 1901–1950* (Madison, Conn.: Sound View Press, 1990).

29. The other artists included were Van Deering Perrine, F. Fuhr, Willard D. Price, and Alfred H. Maurer. Glackens showed a dancer; Henri sent a night scene with Japanese lanterns, a *café-chantant* with ballet girls from his Paris years, and a village street; Sloan was represented by two portraits and *Walnut Street Theater, Philadelphia*.

30. At the turn of the century, the opportunities to exhibit in New York were fairly limited. The extensive network of galleries that would exist only fifteen years later had not yet emerged. The annual exhibitions of the National Academy of Design and the Society of American Artists, as well as annual shows in Pittsburgh, Chicago, Philadelphia, Boston, and several other cities, offered the best chances for showing new work. Although gallery representation was not unknown, except for William Macbeth few dealers were prepared to risk showing the work of relatively unknown American painters. Clubs offered an opportunity that was energetically pursued by the Ashcan artists. The Colonial Club, the National Arts Club, and the Lotos Club all provided venues for them during the first several years of the century. Shinn, who had shown pastels at the National Arts Club in April 1900 in a two-person show with William Merritt Chase, was perhaps the first member of the group to participate in a club exhibition. The two landscapes Henri showed were *Rain Storm, Wyoming Valley* and *The Rain Clouds*.

31. Henri Pène du Bois, "Sage Paintings at the Society," *New York American*, 28 March 1903, Henri Papers, 887: 160.

32. *Town Topics* identified the artists as part of a "new movement," praising Glackens's *Coney Island* and calling Luks's studies of Gansevoort Dock "masterful." Henri's portrait was a "sustained, reposeful piece of work, low in tone, masterly in drawing, and built to endure." See The Expert [identified in a handwritten note on the clipping as Mrs. Ford], "The Oldest Thing in Art," *Town Topics*, 2 April 1903, Henri Papers, 887: 167. The Ashcan artists' main detractor was Arthur Hoeber, critic for the *New York Globe and Commercial Advertiser*. A staunch supporter of impressionism, and himself a painter who exhibited at the academy, Hoeber could not accept the dark tonalities of Henri's paintings and had reservations about Glackens's ballet dancers. In contrast, FitzGerald remarked in the *New York Evening Sun* that the "positive" in Glackens's work was his "interest in the life around him" and his "lively interest in humanity." Glackens, he said, was an artist of "pronounced individuality" and a painter of "more than ordinary ability." He also noted Henri's "keen attention to life." See Charles FitzGerald, "The Society of American Artists," *New York Evening Sun*, 3 April 1903, 4.

33. Ibid.

34. "Six Painters in a Club Show," *New York Evening Mail and Express*, 25 January 1904, 5.

35. Glackens exhibited stage dancers, portraits, and East River scenes; Sloan was represented by *Independence Square, Philadelphia* and *Woman Sewing*.

36. "Paintings Worth Seeing and Some Others," *New York Evening Telegram*, 21 January 1904, in Henri vertical file, NMAA library. Arthur Hoeber, who had described the Allan Gallery show in 1901 as dreary, had gained greater appreciation for the artists' works in the intervening years. He came to see value in Henri's portraits and called Glackens's *Ballet Girl in Pink* a "sterling good performance." Still, he criticized them for depicting the "dreary, the sad, and the bitter," and was particularly distressed by Luks's work. See Hoeber, "Art and Artists: A Most Lugubrious Show at the National Arts Club," *New York Globe and Commercial Advertiser*, 21 January 1904, in Henri vertical file, NMAA library.

37. "Colonial Club's Art Show," *New York Mail and Express*, 3 April 1903, Henri Papers, 887: 168.

38. Of Glackens, FitzGerald wrote, "It may be doubted if any other artist of such recent growth has had so considerable an influence on those about him, and if the evidence of certain paintings here by other hands seems insufficient, we invite any one to pick up one or two of the current magazines and examine the illustrations: if they do not find some reflection of Glackens, the chances are that there are no decent illustrations at all." FitzGerald called him one of the few "strong men" among the painters, with a "very definite personality . . . [a] well-ordered mind and steady intention." He also emphasized Glackens's importance as an illustrator, stating, "The beauty and truth, the science and simplicity, the well-controlled art and abounding life of his *May Day* [fig. 154] should be sufficient to establish his worth and excellence; Mr. Glackens is one of the vital forces in our art today." See Charles FitzGerald, "Certain Painters at the Society," *New York Evening Sun*, 1 April 1905, in Henri vertical file, NMAA library.

39. "From the Easels of Many Artists," *New York Herald*, 11 February 1906, literature and art sec. 3.

40. Charles FitzGerald, "Art Exhibitions of the Week," *New York Evening Sun*, 24 February 1906, in Henri vertical file, NMAA library.

41. The process of ranking submissions and determining what would be installed was complicated. Juries went through the hundreds of paintings submitted to annual exhibitions several times. The works that were accepted were given first-, second-, or third-place rankings to reflect the committee's decision about their relative merits. The hanging committee then arranged placement in the galleries, with first-rank pictures placed at eye level in the most prestigious rooms. Second-rank paintings were then placed, and as many third-rank paintings as would fit were included. It was possible for a painting to be accepted for the exhibition, but not installed for lack of room. Several days after the jury members for the 82nd annual concluded their deliberations, they gathered to review the work of the hanging committee. Henri noted the absence of two third-rank pictures that should have been given a place. They were retrieved and placed on the wall, but were subsequently removed because, it was reported, they were not in keeping with the general "tone" of the room.

42. The *New York Press* critic noted "how strongly this protest was needed the present exhibition shows full well." See W. B. McC. [William B. McCormick?], *New York Press*, 17 March 1907, Henri Papers, 887: 397.

43. "Art Topics of an Important Week. The Academy and Its Slaughter of Candidates," *New York Evening Mail*, 18 April 1907; "Doors Slammed on Painters. National Academy Rejects 33 Artists out of 36," *New York Sun*, 12 April 1907, 1.

44. Throughout the spring of 1907, Henri emerged as a champion of the innovators and, ironically, the potential savior of the National Academy. Charles de Kay, though not entirely sympathetic, called for a new organization: "Let the younger outsiders come together and form a new organization of a lively, militant sort which will attract innovators and at the same time keep the Academicians from going to sleep by holding them to the necessity of doing their very best. That is the way to interest the public and put life into every studio." See Charles de Kay, "Artists at Their Little Games. The Academy Would Be Better Served by Live Outside Opposition Than Squabbles Started by Discontented Juryman," *New York Times*, 17 March 1907, part x, 5. Two months later the *Evening Sun* noted the formation of an "independent group of eight painters" described as individualists. See "The Eight," *New York Evening Sun*, 15 May 1907, 6.

45. See "Protests Against Psychopathic Art. Mr. Vezin Breaks a Lance for Beauty Against What He Considers Ugliness," newspaper clipping identified as *New York Herald*, April 1907, and "Another Blow at Art. Robert Henri Recipient. Charles Vezin Adds Physical to Artist's Mental Anguish," *New York Globe and Commercial Advertiser*, labeled April 1907. Both clippings are in the Henri vertical files, NMAA library.

46. Samuel Swift, "Revolutionary Figures in American Art," *Harper's Weekly* 51 (13 April 1907), 534–36.

47. See, for example, "A New Art Group: Eight Painters Join to Give Annual Exhibitions," *New York Times*, 15 May 1907, 7; "The Eight," *New York Evening Sun*, 15 May 1907, 6; "New Art Salon without a Jury: Eight Artists Form Association in Opposition to the National Academy of Design," *New York Herald*, 15 May 1907, 11.

48. "Eight Independent Painters to Give an Exhibition of Their Own Next Winter: Not an Academy of the Rejected, but an Organization of Men Who Paint Things as They See Them—Not Members of One School—One Exhibition Before," *New York Sun*, 15 May 1907, 5.

49. Ibid.

50. Huneker wrote for a number of magazines and newspapers during the first decade of the century and published several books. For a discussion of his biography and a compendium of his writings on American art, literature, and music, see Arnold T. Schwab, ed., *Americans in the Arts, 1890–1920* (New York: AMS Press, 1985), xxi–lxv.

51. James Gibbons Huneker, "George Luks," *New York Sun*, 21 March 1907, 8.

52. John Spargo, "George Luks, An American Painter of Great Originality and Force, Whose Art Relates to All the Experiences and Interests of Life," *The Craftsman* 12 (September 1907): 600–01.

53. *New York Globe and Commercial Advertiser*, 16 March 1907, 10.

54. "Art. Impressions of the Spring Academy," *The Nation* 84 (28 March 1907): 298.

55. James Gibbons Huneker, "Around the Galleries," *New York Sun*, 25 April 1908, 8.

56. "George Bellows, An Artist with 'Red Blood,'" *Current Literature* 53 (September 1912): 342.

57. "Academy Exhibition," *New York Sun*, 23 December 1907, 4. J. Nilsen Laurvik wrote that Bellows's *Pennsylvania Excavation* and *Club Night* were presented in a "manly, uncompromising manner that gives cause for regret that so little opportunity is afforded the public to see and judge the work of these men who in more than one instance will be the masters of tomorrow." See Laurvik, "The Winter Exhibition of the National Academy of Design," *International Studio* 33 (February 1908): CXLII.

58. Charles de Kay, "Noisy and Quiet Art," *New York Evening Post*, 6 January 1908, 7.

59. James Gibbons Huneker, "Around the Galleries," *New York Sun*, 14 January 1908, 6.

60. "Striking Pictures by Eight 'Rebels,'" *New York Herald*, 4 February 1908, 9.

61. Charles de Kay, "Art Notes: The 'Eight' at Macbeth's," *New York Evening Post*, 1 February 1908, 5; and "Eight-man Show at Macbeth's," *New York Evening Post*, 7 February 1908, 5.

62. As Bellows and Luks claimed the limelight, Henri's reputation suffered a bit of tarnish. In November 1907, the press reported that William Merritt Chase had resigned from the New York School of Art, which he had founded and which originally bore his name. Henri's continued denigration of the artistic values that Chase believed in had finally pushed the school's founder beyond the point of exasperation. Chase's departure left Henri as the most visible and popular member of the school's faculty. The press described the split as a dispute between Chase and the "iconoclastic" Henri, whose teaching was "too modern for the former head of the institution." Widely regarded as one of the country's leading painters, Chase was credited with attracting Henri to the school four years earlier. Given the high regard in which Chase was held, it was impossible for the press to characterize Henri as either victim or hero. Rather, Henri was quoted as saying, "If my ideas are revolutionary, I can only point to my following as the best proof that they have found acceptance." See "Chase, Nettled, Leaves Art School He Founded. Disapproves of Robert Henri's Revolutionary Methods and Joins Art Students' League," *New York World*, 21 November 1907, 8.

63. Joseph Edgar Chamberlin, "Academy's Annual Exhibition," *New York Evening Mail*, 13 March 1909.

64. M. [Frank Jewett Mather?], "Art. National Academy Pictures," *The Nation* 89 (16 December 1909): 607–09.

65. Joseph Edgar Chamberlin. "Good Art Exhibitions. A Splendid Picture by George Luks," *New York Evening Mail*, 18 April 1910, 9.

66. James Gibbons Huneker, "Around the Galleries. The Luks Pictures," *New York Sun*, 20 April 1910, 8.

67. Henry Tyrrell, "The Battle of the Artists. How the 'Art Rebels' of America Are Shocking the Older Schools by Actually Putting Prize Fights on Canvas and Picturing Up-to-Date Life As It Really Is Here and Now," *The World Magazine*, 5 June 1910.

68. Florence Barlow Ruthrauff, "His Art Shows 'The Big Intention,'" *New York Morning Telegraph*, 2 April 1911, magazine section, 2.

69. Quoted in Marianne Doezema, "The 'Real' New York," in *The Paintings of George Bellows*, 106.

70. "Art Notes. 'Insurgents' at the Union League Club," *New York Post*, 15 April 1911, in Henri vertical file, NMAA library.

NOTES TO THE FIGURE CAPTIONS

Fig. 3. Bruce St. John, ed., *John Sloan's New York Scene: From the Diaries, Notes, and Correspondence 1906–1913* (New York: Harper & Row, 1965), diary entries for 26, 10, 13 May 1909.

Fig. 35. James H. Tuckerman, "Park Driving," *Outing* 46 (June 1905): 259.

Fig. 63. Sloan, quoted in Peter Morse, *John Sloan's Prints: A Catalogue Raisonné of the Etchings, Lithographs, and Posters* (New Haven: Yale University Press, 1969), 177.

Fig. 70. "Art and Artists," *Philadelphia Press*, 8 April 1900 .

Fig. 72. *John Sloan's New York Scene*, diary entry for 17 May 1910.

Fig. 77. Mary White Ovington, *Half a Man: The Status of the Negro in New York* (London: Longman, 1911), 64.

Fig. 78. "Life in New York as Pictured by Luks," *New York American*, 21 January 1918.

Fig. 82. "An Impression of the Spring Academy," *The Craftsman* 20 (May 1911): 151.

Fig. 102. Letter from Shinn in curatorial files, The Phillips Collection, and interview with Aline B. Loucheim, "Last of 'The Eight' Looks Back," *New York Times*, 2 November 1952.

Fig. 105. "Coming Polo Season Will Be the Greatest America Has Seen," *New York Herald*, 17 April 1910.

Fig. 109. "Congestion of City on View," *New York Globe*, 3 March 1908.

Fig. 113. *John Sloan's New York Scene*, diary entry for 16 September 1907.

Fig. 128. Gene Fowler, *Schnozzola: The Story of Jimmy Durante* (New York: Viking, 1951), 11; Mrs. Isaac L. Rice, "For a Safe and Sane Fourth," *Forum* 43 (March 1910): 217–37.

Fig. 131. Curatorial files, Munson-Williams-Proctor Institute, Museum of Art, Utica, New York.

Fig. 136. Ovington, *Half a Man*, 41, 68; "'San Juan Hill' Purged," *New York Evening Post*, 8 February 1908.

Fig. 138. "*Willie Gee* by Robert Henri," *Harper's Weekly* 58 (21 February 1914): 2.

Fig. 143. *John Sloan's New York Scene*, diary entry for 21 June 1911.

Fig. 146. *John Sloan's New York Scene*, diary entry for 11 November 1911.

Fig. 164. *John Sloan's New York Scene*, diary entries for 5, 6, 7, 10, 11 June 1907; Rainer Crone, *Andy Warhol* (New York: Praeger, 1967), 54.

Fig. 167. *John Sloan Paintings and Prints*, exh. cat. (Hanover, N.H.: Dartmouth College, 1946), no. 34.

Fig. 176. "New York Types—The Spieler," *New York World*, 23 January 1898; Hutchins Hapgood, *Types from City Streets* (New York: Funk & Wagnalls, 1910), 134–35; James Gibbons Huneker, "George Luks, Versatile Painter of Humanity," *New York Times Magazine*, 6 February 1916, 13; "Two Admired of Robert Henri," *New York Herald*, 31 March 1907.

Fig. 177. "Mr. Luks' 'Wrestlers' Gripping Realism," *New York Herald*, 19 April 1910.

Fig. 179. "Attell from Start to Finish," *New York Globe*, 11 April 1907.

Fig. 194. *John Sloan's New York Scene*, diary entries for 28 April 1909, 9 March 1910; "News·and Notes of the Art World," *New York Times Magazine*, 17 April 1910; "Other Exhibitions," *New York Times Magazine*, 23 April 1917.

Fig. 198. Unidentified newspaper clipping labeled "1907?" but after 1912, vertical files, National Museum of American Art library; Harold Brodkey, "The Second Skin," *The New Yorker* 70 (7 November 1994): 115.

Fig. 201. "Two Other Battles on the Docks," *New York Globe*, 11 May 1907; George Chauncey, *Gay New York: Gender, Urban Culture, and the Making of the Gay Male World, 1840– 1940* (New York: Basic Books, 1994), 189.

Fig. 203. Hutchins Hapgood, "McSorley's Saloon," *Harper's Weekly* 58 (25 October 1913): 15.

Fig. 211. Letter to William Macbeth, 10 September 1900, cited in Bennard Perlman, *Robert Henri: His Life and Art* (New York: Dover, 1991), 45.

PHOTOGRAPH CREDITS

Fig. 50: Geoffrey Clements, New York, © 1994

Figs. 67, 90, and 105: Peter A. Juley and Son Archive, National Museum of American Art

Fig. 72: Michael McKelvey

Figs. 73 and 74: Gerhard Heidersberger

Fig. 98: Edward Owen

Fig. 110: Joseph Szaszfai

Fig. 115: Lynn Rosenthal, 1995

Figs. 159 and 183: Lee Stalsworth

EXHIBITION CHECKLIST

GEORGE BELLOWS (1882–1925)

River Rats, 1906, oil on canvas, 77.5 x 97.8 cm (30 ½ x 38 ½ in.). Private collection, Washington, D.C.

The Knock-Out, ca. 1907, pastel and india ink on paper, 53 x 70 cm (21 x 27 ½ in.). Collection of Rita and Daniel Fraad

Pennsylvania Excavation, 1907, oil on canvas, 86.4 x 111.8 cm (34 x 44 in.). Private collection

Tin Can Battle, San Juan Hill, New York, 1907, crayon, ink, and charcoal on paper, 53.3 x 61.6 cm (21 x 24 ¼ in.). Sheldon Memorial Art Gallery, University of Nebraska–Lincoln, UNL–F. M. Hall Collection, 1947.H-272

Excavation at Night, 1908, oil on canvas, 86.4 x 111.8 cm (34 x 44 in.). Berry-Hill Galleries, New York

Paddy Flannigan, 1908, oil on canvas, 76.2 x 63.5 cm (30 x 25 in.). Erving and Joyce Wolf Collection

Steaming Streets, 1908, oil on canvas, 97.5 x 76.8 cm (38 ⅜ x 30 ¼ in.). Santa Barbara Museum of Art, Gift of Mrs. Sterling Morton for the Preston Morton Collection

Stag at Sharkey's, 1909, oil on canvas, 92 x 122.6 cm (36 ¼ x 48 ¼ in.). The Cleveland Museum of Art, Hinman B. Hurlbut Collection

New York, 1911, oil on canvas, 106.7 x 152.4 cm (42 x 60 in.). National Gallery of Art, Washington, D.C., Collection of Mr. and Mrs. Paul Mellon

Splinter Beach, 1911, pencil, black crayon, pen and ink, and ink wash on wove paper, 43.7 x 58.3 cm (17 ³⁄₁₆ x 22 ¹⁵⁄₁₆ in.). Boston Public Library, Print Department

Men of the Docks, 1912, oil on canvas, 114.3 x 161 cm (45 x 63 ½ in.). Maier Museum of Art, Randolph-Macon Woman's College, Lynchburg, Virginia, First purchase of the Randolph-Macon Art Association, 1920

Business Men's Class, 1913, monotype with ink, crayon, graphite, and collage, 41.9 x 65.4 cm (16 ½ x 25 ¾ in.). Courtesy of the Boston Public Library, Print Department, Gift of Albert H. Wiggin

A Day in June, 1913, oil on canvas, 106.7 x 121.9 cm (42 x 48 in.). The Detroit Institute of Arts, Detroit Museum of Art Purchase, Lizzie Merrill Palmer Fund

Why don't they all go to the country for vacation?, 1913, lithograph, pen, and crayon, 63.5 x 57.2 cm (25 x 22 ½ in.). Los Angeles County Museum of Art, Los Angeles County Fund

Luncheon in the Park, ca. 1913, ink wash on paper, 42.5 x 52.7 cm (16 ¾ x 20 ¾ in.). Albright-Knox Art Gallery, Buffalo, New York

The Newsboy, 1916, oil on canvas, 76.5 x 56.2 cm (30 ⅛ x 22 ⅛ in.). The Brooklyn Museum, New York, Gift of Mr. and Mrs. Daniel Fraad, Jr.

Preliminaries to the Big Bout, 1916, lithograph, 40 x 49.8 cm (15 ¾ x 19 ⅝ in.). National Gallery of Art, Washington, D.C., Andrew W. Mellon Fund

WILLIAM GLACKENS (1870–1938)

Fruit Stand, Coney Island, ca. 1898, oil on canvas, 64.8 x 80.6 cm (25 ½ x 31 ¾ in.). Kraushaar Galleries, New York

Hammerstein's Roof Garden, 1901, oil on canvas, 76.2 x 63.5 cm (30 x 25 in.). Whitney Museum of American Art, New York, Purchase 53.46

Beach, Coney Island, 1902, crayon and chinese white, 56.5 x 73.7cm (22 ¼ x 29 in.). Arkansas Arts Center Foundation

May Day, Central Park, ca. 1905, oil on canvas, 63.8 x 76.8 cm (25 ⅛ x 30 ¼ in.). The Fine Arts Museums of San Francisco, Gift of the Charles E. Merrill Trust with matching funds from The de Young Museum Society, 70.11

Patriots in the Making, 1907, charcoal and watercolor on paper, 81 x 64 cm (32 x 25 ⅛ in.). Collection of Mr. and Mrs. Thomas P. O'Donnell

Figure Sketches Number 2, ca. 1907, chalk, 38.1 x 57.8 cm (15 x 22 ¾ in.). National Museum of American Art, Gift of Mr. and Mrs. Ira Glackens

Curb Exchange, 1907–10, gouache and conté crayon, 67.3 x 46 cm (26 ½ x 18 in.). Museum of Art, Fort Lauderdale, Florida, Ira Glackens Bequest

Skating in Central Park, ca. 1910, oil on canvas, 63.5 x 76.2 cm (25 x 30 in.). Kraushaar Galleries, New York

Far from the Fresh Air Farm, 1911, carbon pencil and watercolor on paper, 64.8 x 43.2 cm (25 ½ x 17 in.). Museum of Art, Fort Lauderdale, Florida, Ira Glackens Bequest

A Football Game, 1911, black ink, 61 x 45.7 cm (24 x 18 in.). Private collection

Christmas Shoppers, Madison Square, 1912, crayon and watercolor on paper, 44.5 x 77 cm (17 ½ x 31 in.). Museum of Art, Fort Lauderdale, Florida, Ira Glackens Bequest

March Day–Washington Square, 1912, oil on canvas, 63.5 x 76.2 cm (25 x 30 in.). Private collection, Washington, D.C.

Patrick Joseph Went and Bought Himself a Grocery Store in Monroe Street, 1912, ink and graphite on board, 53 x 36.1 cm (20 ⅞ x 14 ¼ in.). Collection of Jane Collette Wilcox

Washington Square, 1913, charcoal, pencil, colored pencil, gouache, and watercolor, 73.9 x 56.2 cm (29 x 22 in.). The Museum of Modern Art, New York, Gift of Abby Aldrich Rockefeller

ROBERT HENRI
(1865–1929)

Cumulus Clouds, East River, 1901–02, oil on canvas, 63.5 x 80.6 cm (25 x 31 ¾ in.). Collection of Rita and Daniel Fraad

Portrait of Willie Gee, 1904, oil on canvas, 79.4 x 66.7 cm (31 ¼ x 26 ¼ in.). Collection of The Newark Museum, Purchase 1925

Salome, 1909, oil on canvas, 195.6 x 94 cm (77 x 37 in.). Mead Art Museum, Amherst College, Massachusetts, Museum purchase, 1973.68

GEORGE LUKS
(1866–1933)

The Amateurs, 1899, oil on canvas, 61 x 45.7 cm (24 x 18 in.). Private collection

Widow McGee, 1902, oil on canvas, 61 x 45.7 cm (24 x 18 in.). Joslyn Art Museum, Omaha, Nebraska

The Old Rosary Woman of Catherine Street, New York City, 1915, ink on paper, 43.3 x 20.5 cm (17 ⅟₁₆ x 8 ⅟₁₆ in.). Munson-Williams-Proctor Institute, Museum of Art, Utica, New York

Hester Street, 1905, oil on canvas, 66.3 x 91.8 cm (26 ⅛ x 36 ⅛ in.). The Brooklyn Museum, New York, Dick S. Ramsay Fund

The Spielers, 1905, oil on canvas, 92 x 66.7 cm (36 ⅛ x 26 ¼ in.). Addison Gallery of American Art, Phillips Academy, Gift of anonymous donor, 1931.9

Allen Street, ca. 1905, oil on canvas, 81.3 x 114.3 cm (32 x 45 in.). Hunter Museum of American Art, Chattanooga, Tennessee, Gift of Miss Inez Hyder

Market Place, undated, graphite on paper, 20.1 x 25.8 cm (7 ⅞ x 10 ⅛ in.). Hirshhorn Museum and Sculpture Garden, Gift of Joseph H. Hirshhorn, 1966

Cake Walk, 1907, monotype, 12.7 x 17.8 cm (5 x 7 in.). Delaware Art Museum, Gift of Helen Farr Sloan

Knitting for the Soldiers: High Bridge Park, ca. 1918, oil on canvas, 76.7 x 92 cm (30 ³⁄₁₆ x 36 ⅛ in.). Daniel J. Terra Collection, 2.1990

EVERETT SHINN
(1876–1953)

Barges on the East River, 1898, charcoal and wash on paper, 50.8 x 68.6 cm (20 x 27 in.). Private collection, New York

Cross Streets of New York, 1899, charcoal, watercolor, pastel, white chalk, and chinese white on paper, 55.3 x 74.3 cm (21 ⅝ x 29 ¼ in.). Corcoran Gallery of Art, Gift of Margaret M. Hitchcock by exchange

Spoiling for a Fight, New York Docks, 1899, pastel and watercolor on board, 55.9 x 74.9 cm (22 x 29 ½ in.). Milwaukee Art Museum, Gift of Mr. and Mrs. Donald B. Abert and Mrs. Barbara Abert Tooman

Tenements at Hester Street, 1900, watercolor, gouache, and ink on paper, 21 x 33 cm (8 ¼ x 13 in.). The Phillips Collection, Washington, D.C., acquired 1943

The Docks, New York City, 1901, pastel on paper, 39.4 x 55.9 cm (15 ½ x 22 in.). Munson-Williams-Proctor Institute, Museum of Art, Utica, New York

Trapeze, Winter Garden, 1903, oil on canvas, 49.5 x 58.8 cm (19 ½ x 23 ⅛ in.). Private collection, Washington, D.C.

Eviction, 1904, gouache on paper mounted on board, 21.3 x 33.3 cm (8 ⅜ x 13 ⅛ in.). National Museum of American Art, Bequest of Henry Ward Ranger through the National Academy of Design

Night Life—Accident, 1908, pastel, watercolor, and gouache on paper, 33 x 43.8 cm (13 x 17 ¼ in.). Private collection

Footlight Flirtation, 1912, oil on canvas, 75 x 92.7 cm (29 ½ x 36 ½ in.). Collection of Mr. Arthur G. Altschul

Park Row, Morning Papers, undated, pencil, charcoal, watercolor, and gouache, 21.6 x 33 cm (8 ½ x 13 in.). Private collection

Sixth Avenue Shoppers, undated, pastel and watercolor on board, 53.3 x 67.3 cm (21 x 26 ½ in.). Santa Barbara Museum of Art, Gift of Mrs. Sterling Morton for the Preston Morton Collection

JOHN SLOAN
(1871–1951)

Fun, One Cent, 1905, from the series "New York City Life," etching, 12.5 x 17.6 cm (4 ¹⁵/₁₆ x 6 ¹⁵/₁₆ in.). National Museum of American Art, Gift of Ann Kraft

Man Monkey, 1905, from the series "New York City Life," etching, 11.4 x 17.1 cm (4 ½ x 6 ¾ in.). National Gallery of Art, Washington, D.C., Gift of Mrs. Peter D'Albert

Turning Out the Light, 1905, from the series "New York City Life," etching, 12.7 x 17.8 cm (5 x 7 in.). National Museum of American Art, Bequest of Frank McClure

The Woman's Page, 1905, from the series "New York City Life," etching, 12.7 x 17.8 cm (5 x 7 in.). National Museum of American Art, Bequest of Frank McClure

Fifth Avenue Critics, 1905, from the series "New York City Life," etching, 12.7 x 17.8 cm (5 x 7 in.). Philadelphia Museum of Art, Given by Mrs. Alice Newton Osborn

Roofs, Summer Night, 1906, from the series "New York City Life," etching, 12.7 x 17.8 cm (5 x 7 in.). Philadelphia Museum of Art, Gift of Mrs. Alice Newton Osborn

A Band in the Back Yard, 1907, monotype, 13.7 x 17.5 cm (5 ⅜ x 6 ⅞ in.). Terra Foundation for the Arts, Daniel J. Terra Collection, 1987.30

Election Night, 1907, oil on canvas, 67 x 82 cm (26 ⅜ x 32 ¼ in.). Memorial Art Gallery of the University of Rochester, Marion Stratton Gould Fund

Hairdresser's Window, 1907, oil on canvas, 81 x 66 cm (31 ⅞ x 26 in.). Wadsworth Atheneum, Hartford, Connecticut, The Ella Gallup Sumner and Mary Catlin Sumner Collection Fund

Haymarket, 1907, oil on canvas, 66.7 x 81.6 cm (26 ¼ x 32 ⅛ in.). The Brooklyn Museum, New York, Gift of Mrs. Harry Payne Whitney

Picture Shop Window, 1907–08, oil on canvas, 81.3 x 63.8 cm (32 x 25 ⅛ in.). Collection of The Newark Museum, Gift of Mrs. Felix Fuld, 1925

Fishing for Lafayettes, 1908, oil on linen, 21.6 x 26.7 cm (8 ½ x 10 ½ in.). Private collection

Sixth Avenue and Thirtieth Street, 1908, lithograph, 36.2 x 28.3 cm (14 ¼ x 11 ⅛ in.). National Museum of American Art, Gift of Mr. and Mrs. Harry Baum in memory of Edith Gregor Halpert

Fifth Avenue, New York, 1909, 1911, oil on canvas, 81.3 x 66 cm (32 x 26 in.). Private collection, Courtesy of Kraushaar Galleries, New York

Recruiting, Union Square, 1909, oil on canvas, 66 x 81.3 cm (26 x 32 in.). The Butler Institute of American Art, Youngstown, Ohio

Three A.M., 1909, oil on canvas, 81.3 x 66.7 cm (32 x 26 ¼ in.). Philadelphia Museum of Art, Given by Mrs. Cyrus McCormick

The Theater, 1909, monotype, 19.1 x 22.8 cm (7 ½ x 9 in.). The Cleveland Museum of Art, Gift of Mr. and Mrs. Ralph L. Wilson in memory of Anna Elizabeth Wilson, 61.162

Night Windows, 1910, etching, 13.6 x 17.9 cm (5 ¼ x 7 in.). National Gallery of Art, Washington, D.C., Rosenwald Collection

Pigeons, 1910, oil on canvas, 66 x 81.3 cm (26 x 32 in.). The Hayden Collection, Courtesy, Museum of Fine Arts, Boston

Scrubwomen, Astor Library, 1910–11, oil on canvas, 81.3 x 66 cm (32 x 26 ¼ in.). Munson-Williams-Proctor Institute, Museum of Art, Utica, New York

The Picture Buyer, 1911, etching, 12.7 x 17.8 cm (5 x 7 in.). Delaware Art Museum, Gift of Helen Farr Sloan

The Savings Bank, 1911, oil on canvas, 81.3 x 66 cm (32 x 26 in.). Private collection, Washington, D.C.

Carmine Theatre, 1912, oil on canvas, 66.4 x 81.3 cm (26 ⅛ x 32 in.). Hirshhorn Museum and Sculpture Garden, Gift of Joseph H. Hirshhorn Foundation, 1966

McSorley's Back Room, 1912, oil on canvas, 66.04 x 81.28 cm (26 x 32 in.). Hood Museum of Art, Dartmouth College, Hanover, New Hampshire, Purchased through the Julia L. Whittier Fund

Renganeschi's Saturday Night, 1912, oil on canvas, 66.7 x 81.3 cm (26 ¼ x 32 in.). The Art Institute of Chicago, Gift of Mrs. John E. Jenkins, 1926.1580

Six O'Clock, Winter, 1912, oil on canvas, 66 x 81.3 cm (26 x 32 in.). The Phillips Collection, Washington, D.C., acquired 1922

Sunday Afternoon in Union Square, 1912, oil on canvas, 66.7 x 81.9 cm (26 ¼ x 32 in.). Bowdoin College Museum of Art, Brunswick, Maine, Bequest of George Otis Hamlin

At the Top of the Swing, 1913, chalk and india ink on board, 38.9 x 33.3 cm (15 ⅓ x 13 ⅛ in.). Yale University Art Gallery, Gift of Dr. Charles E. Farr

Hell Hole, 1917, etching, 20.3 x 25.3 cm (8 x 9 ¹⁵/₁₆ in.). National Museum of American Art, Bequest of Frank McClure

Greenwich Savings Bank, undated, charcoal on paper, 19 x 22.9 cm (7 ½ x 9 in.). Collection of Oriana and Arnold McKinnon

INDEX